Law and New Media

Law and New Media

West of Everything

Edited by Christian Delage,
Peter Goodrich and
Marco Wan

EDINBURGH
University Press

Edinburgh University Press is one of the leading university presses in the UK. We publish academic books and journals in our selected subject areas across the humanities and social sciences, combining cutting-edge scholarship with high editorial and production values to produce academic works of lasting importance. For more information visit our website: edinburghuniversitypress.com

Edinburgh University Press Ltd
The Tun – Holyrood Road
12 (2f) Jackson's Entry
Edinburgh EH8 8PJ

Typeset in 11/13 Adobe Garamond Pro by
IDSUK (DataConnection) Ltd, and
printed and bound in Great Britain

A CIP record for this book is available from the British Library

ISBN 978 1 4744 4582 5 (hardback)
ISBN 978 1 4744 4584 9 (webready PDF)
ISBN 978 1 4744 4585 6 (epub)

Contents

Part 2 New Frontiers of Jurisprudence

Figures

Contributors

Michelle Castañeda (New York University)

Emanuele Coccia (School of Advanced Studies in the Social Sciences – EHESS, Paris)

Laurent de Sutter (University of Brussels)

Christian Delage (Université Paris 8 and Director of Institut d'Histoire du Temps Présent – IHTP)

Claire Demoulin (Université Paris 8 and IHTP)

Daniela Gandorfer (Princeton University, NJ)

Peter Goodrich (Cardozo Law and New York University Abu Dhabi)

Thibault Guichard (Université Paris 8)

Christopher Hutton (University of Hong Kong)

William MacNeil (School of Law & Justice, Southern Cross University, Lismore, New South Wales and Coolangatta, Queensland)

Antoine Rocipon (Université Paris 8 and IHTP)

Raja Sakrani (University of Bonn)

Marco Wan (University of Hong Kong)

1

Introduction: West of Everything

Christian Delage, Peter Goodrich
and Marco Wan

What is a symbol? It is to say one thing and mean another. Why not say it right out? For the simple reason that certain phenomena tend to dissolve when we approach them without ceremony.

Stephen Gough, that most famous of naturalists, the subject of numerous scholarly syntagms and artistic exhibitions, known to the press as the naked rambler, is the first man to have appeared nude in the Court of Appeal.[1] To the question as to how such a surprising impropriety was permitted by their Lordships and, as it happens, her Ladyship, the answer is paradoxical: he appeared, but only as a simulacrum. Gough remained in prison for the hearing but was allowed to appear on screen by videolink before the Court of Appeal, with the decorum of a table hiding 'his person' from the camera. He was present, but only virtually, as an image, by digital relay rather than as flesh and blood. The event is symptomatic of a sea change in the mode of law's presence in the social, in the manner of its transmission, the forms of its storage and reporting. Virtual justice, in literal terms, is not real justice.[2] Nor is it actual justice. This does not necessarily mean, however, that it is injustice but it does unquestionably indicate radical changes in the thresholds and boundaries of law, in the character and quality of jurisdiction and in the technologies and social media through which law's formerly textual corpus is available and circulates in the multiple zones and platforms of the online public sphere. The literary deceit of before the law, the waiting at the gate, is displaced by novel portals, virtual geographies, and the twilight of classical legal forms which will here be depicted as post-law:

[1] *Regina* v. *Gough* [2015] EWCA 1079, Lady Justice Rafferty: 'By videolink from prison today he sat unclothed from the torso upwards, his lower body obscured by a table. For all we know he was clothed other than above the waist.'

[2] Cornelia Vismann, 'Tele-Tribunals: Anatomy of a Medium' (2003) 10 *Grey Room* 5. See also Delage et al., *Images of Conviction: The Construction of Visual Evidence* (Paris: Le Bal, 2015).

a law unbound, free of its former thresholds, relocated and in the process of reinvention. West of everything is post-law. It comes after the book, outside of the court, as an angelological norm, a byte, a pixel, a tweet, an emoji, a gif attaching and separating, assembling and freeing in the novel networks of the social media and their collectivities made possible through exponential modes of connectivity.

1. Fragmentation

The camera, the first new technology to intrude into the courtroom, initially functioned to bring the world into the space of trial in the form of photographs and visual evidence.[3] The image impacted upon proceedings but did not fundamentally challenge or disrupt the ordered character of the process or the dignity of the ritual as a secluded and sanctified liturgical enactment separate from the quotidian *socius*, protected still by architectural columns, courthouse steps, costumes, ushers, officials and closed doors.[4] Historically, justice might be 'seen to be done' but it would be so visible in seclusion. The courthouse was protected by architecture, the courtroom hidden, most often in the windowless interior of the building, cameras prohibited, sketch artists frowned upon and surveilled, an enigmatic theatre and in visual appellation a twilight and occult space of vanishing signs of actual presence where record and inscription reigned over presence. The internet, audio-visual linkages, computers and handheld smartphones have changed all that. The world enters the courtroom, but the law now also inexorably exits its spaces of sanctuary, egresses, goes viral and enters the world. There is no escape. The enigmatic theatre becomes a crystalline cube, a space of viral and virtual visibility, of ingress and egress beyond the control of legal rules of procedure and decorum of court.

The law has to open out into the social and secular. It has to relocate, virtually and also increasingly in real terms as well. A recent example can be taken from Paris, appropriately enough the city of light, and the new Palais de Justice, the juridical greenhouse designed by Renzo Piano. Located in the district of Batignolles, the new Paris courthouse consolidates five sites currently scattered throughout Paris: the high court, the police court and government law offices. It will also host all borough courts of first instance. Overall, this vast glass courthouse tower will accommodate more than 8,000 people a day (Fig. 1.1).

[3] On which, see Christian Delage, *Caught on Camera* (Philadelphia: University of Pennsylvania Press, 2014) on the history and role of film as evidence.
[4] On closed doors, see *McPherson* v. *McPherson* [1935] All ER Rep 105; *Storer* v. *British Gas* [2000] 2 All ER 440, and for commentary, see Peter Goodrich, 'Specters of Law: Why the History of the Legal Spectacle has not been Written' (2011) 1 *UCI Law Rev.* 773.

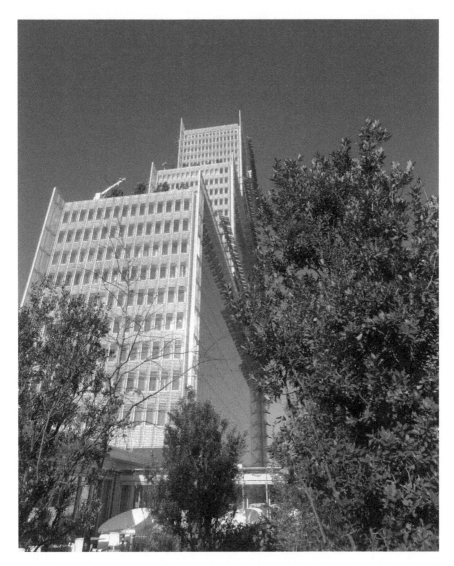

Figure 1.1 Palais de Justice, Paris. © Ninon MAILLARD.

This monumental presence of justice in the city is remarkable for its transparency and apparent accessibility. It wants to be seen and seen through, like a window into the interior, the floor to ceiling glass figures a mode of virginal and pure presence as if law can be walked into and looked through without either guile or deflection. It is designed, recollect, by the architect of the Pompidou Centre, and is mostly white, bright and everywhere windowed, protesting too much that nothing is hidden, that law looks out

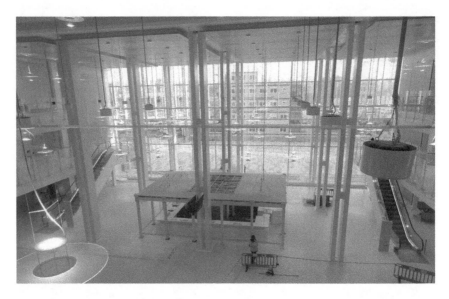

Figure 1.2 Entrance to the Palais de Justice, Paris. © Ninon MAILLARD.

as well into the social, without threshold or apparent separation. Distinct but visible, acting quotidian but remaining esoteric, present yet divided, it may resemble reality TV but, as one commentator opines, it is an exclusive show (Fig. 1.2).[5]

The entire edifice appears gauged to facilitating ordinary, everyday life as the mundane and quotidian modality of what is ironically still titled the 'palace' of justice. The stated purpose of the design is to facilitate and allow 'the citizen to apprehend Justice with a certain serenity', says Piano, as opposed to 'the intimidating, hermetic, dark palace of the past'. Hence the opening out, the invitation, the lack of thresholds are all so many ways of erasing separation, of popularising appearances, of bringing the world into the courtroom while simultaneously allowing the law to exit the confines and spaces of the building and enter the social.[6] The inversion of traditional design makes the court into part of the lawscape of the city in an active and mobile, transitional

[5] Laurent de Sutter, *Post-Tribunal* (Paris: Éditions B-2, 2018) 62.

[6] On questions of court, city and space, see most recently the admirable Andreas Philippopoulos-Mihalopoulos, 'To have to do with the law: An Essay', in Philippopoulos-Mihalopoulos (ed.), *Routledge Handbook of Law and Theory* (2018), perceptively remarking of his own velocipede-inspired work, that 'my contribution to this desire for different conceptualisations has been the lawscape, namely the tautology between law and matter. The lawscape differs from the above in the way it keeps manoeuvring its bodies (which includes our bodies) into regimes of visibilisation and invisibilisation, in the name of the lawscape's self-preservation.'

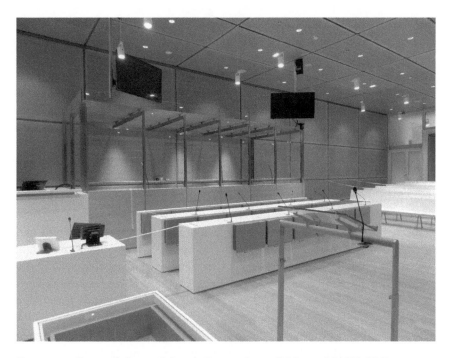

Figure 1.3 Criminal Court, Palais de Justice, Paris. © Ninon MAILLARD.

form, integrating, inviting and expressing, appearing and sending the image of justice on to the streets. To this end, again inverting prior processes, the transparency of glass, the crystalline physical presence, also inevitably augurs the arrival of lenses, cameras and other mobile modes of filming and relaying what occurs within the law. All the ninety courtrooms are equipped with cameras and screens, not only to allow the proceedings to be filmed, but to create a live visual setting, a reality staging in which the process now circulates through diverse relays, of which actual presence is only one and for obvious reasons the most limited in duration and localised in place. The stage and the ceremony become secondary to their own reality as the rites of legal encounter instantaneously leave the real for their fragmented and virtual life on the myriad platforms and relays both within the tower of justice and within the web of non-law (Fig. 1.3).

The protagonists of the trial will not only face each other physically and orally but will also be separated by the technologies of their virtual relay. They will be seen on screen, an interposition and relay which cannot fail to create a kind of distance between them, instead of bringing them closer together in the blush and brine of actual presence and corporeal drama of trial. The world looks in and it is precisely in this mediatisation that the liturgy of the

legal gives way, and the agon and entertainment of trial exits the courthouse to become the subject matter of social media relay, the object of the multiple tribunals of public opinion, the other courts in which the image and avatar of online action becomes the primary character in the drama of post-law.

Novelty, both architectural and technological, and with it remediation and translation, thus bring the possibility of confusion and reaction. While the new translucent and transparent Palais de Justice has been built in Paris, the common law courts continue to fight to restrict the escape of law from the courtroom by means of antique and extraordinary rules, or, more accurately, conventions concerning publicity, imagery, photograph and film. While Paris may be attempting architecturally to see the inside as outside, intimacy as extimate, the paradox of hiding law in plain sight is experienced in British courts in the form of the theft of images and reports from the generally anti-quated courtrooms of 'our lady' common law. Doctrine and administrative dictate still failingly deem real-time commentary, photography and film to be officially illicit. In a fairly standard instance, *Her Majesty's Attorney General v. Kasim-Davey and Joseph Beard*, the two defendants were jurors indicted for disobeying judicial instructions and going on the internet during trial.[7] In the former case, a criminal trial in which the defendant was accused of sexual activity with a minor, the juror went on his smartphone and posted the fol-lowing on his Facebook account:

> 'Woooow I wasn't expecting to be in a jury Deciding a paedophile's fate, I've always wanted to Fuck up a paedophile & now I'm within the law!'

Kasim, twenty years old, did what millennials do and posted or over-shared his experience and viewpoint in a dramatic instance of justice being seen being done in one of its most intimate spheres. In the somewhat less graphic case of Joseph Beard, the juror, during the course of a lengthy and complex fraud case, had used Google to search for the number of investors who had been affected by the scheme and was reported to the clerk when he corrected the omission of figures by another juror.

In both instances the committal for contempt was upheld by the High Court. While it was acknowledged that jurors could not but go on the inter-net during trial – they had to pay their mortgage, other bills, attend to work issues, communicate variously and do their shopping – court instructions not to research or comment on the proceedings had to be respected on pain of fine or imprisonment. To acknowledge, however, that jurors and other partic-ipants are necessarily in court and online, that the world intervenes, already

[7] *Her Majesty's Attorney General v. Kasim Davey, HMAG v. Joseph Beard* [2013] EWHC 2317; see also *Attorney General v. Dallas* [2012] 1 WLR 991.

inaugurates a dissolution of boundaries, a blurring of presence and virtuality, body and image in a fashion that is neither necessarily threatening to law nor as yet comprehended. In another example, a Scottish case, *Howden*, the defendant juror had gone on Facebook and looked at the account of the sister of a witness to determine whether, as she thought, she knew him.[8] Although she sought no further information about the witness, the search was deemed contempt and resulted in a substantial fine. Rules, however, that ignore the virtuality of reality and the reality of virtuality will not last long. The contours and the location of the trial are dissolving, or at least changing and multiplying, and the attempt to maintain a screen or bar between real and virtual, trial and world, becomes ever more extreme and harder to defend.

It remains the case, however, and it is something of a last instance, but penalties and sometimes imprisonment await the juror who accesses the internet or posts online in relation to the trial they are hearing. The contempt is primarily that of disregarding court and frequently expressed judicial instructions to refrain, but it is also infraction of a rule against commenting upon the proceedings, posting reports or circulating images of the process. In *Solicitor General* v. *Cox & Parker Stokes*, to address a further extremity, the committal proceedings were brought because the defendants had taken photographs of a friend who was being sentenced for murder in Crown Court 2.[9] They took five photographs of their friend in the dock and a short video: 'Some images show dock officers. Some images, and the video, include part of the notices prohibiting the use of mobile phones.' Other photographs were of the judge and the courtroom. Whatever the tone of disparagement or outrage, the description is simply of images of what was there and what was happening. It is not as if the charge is of illicit editorial work, of post-production irrealising of the images, and so at most the complaint is in this regard of poor camera work. But that is not addressed and the issue remains that of revealing what is supposed to be open to the world and there to be seen. To continue, however, several of the images were uploaded to Facebook and the second defendant added comments. The defendants were sentenced to prison terms for contempt of court. The paradox of such a juristic outcome, when the whole purpose of trial is publicity, emerges ever more starkly. The camera, the computer, the other handheld devices and terminals present in court inevitably place the trial in the videosphere, on the internet, in the cyber relay of social media presence. Neither criminal stigmatisation nor rulebooks, nor codes of practice nor legislative interdictions can prevent the escape of images and commentary into the variegated and multiple media platforms and relays that mobile technologies

[8] *Howden* v. *Lord Advocate* [2015] HCJAC 91.
[9] *Her Majesty's Solicitor General* v. *Cox and Parker Stokes* [2016] EWCH 1241 (QB).

desire and promote. In bringing the world into the courtroom, the camera and the net now also inexorably relay the court, in Paris, in London, in New York, into the world in myriad forms and received via multiple devices, in snippets, bytes, images and diverse other fragmentary and relocated forms. Technology has catapulted trial, library, rulebook and convention west of everything, into *terra incognita*, unmapped terrain.[10]

The world is linked, and much as the monumental and unmoving facades of traditional courthouses would wish to intimate otherwise, the sedentary and sedimented practices of law have become virtual and viral. Prisoners and witnesses appear in court on videolink, and judges and lawyers enter the carceral regime and the prison cell on television screens, as digital visages – as bald heads, torsos, rears, hands, garments, part objects – and not as visceral bodies, not as the flesh, blush and brine, touch and smell of presence. This virtuality of interaction, the disembodiment of subjects, trial in a floating world, is a radically different event to the haptics and affects of actual inter-actions in what is legally termed 'the presence of the court' (*in praesentia curiae*). The intervention of video and the leakage out of the courtroom and into the world undoes, as our case examples show, the fiercely guarded but ineluctably unsuccessful closure of the court and the rigidity of the places, the hierarchy and ritual of closed legal monologues.[11] The boundaries of the law are broken and the new technologies institute a mobile ontology that law must eventually also be carried by and relayed through.[12] Relocation of law on the internet raises visibility, for sure, but it also diffracts and dissipates, disseminating fragments and posting images of undoctored parts of doctrine and rule. The symbolic statuses and assigned places of the participants are unleashed from their lair and now subject to revision, review and rectification in an era of avatars, blogospheres, video remediation and relay. By the same token the textuality of law and doctrine, the vellum of legislative enactment and the carefully bound volumes of reports, has also been cut loose and set adrift in the fragmentary and unedited dominions of hashtag relay and tweet. Justice is now, increasingly, without administrative filter, being seen and its doing is at least in that sense more open to question.

[10] The expression comes originally from Louis L'Amour, *Hondo* (1953), and is resurrected to great effect in Jane Tomkins, *West of Everything: The Inner Life of Westerns* (Oxford: Oxford University Press, 1992).

[11] Carolyn McKay, 'Video Links from Prison: Court "Appearance" within the Carceral' (2015) *Law, Culture, Humanities* 1–21 at 7: 'The separationist courtroom design specifies and codi-fies the distribution of participants, and hierarchically arranges the proceedings, relationships and communications.' The key early study is Linda Mulcahy, *Legal Architecture* (London: Routledge, 2013) and subsequent essays.

[12] On mobile ontology, see Maurizio Ferraris, *Where Are You?* (New York: Fordham University Press, 2014).

The law library was also historically out of reach, linguistically, semantically and physically, from the general public. Enclosed behind doors marked private, or secreted in the law school, in law offices, in judicial chambers and in courthouses, access was a problem in that few public libraries, for reasons of cost and lack of demand, had any comprehensive legal holdings. The black letter of the legal text could remain inviolate and pretty much unchanging. The old rule, and the source of the term 'black letter law', was that changes to the text had to fit on the page, and so what was added had to be matched exactly to what was removed, as otherwise the prohibitive costs of repagination would render the reporting economically unfeasible. Digitisation also changed that, and although the original platform providers, Lexis and Westlaw, placed high tariffs on entry, the web took care of such confinement and vast amounts of legal materials are now freely circulating on the internet, and again, even in its jealously guarded scriptural bundles, the law is in the world in forms and manners, remediated and fragmented, in ways that had hitherto been frowned upon by the authorities. Even the authorised digital service providers have slackened their controls, and formatting infelicities and typographical errors abound in the online reports, while in the unauthorised snippets and nibbles that circulate and recirculate on the net, the law is close to unrecognisable. Fragmentation and mobile optimisation have not simply removed all context but have also subjected the juridical to the phenomenon of zapping or the inattentional blindness of sending, reading and watching on handheld devices subject to an epistemic of ambulatory viewing.[13] The most striking instance of such unbounded exposition of what we here term the post-law of the web or the becoming law of the fragment is the current use of Twitter by the President of the United States for expostulation of policies and other edicts.[14] While these may have a dubious administrative status and lack the deliberative quality of legislative enactments, the tweets form strong evidence of government policy and also place great pressure on the relevant agencies to comply or at least to prepare to comply.

The tweet is the presidential equivalent of the Facebook posting commenting on the trial at which a juror is serving, in the sense that it conflates spaces and media, and transgresses the traditional boundaries between the interior and secluded – formal and deliberative – proceedings of legal governance and the realm of publicity in a videosphere of exponentially accumulating platforms of social transmission and remediation that mix fact and fake, news

[13] This is the theme, inter alia, of Gabriele Pedulla, *In Broad Daylight: Movies and Spectators After the Cinema* (London: Verso, 2012).

[14] For discussion of the legal status of presidential tweets as directives or edicts on policy, see Note, 'Recent Social Media Posts' 131 *Harvard Law Review* 934 (2018).

and entertainment, politics and law. It is the latter imbrication that is the most symptomatic and transgressive of traditional doctrine.[15] The presidential tweets are treated as evidence of government policy and as grounds for the courts to refuse to implement, as for example in *State* v. *Trump*, where the court takes tweets as probative. For example, on 5 June 2017, the President endorsed the 'original Travel Ban' in a series of tweets in which he complained about how the Justice Department had submitted a 'watered down, politically correct version' to the Supreme Court, and continued: 'People, the lawyers and the courts can call it whatever they want, but I am calling it what we need and what it is, a TRAVEL BAN!'[16] Here, and even more so in relation to the banning of transgender personnel from the military or tweets directed at the Department of Justice and indirectly at the FBI insisting on further investigation of his opponent in the presidential election, Hillary Clinton, the line between politics and law becomes ever more blurred and we witness in the new media 'the total collapse of distinctions between informal speech and presidential directives', at least, in this instance, during judicial review.[17]

Take another related example, the Twitter account @realDonaldTrump. It has become a significant source of news and information about government, and an important public forum for speech by, for and about the President.[18] The issue in US law that Twitter here pushes is that of freedom of speech in relation to novel platforms and forums. The Supreme Court has recognised that Facebook and Twitter provide 'perhaps the most powerful mechanisms available for the citizen to make his or her voice heard'.[19] The shift in power suggests a species of direct democracy, of instantaneous communication between civic constituents and public officials becomes possible in what could be described as a transformative fashion. Politicians are almost universally on Twitter. The legal issue that arose in the Trump Twitter case was that @realDonaldTrump blocked the plaintiffs from the account because of the negative views that had been expressed in response to Trump tweets. The plaintiffs' argument is that the Trump Twitter account is an official public forum, a site of presidential communication and part of the official record of the administration that has to be preserved under the Presidential Records Act.[20] The tweep Trump's tweets are treated by the

[15] Katherine Shaw, 'Beyond the Bully Pulpit: Presidential Speech in the Courts', 96 *Texas Law Review* 71, 76 (2017).

[16] *State* v. *Trump* 265 F. Supp. 3d 1140 (2018).

[17] Shaw, 'Bully Pulpit' at 128.

[18] *Knight First Amendment Institute at Columbia University, et al.* v. *Donald Trump* 302. F. Supp. 3d 541.

[19] *Packingham* v. *North Carolina*, at 8.

[20] *Knight First Amendment Institute* v. *Donald Trump* (filing) at 15.

courts, as adverted to above, as statements of policy and as evidence of the motives for the Travel Ban and so, arguably falling under the protection of the First Amendment, the argument for the plaintiffs is that commentators cannot be blocked. Earlier case law relating to an official of a county board of supervisors blocking a constituent from Facebook has indeed supported such a conclusion.[21]

Whichever way the courts decide the @realDonaldTrump suit, the significance of the case is not in its outcome but in the medium and form. Law has to head West and address a variable and instantaneous domain of Twitter and Facebook web pages, 140-word tweets and retweets, likes and dislikes, followers and commentators. Text is displaced by image and splashpage as the visual evidence of fragments and sequences of communication that know little of archive, library or classical black letter texts. Abbrevs, emoticons, emojis, gifs and other forms of cut and paste of symbols and pictures, together with hyperlink and handle, reference a plurality of spheres and media that increasingly escape morals and law alike. It is important to note here that west of everything is intrinsically open to multiple uses, not content specific but rather an escaping, anarchic form that has populist as well as dialogic uses, that is open to robots, to humans, to scraping and trawling, to the pornography of law or, as was posted on @realDonald Trump: 'My use of social media is not Presidential – it's MODERN DAY PRESIDENTIAL.' That is indeed, and ironically, the message. The messenger is the message, the medium is the law, a point that can also be seen by viewing the images used to make the case against Trump. Fig. 1.4 shows the authorisation and promotion of presidential action, replete with a plausive Vice-President, an official backdrop, and a podium with the insignum of POTUS. To the side there is the designation, '45th President of the United States of America', the photoportrait and the tweet. All of which combine in an image, a splashpage that forms an unclassified videogram, a quasi-legal normative posted pronouncement which, while not properly in the mode and manner of admissible legal procedure of lawmaking, is not unrelated to legal edict, executive order or legislation. The virtual collapse of the separation of powers suggests also a dislocation of the distinction of discourses, of law and politics, economy and *oikonomia*.

According to traditional, positivistic legal doctrine, these tweets not only do not make law but should be ignored as markers of administrative policy for the very good reason that 'in each case in which presidential statements are invoked, their treatment appears largely ad hoc, undertheorized, and badly in need of guiding principles'.[22] Law, in sum, is slipping away, taking

[21] *Davison v. Loudoun County Board of Supervisors* 227 F.Supp.3d 605 (2017).
[22] Shaw, 'Bully Pulpit', at 76.

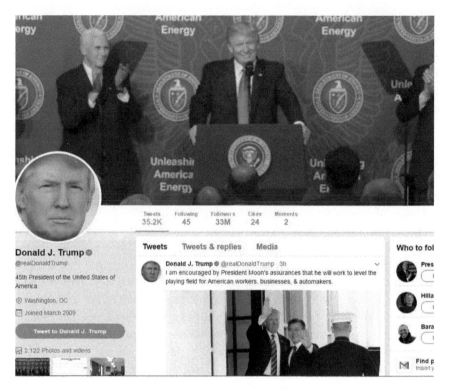

Figure 1.4 @realDonaldTrump. Public site.

new and unwarranted forms, and yet, however much one might agree with the scholarly commentators and humanistic critics of informal or post-law, it is increasingly here to stay. Law porn is a reality. The desire that secrecy generates, the phantasm that there is something to discover, that entering the bounded space of law will reveal its secrets, lingers here in its death throes as the pages are opened and mutilated, tweeted and retweeted, fragmented and mobile optimised as entertainment, as one more channel or yet another fragment to be browsed, trimmed, liked or ignored. What Deleuze and Guattari term the 'porno book' of law is now on Twitter, YouTube and #Hashtag Law.[23] And, through exposure and familiarity, it is moving in the direction of everywhere and nowhere. Familiarity also breeds content, multiplication, diffusion as dilution. There is the danger or the hope that law will be drained of almost all of its catharsis, and denuded of its desire. Bereft of threshold and deprived of ceremony, law resiles to mere administration.

[23] Gilles Deleuze and Felix Guattari, *Kafka: Toward a Minor Literature* (Minneapolis: Minnesota University Press, 1986) at 49.

2. Post-law

The axes of post-law are those of relay and transmission. It is a question of opening out, of transgressing the traditional modalities and media, forms and boundaries of legal expression and delivery. West of everything, law porn, has a certain twilight quality, not because we are beyond or after law, but rather because in its exponentially proliferating and multiform fragmentations, legality is unloosed from its texts and their sepulchre, the library. This relocation, the novelties of new postings, are initially those of pixelated incontinence, of leakage, the slippage of instantaneous vapour exiting any confine, actual, virtual or augmented real. The clip, the byte, the meme or tweet that are posted, blogged, tagged or otherwise circulated in emended and untethered forms, are first a mode of relocation of law, changes of sites, sightings, venues, occasions and events. This is an insight that derives from post-cinema studies in that the breakout of film from the 'dark cube' or theatrical showings on to the mobile sites and viewing devices of the optimised web institutes a pattern that, with all its usual lag, law follows. Thus, for Pedulla, the movement of film out of the dark and intense collective and extended temporal experience of the auditorium viewing, on to the television, with its remote control and constant channel zapping, and then to smartphones and computer screens, pads and pods, more than anything else dissipates the cathartic impact of the movie. Empathy evaporates, attention wanders and the volatility of the spectator changes the medium. Film, in these new post-cinematic environments, in broad daylight (*in piena luce*), has to battle both the disengagement of the viewer and the myriad forms of competition for attention that zapping and now clicking can provide. Cinema loses it gravitas, the theatre no longer sits at the pinnacle of a hierarchy of sites of viewing, and instead an aesthetic of the fragment, a cinephelia of the sequence, now fights for the volatile spectator's viewing attention.[24]

The latter point, that the volatile spectator has to be lured and their attention retained, if only for a sequence, is the crucial one. For post-cinema studies this means attending to very different techniques of filming – close-ups, zooming, tracking, panning and craning, special effects, green screen, digital post-production – work to effectuate a species of shock and awe that Pedulla discusses in terms of 'shark aesthetics'.[25] The fragment, unleashed from the film, has to capture attention, and the most effective way of doing so is by

[24] Pedulla, *Broad Daylight*, at 135: 'It is possible . . . that video players, as well as the ability to download movies, have stimulated a cinephilia of the fragment and the sequence – a cinephilia that works with and without authors – that just a few decades ago was simply unthinkable.'

[25] Pedulla, *Broad Daylight*, 83.

using images to appeal to a pre-rational reaction from the viewer. The pupil automatically dilates upon seeing an image of a naked wo/man, a baby, a tiger or a shark. This instinctive response to the depiction operates as a species of hidden persuasion in the sense that while the viewer may know that the tiger is not real, the visual apparatus does not react initially in that way, but rather refuses to distinguish the real from the represented.[26] The struggle for viewers in the post-cinema era triggers new media forms and techniques that circumvent the traditional criteria of truth in discourse in favour of impact and effect, circulation and adhesion.[27]

The post-cinematic – the west of everything that we now inhabit as our filmic virtuality – by analogy relocates the legal institution and imposes the choice of reinvention of law or desuetude and demise.[28] It is this relocation that the present volume embarks upon tracking in its varied spheres and forms since the invention of photography and film. Relocation of law seems, as adumbrated in terms of the necessary connectivity of court and law, enactment and practice, the inevitable recognition of technologies that catapult the juridical into the virtual and place the fragments and images, bytes and pixels of legality, of rules and decisions, on the web, in the context of and in competition with the myriad flow and effulgence of other fragments and sequences. The first effect of this relocation is the phenomenon of zapping, the heightened levels of competition for attention. Post-law, which is also of course law that is posted, has to withstand juxtaposition and comparison with the myriad alternative clips, bytes, sequences and fragments that inhabit the videosphere. In an era of zapping, channel surfing and mobile-optimised viewing, the competition for attention is extreme and the traditional forms of theatrical staging, the unities of time, space and narrative continuity, are dissolved.

Courtrooms are filmed, reality TV follows fictional courts and media-star judges, clips and fragments from a swathe of different courtroom dramas and actual trials appear and go viral on the internet. Competition for viewers encourages dramatic sequences, comedic moments, 'reveals' of outcome rather than process or doctrinal elaboration. The mediatisation of the juridical throws the law into a realm of uncontrolled, volatile and fickle platforms and relays in which only the most attention-grabbing and screen-capturing sequences survive in the competition for viewers. The import of such diffracted diffusion is that there is an interchange, a necessary though often

[26] Pedulla, *Broad Daylight*, at 84.

[27] Traditional, which is to say pre-virtual, theories of truth depended for materialists upon some version of a correspondence to truth, while for idealists it was rather coherence and occasionally aesthetics that determined veracity.

[28] On relocation and reinvention, see Francesco Casetti, *The Lumiere Galaxy: 7 Key Words for the Cinema to Come* (New York: Columbia University Press, 2015) 203–15.

denied interaction between new media and old law. The courts increasingly communicate via social media, organisational communication is shaken up, and, as adumbrated earlier, cameras, pictures, posts, emails, tweets and blogs flow ever more frequently between and through court and world.[29] The mixing of images and stages, as courtroom dramas, reality TV and televised proceedings all indicate a reformulation in the twilight of the classical rule of law, is suggestive of a greater bandwidth to the interaction between, and exodus of, court and law into the world.[30] Take another instance, 'Hashtag law', as discussed by Carr and Cowan.[31] The internet loops the law into the flux of new social media and the repetitive and evaporating scenography of online sequencing and mobilisation. The authors use the example of a change in housing benefit regulations in 2012. As part of an austerity drive, the British government enacted the Housing Benefit (Amendment) Act 2012, which introduced a reduction in benefit for under-occupied social housing, with immediate effect.[32] The legislation was poorly drafted, ill-thought-out and predicated upon erroneous economic assumptions. It was also highly unpopular with those impacted and so resistance took not to the streets but to the internet and to Twitter.

The implementation of the regulations had severe and probably unintended effects upon the disabled, the ill and the vulnerable. There were reports of suicide attempts at housing and job centre offices, and considerable criticism of the logic of the rules from the opposition. The response to the regulations that is of interest here is that of the co-ordinated and successful microblogging that the new rules triggered and which resulted in a degree of legal change. The internet, hashtag and tweet, in other words, became a platform for a polyvocal and pluralistic set of juridical interactions as also doctrinal and policy interchanges that circulated not only in the legislative and administrative bodies but also in the decisional tribunals. The remediation process can be schematised in terms of tagging (hashtags), shaming (trolling) and swamping (crowding). Perhaps the most successful aspect of the campaign against the regulations was the hashtagging or renaming of the Act as the 'bedroom tax'. Drawing on the unpopularity of taxation, and

[29] See, for example, Jane Johnstone, 'Courts' Use of Social Media: A Community of Practice Model' (2017) 11 *International Journal of Communication* 669.

[30] The phrase is a reference to John Gardner, 'The Twilight of Legality', Oxford Legal Studies Research Paper No. 4/2018. Available at SSRN: https://ssrn.com/abstract=3109517.

[31] Helen Carr and Dave Cowan, 'What's the Use of a Hashtag? A Case Study' (2016) 43 *Journal of Law & Society* 416.

[32] S.I. 2012 3040 Reg. 5. Specifically, if a property was under-occupied by one bedroom, there was a 14 per cent reduction, rising to 25 per cent for two bedrooms. A bedroom, however, is not defined in the regulations.

distant memories of the 'Poll Tax', the tag pulls a dull administrative code into the viral environment of social media. The consequence is widespread circulation, rapid redefinition and a general exposure that inexorably drags the administration, lawmakers and law interpreters into the incontinent and volatile relays of the new media. The cohesive effect of the tag also attracts followers and produces strategies. Scraping, shaming and trolling ensue, meaning that dubious or simply incoherent First Tier Tribunal decisions get reported, dissected, criticised, mocked and blamed. This occurs, of course, at variable levels of sophistication, but the tag and the reporting distil a crowd-based antipathy and oppositional network of resistance, as well as remediating the doctrinal elaborations and parsing in images.

The hashtag rapidly crowds and swamps the tax, its administration and interpretation, in ways that serve to fill up the empty spaces of law. The tweeps are too numerous to be ignored and thus swamping occurs at the level of regulatory or governmental practice, and reinterpretation of the code ensues. Legislature, Department of Work and Pensions, and courthouses are all hooked up, linked in and virtually engaged, sensitive, as policy must always at some point be, to the online crowd critique, the imagery, labelling and exposure of adverse effects. The hashtag law is one of remediation and looping whereby microblog fragments, the sequences and clips, images and banners that circulate virtually, rapidly – which is to say much more rapidly – become part of the discourse of administrative practice and of law. If the actual legal impact, in this example, is somewhat diffuse and partial, there is still no question that it is there and that law changed. The courts stipulated that Article 14 of the Human Rights Act 1998 would be infracted if discretionary payments were not provided for the disabled.[33] More to the point, the political and the legal intersect in this new media environment in a manner that exponentially changes the course and circulation of law. As the authors of the study argue, the hashtag represents a flattening of power structures, a potential democratisation or, depending upon one's viewpoint, vulgarisation of law, in that the boundaries of the juridical are collapsed by the media of their dissemination, both intentional and unintentional, as they are released, leaked or hacked.[34] There is no longer any wall, moat, dyke or division between the interior and the exterior, the wholly controlled diffusion and the freeplay of the net. They are indissolubly joined, Siamese.

Post-law thus suggests transgression, a movement beyond law, a remediation of legality by virtue of the move to the virtual and by dint of the novelty of the digital media, the videosphere and its variable capacities. The concern of lawyers, at least of traditional and black-letter positivistic officials, is that the rules of

[33] *R (MA and others)* v. *Secretary of State for Work and Pensions and others* [2014] EWCA Civ 13.
[34] Carr and Cowan, 'Hashtag', 439–43.

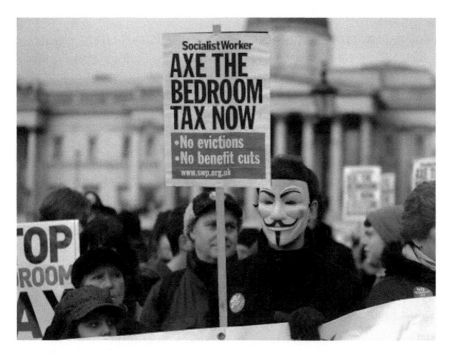

Figure 1.5 *V for Vendetta* mask in London 'Bedroom Tax' protest. Digital commons.

recognition are being scrambled. The fragment is a byte, some mediated mode of momentary incursion, an atmosphere, a Deleuzian reticule that circulates with and intervenes in and as law, decomposing and realigning rule and desire, norm and affect in the immediacy of a swamping or at least crowd-sensitive response. The image, in this regard, plays the role of invention or instigation, of banner or clarion. It has its own network and genealogy which we can instance briefly by returning to the example of hashtag law and the bedroom tax. Borrowing from one of the most extreme instances of post-cinema, the mask from *V for Vendetta* is activated in the protest and goes viral in an image (Fig. 1.5). The mask wields a heavy weight of connotations of collectivity.[35] It is the symbol of the 99 per cent, a global signifier that was used not only in Britain, but in Brazil, in Hong Kong, in Saudi Arabia, and in short in a stunning diversity of contexts and locations as a sign of anonymous resistance, of impersonality in the sense of collectivity.[36] The mask brings a multitude. This is so by visual connotation

[35] See Peter Goodrich, 'The Mask as Anti-Apparatus: On the Counter-Dispositif of *V. for Vendetta*', forthcoming in Thomas Giddens, *Comics and Critique* (Columbia: University of Missouri Press, 2018).

[36] On the history of the person and the theory of impersonality, see Roberto Esposito, *Third Person* (Cambridge: Polity, 2012) ch. 2; and again in Esposito, *Two: The Machine of Political Theology and the Place of Thought* (New York: Fordham University Press, 2015).

as well as by emblematic depiction. The mask, the quintessential sign of legal personality, is also a theatrical device which makes plain that the *persona* that is presenced in the mask is a simulacrum, a sign in the public play of the social, and here, in *V*'s mask, an anti-apparatus, a rebellious marker of identity as a refusal to be identified and so a common visage of commonality. Appropriately enough, it is one of many such variably staged images of libertarian resistance to centralised and oppressive power, signalled visually in the domed, neo-classical, governmental architecture in the background.

In Fig. 1.5 it is the National Gallery, but in others it is courthouses, steps, thresholds, against which the mask manifests as collective freedom and opportunity of expression. As anti-apparatus, the assertion of identity as the absence of identity, as the collectivity of personality and the sociality of freedom, the image carries an affective surplus that imbues discourse with desire, law with affect.[37] The moment of invention, the motive of collect and congregation, becomes visible in the opaquely recognisable painted face of protest, the theatre of the social laid bare by its bearers.

3. Imaginal Law

The law's relationship to the image is marked by ambivalence. It is a relationship of both need and repudiation, love and hate, appreciation and disdain. On the one hand, the image is a crucial part of the law's self-formation. On the other hand, the image can ironically undermine the law's vision of itself. The image has the power to both make and unmake the law, to enhance and dissipate the law's gravitas, to entrench or subvert law's authority. The lawyer's attire, such as wigs and gowns, for a long time constituted a crucial part of his professional identity, and the portraits of judges in the law courts often serve as an important reminder of the weight and grandeur of judicial office. Judicial portraits are 'state portraits' in that they depict judges not simply as individuals but as officers of the state. As such, they contribute towards the forging of the institutional identity of the judicial branch. Moran posits that 'in the judicial portraiture, the pose of the body, background, costume, props, and so on are all signs through which the values and characteristics of the judicial institution are represented'.[38] The judicial robes, for instance, that hide the specific bodily features of each individual 'symbolize the judicial

[37] For erudite and provocative deliberations on masks and masking, see Connal Parsley, 'The Mask and Agamben: The Transitional Juridical Technics of Legal Relation' (2010) 14 *Law Text Culture* 12–39; and most recently, Timothy Peters, '"Holy Trans-Jurisdictional Representations of Justice, Batman!": Globalisation, Persona and Mask in Kuwata's Batmanga and Morrison's Batman Incorporated', in Tranter et al. (eds), *Law and Japanese Popular Culture* (London: Routledge, 2018).

[38] Leslie J. Moran, 'Judicial Pictures as Legal Life-writing Data and a Research Method', 42 *Journal of Law and Society* (2015), 74–101 (87).

virtues of individual self-effacement through dedication to justice and the word of the law'. The robes are meant to make the judges look alike, and thus constitute 'part of a visual code that makes public the judicial subject's embodiment of the key judicial virtues of sameness, repetition, endurance, continuity, and consistency'.

When we turn from the law courts to law schools, we find a similar dynamic of visual inculcation at work.[39] There exists a series of photographs of tenured law professors in the main corridor of Wasserstein Hall at Harvard Law School. This part of the corridor is known informally as the 'Faculty Wall'. The idea of displaying images of law professors at Harvard began in the nineteenth century; the first faculty portrait was of Simon Greenleaf, who was first Royall Professor and then Dane Professor, and it was acquired in 1848.[40] As different technologies developed over time, the oil paintings were superseded by black-and-white photographs, which were in turn superseded by the digital prints that still hang on the wall today. Yet the effect of the display of these images remained the same: as one law professor put it, the prints provide 'a real sense of continuity' and remind members of the law school that they are 'part of a tradition'. The images of the law teachers are thus proxy for the continuing endeavour of legal training over time. They are a crucial part of the law school's self-identity; they not only remind its members of the institution's past but actively interpellate them into an ongoing tradition of professional self-formation.

The same law professor also, however, notes that it was not uncommon to see students 'laughing' at what their teachers looked like at the time the photos were taken. The students' reactions suggest that despite its efforts at self-fashioning through the careful creation, selection and arrangement of images, whether in the law courts or at the law school, the law can never fully control the effect such images have on its identity. Time throws issues of race, gender and performativity at the bastions of tradition and icons of professional probity. While the images are supposed to underscore the institution's authority and perpetuate its values, they can also cause laughter, and invoke ridicule, mockery, critique, or the indifference and disidentification that comes with the simple passage of time. Law has also and always been wary of images because they reveal too much. While it uses images to imagine itself, to impose on the public sphere, law's dependence upon depiction increasingly interrupts and threatens to subvert the ways in which law self-imagines. From the call to banish the painter along with the

[39] On portraits at Yale Law School, see Kenji Yoshino, *Covering: The Hidden Assault on our Civil Rights* (London: Random House, 2006). On decanal portraits, see Goodrich, 'Megalography' in Ahrens Stierstorfer (ed.), *Symbolism* (New York: AMS Press, 2008).

[40] Harvard Law School's Faculty Portraits: a Backdrop for Daily Life at HLS. https://www.youtube.com/watch?v=nUtVTyw0-uI

poet in *The Republic* of Plato to the banning of mobile phones and video cameras in the courtroom, it is the image that is hardest to contain and most resistant to conscious control.[41]

Paintings, lithographs, films, television programmes and digital images have all interrogated law in different ways. One could do worse than to start with the lithographs of the nineteenth-century printmaker, sillographer and caricaturist Honoré Daumier.[42] Daumier worked as a clerk to a *huissier* and later lived across from the Palais de Justice in Paris. His drawings of lawyers, judges, and the operations of the law courts are primarily gathered in three series, *Caricaturana*, *Les Gens de Justice* and *Les Avocats et les Plaideurs*. Daumier's caricatures of snoozing judges, greedy lawyers, corrupt advocates and hapless defendants, among other characters, not only mocked the justice system but forced it to acknowledge its imperfections. In the twentieth century, television programmes such as *Ally McBeal* further eroded the gravitas of the law by exposing lawyers not as defenders of justice but as normal human beings marked by imperfections such as self-absorption and insecurity. In East Asia, Joe Ma's *Lawyer, Lawyer* (1997) debunked the myth of the rule of law in colonial society and portrayed the British judge in colonial Hong Kong as incompetent, stubborn and intellectually unimaginative. In Ma's film, the judge is ultimately outwitted by the Chinese *songshi* and forced to release a man who had been framed for murder. Finally, figures such as Judge Judy and Judge Rinder create a populist conception of the legal process by presenting it as a form of light entertainment. As the courtroom is turned into a series of televisual images, part of the solemnity of law is sacrificed for higher ratings.

Approaching and apprehending the imagery in and of judgement and more precisely the imaginal character of law in an increasingly imaginal videosphere is a specific focus of post-law and the 'west' of west of everything. Etymologically, west, from the Greek *hesperos*, and the Latin *vesper*, means evening, and by extension, the end of the day, dusk, demise and death. West of law is the twilight or impending end of a positivised conception of law, the demise of the jurist's *usus modernus*, and, as adverted earlier, its relocation in the non-place or atmospherics of virtuality where

[41] On the juridical fear of images, see Costas Douzinas, '*Whistler* v. *Ruskin*: Law's Fear of the Image' (1996) 19 *Art History* 353; and the essays collected in Costas Douzinas and Lynda Nead, *Law and the Image: The Authority of Art and the Aesthetics of Law* (Chicago: University of Chicago Press, 1999); Rebecca Tushnet, 'Worth a Thousand Words: The Images of Copyright Law' (2012) 125 *Harvard Law Review* 683.

[42] Harold F. Porter, Jr, 'A Lawyer Looks at Daumier', 44 *American Bar Association Journal* (1958), 530–3.

the increasing isomorphism of post-law and post-cinema reveals the histori-cally hidden genesis and desire of legal action in the various scenes of its enactment.[43] The image is the device of juristic performance and changes the epistemic status of law, its mode of being and trajectory in the social. First, the term imaginal has its roots in the Arab reception of Aristotle and its translation into English.[44] It is this morphology that motivates Coccia in his work on *la vita sensibile*, sensible and sensory life, in which the imaginal is our mode of being in the world, the embodiment of our spirit, the medium of our ideas.[45] The imaginal is for Coccia our other life and it is here, drawing on Averroes, that he argues for our philosophical citizenship, the republic of ideas, as having a medial existence, an imaginal sociality outside of ourselves in the collectivity of thought. The imaginal, in the theory of sensible life, is the embodied: medial space exists objectively, which is to say externally, in images that form what Coccia designates an '*objective unconscious*'.[46]

Inhabitants of images, denizens of an imaginal, diffractively shared world, we are subjects, as the antiquaries liked to say, of the *ius imaginum*, the order of images. It is images that make life possible: 'The image captures the real (whether this be psyche or object), and transforms it into something that is able to exist beyond itself, beyond its nature and individuality; the image multiplies the real and renders it infinitely appropriable.'[47] It is the ground, in this sensibility, of the social, the imaginal medium of existence as plurality, of consciousness as transmission, the form of appearance and identity, and the origin of law as a theatre of justice and truth. It is in this latter sense of institutional norms and political pathways that Bottici takes up the philo-sophical dimensions of the imaginal, arguing not only that it is our state but also our condition of possibility. The imaginal is not reducible, it is a presence in itself and not a manifestation of something else. For Bottici, the imaginal thus has an intermediary status of being both real and fictitious: 'it is what makes the world possible . . . the imaginal is a field of possibilities'.[48] Turn to your images is her rallying call, enter the imaginal as both conscious and

[43] Janet Harbord, *The Evolution of Film: Rethinking Film Studies* (Cambridge: Polity, 2007) use-fully develops this theme in terms of morphogenesis and inertia.

[44] This genealogy is provided in Chiara Bottici, *Imaginal Politics: Images Beyond Imagination and the Imaginary* (New York: Columbia University Press, 2014) 55–6.

[45] Emanuele Coccia, *Sensible Life: A Micro-ontology of the Image* (New York: Fordham University Press, 2016) at 8.

[46] Coccia, *Sensible Life*, 52.

[47] Coccia, *Sensible Life*, 97.

[48] Bottici, *Imaginal Politics*, 61.

unconscious, individual and collective, and become aware of the world you inhabit in its sensible mode and medial forms. Critique is here awareness of images, openness to thought and to the collectivity of thinking.[49]

For Bottici, as for Coccia, the image world is what makes existence possible: it is internal and external and it is not only undeniable but increasingly insistent, impossible to ignore in the domain of populist politics and now also coming to be recognised in the previously confined spaces of law. Manderson has done much to develop a theory of image laws in the form of a critical awareness of the imagery internal to and used by the legal institution in its various modes of social presence.[50] The imagistic media of law, the various online platforms and microblog sites and apps that disseminate the decisions and other legislations of the jurist are shared media and social modes of digital relay. Law is untethered from its pretended materiality, it enters the social in an inescapable form of commonality and increasingly it loses its authorisation and authority and is remediated in fragments, juxtaposed with other fictions, circulated in nibbles, bytes, memes and blogs in a videosphere that glories in the absence of borders and the anarchy of free expression. Post-law is exactly that, posted law, and equally it is a law that comes after, west of the antiquated scriptural confines of gothic black letters and their cloistered confines. As Manderson puts it, law is increasingly fought out in the realm of images and via the oscillation between image and discourse, law and the social, in viral patterns: 'Imaginal law requires a constant recalibration of the dialogue between law and society, history, visual studies, and theory.'[51]

It is not just that the blank spaces of law are increasingly directly filled in with media taken from the informal or at least juristically unofficial virtual relays of the net, that the meaning of terms, the purpose of a norm, the scope of a category are deliberated in and through shared medial channels and sensible – synaesthetic – relays. It is as much, or more, that the performance of law materialises, is visible, on the web and in the social. The inescapably performative character and visceral effects and affects of determinations used only to be visible in the past: in the mode of murals, paintings, documentary and narrative film. Precedent, as Castiadoris observes, is 'the will to abolish novelty as such, and to unify the flow of time', whereas the dispersion of

[49] We can here also note the important contribution of Roberto Esposito, *Two*, at 143 et seq., elaborating his theory of impersonality and developing Averroes' concept of the 'materiality' of the intellect outside the confines of the individual.

[50] Desmond Manderson, *Danse Macabre: Temporalities of Law in the Visual Arts* (Cambridge: Cambridge University Press, 2019); and Manderson (ed.), *Law and the Visual* (Toronto: University of Toronto Press, 2018). Again on the visual and the legal, see Goodrich, '*Imago Decidendi*: On the Common Law of Images' (2017) 1 *Art and Law* 1.

[51] Manderson, 'Introduction: Imaginal Law', in *Law and the Visual*, at 6.

forms and images on the net multiplies and diffuses the temporalities of law.[52] The plurality of platforms and sites of transmission, the increasing visibility of law's performances, engages new audiences, new modes of emancipation of the spectator and a diversity of novel inputs and interventions, from Hashtag law to reality TV. This is law unwired, as Julie Peters puts it, and it represents an opportunity, the explosion and diffusion of the legal via the mediality of its instruments and proofs, from the dashcam to the chestcam to the helmetcam, the performances of the law enforcers are there to be seen, just as phonecams, touchpadcams and computercams relay pretty much any and all juristic events.[53] The result is post-law, a relocated realm of the visiocratic – of scopic regimes of control, and contested relays of recognition – and the ever-present need for a dormant legality to reinvent itself as collective thought embedded in and contributing to quotidian modes and fashions in inventive and imaginative manners.

To be west of everything is to acknowledge a sea change, and in post-law this means recognising and rethinking the legal in the spaces and senses of the previously hidden, the appearance of the social interior in the imagistic realm of invention and performativity on the stages and sites of an augmented scopic regime and dominion. These instances of normative governance and administrative practice may be good or bad, coherent or irrational, but that an image-laden, thoroughly visible legality is now our fate can only be denied by means of evasion of the medial apprehension and haptic relays of contemporary judgement in the videosphere.[54] Post-law means that law is everywhere, that it is numerous and pervasive, and so also that it potentially no longer clings to the essentially theological character of the nomocratic and spectacular state of sovereignty. Increasingly we judge by looking, watching, viewing, voyeuristically intoning and deciding. The same sea change accosts judges who are drawn to perform and forced into the political in novel ways.

4. Exponential Connectivity

The coming struggle is one over the sites and the media of social disposition. It is a question not simply of jurisdiction, of what law governs, of who is authorised to speak, to determine and rule, but also of an anarchic multiplication of spheres and forums of connectivity, of platform and relay.

[52] Cornelius Castiadoris, *The Imaginary Institution of Society* (Cambridge: Polity, 1987) at 158.

[53] For an excellent overview, see Julie Stone Peters, 'Theatrocracy Unwired: Legal Performance in the Modern Videosphere' (2014) 26 *Law and Literature* 31; and Alan Read, *Theatre and Law* (London: Palgrave, 2015).

[54] Julie Stone Peters, 'Law as Performance: Historical Interpretation, Objects, Lexicons, and Other Methodological Problems', in Elizabeth Anker and Bernadette Meyler (eds), *New Directions in Law and Literature* (Oxford: Oxford University Press, 2017) 193.

If assemblages, meaning bodies, spaces and networks, are momentary and multiple, both real and virtual, novel combinations of image and materiality, simultaneously apparent and vanishing, then law inevitably must change or resile to desuetude. What does this mean? First, most strikingly, new media inaugurate a change in sensibility, a relocation and reinvention of the lawscape, the atmosphere of the norm, as contingent upon the bodies that relay it and the media of its apprehension. What, after all, is a law other than a patterning – framing or assembling – of behaviours in their disparate and now increasingly mobile moments of enactment. Law, as apparatus or *dispositif*, frames or excludes what does not conform to the regimen of its vision.[55] What law cannot apprehend, it cannot govern, and so in moving west of everything the jurist has to defer to novelty and learn from encounters with their own incompletion, the law of transmission beyond law, the space of non-law as that of the opening, the hole in the fabric of habitude, the last stop on an endless line.

Exponential connectivity, the multiplication of subjects and environments, presents not only radical novelty but also opportunity for the reinvention of law appropriate to the mobile relays, contexts and sequences in which the imaginal appears within and outside, internally and externally as law and as a law beyond law. The methodological starting point is that of opening to new environments, of letting the context, the image, the assemblage of bodies feel, express, speak or show. The question of opening, well developed by Georges Didi-Huberman, is precisely a matter of attention to what is encountered, viewed, interacted with, responded to and born from without within.[56] The image opens, it breathes, it comes alive if the viewer is attentive to their relation to it, their intervention and interaction on the matter and materiality of their making sense. What is encountered west of everything creates the law as much as it is subject to it. It has its own jurisdiction, rights, vision, affect, speech, which this volume endeavours to track and depict in the mode of their freedom.

Returning to the exemplum of Twitter as a social media platform that effects a loopback impacting law, the notorious and highly publicised case of *Chambers* v. *DPP* is instructive.[57] Recollect – how could you not? – that the appellant, Paul Chambers, was due to fly to Belfast to meet a fellow tweep, 'Crazycolours', who he had met on Twitter. He was scheduled to

[55] Allen Feldman, *Archives of the Insensible: Of War, Photopolitics, and Dead Memory* (Chicago: University of Chicago Press, 2015).
[56] Georges Didi-Huberman, *L'Image ouverte* (Paris: Gallimard, 2007).
[57] *Chambers* v. *DPP* [2012] EWHC 2157.

fly on 15 January, but on 10 January he became aware that conditions at Robin Hood Airport had led to its closure. Chambers tweeted:

> Crap! Robin Hood Airport is closed. You've got a week and a bit to get your shit together otherwise I am blowing the airport sky high!

This tweet landed the tweep in court on criminal charges and he was convicted for sending by a public electronic communication network a message of a 'menacing character' contrary to s.127(1)(a) and (3) of the Communications Act 2003. The conviction was upheld in the Crown Court, the message being deemed 'menacing per se', and the case then went on appeal before the aptly named Lord Judge in the High Court.[58]

It is significant first that the appeal was crowdsource funded, with a general social media push back, including several celebrity contributors, leading to considerable adverse comment and a refusal to accept the humourless and draconian decisions of the Magistrate and the Crown Court. Lord Judge makes, of course, no reference to the context or the social media critique of the decision, but rather begins his judgement, as if to deter comment, with a two-page extract from the 2003 Act. He then mimics the twelfth-century philosopher John of Salisbury and defines Twitter as 'communication without speech' that is made public by virtue of passage via the internet, a public electronic communication network. While the influence, impact and sourcing of the arguments remains undisclosed, the judgement accords with the outcry on Twitter that this was a tweep, it was a joke, it was free speech. Thus Judge Judge concludes as a finding of fact that 'if the person or persons who receive it . . . would brush it aside as a silly joke, or a joke in bad taste, or empty bombastic language, or ridiculous banter, then it would be a contradiction in terms to describe it as a message of a menacing character'.[59] Twitter, in other words, becomes the law, subject to judicial review and criminal sanction, while at the same time being informed by and impacted from the Twitter sphere. View it as one may, the final judgement was in significant measure a decision in which the tweeps determined the determination. Hashtag law here took a direct and compelling form: a law of emergence, to borrow from Butler, was triggered by an assemblage, a disparate or serial collectivity that proved too numerous, mobile and uncontained to be excluded.[60] A hinterland of law spoke out, called back, made up the rule.

[58] *Chambers* v. *DPP* at para. 17.

[59] *Chambers* v. *DPP* at para. 30.

[60] Judith Butler, *Notes Toward a Performative Theory of Assembly* (Cambridge, MA: Harvard University Press, 2015) 75.

The key issue is that of the novelty of the forum and the feedback effect. Twitter did not exist when the 2003 Act was passed, and even less so at the time of passage of the 1935 Post Office Amendment Act which was also relied upon.[61] Suddenly the Judge had to deal with a medium in which each exchange between Twitter handles is potentially viewed by the entire populace of the blogosphere. The forum is private and public, and it is in its public dimension that the response of the forum as also in other social and traditional media forced Judge Judge to back down and deflect by citation to Shakespeare: 'they are free to speak not what they ought to say, but what they feel'.[62] The poetic citation is a crucial indication of a boundary point, a liminal moment of jurisdiction in which the court effectively confesses to its own narrative of invention, the fiction of law made visible as it is written. The forum exhausts the judge as he encounters a beyond of law, a novel sphere, which in its turn acts and responds as a law of the beyond, a new frontier, an unexpected assembly with atmosphere and affect of its own. Custom and use, the traditional pattern of collective behaviour that generates norms of law, is here, suddenly, instantaneous and interactive, the play of law and non-law, exterior and interior a matter of negotiation.

New media force judge, legislator, lawyer and lawmaker to exit the comfort of texts, the harbour of archives and the sanctuary of libraries, in favour of viewing media and spaces that belong west of convention, unmarked by classical grammar, mores or laws. As evidence becomes ever more visual, on screen, fragmented and mobile-optimised, screen-captured, the stability of legal regimes, the tethers of tradition, are unloosed in favour of the zapped and instantaneous, the movie as image and thought in collective motion, as assembly and forum. In this context, our contemporary last instance, we can adopt and adapt Nietzsche's aphorism and ask who could believe in a law that does not dance? At the very least, as a first two-step, law has to engage in novel forums, new media, platforms and videospheres, so as to decide whether and how to interact, what reason governs, what forms apply and how to deliberate, what deportment and dialogue is appropriate and rational in such a sphere of imagery contesting the sedimentation of reason, of pictures challenging texts.

There is in sum a diffraction of discourses in which the visual and virtual pulls away from the phonic and scriptural, the digital reorganises the textual

[61] There is similar law in the US around threatening speech 'in interstate commerce'. See, for example, *Elonis v. US* 135 S. Ct 2001 (2015), *Packingham v. North Carolina*, slip op. at 8, 582 U.S. 101 (2017) and, for commentary, Lyrissa Lidsky and Linda Norbut, '#I❥❥U: Considering the Context of Online Threats' 106 *California Law Review* 1885 (2018).

[62] *Chambers v. DPP* at para. 28.

and confronts the decisional structure of precedent with the multiple and mobile, instantaneous and fragmented modes of social media communication. Just as executive order by means and medium of Twitter challenges traditional notions of governmental action and of legal order, so too the mask of the occupiers, the tweeted images and Instagram messages indicate a shifting sphere and relay of democratic direct action. Law changes because society changes, and this is true at the level of government but also at that of judicial decision and administrative action. The videogram comes to play a more normative role as a nomogram in its own right, as rallying call, opposition, comment and criticism on multiple platforms and their necessary interfaces with the *dramatis personae* of law. Take a final example, from today's social media and newsfeeds. The school shootings in Florida led to a rally in Washington, the 'March for our Lives' of Saturday, 24 March 2018. Media, social media, blogosphere and videosphere are all atwitter with the mask of Emma Gonzalez, a 17-year-old student from Marjory Stoneman Douglas High School in Parkland, Florida where the shootings and deaths of seventeen students took place.

Figure 1.6 Emma Gomez's six minutes of silence. Screencapture by Peter Goodrich.

Two minutes and sixteen seconds into her speech, she stopped speaking and for six minutes and twenty seconds maintained silence, staring over the crowd and towards Congress in the background. The length of the silence mirrored the time that the shooter was active before dropping his gun and leaving the school. She, the face of silence, imposed an extended pause *in memoriam*, in the present, a lengthy instance of boredom, of weariness, of the quieting of the babble, a time out and a return to reflection.[63] This extended exodus from speech left only a mask, a face, a theatrical apparatus, replete with tears, as the signifier of resistance and a call to action, to legislation and to law. If it succeeds it will be because of the invocation of a beyond of words, the other side of BS as Emma Gonzalez has also coined, in the mode of an image in its oldest of senses as *imago*, as eternal mask, the sign of law. It is an old sense of *silentium* as emblematic of reserved speech, of carefully chosen words, of giving weight to what comes after extended silence from the visage that has not yet spoken, that has held back, who has given thought her due. In early law, silence, both theologically and politically, was a mark of wisdom and of counsel, which the jurists also proposed. Silence is the prelude to action, the counsel of thought that leads to new legislation. Here, for our purposes, already viral, contested, babbled lengthily over, it is the image, silent tears, a face that does not speak that says the most. West of everything, in tears, in dust, marking death, the mask of silence presages new beginnings.

[63] For a brief discussion, see Christian Delage, 'Le Silence d'Emma Gonzalez' (2018) IHTP: http://www.ihtp.cnrs.fr/content/le-silence-demma-gonzalez-par-christian-delage

Part 1

Heading West

Part I

Reading ...

2

The Aesthetics of *Convivencia*: Visualising a Mode of Living Together in Al-Andalus[1]

Raja Sakrani

Introduction

It may be strange to speak about *Convivencia* – a concept related to the co-existence of Jews, Christians and Muslims during ancient times in Al-Andalus[2] – in the context of *West of Everything*, a book that brought Western popular culture back to Americans.[3] This undertaking stands in contrast to highbrow cultural attempts as well. However, my starting point is exactly the fact that speaking about *Convivencia* has become an element of a global popular culture, where festivals or European Capitals of Culture encounter the Pope's speech in a time of despair.

This is why this chapter has been conceived in the following way: firstly, I try to provide insight into *Convivencia* in order to familiarise readers with the concept.[4] The question of whether *Convivencia* is nothing more than a myth will also be alluded to after a short introduction (I). Secondly, I will attempt to

[1] This chapter is based in part on my unpublished working paper '*Convivencia*: Reflections about its *Kulturbedeutung* and Rereading the Normative Histories of Living Together', Max Planck Institute for European Legal History – Research Paper Series, No. 2016-02. I would particularly like to thank Jenny Hellmann for her help in finalising the chapter. It was first presented as a paper at Cardozo Law School on 28–9 August 2016 in New York.
[2] For a short history of the conquest of Al-Andalus, see especially Collins (1983), Makki (1994) and Constable (2012), especially the chapter: Accounts of the Muslim Conquest, 32–43.
[3] Tompkins (1992), *West of Everything: The Inner Life of Westerns*.
[4] Here I am following the account of the research group '*Convivencias* – Legal Historical Perspectives', which I am leading together with Thomas Duve at the Max Planck Institute for European Legal History (MPIeR) in Frankfurt. It is part of the interdisciplinary research project 'Convivencia: Iberian to Global Dynamics, 500–1750', which is being pursued in co-operation with colleagues from the United States and Europe, as well as with three other Max Planck Institutes: Max Planck Institute for History of Science (Berlin), Max Planck Institute for the History of Art (Florence) and Max Planck Institute for Social Anthropology (Halle).

Figure 2.1 Puente Maria Cristina, inauguración Capitalidad Europea.
© San Sebastián 2016.

deepen my understanding of the use of images involved with this project: on the one hand as historical sources in their own right, on the other hand as ways to obtain aesthetical access to the beauty of such transcultural sociability[5] – a utopia, perhaps more necessary than ever. This then leads me to the question of whether further and/or different aesthetics are required in order to establish a respect for 'otherness' in societies where all people are strangers, others and outsiders,[6] and the commonality of belief we might need – the belief in *convivenciability* – must find new grounds. This potential represents the *Kulturbedeutung* of *Convivencia* as developed in the second part (II). Alongside these reflections, this publication would like to whet your appetite for unseen pictures, cross-cutting linguistics and inter-visuality. Furthermore, ornament and abstraction in Islam can be read as a consequence of an iconoclastic tradition that had its repercussion in the floral and geometric patterns of Art Nouveau.[7] At the same time, Andalusian Islamic art seems to be more open to images than rigid interpretations of iconoclasm. These interactions need to be studied more precisely, and one should not forget that the series of odalisques painted by Matisse are linked to his visit in Granada. Lastly, I will present some examples of visualising myths and realities of *Convivencia* trying to point out some legal and normative issues of living together in architecture, text and artwork (III).

Convivencia is the project of displacement and reunion: the displacement and questioning of some of the cultural evidence on Jews, Christians and

[5] See, for example, *Cosmopolitan Sociability* by Darieva, Glick Schiller and Gruner-Domic (2014).
[6] Seidman (2013) 3–25; Benhabib (2004); Emon (2012).
[7] For more reflections on the relationship between law and the arts, see Gephart and Leko (2017).

Muslims living together in the Iberian Peninsula from the Muslim conquest in the eighth century to the definitive expulsion of the Moriscos in the seventeenth century. My work is primarily rooted in the Arabo-Islamic legal and cultural perspective and seeks – for exactly this reason – to be the bearer of a perspective of reunion between the historical ties woven throughout these three religions, three communities and three worlds in Al-Andalus, not only during the nine centuries of tension between tolerance and intolerance, between passion and oppression, but much earlier within the Arabian Peninsula and even after the sixteenth century in the Maghreb[8] and Latin America.

I. Reflecting on *Convivencia*: Between Myth, Methodology and Iconography

The big conceptual battle surrounding the definition of *Convivencia* is not merely the consequence of methodological rifts and disputes.[9] It results as much from methodological conflicts within the humanities, as it follows in the wake of the linguistic turn.[10] In any case, the issues of polemics are well removed from methodological questions. At issue is history – the rewriting, interpretation, invention and reinvention of history. At issue are also the three monotheistic religions, Europe and the 'other'. Since Américo Castro, and even well before him,[11] *Convivencia* has incessantly been pulled every which way. It is the enigma to be unravelled, the historical reality that has been buried for a long time, the religious syncretism, the exaggerated social and cultural symbiosis,[12] the myth of tolerance, the myth of the Spain of

[8] See below, the example of Testour in Tunisia.

[9] This chapter is not concerned with cataloguing these methodological problems, or with providing an in-depth critical analysis of these difficulties. Such efforts, for the most part, go beyond our present scope. The literature on this subject is abundant. See, for example, Chacón Jimenez (1982), García-Sabell (1965), Guillen (1975), Mann, Glick and Dodds (1992), especially Glick (1992a) and (1992b). For more recent works, see Tolan (1999), Catlos (2001–2), Arízaga Bolumburo (2007), Fuente Pérez (2010) and Cabedo Mas and Martinez (2013).

[10] For a reasonably complete summary of this question based on historiographic polemics through the lens of philology, see Szpiech (2013), 136.

[11] For a more precise analysis of the work and legacy of Américo Castro, one should return to his teacher, Ramón Menéndez Pidal, so as to better understand the linguistic and conceptual premises of the word *Convivencia*. In effect, Castro starts by using the expression not in the proper sense of a linguistic variant, but rather to designate the social co-existence of Christians, Jews and Muslims in the Iberian Peninsula during the Middle Ages, in Castro (1956), 48.

[12] For these critiques, see, in particular, the attack by Sánchez-Albornoz (1956); see also in the same sense, Asensio (1976) 26ff. Cf. further for later works and their extended treatment of this conflict and its outgrowths: simply by way of example, Gómez-Martínez (1975) and Glick (2005), in particular 6–13. Further, on the notion of *Convivencia* in general and its origins, see Akasoy (2010), 489–99, Wolf (2009), 72–85 and Martínez Montávez (1983–4), 21–42.

three cultures,[13] the 'romanticisation' of Islam,[14] the lyrical 'nonsense', the camouflaged violence under a fantastical myth, and even apartheid.[15] Will the images, the poetics, the legal textures reflect the semiotic multitude of meanings and interpretations of a *convivencial* utopia?

The role of images has become so important in the humanities that some scholars have spoken of an *iconic turn*. Our world is overflown with images by the old and the new media, publicity, the movie industry, image worlds in the fine arts, and the internet (including a new phase in the spread of pornography), which is inherently shaping our world view. Thus, a greater *iconic capacity* is being asked from the competent inhabitant of our world. And, because there is a specific power of the image, its mistrust and its seduction, this iconic competence must be a critical one! This proves even truer for using images in a scientific context. Following a previous denial of the use of images, it is, however, observable that icons are being increasingly recognised as legitimate sources of historical, sociological and legal information. But a set of recognised strategies on how to view, express and interpret the meaning of an image have yet to be developed.

In the discipline of art history, this capacity has always played a major role. Therefore, it is unsurprising that the most influential insight into this debate comes from art history. *Iconology* and *iconography* are the two terms through which both the technique of grasping the larger cultural (iconology) meaning is condensed and the descriptive task of saying what can be seen (iconography) is created.

Images, in themselves, are quite often linked with textual elements. This is why one should try to read them and describe their positions in the composition. *Emblems*[16] contain important information, and they constitute, together with the pictorial element, a complex source of information.

Finally, we must answer the question concerning which of the image's senses gives us more information or another direction than we would have had with only our textual knowledge, obtained by way of textual narratives or other indicators of historical truth. Is there even a type of *Convivencia imaging* (that is, sharing wine together, celebrating Christmas and the New Year (Yannair), making music, embracing, exchanging weapons, etc.) and what could this tell us about the realities of living together and the

[13] The topic of the three cultures is not new. Besides publications, multiple encounters have been organised. See, for example, Actas del II Congreso International Encuentro de las Tres Culturas. 3–6 de octubre 1983, Ayuntamiento de Toledo, 1985.

[14] The 'romanticisation' of Islam or of Arab Studies linked to the Iberian Peninsula is a topic of research that deserves its own separate discussion. Suffice it to say here that the legacy or impact of the works of Américo Castro also extend to this branch.

[15] See, for example, Fanjul (2004), 28–9.

[16] See Goodrich, *Legal Emblems and the Art of Law* (2013).

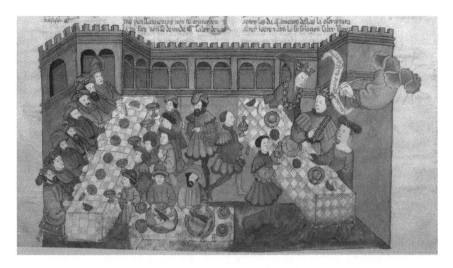

Figure 2.2 Muslims and Christians celebrating together, as they used to, for example, in the Alhambra at Christmas and on New Year's Eve, Biblia de Alba, 1422–33, Palacio de Liria, Madrid. © Facsimile edition of the Alba Bible, www.facsimile-edition.com

truths of interpreting ideologically, expressing wishes or describing dangers of decadence?

On the juristic-normative level, these images do not have deontic power as such, even if the images seem to represent peaceful co-existence, shared pleasure or simply the use of the other's art or medium of expression (architecture, painting, writings, etc.). However, they may offer valuable information through another medium that can only be detected with the help of a visual lecture, a cultural gaze that differs from juristic or historic texts.

II. On the *Kulturbedeutung* and Normative Implications of *Convivencia*

Convivencia as a meaning, symbol, wish and perspective has become a very fashionable 'watchword'. The concept has made a career of being a fantastic account that can be adopted by everyone to suit their narrative and ends.[17] It has turned into a soft nostalgia that has seen a sudden resurgence to soothe wounds and recall hope for the possibility of living together in a global context plagued by conflicts and terrorist attacks not seen since the two world wars.

[17] We have been able to observe, in fact, this kind of global 'renaissance' for several years. See, for example, the book edited by Fornet-Betancourt (2011), *La Convivencia Humana: Problemas y posibilidades en el Mundo actual. Una Aproximación intercultural.* The authors referred to several countries and continents in order to contextualise 'living together' in Asia, Latin America, Europe, Africa and the Arabian world.

From the Pope to the Arab streets to the *Manifeste convivialiste*[18] to Plantu and his caricatures of the scenic *nouveau vivre ensemble*[19] or San Sebastián and its European cultural dream of *la convivencia para convivir*,[20] *Convivencia* is, at least almost, increasingly on everyone's minds worldwide.

Let me explore some of these examples:

1. Since his first visit to Sarajevo on 6 June 2015, and during his later visits to Europe, Latin America and elsewhere, Pope Francis continues to centre his discourse on the grammar of *Convivencia* in order to promote tolerance and peaceful co-existence. During his visit to Sarajevo, Pope Francis pronounced words of hope during his first welcome address: 'Bosnia Herzegovina [tiene] un significado especial para Europa y el mundo entero',[21] as they are places of 'dialogo y pacífica convivencia'. The Pope made sure to recall the contribution of the Catholic Church in the material and moral reconstruction of Bosnia and Herzegovina, as well as the care taken by the Holy See in promoting peace, reciprocal understanding and 'una convivencia civil'.[22]

The papal usage of the term *Convivencia* is more than just simple cordial or diplomatic discourse. 'La convivencia y la colaboración cotidiana' are also at the centre of his inter-religious message in his speech held on the occasion

[18] Cf. Les Convivialistes (2013), *Le manifeste convivialiste*, a small booklet of 39 pages published as the outcome of collective work and discussions held by francophone authors representative of numerous current thought and action. In the third chapter, *Convivialisme* is defined as: '[. . .] le nom donné à tout ce qui dans les doctrines existantes, laïques ou religieuses, concourt à la recherche des principes permettant aux êtres humains à la fois de rivaliser et de coopérer, dans la pleine conscience de la finitude de ressources naturelles et dans le souci partagé du soin du monde. Et de notre appartenance à ce monde' (25). However, neither the booklet, translated into several languages, nor the recent book by Caillé (2015), *Le convivalisme en dix questions*, make any mention of the historical concept of *Convivencia*, esp. 117ff., where 'un vivre ensemble métissé', 'les bases morales partageables', etc. are evoked.

[19] Following the terrorist attacks in November 2015, Plantu, in his newspaper column in *Le Monde*, painted a surrealist assembly of several presidents throughout the world (Assad, Rouhani, Putin, Hollande, Sarkozy, De Gaulle . . .) seated around a single table with the title: *Le nouveau 'vivre ensemble'*.

[20] San Sebastián was the 2016 European Capital of Culture, a title it shares with the Polish town of Wrocław.

[21] 'Bosnia Herzegovina hold[s] a special meaning for Europe and the entire world', Pope Francis (6 June 2015a), own translation. This first discourse was pronounced in the presidential palace during the official welcoming ceremony. The Pope's hope referred particularly to children: 'Yo he visto hoy esta esperanza en los niños que he saludado en el aeropuerto: islámicos, ortodoxos, judíos, católicos y de otras minorías [. . .] ¡Todos juntos con alegría! ¡Ésta es la esperanza! ¡Apostemos sobre ella!'

[22] Ibid.

Figure 2.3 Declaración por la paz y convivencia entre los pueblos, 7 June 2014. © Webislam. Creative Commons Licence.

of an ecumenical meeting at the International Franciscan Student Centre of Sarajevo.[23] While Sarajevo is certainly a symbol for Europe, on the other side of the Atlantic in the Holy Father's homeland, *Convivencia* also runs the course of all of Latin America. His visits to several Latin American countries in summer 2015 are already a testament to this, and his discourse is abundant in the grammar of 'la convivencia', used in various forms from the family to the global 'other'.[24]

[23] Pope Francis (6 June 2015b): 'El encuentro de hoy es signo de un deseo común de fraternidad y de paz; y da fe de una amistad que se ha ido construyendo a lo largo del tiempo y que ya vivís en la convivencia y la colaboración cotidianas.'

[24] In Ecuador, he presents 'algunas claves de la convivencia ciudadana a partir de este ser de casa, es decir a partir de la experiencia de la vida familiar'. The Pope further analyses what threatens *la convivencia social* in many Latin American countries. The Pope's message of *convivencia pacífica* is addressed towards Colombia and Venezuela, while a telegram addressed to King Felipe of Spain on the way back to Rome expresses the desire to live in *armoniosa convivencia*. Does this mean that the Argentine Pope is simply drawing from the depths of Latin America's Iberian roots and the Iberian experience itself? Or is it his awareness – apart from a call for inter-religious tolerance – of a global religious context in which fundamentalist Islam plays an important role? These are big questions that certainly deserve in-depth study elsewhere.

2. A second recent example is that of *Convivencia* in order to promote the 'European-ness' of European culture. To those who have viewed the 2016 European Capital of Culture as 'un legado de convivencia'[25] and who have created the 'programa por la convivencia' for Donostia (a beautiful Basque seaside resort town), living together is the message 'por la tolerancia y el respeto al otro'[26] and the panorama that orchestrates all the civic waves of energy (*ola de energía ciudadana*). *Convivencia* has thus become the chief orchestrator of a 'cultura para convivir', which a short audio production for the opening understands as follows:

> [. . .] pero convivir es vivir con [. . .] convivir es vivir con mormones, católi-cas, musulmanes, agnósticos y ateas, con turistas, con argentinos, ucranianas, chinos o personas de cualquier otra comunidad extranjera. Convivir, es vivir con gente que piensa, habla, reza distinto a ti. Vivir con [. . .] izquierdistas, anarquistas, independentistas, nacionalistas, capitalistas o miembros de cual-quier otro –ismo [. . .] Convivir, es vivir con aqellas personas con las que creemos no tener demasiado en común.[27]

Yet how can one have little in common and still find a model for living together? This is the bridge that leads to the final and most complex example.

3. Essentially, the revolutionary earthquake, an event full of unknown vari-ables and a great upheaval that produced what Milan Kundera calls 'the sudden beauty of the impossible',[28] took place in a stifling and stymieing environment – one of dictatorship and monolithism of all sorts. Then, sud-denly, the religious, ideological and social forces found themselves before

[25] *El País* (17 December 2015), 'San Sebastián despliega su programa por "la convivencia"'.

[26] *El País*, op cit. In his presentation of the programme for *Convivencia* at the Museo Reina Sofía in Madrid, Pablo Beràstegui clarified that what sets San Sebastián apart is that: '. . . frente a anteriores capitalidades culturales, "que eran más de grandes nombres y grandes espectáculos", Donostia dará prioridad "al legado", a lo que quede "de acelerar un proceso para recuperar la alegría de vivir", y con atención a la memoria de los que sufrieron el terrorismo', adding: San Sebastián 2016, 'no puede contratar convivencia pero la favorecerá'. Cf. further on the 'Cultura para la convivencia', *Diario de Navarra* (17 December 2015).

[27] '[. . .] but "convivir" is to live with [. . .] "convivir" is to live with Mormons, Catholics, Muslims, agnostics and atheists, with tourists, Argentineans, Ukrainians, Chinese or per-sons of any foreign community. "Convivir" is to live together with people who think, speak, pray differently to you. Live with [. . .] leftists, anarchists, independentists, nationalists, capitalists or members of any other -ism [. . .] "Convivir" is to live with those persons whom we think of not having too much with in common'; Donostia/San Sebastían(2016), personal transcript of words from the video *Cultura para convivir*, own translation.

[28] Kundera (1984).

Figure 2.4 Puente Maria Cristina, inauguración Capitalidad Europea.
© San Sebastián 2016.

each other and were faced with one single question: What must be done in order to 'live together' despite their differences? All of the countries that experienced revolutions subsequently descended into violence and massacres, with Tunisia being the sole country still resisting despite the fragility of a 'living together' that is seriously threatened by terrorism and corruption, and where the debate on *ta'āuš*[29] is not well articulated. What many intellectuals call *Ḍarb al-ta'āuš*, i.e. the frontal attack on and destruction of the mode of living together – already fragile and imperfect – between Muslims and non-Muslims, particularly in Syria and Iraq, is in return nourishing the discussion on an *Arab Convivencia*. Let me nonetheless remark that the semantics are very revealing. The word *ta'āuš*, which is a kind of direct translation of *Convivencia*, is fairly recent. Its usage is increasingly generalised with reference to *Tasāmuḥ*, which means tolerance, a term that has been used for a long time, also by the dictatorships in power in the guise of political propaganda. This *Convivencia* currently has an enormous theological and legal dimension within Islam, even if its articulation is still quasi-embryonic and not always explicit. A discussed and dreamt-of *Arab Convivencia* expresses an intellectual effervescence that survived post-revolutionary disillusionment, wars, destruction and self-destruction.

The *Kulturbedeutung* of *Convivencia* goes beyond the obvious or even fashionable use of the semantics. It expresses a profound need for change. And just like the history of the relations between Jews and Muslims, i.e. by turns fruitful, hostile or even violent, the history of the relations between Muslims and Europe, and by extension all of the West, evolved from the first

[29] The content of this debate will not be dealt with here. Suffice it to point out that a similar debate also took place in Morocco (though there had been no revolution), in Egypt, in Libya in 2011/12 and in Syria as well.

links between Jewish tribes in Arabia and the Prophet Mohammed[30] to recent conflicts in the Middle East to the Golden Age of the civilisations of Córdoba and Baghdad, thus inherently passing the Andalusian period.

III. Some Elements of Visualising Myths and Realities of *Convivencia*

The representation of social relations, models of sociality in their emotive meanings, and collective identity-creating functions is not a major topic in the sociology of art. Social conditions of production and the social consequences of its reception seem to be more interesting for sociologists and historians of art than the *content* of art itself.[31] My way to read may therefore seem old-fashioned, but this is certainly intended!

Convivencia is today commonly translated in Arabic as *ta'ūš* (to live together). My first socialisation within an Arab society led me to reflect upon another word that has not, to my knowledge, been used in this context, namely the word *'išra*, which comes from the same root – the verb *āša* (to live) or the noun *'ayš* (life) – but is etymologically and sociologically richer and more complex than *ta'ūš*.

1. Architecture: From Testour to Toledo

An interesting example of this 'ethic of *'išra*' is Testour, a small town situated in northeast Tunisia that was founded by Jewish-Muslim Andalusians who fled to this country after the *Reconquista*. The masterpiece of Morisco immigration to Testour is the Great Mosque, a unique edifice in its conception in Tunisia. This monument was built by Andalusians according to Spanish techniques, as if to imprint the event of their forceful separation from their beloved former homeland into their memories.[32] This mosque is unique, with its clock that turns counterclockwise.[33] It was constructed in the early seventeenth century

[30] In order to understand the mechanisms and codes of *Convivencia*, it is necessary to return to the origins of Islamic texts governing co-habitation between Muslims and non-Muslims. The *ṣaḥīfat al-Medina*, better known as the *Constitution of Medina*, and the *Pact of 'Umar* (the second successor of the Prophet Muhammad) are the two major documents to be mentioned. For more details, see Sakrani (2018), 112–15.

[31] This is in the line of Max Weber's dictum that one day he would deliver a *Soziologie der Kulturinhalte* (see Max Weber's letter to his editor of 31 December 1913, which is exactly what he did in his Musiksoziologie, *Max Weber, zur Musiksoziologie*, Brown and Finscher (2004) MWG, I / 14. See also Gephart (1998).

[32] See, for example, Hamrouni (2000); idem. (1995).

[33] Note that this clock was restored thanks to an initiative by the Testour Association for the Safeguarding of Medina in collaboration with the Goethe Institut.

Figure 2.5 (L) The Great Mosque of Testour and (R) detail of the mosque.
© Agnieszka Wolska/Wikimedia Commons; © Takouti Hayfa/Wikimedia Commons.

Figure 2.6 The mihrab of the Mosque of Testour. © Museum With No Frontiers
(Discover Islamic Art).

by Muhammed Tagharino, a Morisco with origins in Aragon. It was followed by the quarter of Tagharino and the quarter of Hara, occupied by the Jewish community that accompanied the expelled Muslims in their painful fate. The mosque rises into the sky, with its octagonal minaret in the image of towers dominating ancient Spanish churches, with two Stars of David. The miḥrab is topped by a triangular pediment borrowed from the art of the Italian-Spanish Renaissance. This ensemble reunites to reinforce the original character of the building and its universal vocation.[34] Observable here is hence a living together of signs, namely the Stars of David decorating the most cherished element of a mosque, the minaret.

This architecture of the mosque, its ornaments and its symbols, as well as the special distribution of quarters for Muslims and Jews, is in fact the expression of a normative model of *Convivencia* unique in its genre in North Africa. Buildings, ornaments and urban symbols introduce not only a whole range of socio-judicial norms that regulate public spaces, rituals, codes of sharing (music, festivities, etc.), but also norms that are able to regulate the necessary social distance between those groups, a kind of *régulateur* of *Convivencia*.

Going back in history and back to Spain, a symmetrical visual situation can be found in Toledo,[35] a capital stemming from a now-destroyed Toledan synagogue, preserved in el Museo Sefardí, featuring bilingual inscriptions in Hebrew and Arabic. To remain in Toledo: the church of San Roman (Iglesia de San Román[36]), built by the Castilians of Toledo in the twelfth century, contains ornaments known as arabesques as well as inscriptions in Arabic letters. The church was built in a Mudéjar[37] architectural style in the thirteenth century on the grounds of what was likely previously an ancient Roman building designed according to old Visigothic architecture.

For some Muslim visitors today, a spontaneous question arises: is it not prohibited in Islam to construct or contribute to constructing and 'decorating' a church or a synagogue? This question invites yet a further thought, more difficult and sophisticated: how can we read medieval Spanish artwork, monuments

[34] About the mihrab, see Álvarez Dopico (2005), 45–53.

[35] As an indicator of the medial presence of our questioning, see the very recent article by Joshua Cohen (10 February 2018), 'Toledo im Transit', *Frankfurter Allgemeine Zeitung*, 12.

[36] The church is currently the Museum of the Councils and Visigothic Culture.

[37] Mudéjar is the name given to Muslims of Al-Andalus who remained in Iberia after the Christian *Reconquista* but were not converted to Christianity. This term is used to contrast both Muslims in Muslim-ruled areas (for example, Muslims of Granada before 1492), and also in contrast to Moriscos who were forcibly converted and may or may not have continued to secretly practise Islam.

Figure 2.7 Church San Román of Toledo. Photo by the author, 2018.

Figure 2.8 The Synagogue del Tránsito, since 2003: El Museo Sefardí, Toledo; detail of the Sala de Oración (room of prayer). Photo by the author, 2018.

or text, especially when multilingual,[38] to decipher the normative 'arsenal' of a complete *Convivencia*, some *Convivencia* or no *Convivencia* at all? To what extent can the visuality of images and icons function as a medium that expresses normative orders of medieval *Convivencia*? What can be learned from this and be applied to the present day?

2. Text and Language: Taking the Lingual Role of the 'Other'

Even more surprising is the adoption of the lingual role of the 'other' when religious texts are produced through the language of the 'other's' culture. Here are some astonishing examples: the Bible translated into Arabic by the famous Jewish philosopher Saadia Gaon (tenth century), as well as the Koran transcribed in Hebrew characters in the Vatican's library!

And how can we forget Maimonides' *The Guide for the Perplexed*, written in a Judeo-Arabic mélange?

Figure 2.9 The Bible translated into Arabic by Saadia Gaon, tenth century. Paris, BNF.

[38] We find in Seville, for example, applied to the tomb of Ferdinand III not only inscriptions in Latin, but also in Arabic, Hebrew and Castilian (1252). No language seems to dominate. On the contrary, a kind of linguistic equality is expressed.

Figure 2.10 Estatua para Maimónides (*1135 Córdoba, †1204, Cairo) en Córdoba, Plazuela de Maimónides. © Howard Lifshitz/Wikimedia Commons.

Figure 2.11 Maimónides, Judeo-Arabic draft of 'The Guide for the Perplexed', Egypt, end of twelfth century. © Cambridge University Library.

3. Narrating Islamic Justice from Kalila and Dimna to *collección de cuentos castellanos*

The narrative of *Kalila wa Dimna* is quickly told: tales teaching political wisdom, much more complex than can be explained here.[39] *Kalila wa Dimna*, in fact, transcended languages, religions[40] and cultures. The Arab text is a

[39] There once lived a lion who terrorised the animals of the jungle by hunting them. This continued until one day they agreed to supply him daily with an animal as long as he stopped his cruelty. The animals continued to cast their lots every day until one day it was the hare's turn. The crafty hare arrived late to the hungry and angry lion and explained to him, 'I was bringing another hare for your lunch, but on our way here another lion snatched the hare from me, proclaiming that he is the true king of the jungle.' The furious lion wished to confront his adversary, and so he followed the hare to a deep well full of clear water. 'Look here, my king!' said the hare, perched over the well. The lion saw his reflection and, thinking it was the other lion, leaped in and drowned. Thereafter, the animals lived happily ever after.

[40] *Kalila wa Dimna* has changed its religion throughout history: from Hinduism, Buddhism and Zoroastrianism to Islam and then from Islam to Christianity – thanks to Al-Andalus.

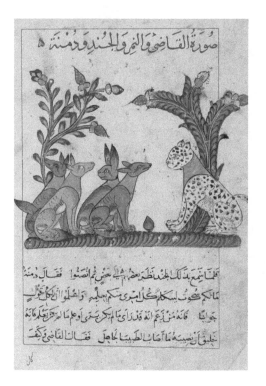

Figure 2.12 Scene of Judgement in Kalila wa Dimna. Syrian copy from the tenth century. Bodleian University, ms. Pococke 400, fol. 75 verso.

Figure 2.13 Manuscrito de Calila e Dimna, colección de cuentos castellanos de 1251. © PD-Old/PD-Art/Wikimwdia Commons.

fable taken from a Persian model, which was then adapted and translated into Arabic around 757 by Abdullah Ibn al-Muqaffaʻ. It is the first 'secular' fiction in Arabic culture and shows a new sophisticated structure of narration, which differed from popular literature in Islamic civilisation. It is well-known that fables have a normative dimension. The reception process from Indian to Persian to Arabic translations cannot be traced here.[41] But it is noteworthy that a court scene is literally and visually included in the narration. The drawing represents a scene of judgement: the leopard on the right side is playing the role of the judge, confronting a jackal with the plea of attempting to take the power of the lion as king. The animal-soldiers in

[41] For the problem of comparative translation of *Kalila wa Dimna*, see, for example, Brown (1922).

the background are testimonies of that crime. The jackal, however, contests the correctness of the testimonies by referring to the story of the ignorant doctor . . . Storytelling is the way to frame procedural arguments! The question of the Islamic practice of justice in Al-Andalus but also in the entirety of medieval Spain is a fundamental topic in the fields of both Islamic and European legal histories.[42]

4. Loyalty of Class and Profession

Besides having religious, political, lingual and cultural dimensions, *Convivencia* must be read in the context of the complex discourse on *Otherness*. It must be reflected in view of theorising the fundamental relation between the 'self' and the 'other': the question of living together among others. The 'other' casts a special light on this issue.

Throughout the entire course of Andalusian history, but particularly during precise historical moments (between the eighth and eleventh centuries), the non-Muslim 'other' ceased to be identified as an 'other'. He/she was rather considered a participant in a shared programme: the contact and co-operation between Muslim, Christian and Jewish scholars serve as prime examples. Within certain professions like medicine, for example, Jews, Muslims and Christians were bound together by what historian Mottahedeh[43] calls 'loyalty of class', which cast religious hierarchy between Muslims and non-Muslims to the background and encouraged a certain tolerance.

5. Images of Communality and Leisure

The complex problem of living together among different communities that are not only defined by their religious belief, but also by their rituals, symbols and normative ordering of the world, will become crucial when the question of *connubium* and *commensality*[44] arises. Some examples of sharing free time can be mentioned here, including the delicate situation of drinking together. A beautiful textile piece representing two drinking ladies (Spain, thirteenth century, National Museum, New York) is testimony to this. We do not know whether the cups are filled with wine or another kind of beverage, but drinkers (ladies) are represented in a moment of shared conviviality. The aesthetics of *Convivencia* hence express the beauty of 'commensality', or, in some other examples, just moments of leisure time

[42] See Sakrani (2014), 90–118.
[43] Cf. Mottahedeh (1980).
[44] See, for example, Waines (1994), 725–38, and Freidenreich (2008), 41–77.

Figure 2.14 Alfonso X dialoga con médicos árabes, 'La Medicina en Al- Andalus'. © Patrimonio Nacional, T-I-1, folio 226v.

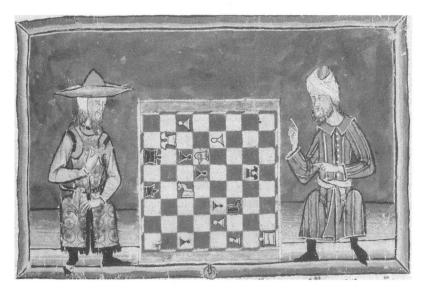

Figure 2.15 A Jew and a Muslim playing chess in thirteenth-century al-Andalus. El Libro de los Juegos. © Patrimonio Nacional, T-I-6, folio 63r.

shared together, as one can see in the representation of a Jew and a Muslim playing chess in Al-Andalus.

In other representations, one could see members of different religious communities (Muslim and Christian) playing music together – and this was long before the experimental world music projects. This is not self-evident in the least, as historians of music have told us how diverse the logic and rationality of Occidental and Oriental music can be.[45] But here, in the picture, this problem does not lead to disharmony but commonness in a musical performance!

Figure 2.16 School of Alfonso X, later half of the thirteenth century, Muslim and Christian Musicians. © Ganesh/Wikimedia Commons.

[45] According to Max Weber's *Musiksoziologie*, the development of music in the Occident, including the level of instruments, notation systems and logic of irrationalities in the harmonic system, becomes a major argument for Occidental exceptionalism, ibid.

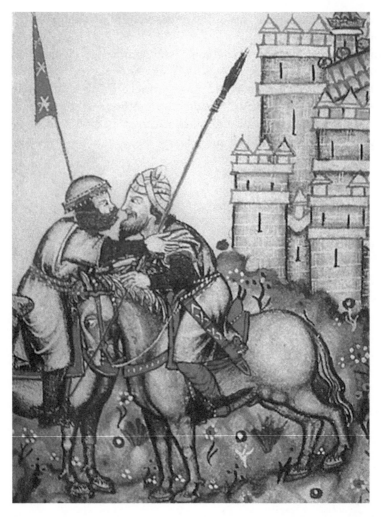

Figure 2.17 Muslim and Christian knights embracing in greeting. © PD-Old/ PD-Art/Wikimedia Commons.

A further image shows a Muslim and a Christian knight sitting on horses, wearing weapons and their armour. But they do not meet as enemies and are instead united in the manners of court games, even embracing one another.

Conclusion

There remains the question of what is meant when speaking of the aesthetics of *Convivencia*, the beauty of 'living together'. It was Georg Simmel who opened our eyes to such a perspective: society is not the ugly thing in the world, not a painful, *ärgerliche Tatsache*, but it may be endowed with the quality of beauty.

As argued in his essay 'Soziologische Ästhetik' (1896), written for the journal *Die Zukunft*, symmetry is one of the main aesthetic motives, and this motive can be found in a multitude of societal institutions and their representations, for example, the pyramids. However, for an advanced aesthetic sensibility, it is the tension, sometimes the contradiction, between elements of symmetry and asymmetry which stands for aesthetically high values:

> Das Wesen der ästhetischen Betrachtung und Darstellung liegt für uns darin, daß in dem Einzelnen der Typus, in dem Zufälligen das Gesetz, in dem Äußerlichen und Flüchtigen das Wesen und die Bedeutung der Dinge hervortreten.[46]

One could perhaps say that Simmel, the theorist of social differentiation, is praising the beauty of difference here: different world views, different ways of rising in everyday life, of giving meaning to the world while simultaneously being a part of a 'living whole', of viewing current difference not as a threat but as an enrichment, of transforming 'otherhood' in brother- or sisterhood. Wouldn't such a society be a beautiful one? Images of multiculturalism attempt to capture this idea through fancy images, such as 'melting pot', 'salad bowl', 'Jamaica colors', etc. Here, the meaning is not solely directed to the 'multi-colors' that served as an advertisement for a fashion brand (namely Benetton), but to the imbrications of universal and of particular communities and their specific symbols and rituals; of the interweaving of different ways of living and different conceptions of the world; of spices, tastes, smells, sounds and sensualities; and of literatures and aesthetics, including the praise of the ornament as a side effect of iconoclastic imaginations and the realities of figuration in Islamic art and poetry.

As a jurist, I must admit, however, that the normative ordering of such a society of *Convivencia* remains a key problem. In other words, exploring its necessary constitutional form in which the domination thesis[47] linked to the historical example of Al-Andalus competes with more naïve interpretations about a peaceful living together may prove difficult. Whether the so-called 'constitution' of Medina, where Jews and Christians were both included in the umma, or the practices of treating the 'peoples of the book' as *dhimmi*, deliver the basic elements for that societal constitution of *Convivencia* cannot be resolved in this article.[48]

[46] Simmel (1896), 205.

[47] About the mechanisms and dynamics of domination in medieval Spain, see Catlos (2004), especially 23ff, Nirenberg (1996) and Simmel (1969).

[48] Sakrani, 'The *Ḏhimmī* as the Other of Multiple *Convivencias* in al-Andalus. Protection, Tolerance and Domination in Islamic Law' (2018).

While being more sensitive to the aesthetics of *Convivencia* might enlarge the acceptance of such a way of living together, it might also deepen our desire for more institutional intelligence to answer our need for harmonious, pleasant social relations. One might object that a pure aesthetics of the beautiful would ignore the aesthetics of the ugly, or the aesthetics of the unfinished, the fragment. However, the drive for beauty is so universal that man should not only be seen as *Zoon Politicon*, but also as *homo aestheticus*, as long as the false glamour of fascism is avoided. In this sense, Georg Simmel's idea to observe societies and their figurations also through the lens of aesthetics requires a more sophisticated and concerted effort from sociologists and legal historians, for whom the 'beauty' of a decision still remains an argument for its validity.

At the same time, everything in the world has passed through the media, as Niklas Luhmann[49] rightly said. That is why this article began with an astonishing number of references to *Convivencia* in public discourse. But as long as this ideology-laden term is not used in a more precise way, its gains will be limited. A look at the aesthetics of *Convivencia* as a commonly shared belief in beauty might also clarify some dark spots in the scientific and mediatised discourses about *Convivencia* as such.

Bibliography

Akasoy, Anna (2010): 'Convivencia and its Discontents. Interfaith Life in al-Andalus', in *International Journal of Middle East Studies* 42, 489–9.

Álvarez Dopico, Clara-Ilham (2005): 'Le Mihrabe de la grande mosquée de Testour: Une affirmation d'hispanité', in Temimi, Abdeljalil (ed.), *Actas del XIe congreso de estudios moriscos sobre: Huellas literarias e impactos de los moriscos en Túnez y en América Latina, Túnez*, FTERSI, 45–53.

Arízaga Bolumburu, Beatriz, and Solórzano Telechea, Jesús Angel (2008): La convivencia en las ciudades medievales. Actas del 4° Encuentros Internacionales del Medioevo, Nájera, 24–27 julio 2007, Logroño.

Asensio, Eugenio (1976): *La España imaginada por Américo Castro*, Barcelona.

Benhabib, Seyla (2004): *The right of others. Aliens, Residents, and Citizens*, Cambridge.

Brown, Christoph and Finscher, Ludwig (2004): *Max Weber, zur Musiksoziologie*. Nachlaß 1921, MWG, I /14, Tübingen.

Brown, W. Norman (1922): 'A Comparative Translation of the Arabic Kalīla Wa-Dimna', Chapter VI, in *Journal of the American Oriental Society*, Vol. 42, 215–55.

Cabedo Mas, Alberto and Gil Martinez, Joaquín (2013): *La cultura para la convivencia*, Valencia.

[49] Luhmann (2009).

Caillé, Alain (2015): *Le convivialisme en dix questions. Un nouvel imaginaire politique*, Lormont.

Castro, Américo (1956): *Dos ensayos*, Mexico.

Catlos, Brian (2004): *The Victors and the Vanquished. Christians and Muslims of Catalonia and Aragon, 1050–1300*, Cambridge.

Chacón Jimenez, Francisco (1982): 'El problema de la convivencia. Granadinos, Mudejares y Christianos-viejos en el reino de Murcia. 1609–1614', in *Mélanges de la casa de Velasquez* 18,1, 103–33.

Cohen, Joshua (2018): 'Toledo im Transit', *Frankfurter Allgemeine Zeitung*, 10 February 2018, NR 35, p. 12.

Collins, Roger (1983): *Early Medieval Spain. Unity in Diversity, 400–1000*, Basingstoke.

Constable, Olivia Remie (2012): *Medieval Iberia. Reading from Christian, Muslim, and Jewish Sources No. 6*, Philadelphia: University of Pennsylvania Press.

Darieva, Tsypylma, Glick Schiller, Nina and Gruner-Domic, Sandra (2016): *Cosmopolitan Sociability. Locating Transnational Religious and Diasporic Networks*, Munich.

Diario de Navarra (17 December 2015) 'Convivencia en paz, alma de San Sebastián 2016': last retrieved on 21 February 2018: http://www.diariodenavarra.es/noticias/mas_actualidad/sociedad/2015/12/17/convivencia_paz_alma_san_sebastian_2016_361979_1035.html

Donostia/San Sebastián (2016): 'Cultura para convivir': last retrieved on 21 February 2018: https://www.youtube.com/watch?v=nekT3uGiuWs

El País (17 December 2015): 'San Sebastián despliega su programa por "la convivencia"': last retrieved on 21 February 2018: http://cultura.elpais.com/cultura/2015/12/17/actualidad/1450372280_241727.html

Emon, Anver (2012): *Religious pluralism and Islamic Law. Dhimmīs and Others in the Empire of Law*, Oxford.

Fanjul, Serafín (2004): *La quimera de Al-Andalus*, Madrid.

Fornet-Betancourt, R. (ed.) (2011): La convivencia humana: problemas y posibilidades en el mundo actual. Una aproximación intercultural / Das menschliche Zusammenleben: Probleme und Möglichkeiten in der heutigen Welt. Eine interkulturelle Annäherung, Dokumentation des IX. Internationalen Kongresses für Interkulturelle Philosophie, Denktraditionen im Dialog: Studien zur Befreiung und Interkulturalität, Band 32, Mainz/Aachen.

Freidenreich, David (2008): 'Sharing Meals with Non-Christians in Canon Law. Commentaries, circa 1160–1260: A case study in Legal Development', in *Medieval Encounters* 14, 41–77.

Fuente Pérez, María Jesús (2010): *Identidad y convivencia. Musulmanas y judías en la España medieval*, Madrid.

García-Sabell, D. (1965): 'Concepto y vivencia', in *Collected Studies in Honour of Americo Castro's Eightieth Year*, Oxford, 109–17.

Gephart, Werner (1998): Bilder der Moderne. Studien zu einer Soziologie der Kunst- und Kulturinhalte, Opladen: Leske + Budrich (Sphären der Moderne; Bd. 1).

Gephart, Werner and Leko, Jure (eds) (2017): *Law and the Arts. Elective Affinities and Relationships of Tension*, Vittorio Klostermann, Frankfurt.

Glick, Thomas (2005): *Islamic and Christian Spain in the Early Middle Ages*, Leiden/ Boston.

Glick, Thomas (1992a): 'Convivencia. An Introductory Note', in: Mann, Vivian et al. (eds), *Convivencia. Jews, Muslims and Christians in Medieval Spain*, New York.

Glick, Thomas (1992b): 'Science in Medieval Spain: The Jewish Contribution in the Context of Convivencia', in Mann, Vivian et al. (eds), *Convivencia. Jews, Muslims and Christians in Medieval Spain*, New York.

Gómez-Martínez, José Luis (1975): *Américo Castro y el Origen de los Españoles: Historia de una Polémica*, Madrid.

Goodrich, Peter (2013): *Legal Emblems and the Art of Law*. Obiter Depicta *as the Vision of Governance*, Cambridge.

Guillen, Jorge (1975): *Convivencia*, Madrid.

Hamrouni, Ahmed (1995): *Testour. Histoire et récits de voyage*, Carthage.

Hamrouni, Ahmed (2000): *Testour. Documents et études*, Carthage.

Kundera, Milan (1984): *The Unbearable Lightness of Being*, Paris.

Les Convivialistes (2013): *Manifeste convivialiste. Déclaration d'interdépendance*, Lormont.

Luhmann, Niklas (2009): *Die Realität der Massenmedien*, Wiesbaden.

Makki, Mahmoud (1994): 'The political history of Al-Andalus (92/711–897/1492)', in Salma Khadra Jayyusi (ed.), *The Legacy of Muslim Spain – Vol. I*, 3–87.

Mann, Vivian, Glick, Thomas and Dodds, Jerelyn Denise (1992): *Convivencia. Jews, Muslims and Christians in Medieval Spain*, New York.

Martínez Montávez, Pedro: 'Lectura de Américo Castro por un arabista. Apuntes e impresiones', in *Revista del Instituto Egipcio de Estudios Islámicos en Madrid* 22 (1983–4), 21–42.

Mottahedeh, Roy P. (1980): *Loyalty and leadership in an early Islamic society*, Princeton.

Nirenberg, David (1996): *Communities of Violence. Persecution of Minorities in the Middle Ages*, Princeton.

Pope Francis (6 June 2015a), 'Discurso de bienvenida a las autoridades en Sarajevo', in *Revista Ecclesia*, last retrieved on 23 February 2016: http://www.revistaecclesia. com/el-papa-francisco-ensarajevo-4-discurso-de-bienvenida-a-las-autoridades/

Pope Francis (6 June 2015b), 'Discurso del Papa Francisco en encuentro ecuménico e interreligioso en Sarajevo', in: *aciprensa*, last retrieved on 23 February 2016: www.aciprensa.com/noticias/textodiscurso-del-papa-francisco-en-encuentro-ecumenico-e-interreligioso-en-sarajevo-32707

Sakrani, Raja (2018): 'The *Dhimmī* as the Other of Multiple *Convivencias* in al-Andalus. Protection, Tolerance and Domination in Islamic Law', *Rg*, 26-2018, 95–138.

Sakrani, Raja (2016): *Convivencia: Reflections about its Kulturbedeutung and Rereading the Normative Histories of Living Together*, Max Planck Institute for European Legal History Research Paper Series No. 2016-02.

Sakrani, Raja (2014): 'The Law of the Other. An unknown Islamic chapter in the legal history of Europe', *Rg*, 22-2014, 90–118.

Sánchez-Albornoz, Claudio (1956): *España, un enigma histórico*, Buenos Aires.

Seidman, Steven (2013): 'Defilement and disgust: Theorizing the other', in *American Journal of Cultural Sociology* 1(1), 3–25.

Simmel, Georg (1896): 'Soziologische Ästhetik', in Maximilian Harden (ed.), *Die Zukunft*, 17. Bd. Nr. 5, 204–16.

Simmel, Georg (1969): 'Forms of domination', in Coser, Lewis and Rosenberg, Bernard (eds), *Sociological Theory: A book of Readings*, Basingstoke.

Szpiech, Ryan (2013): 'The Convivencia Wars. Decoding Historiography's Polemic with Philology', in Conklin Akbari, Suzanne and Malette, Karla (eds), *A Sea of Languages: Rethinking the Arabic Role in Medieval Literary History*, Toronto, 135–61.

Tolan, John (1999): 'Une convivencia bien précaire: la place des juifs et des musulmans dans les sociétés chrétiennes ibériques au Moyen Âge', in Saupin, Guy et al., *La Tolérance, Colloque international*, Nantes, 385–94.

Tompkins, Jane (1992): *West of Everything: The Inner Life of Westerns*, Oxford.

Tönnies, Ferdinand (1887): *Gemeinschaft und Gesellschaft. Abhandlung des Communismus und des Socialismus als empirischer Culturformen*, Leipzig.

Waines, David (1994): 'The Culinary Culture of Al-Andalus', in Salma Khadra Jayyusi (ed.), *The Legacy of Muslim Spain – Vol. II*, Leiden, 725–38.

Wolf, Kenneth Baxter (2009), 'Convivencia in Medieval Spain: A Brief History of an Idea', in *Religion Compass* 3,1, 72–85.

3

Auriculation

Peter Goodrich

To hear is to obey. To listen in Latin is *obaudire*. *Obaudire* has survived in French as *obéir*. Hearing, *audientia*, is an *obaudientia*, is an obedience.[1]

The genius of law is in its nose. Justice, however, is all in the ear. While reason is tied to the olfactory organ, to the sniffing out of malversation, justice is more classically bonded to the acoustic erotics of the ear (Fig. 3.1). It is the organ that is never closed. The ears have no eyelids, they cannot but

Figure 3.1 *Auditus*, from Daniel Heinsius, *Emblemata amatoria* (1620). Photo by Peter Goodrich.

[1] Pascal Quignard, *The Hatred of Music* (New Haven: Yale University Press, 2015) 71.

listen, they are forced to receive. The opening emblem of *auditus*, from a long-lost text, *Emblemata amatoria* of 1620, can help make the point. The woman is tied to an organ, a huge ear whose focal centre, the *concha* of the auricle, is in the shape of a clef, a musical key, the symbol indicating the pitch of notes and the harmony that in Pythagorean theory will do justice and bring peace. She is all ear, an appendage to the aural, and the emblem allows the observation by extension that we are connected to the law by the *umbilicus* of audition, as listeners.

It is time, then, to take an ambulation around the oracle of auriculation (Fig. 3.2). The labyrinth and utricle of the internal ear, the sanctum or indeed inner temple of auscultation requires a hearing, an *oyer*, lest noise-cancelling technology and digital relays of the visual close the interruption and opening of acoustics. Law has historically provided a hearing in a dual sense. First in the form of *in vivo* trial, the audition of the cause, the coming to presence in the agonistic mode of seeing, hearing and smelling the parties. Sound waves, light waves, olfactory emanations create the scene and scent of the tribunal. In a second meaning, however, auriculation, the whisper of the law, is as

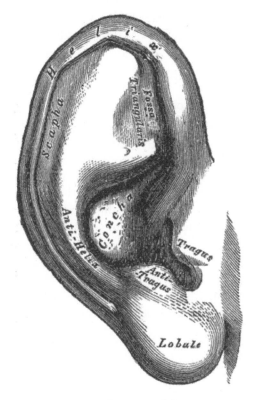

Figure 3.2 Diagram of the ear.

old as the *ius commune* or *commune ley* as the practices and uses 'time out of mind' orally transmitted, sensed and apprehended through the ear, *oyer et terminer* – first heard and then determined. The unwritten tradition of legality as the rendering of justice over time is for this reason conceived classically by common lawyers to be a pattern of sounds, a rhythm, a melody recorded and passed on in scripts that can always be rectified where the transcription has inaccurately heard the originating voice or mis-transcribed the rhythm of passage over time.

It is music, in the Pythagorean tradition, that precedes and constitutes the earliest harmony and first norms. There is a continuing sense of norm and rule as rhythm, as sonic patterning, whereby an argument is still said to 'sound' in law, but I will argue that this reliquary connotation in fact houses a more enigmatic and substantial history of the *eros* of hearing, a Nietzschean erudition *in eroticis* that comes much closer to the common law's ideal of listening as the inversion of the Christian imperative *audite me* or silencing of the audience. It is within the early tradition that the aural gains its strongest representation in the mystical writings of Aelian, who argued that 'the word entered through Mary's ear', meaning that she conceived Christ through her ear, a view that gets repeated in later Missals by Enodius who cites the Aelian theory: 'Be joyful, Virgin Mother of Christ / Who conceived through her ear – *quae per aurem concepisti*.'[2] The (non-)sexualisation of the ear, the image of the word penetrating the auricular, was denounced by the Council of Nicea, but not in any very definitive or dogmatic form. The erotic connotations of the aural, of Pentecostal tongues and labile ears, of the word going out and entering the heart via the auricle became a significant facet not only of the *ars praedicandi* but also of the brotherhood and *amicitia* of an embattled Christianity.

It is St Paul in the Epistles to the Romans who is most direct in relating faith to hearing and dictating that belief comes through hearing (*ex auditu*), and that the message is heard (*auditus*) through the word.[3] The advent and epiphany of faith is an auditory phenomenon: 'their voice (*sonus eorum*) has gone out all over the world, their words to the ends of the earth'.[4] For lawyers this sounding of the word, the transmission of faith, belief in the ceremonies and rites of an hieratic code, lies at the base of the tradition as an oral and aural passing on of unwritten and esoteric knowledge of community and law from generation to generation. *Traditio*, as Lord

[2] Cited in Rémy de Gourmont, *Le Latin mystique* (Paris, 1913) 315.
[3] *Romans* 10:18.
[4] *Romans* 10:18.

Chancellor Sir Thomas More was fond of pronouncing, in his polemics against St Germain, was a priestly knowledge, the hierophantic truth that only the initiated could properly comprehend and relay. This, for him, had ironically to be in Latin because separation was necessary prior to drawing the faithful together through the word.[5] The Church is for More before the word, an argument that deserves some expatiation. For Sir Thomas, 'the word of God is part written in the scripture and part unwritten, that appears not proved therein, as for example the perpetual virginity of our lady and other diverse points which were only taught by Christ to his apostles, and by them forth to the Church'.[6] While one might understand that perpetual virginity is best not written, the example is broader, in that whether it is seed or ink that is inscribed, there are consequences to that writing, to externalisation, to spillage, that cannot be taken back and do not admit of change or interpretation once in print or *in utero*. The basic point, however, is an extension of this *eros* of faith that the letter might kill or pregnancy profane.

The teaching of the Church, 'delivered from age to age', is for More transmitted primarily through faith, through the unwritten word, assisted by 'the spirit of God', by grace and discretion carried by tradition. The key role, literally the *clavis regni caelorum*, is held by the preacher who preaches the word of God as 'signs and tokens that signify the things in the mind, which are by his words brought unto the hearer's ears, and from the ears to the heart, as the water [of baptism] signifies and betokens the inward washing of the soul in the sacrament'.[7] To this we need simply add that what is true of the law of the Church is equally the case for temporal law, in that 'the good ancient laws and commendable usages long continued in this noble realm' depend ultimately upon the unwritten inscription of the *regulae iuris* upon the heart. The concord of spirituality and temporality lies in a shared origin and a shared grace transmitted through the spoken word both in the sacrament and in the liturgy of trial.

Turning to other sources and first to the philology of the word, More's argument as to the unseen, oral mechanism of transmission gains support in the classical tradition. For Isidore of Seville, in the *Etymologies*, *auris*, ear,

[5] On the longevity of Latin as a pure symbol, in the sense of an effective sign, both visual and auditory, of status and power without needing to be understood, see Françoise Wacquet, *Latin, or, the Empire of a Sign: From the Sixteenth to the Twentieth Centuries* (London: Verso, 2001). For discussion of the theme in a legal frame, see Goodrich, 'Distrust Quotations in Latin', 29 *Critical Inquiry* 193 (2003).

[6] Sir Thomas More, *The Apologye* (London, 1533) fol. 26v–27r.

[7] More, *Apologye*, fol. 54v.

auditus, hearing, and *audire*, to hear, all share a root in *haurire*, to draw in, pull together, fetch, and in a metaphor drawn from Vergil, the ears drink in the words of others.[8] The same sense of imbibing, of touching, of being washed by, cleansed and invaded through the unwritten character of the word can equally be found in More's near contemporary Sir Philip Sidney's *Apologie for Poetrie*, where the first lawyers are bards and music plays the role of the earliest norm in the 'Zodiack of [one's] wit', because it is 'a heavenlie poesie, wherein almost hee sheweth himself a passionate lover of that unspeakable and everlasting beautie to be seene by the eyes of the minde, onely cleered by faith'.[9] We lead, in other words, by the ear, not by the nose. The capture of the subject has to get under the skin. To be effective, law must enter the heart, a route that is well captured in the dual meaning of auricle itself, being both ear and cavity of the heart. It is that copula and copulation, the passage from outside to inside, from auricle to utricle and then through the labyrinth to the unseen scripture of the heart, to an internal knowledge, a perpetual virginity, that the ear facilitates and relays.

The cavity, the opening, the *imago* of the ear is reflected in the symbolism of the aural, as also in the predominance of rhetoric and of auricular figures in the legal curriculum. For the early lawyers, the ear was the path to that *eros* that expresses itself in faith, in worship of the higher power, in marriage to the brotherhood, the Church, which in its turn is married to Christ. This may be a perpetual virginity, a spiritual love, but it represents a voluntary capture, wedlock, a golden chain that gains its classical expression in the aul (awl) that is thrust through the auricle to signify the freely chosen bondage of 'thy servant' (Fig. 3.3). The source is *Deuteronomy* but it gains later expression in the more generalised form of an ear pierced to symbolise capture by the Christian bond of love, and so to be held *in vinculis caritatis*. This leads, so Paradin writes, to the divine – *Omnia traham ad meipsum*.[10] Note that it is the ear that is pierced and precisely the auricle that is the avenue of entry into the fulfilment of the law *ex auditu*, as the chain that ties the subject to the community in a bond of shared desire. This is not simply unstable *amicitia*, it is commitment, entry into the 'many Grounds and Rules of the Lawes of this Realme [that] are derived from Common use, Custome, and Conversation among men, Collected out of the general disposition, nature, and condition of humane kinde'.[11] The past, as a figure from Valeriano indicates, will foretell the future, the auditory providing

[8] Isidore of Seville, *Etymologies* at 232, 234.
[9] Sir Philip Sidney, *An Apologie for Poetrie* [1595] (Oxford, 1907) 8.
[10] Claude Paradin, *Devises heroiques* (1551) 78.
[11] Sir John Doderidge, *The English Lawyer* (London: I. More, 1631) 154.

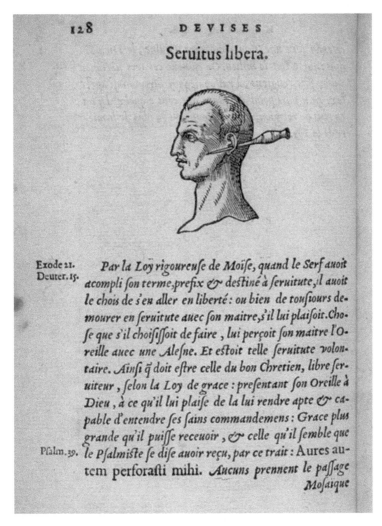

Figure 3.3 Paradin, *servitus libera*, from *Symbola heroica* (1560). By permission of Duke University Library.

auditurus, what will be heard (Fig. 3.4).[12] The bigger the ears, as the later author of *The Human Face Divine* expostulates, the more likely the figure is a democratic one, a reformer, a leader: 'a large ear goes with large features,

[12] Piero Valeriano, *Hieroglyphica sive de sacris Aegyptorum literis commentarii* (Basle, 1550) 237 recto. The source of this interpretation of the ear is Artemidorus, *Oneirocritica*, where he posits that to dream of having the ears of an ass is good only for philosophers, because the ass does not shift its ears quickly.

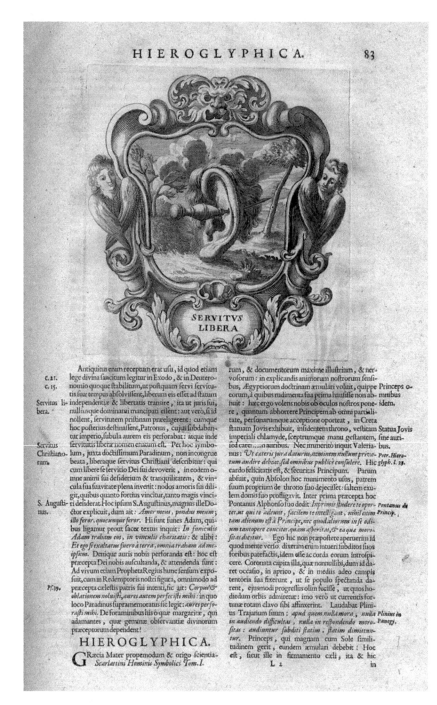

Figure 3.4 Otto Scarlattini, *Homo et eius partes figuratus* (1695), p. 83. By permission of the University of Mannheim Library.

large hands, large feet, and a large heart'.[13] Wells also, however, notes the importance of distinct and fine definition and calibration of the variable parts, the ridges and troughs of the auricle. The greater the precision and articulation of the auriculation, the more refined the hearing.

It is in this latter and expansive sense that the ear marks the gateway to justice and the higher law, as visible in Scarlattini's derivative image of a pierced and so perforated ear, signifying obedience to law, stability of affection, and shows the earhole itself, the *cavum* of the *concha*, in the shape of a key – *clavis regni*, the key to the kingdom, to the other realm, the interior that is innermost and so also in theological terms the most extimate of all (Fig. 3.5). The hair indicates laconically the marriage of the ear to the head, the locket can be filled, according to the *lex amatoria*, while in juristic terms the hair suggests the possibility of a judicial earwigging. The dramatic background of trees symbolises the community and *amicitia* of the brothers that make up the Church. Here, for Scarlattini, the disciplines begin because the ear is their auricular *modus scribendi*, the sensory organ of the intellect, the means of access to the sightless space of cerebration, the candle-less theatre and dark sensorium of the skull. Law needs colours like ears need lobes, and to that effect Scarlattini reproduces the hieroglyph of the ear with the motto *servitus libera*, voluntary captivity, or Nietzsche's free choice of necessity. The ear and the aul (awl) signal a belonging to tradition, to the oral and unwritten, to the unspoken bonds of physical affection and group bonds and bands, or in the Christian argot the ecstasy of anticipation that constitutes faith in what is not.

The ear is a strange object of desire, a liminal point, the most open organ, uncanny in that it cannot close and extensive in its sticking out. It is the ear, for instance, that features in Judgement 18 of Auvergne's *Arrêts d'amour* and merits attention.[14] The appellant complained that her lover had stolen a kiss. She had been with several companions in a park when her lover had come by and, pretending to whisper something in her ear, had kissed her auricle. This she claimed was public theft of a kiss, *furtum manifestum* in the gloss and a misdemeanour: a licit kiss should be given in private whereas here there was an apparently lascivious aural osculation and one which if witnessed by

[13] Samuel Wells, *New Physiognomy, or, Signs of Character as Manifested Through External Forms, and Especially in 'The Human Face Divine'* (New York, 1867) 269.

[14] Martial d'Auvergne, *Les Arrêts d'amour* [1528] 257. I have used the edition of 1731 with its elaborate gloss by Benoit de Court (Benedictus Symphorianus): *Cum erudite Benedictii Curtii Symphoriani explanatione*. For an analysis of the juristic status of the *Commentaries*, see Valérie Hayaert, 'Serio ludere et humanisme juridique: Les glose de Benoît de Court aux Arrêts d'amour de Martial d'Auvergne', in Géraldine Cazals and Stéphan Geonget (eds), *Des 'Arrests Parlans'* (Paris: Droz, 2014) 103.

Pierii Val. Nasus.

de Naso quidem unum tantùm nunc succurrit, quod ad hanc rem facere uidea, D
tur. Nares quippe in Deo perscrutationé eam significare, qua ipse corda homi,
num odoratur:eoςϑ spectare illud ex lib.Regũ:Ascendit fumus de naribus eius.
Alibiςϑ in sacris literis,odorari, cuius & indiciũ & instrumentũ est nasus, place,
re significat. Ita Noë sacrificante odoratus est Dominus Deus odorem suauita,
tis:hoc est,placuerunt illi sacra,quæ uir ille probus obtulerat. Idcirco Lex homi
nem qui uel paruo, uel magno nimis, uel obtorto naso fuerit, ab altari sancto
summouet,ne scilicet accedat ad ministerium eius.Tales sunt, quibus uel pauca
admodum habentur in diuinis institutionibus quæ ipsi probent, uel quibus o,
mnia nullo discrimine tam bona quàm mala placēt:uel illi,quibus mala prauaςϑ
tantùm placent,diceret Hesychius. Deinde ad Ranerium cōuersus:Scio uerò
coniectores hac parte super multa cōmentos,quæ tu recensere potes Raneri,qui
partem hanc tibi agendam suscepisti.Libentissimè,respondit R A N E R I V S.Et
quandò incidimus in nasum,ut ordinem sequar tuum,apud Onirocritas Vrba
ne pater, eum qui se magno naso per somnium uiderit, magna in rebus agendis
sagacitate prudentiaςϑ fore promittitur. Hinc etiã emunctæ naris uiros dici eos E
usitatum,qui acri sunt iudicio conspicui.

M O R S.
S I uerò aliquis morbo decumbat, & absςϑ naso se imaginetur, futurã illi mor,
tem inde præsagiunt,quòd ea pars acturùm abit à cranio.

V T uerò ad aures redeamus, id in primis io
cosum est quod apud eosdem Onirocritas
habetur de auribus asininis, quas qui se habere
per somnium imaginatus fuerit,'seruitutem ij
atςϑ ærumnas ingruere homini præsagiunt,ni,
si fuerit is philosophus, cui tantùm eam spe,
ciem prospera ominari tradunt, ob tardiorem
aurium motum, quæ contanter in huiusmodi
animali mouentur, quemadmodũ firmam esse
debere philosophorũ auscultationem uolunt.

SERVITVS.

L O N G A S E R V I T V S.
Q Vin etiã humanæ aures apud eosdem cōie
ctores si seruo homini plures accessisse uisæ fuerint,longæ sunt seruitutis F
indiciũ:multa enim ostendunt extare imperia,quæ somniator is sit auditurus.

A M P L I T V D O F A M I L I Æ.
C Ontra uerò si paterfamiliàs is fuerit qui plures habere se aures imaginetur,
familiæ huic aiunt amplitudinem significari, propterea quòd plures filios
& seruos dicto parentes sit habiturus.

L V C R V M.
O Pificibus autem insomnium idem lucrum apportat: audiet enim multo,
rum uoces opera locantiũ. Verùm hæc & huiusmodi pleraςϑ, ut ingenuè
fatear quid ego sentiam, ingenij humani argutias potius ostendunt, quàm soli,
diorem ullam sapiant disciplinam. His dictis ad te Patrue conuersus addidit:
Nunc tu autem Vrbane pater,si quid sacratius habes super auribus,in medium
asferre potes.Tum tu nihil contatus,

C O N T E M P L A T I O.
D Vm de supercilio disputatum est,unum mihi uidetur esse præteritum,per
quod

Figure 3.5 *Servitus*, Valeriano, *Hieroglyphica* (1550).

her husband could have had deleterious effects. Our glossator notes that this
seems to be the condemned act of *coitu liberos*, free love, and against the law.[15]
For his part, the lover asserts that he had intended to whisper in her ear but
had lost his balance and had slipped, resulting in his lips brushing her cheek
and ear. This should not be taken for 'un baiser' or sexualised embrace. Our

[15] D'Auvergne, *Arrêts*, 258.

glossator had earlier distinguished the licit *osculum* or conventional kiss from *suavium*, which is a seized and sensual licking of the ear, and is a matter for the law. It involves a libidinal economy, and a sexualisation that also attaches to *basium*, a kiss that penetrates, or here copulates the tongue in the ear.[16] The oral encounters the aural, the lingual the labial, in an act, to use the urban slang, of *aurilingus*.

In Derrida's terms, the issue is that of which ear had been kissed, a question that our glossator Benoit de Court formulates in terms of *subintellectio*, and most obviously references the distinction between the auricle and the utricle.[17] Underlying this, *subauditio* or heard below, is the distinction between law and equity as the distinct ears of the legal process which gain expression here in the *duplex sententia* or dual sense that the laws of love attribute to all words. They belong either to the libidinal economy of equity or to the rigid economics of law. It is the ear that will distinguish, one or other auricle that will listen, outer or inner that will respond to the hearing. The dual sense is one that tries to read the case so as to maintain the relationship – *res . . . magis valeat quam pereat*, according to *Digest* 34.5.12. *Amicitia* was to be fostered and love should be kept alive, an interpretation that also references the other dimension of the technique of the *duplicem sententiam* or double sense, of *subaudio* as the method of interpreting so as to fit the past to the present circumstance, so as to listen anew to what is hidden or forgotten in the potential, the desires, earmarks of the precedents.

Allow me one more example, a fiction, from Duhamel's immortal *Salavin*, and specifically his 'Midnight Confession'. Salavin works for a publishing house run by M. Sureau. He seldom sees Sureau but on the occasion in question is asked to deliver some pages for the Director's scrutiny. This does not go well. Sureau is enraged: 'Badly written – illegible – what the devil's this word', to which question Salavin supplies the answer 'supererogatory', a term, ironically, that means beyond questioning, though also connotes a good that exceeds what is required, something past the call of duty. Reading the word, however, has brought Salavin very close to Sureau, next to his left elbow: 'It was then that I noticed his left ear . . . It was the ear of a rather full-blooded man: a large ear covered with hair and a few wine coloured blotches.'[18] The ear, Salavin thinks, was very near, it was human flesh and it

[16] See Hayaert, '*Serio ludere*' at 114–15, where she notes the distinction between the *osculum*, a conventional and sometimes religious kiss, as in the *osculum pacis*, and *basium*, signifying lasciviousness. Here we are dealing with the distinction between accidental and opportunistic aural sex.

[17] Jacques Derrida, *The Ear of the Other: Otobiography, Transference, Translation* (Shocken Books, 1985) at 4: '(everything comes down to the ear you are able to hear me with)'.

[18] Georges Duhamel, *Salavin* [1920] (London: Dent, 1936) at 7.

would for some people be quite natural to touch it; 'people to whom it's a very familiar object'. His reverie then continues and he sees Mademoiselle Dupère, the stenographer with whom Sureau had a quite well-known affair, leaning over and kissing him 'right there, on that very spot, behind his ear'. At this point Salavin becomes aware that he has moved his right arm slightly with the forefinger pointed out and 'then I realized that I wanted to place my finger there – on M. Sureau's ear'. And so to the crux of the confession: "For a thousand reasons which I perceived only dimly, it had become urgent for me to touch M. Sureau's ear, to prove to myself that that ear was not a forbidden, imaginary and non-existent thing, that it was made of flesh and blood like my own ear. Suddenly I reached forward and deliberately, carefully, placed my finger where I had wanted to, a trifle above the lobe on a brick-coloured patch of skin.'[19] Sureau, just for the sake of completion, becomes apoplectic at the touch and reaches into a drawer for his revolver.

Ignoring the passage from Mademoiselle *Dupère au pire* and the various other humorous possibilities, including the very minor quality of the transgression, we can note briefly, on topic, that the name Salavin has its roots in Solomon, while Sureau derives from the Latin *sambucus*, meaning a triangular musical instrument. Thus our protagonist, our innocent Solomon, seeks to play the ear, to tune the auditory instrument, to achieve a harmony with his employer and manager, his superior, through the reverie and then the tactile act of touching the auricle just above the lobule and so on the *anti-tragus* – the lower posterior portion of the *concha* of the external ear, the erectile part of the auricle and etymologically the antithesis of smell. Touch here opposes reason, the ear against the nose, auriculation in this instance being antinomic to the nostrillations – the nosarian illations – of law. There is, however, more to this fiction from the perspective of auriculation. Salavin has been unjustly treated by his immediate superior, Jacob, who is the party responsible for the pages and who should have taken them to Sureau. When the Director becomes enraged at the poor quality of the pages, it is not Salavin who is to blame, but Jacob. Sureau should have realised this, and should have given Salavin a hearing, an audition, a chance to speak. The importuning of the auricle is a fairly direct attempt at garnering attention, at requesting that Sureau lend him an ear and become a listener. Salavin thus traverses the distance between two *corpora*, between the *corpus* and the body, between writing and speech, between the abstraction, the dead weight of law and the tactile and living call of natural justice which dictates, somewhat hieratically, *audi alteram partem*, or in this instance hear the case.

[19] Duhamel, *Salavin*, at 8.

Sound, the immaculate conception of music, the perpetual virginity of words, precede law and dictate the conditions of justice within which law should act. Sound is equally supererogatory, a good beyond legal formulae, records and rolls and hence the primary desideratum of natural justice – properly *audite alteram partem*, listen to the other, and in the previous fiction, hear Salavin. It is time to borrow from Zarathustra that there are some who lack everything except that they have too much of one thing, as for instance 'an ear as big as a man! I looked more attentively and actually there did move under the ear something that was pitiably small and poor and thin. And in truth this immense ear was perched on a small thin stalk – the stalk, however, was a human!'[20] Where his auditors think the great ear a genius, Nietzsche thinks it a reverse cripple, a sign of humanity reduced to fragments and limbs, broken up, scattered about. His point, however, at this juncture, is that it is necessary to re-establish will, volition, the unity and belief in action that comes with the auditory and leads to the *Will to Power*. The ear needs to find its place in the new order of emancipation. Zarathustra needs an audience – 'I am not a mouth for these ears' – and he seeks 'whoever still has ears for the unheard . . . who listens also with the ears of the mind'.[21]

A comparable argument arises in law at the very roots of the tradition of legal trial and takes pride of place as a primary rule of natural law. There must be a hearing. The ears of the law should be open because what is said by tradition, passed on orally as common erudition, is the immemorial law. In a more precise sense, the facts must be entertained and the parties heard according to the Latin maxim *audi et alteram partem*, hear the other side. The source in common law is *Boswel's Case* from 1601, when a plenary Court of King's Bench held that Boswel, who had not been summoned to a litigation as to whether or not his living – his incumbency of a parish – could be transferred to another, was not to be ejected without being heard. It was a case of advowson.[22] As the incumbent of the Church of Wymbish, Boswel was the beneficiary of the grant of the living by the Bishop of London, which living and benefice the plaintiff, one Anthony Lowe, claimed attached to the Manor House in Wymbish, which he had just purchased. As the legal claim was between Lowe and the Bishop of London as to the right to present the living, Boswel was strictly superfluous and was not named in the writ. The Court, however, took a different view and held

[20] Nietzsche, *Thus Spake Zarathustra* (1914) 166–7.
[21] Nietzsche, *Zarathustra*, at 14, 21.
[22] *Boswel's Case* (1606) 77 *Eng.Rep.* 326. For the literary history of the rule, see Kelly, 'Audi Alteram Partem' (1964) 84 *Natural Law Forum* 103.

that as a matter of reason – *eadem est lex ubi eadem est ratio* – Boswel should not be harmed without being heard. No incumbent, the Court intoned, 'shall be removed . . . unless the incumbent be named in the writ *quia res inter alios acta alteri nocere non debet* although the incumbent be in a defeasible title [things done between strangers cannot harm one who was not a party to such acts]'.[23] The Court then cites Seneca to the effect that a court that judges without hearing one side, judges unjustly, whatever the reason in law for the determination. It might appear to be right, it might be good law, but it would not be justice or, in an antique German maxim, the word of one party is no word at all.[24]

Justice Fortescue in *Bentley's Case* offers an alternative source which perhaps fits more closely with the dualism of the tradition of two laws. 'I remember to have heard it observed by a very learned man upon such an occasion, that even God himself did not pass sentence upon Adam, before he was called upon to make his defence. Adam (says God) where art thou? Hast thou not eaten of the tree, whereof I commanded thee that shouldst not eat? And the same question was put to Eve.'[25] The serpent, incidentally, does not get to defend herself but is sentenced *instanter*, as lawyers say, on the strength of Eve's testimony alone. God and humanity ironically bond in the moment of expulsion from *paradiso*. That aside, unable to see Adam, God, sensing, perhaps hearing him, calls out and demands audition – *audite me*. The conclusion is that 'the objection for want of notice can never be got over. The laws of God and man both give the party an opportunity to make his case.'[26]

Natural justice dictates that the parties have a right to be heard, the ears, the hairy utricle and vestibule, the membraneous labyrinth that constitute the balancing apparatus of the inner ear must all be engaged. It is both literally and legally true that without hearing there is no balancing, no justice. It is from early on evident that inability to hear generates imbalance and its consequence, injustice. That is the import of *Boswel's Case*, namely that to be a judge is first to listen, to summon and to hear, to unwax the ear, to draw together in the rite of an albeit agonistic conversation – *inauditum est injustum*. Thus the obsession in early legal texts with remembering what had been heard said, in court, in chambers, in the alcoves of the Inns, where the oral tradition of common law was relayed. The sources are well enough known.

[23] *Boswel's Case* 328. For further detail on this point, see Goodrich, 'The Great Dialogue', in Goodrich (ed.), *A Cultural History of Law: The Early Modern Age* (London: Bloomsbury, 2017).

[24] Daan Asser, '*Audi et alteram partem*: A limit to judicial activity', in A. Lewis and D. Ibbetson (eds), *The Roman Law Tradition* (Cambridge: Cambridge University Press, 1994) 210.

[25] *R v. University of Cambridge* (1723) Ld Raym 1334, 93 ER 698, 704, concluding *per Cur. ulterius concilium*.

[26] Ibid. at 704.

Where arguments were inaudible, where the reason for decision had not been heard, the law was likely to be uncertain, its logic obscure or unknown yet nonetheless usually repeated, not least because *communis error*, as likely as not, *fecit ius*. Lawyers went to court with their ears, erudition was the result of audition and, as in *Boswel's Case*, where a party had not been heard then justice could not be done.

That leaves one final point, a synaesthetic idiosyncrasy of common law. First, the classical sense of bodily interiority or internal perception was the synaesthetic root of common sense and the ground of judgement. Hearing, as also those other occasions of sensorium to be found in sight, taste, touch and smell, were linked in the scholastic tradition to reason, memory and imagination. Hearing, at the deepest level of being, produces the reason of judgement and by extension and specifically by auriculation the body participates in and houses the immediate theatre of decision. The law of the body generates the law of the realm, and yet the corporeality of the legal organs is as yet, contemporarily at least, unknown. The body houses and hears before pronouncing or judging, and it is that physical placement, that ambulant presence of the juridical – *regula iuris* as *forma vitae*, the rule of law as a form of life – that links the body to its places and the law to its architecture as habitation, office and undying dignity expressed in the repetition of tradition and the slow vibration of structures. That these walls can hear constitutes a threshold to all audition, and nowhere more so than in the strangely auricular space of the original Inns of Court.

The requisite metaphor comes in the form of the law of the echo, the auditory apparatus here acting juristically as the site of precedent, the institution of memory through the recollection of sounds. Walter Benjamin is the most precise of chroniclers of the noise of history, the *otos* of autobiography, and by extension the sound of the past in the rustling of law, in the fluttering of the robes.[27] 'The moment of *déjà vu* has often been described. But I wonder whether this designation is actually fortunate, and whether the metaphor most appropriate to the process should not rather be taken from the realm of acoustics. One ought to speak of events which affect us like an echo to which the call, the sound that awakened it, seems to have at one point dissolved into the darkness of a life that has passed.'[28] The repetition, the beat of precedent, the sound of juristic history, of the dead, makes the text, the *corpus* of the judge, an echo chamber of the law. The role of reading, the scrutiny of the precedent texts, is one of legal otoscopy, of staring into the auditory canal of

[27] On the ear and memory, see particularly Gerhard Richter, *Walter Benjamin and the Corpus of Autobiography* (Detroit: Wayne State University Press, 2000) ch. 3.

[28] Walter Benjamin, *Reflections* (New York: Schocken Books, 1978) 59.

the juridical institution, of listening to the past with the variable apparatuses of an acoustics of memory. Tradition is something that we listen to, a tympanum, an eardrum that we strike to hear the strains, the conflict and cases of the past. It is these reverberations, the echo chambers of an acoustically generated memory that tilt the wigged head towards decision, in the direction of the potential of law which is the possibility of justice.

The body of the law is in significant part a sonic apparatus, a dance to the music of time as apprehended through the ear of the jurist. The body of the institution, the other and more permanent *corpus* of legality, mimics that of the lawyer in the architecture of its presence. It is in the chambers, corridors, courts and canals of the buildings, in the alcoves and antechambers, vestibules, courtyards and cloisters of the built environment, in the structures, in the echoes of the places that we find the hauntings that are the sites of law's monumental presence.[29] It is my concluding trope and trophy, aural play and architectural adumbration that the Inns of Court, the legal lodgings and sites of juristic hospitality that form the angelological houses of the early common law that take the shape of an ear. The *corpus iuris* is in this grounding a series of houses, a body of buildings, doors and gardens, inner vestibules, chambers, halls, dining spaces, meeting rooms, trophies, portraiture, statuary and reticules. As David Evans brilliantly if briefly suggests, these spaces of juristic haunting in the City of London are shaped as an ear (Fig. 3.6).[30] Look briefly at the map and Chancery Lane, the heart of the law, is the *cavum Concha*, the hole of the ear, with Fleet Street as the *Antitragus* and Staple Inn above as a near-perfect *Triangular Fossa*. To the rear, Kingsway and Holborn are the lateral and upper *Helix*, the final turn of the *Scapha*, the cupping that returns the outer extremity of the *auricle* back towards the *cavum*. The entire physical presence of the law in the city is shaped as an ear, an external cup that will simultaneously keep out and draw in, entice and guard.

The body of the law is replicated in its topology, the law of its spaces, and specifically the constitution of an interior and an exterior that divides, marks and encloses the secrets, the labyrinth of legality, into which the subject is drawn. Here there is a further point, another fold in the cartilage and skin that make up the auricle, an excess in the form of the door that leads into the Inns, and specifically into Lincoln's Inn with its fields, its own division of the territorial army, its manifold insignia, mosaics, vestibules, corridors

[29] Lior Barshack, 'The Constituent Power of Architecture', 7 *Law, Culture and Humanities* (2010) 217 provides an elaborate account of the relation between architecture and death, monumentality and law.

[30] David Evans, 'The Inns of Court: Speculations on the Body of the Law', 1 *Arch-Text* 17 (1993).

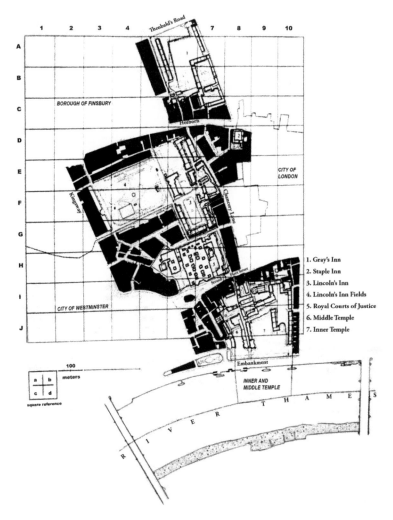

Figure 3.6 Map of the Inns of Court. Digital enhancement by Nancy Shon.

and labyrinth of chambers (Fig. 3.7). The door, of course, plays a key role as threshold, and when closed acts as a wall, a suppression or structure of forgetting, of hiding the law, while when open it invites entry into the crypt of legality.[31] Here there is actually a door with rites and privileges of opening and closing, of access and exclusion, a before the law and an inside the law. Inside is most immediately the vestibulary space of interior access, of

[31] On which, attend to Mark Wigley, *The Architecture of Deconstruction* (Cambridge, MA: MIT Press, 1993) 150–7.

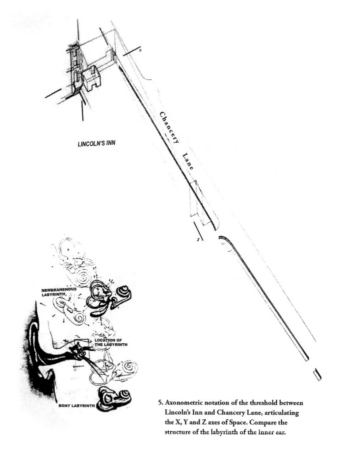

LINCOLN'S INN

Chancery Lane

MEMBRANEOUS
LABYRINTH.

LOCATION OF
THE LABYRINTH

BONY LABYRINTH

5. Axonometric notation of the threshold between
Lincoln's Inn and Chancery Lane, articulating
the X, Y and Z axes of Space. Compare the
structure of the labyrinth of the inner ear.

Figure 3.7 Chancery Lane. Digital enhancement by Nancy Shon.

entry into the body, the membraneous *sanctum* of the *Concha* and canal of
the auricular. It is structured architecturally in mimicry of the inner ear, the
labyrinth and utricle with which I began. Here, inside the body, internal to
the Inn, are the vessels and channels, fluids, tubes and sacs that make hear-
ing possible. It is by displacing the fine hairs of the acoustical canal, by shak-
ing the follicular tissue that hearing is effected, and balance, a sense of force
and gravity is enacted. It is by disturbing the inner hair, the membraneous
follicles of the law, by circulating in the cloisters, by disrupting the wigs of
the barrister, listening to the fluttering of the judicial robes that the possibil-
ity of justice comes into play in the acoustical apparatus of legality.

4

Is Pasteur American? *The Story of Louis Pasteur* (William Dieterle, 1936): From Nineteenth-century Laboratory to Twentieth-century Trials – A Transnational Perspective

Claire Demoulin

When a mad dog bit six children in Newark in 1885, the boy's life-saving journey to Paris looking for Pasteur's cure echoed resoundingly in the American press. Increasingly present in the following months and years, Pasteur's iconography had a massive and lasting impact through media coverage, making him a leading and popular figure in the American illustrated press.[1] As his image circulated through painting, photography and cinema, it animated the visual health imagery of the early twentieth century, while associating his name and face with sanitary messages. These works coincide with a time when public sanitary policies were being established. By exploring both the American and European reputation of Louis Pasteur, cinema reinforced a long tradition of popularising scientific figures while pedagogically conveying hygienic rules.[2] And this led to one

[1] Bert Hansen, *Picturing medical progress from Pasteur to Polio. A history of mass media images and popular attitudes in America* (New Brunswick, NJ: Rutgers University Press, 2009) 9, 80–5. On 19 December 1885, at least four magazines covered the story: *Harper's Weekly Story, Scientific American, L'Illustration, Daily Graphic.* In ibid. 57.

[2] For Anneke Smelik, the scientific knowledge acquired during the twentieth century has been directly linked to its representation on screen, in: Anneke Smelik, *The Scientific Imaginary in Visual Culture* (V&R unipress GmbH, 2010) 10. More specifically, the moving images have also been used as propaganda tools for healthcare messages: 'Health education films, [. . .] did not simply represent medicine and health, they were conceived as their instruments: each film was, in one way or another, intended to alter public behavior to enhance health.' In Sir Kenneth Calman, *Signs of Life: Cinema and Medicine* (London: Wallflower Press, 2005) 45.

of the first American biopics[3] on Pasteur, directed in 1936: *The Story of Louis Pasteur*.

The French scientist, however, was not an obvious choice for inaugurating this new genre path. In fact, when William Dieterle the director of *The Story of Louis Pasteur*, and Paul Muni and Henry Blanke, actor and producer respectively, approached the Warner Brothers Studio directors for financial support, they reluctantly offered only minimal support, considering Pasteur as merely 'a milkman'. The use of such a derogatory nickname indicates a cultural assumption about what is not filmworthy, namely: a European scientist being at the forefront of an emerging American genre of film instead of it promoting the depiction of national benefactors.[4] In the 1930s, *Pasteur* opened a cycle of Hollywood films picturing European scientific characters, as new waves of emigration punctuated the period. The film brought these European portraits closer to the studios' industry codes and mise-en-scène practices, embodying a trend of cultural circulations between Europe and the USA. I posit that *Pasteur* conveys a transnational history and a multicultural perspective that represents a shift in both the depiction and the choice of subjects in film history.[5] The studios zero in on the old Continent for the overflow of distinguished self-made men and their related epoch, while promoting and shaping them according to American societal expectations. Such an intriguing turnaround leads to one simple question: what makes these characters remain European?

From this latter point, I therefore argue that European references not only serve as a stamp of prestige or of sophisticated cultural quotation, but are of great significance within film discourse. Edelfelt's painting, *Pasteur in his laboratory* (1885), proves to be a landmark in Dieterle's setting, not only for transposing cultural background, but mainly for the ambivalent historical

[3] 'A biographical film is one that depicts the life of a historical person, past or present.' In George F. Custen, *Bio/Pics, How Hollywood constructed Public History* (New Brunswick, NJ: Rutgers University Press, 1992) 5. The conflicting search for historical truth and fiction is one of the main tensions inherent to the genre.

[4] The biopics rather praise American names: *Daniel Boone* (David Howard, 1936), *Young Mister Lincoln* (John Ford, 1939), *Young Tom Edison* (Norman Taurog, 1940), *The Pride of the Yankee* (Sam Wood, 1942), etc. William Dieterle's series of European figures are some of the few exceptions (including *Queen Christina* by Rouben Mamoulian in 1936 or *Marie Antoinette* by W. S. Van Dyke in 1938) that nevertheless stood aloof with a focus on classical historical figures and not self-made men. Alexander Korda, another European-born director, already conveyed European historical names in his films, but their characters were primarily structured around the intimate sphere: *The Private Life of Helen of Troy* (1927), *The Private Life of Henry VIII* (1933), *The Private Life of Don Juan* (1934).

[5] The biopics of scientists, for example *Yellow Jack* (George B. Seitz, 1938), *The Great Moment* (Preston Sturges, 1944) and *Sister Kenny* (Dudley Nichols, 1946), predominantly favour American personalities.

moment this painting represents. Based on the painting, *The Story of Louis Pasteur* goes beyond ranking Pasteur among a pantheon of great men. Like almost all of Dieterle's biographical pictures, *Pasteur* belongs to nineteenth-century Europe and represents men fighting against the received orthodoxy of the day, depicting this century for its modern and humanist society. In the film, Pasteur's microscope embodies a transition in the art of seeing, which links the scientist to the artist as they also both face the throes of authoritarianism. Looking deep into the nineteenth-century built environment, the film relates more than the life of its hero, opening on the conflicting relationships that structure the fictions via protagonists standing against their institutional rules: traditional science versus scientific progress, norms versus testing. These films are not about life-narrative, but about profound changes in social trends; if they are biographies, they are of society.

In *The Story of Louis Pasteur*, the advent of microbiology and the presence of the microscope allow this turnaround from subject narratives and prompt the background to move into the foreground. Indeed, the microscope embodies a transition in the art of seeing and the lens introduces bacteria as new agents in society. The microscope accompanies what Francesco Casetti[6] would presumably call a glass-media revolution, for it encapsulates a new gaze – from the visible to the invisible – introducing a significant reconfiguration of our social environment.

To insist on the impact of such new discoveries as operators of cultural habits, historical references and social interactions, Dieterle employed the rhetoric of trial scenes. He empowered the voice of opposition by positioning his hero in defence of existential research. In respect of the outcome, a 1936 film camera re-enacts past trials to illustrate their universal and present-day enlightening perspectives. *The Story of Louis Pasteur* embodies a struggle that speaks to its contemporary audience (concerned about new diseases, the growth of fascism in Europe) and bridges the social, historical and ideological considerations that lie behind its political background.

I. From Artists to Scientists in Nineteenth-century Europe: Diving into Conflicting Views of the World

The painting by Albert Edelfelt exhibited at the Musée d'Orsay in Paris portrays Louis Pasteur as he contemplates the dual-tube jar he is holding in his right hand.[7] Edelfelt painted the jar in great detail because, importantly, it contained a sterile breeding ground. The mixture and what it predicts is the reason for the painting's distinctiveness; from the moment it was created in

[6] Francesco Casetti is a Professor of Film Studies at Yale University and a specialist in media archaeology.

[7] See Fig. 4.1.

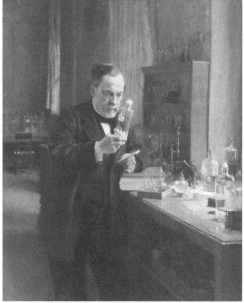

Figure 4.1 Pasteur, painting of Albert Edelfelt. © Musée d'Orsay, Paris.

Figure 4.2 Pasteur, mise-en-scène of the film. © Warner.

1885 to the time it was put on display a few months later, a great scientific event was to occur; Pasteur discovered the rabies vaccine.

William Dieterle, a German-born film director,[8] reused this significant event when he directed *The Story of Louis Pasteur* with an evocative mise-en-scène that clearly matches the painting.[9] Another director inspired by Edelfelt, Sacha Guitry, made a film about Pasteur in 1935 in which he played the main role, and he also took ownership of the same painting to open its fiction. How noticeable that two films directed with an interval of one year between them but in different parts of the world (France/US) pay similar tribute to the portrait. What does the painting contain that attracts such attention? According to Bert Hansen, Edelfelt is the first European artist to have portrayed the scientist as a great man and reset the laboratory as the working place where progress happens.[10] He positions him alongside the

[8] Dieterle had been contacted by Warner Brothers Studio in 1929 following his success as an actor in German films such as *Waxworks* by Leni and *Faust* by Murnau. He was also an author of essays, fiction and plays. But he devoted his entire career to one main purpose – filming other people's lives. As a European in Hollywood, he had a prominent voice in the German exile community.

[9] See Fig. 4.2.

[10] Bert Hansen, op. cit. 80.

customary leading figures of the nineteenth century, such as politicians, intellectuals and artists. Staying true to historical portraits of the time through the use of oil on canvas, imposing dimensions, and flattering outfits and poses, Edelfelt still managed to defy conventions. Despite the fact the scientist is wearing a frock coat, he is depicted in the act of carrying out an experiment. The scientist, a 'great man' of the nineteenth century, embodies the working man, someone in the process of doing what he does best, thereby turning his laboratory into a social environment. The graphical depiction of the workshop includes two opposites: a place defined by its tools and furniture, and a private space defined by its master, or his characteristics with his personal view of the world. Scientists, like artists, show evidence of their new vision, imparting their forward-thinking ideas of the Age of Enlightenment from the comfort of their study. In the nineteenth century, scientists became key figures of positivism, portrayed in the laboratory from where discoveries were made and thoughts were generated. Following the transition from artists to scientists, laboratories recreated in Hollywood studios were set according to the standards of European nineteenth-century artistic studios. In both cases, artists and scientists are depicted as men belonging to a specific working environment, alongside their instruments, resulting in analogical visual representations of place. Therefore, the portrait of Caspar David Friedrich, painted by Georg Friedrich Kersting in 1819,[11] introduces an easel, a palette, a hand support and a wide range of colours used by artists to produce their detailed version of the world. Similarly, Edelfelt and Dieterle offer an evocative spatial arrangement using graduated phials, conical flasks, burettes and test tubes. Both are leaning on their elbows, deep in thought before their creations. An artist's studio and portrait of great men intertwine, resulting in a favourable transition of artist to scientist, art studio to laboratory, thus highlighting a distinctive view of the world.[12] Both overwhelmed in the act of creation, and the transposition of a reflexive process is exactly what drew Pierre Larousse's attention when he underlined in his Second Supplement of the *Great Universal Dictionary* in 1890 that: 'in his laboratory, concerned with problems he is helping to make even more mysterious [. . .] M. Edelfelt brings him alive in front of our very eyes as we watch his thought process in action, witness the condition of his soul and his mind'.[13] Above the artist-scientist creative pair,

[11] Cf. Fig. 3. Georg Friedrich Kersting, *Caspar David Friedrich*, 1819, Alte Nationalgalerie, Berlin.

[12] Michael Fried's reading of a painting of an American surgeon in *The Gross Clinic* by Thomas Eakins also connects the surgeon's scalpel with the paintbrush. In Michael Fried, *Realism, Writing, Disfiguration* (Chicago: University of Chicago Press, 1987).

[13] 'Dans son laboratoire, tout préoccupé des problèmes dont il aide à approfondir les mystères. [. . .] M. Edelfelt le fait vivre devant nous dans la marche de sa pensée, dans l'état de son âme ou de son esprit' (my translation).

Larousse describes the laboratory as a mysterious location. In the film, there is a troubling atmosphere, especially when the research scientist descends into the shadows of his laboratory to carry out his experiments. The progressive scientist makes way for another vision attracted by opposing spatial arrangements, a different, complementary vision imagining the scientist as an evil character.

The choice of lighting technique reinforces the dual atmosphere of the place. Remedies, miracles even, are made on the first floor, illustrated by the well-lit room occupied by the convalescing young man, Joseph Meister, the first patient to be treated for rabies. But the dark workshop reminds us of *Faust* directed by Murnau some ten years before in 1926, in which Dieterle played Valentine's role. Just like Pasteur, Murnau's alchemist drives himself to exhaustion in his quest to find a remedy that would rid his town of the plague. Murnau uses the chiaroscuro technique in the study to light up the face, the phials, the spell book and retort, in stark contrast with the rest of the room swallowed up by the inky darkness. According to Siegfried Kracauer, Murnau's film emphasises the metaphysical conflict between good and evil[14] and illustrates through dialectics –typical of the expressionists' films – the relationship between shadows/evil/darkness and light/good/knowledge. Eric Rohmer based his dissertation on spatial arrangements of *Faust*, in which he noticed the presence of a special chiaroscuro in the study around what he calls Murnau's *ornaments* – just a few key objects, mainly phials. For him, light comes first and the object will achieve a higher level of existence if it identifies itself with the light, either by emitting it or by reflecting it.[15] In Dieterle's portrayal, before Pasteur lit his candle the only source of light was the graded phial in the bottom right-hand corner of the image. Objects are light wells, instruments of knowledge and wellbeing, a source lighting the way forward and the prospect of a cure. And so two worlds clash; one full of shadows, darkness and obscurantism, the other filled with research and scientific instruments, the bearers of modern thinking. If Pasteur ensures the passage from one space to another, his progressive use of the microscope as a core element of the fiction perpetrates another opposition: the visible world to the invisible world, symbolised by microbiological research.

The microscope accompanies Pasteur on his scientific revolution as outlined by his theory – the spontaneous generation – according to which germs, invisible to the naked eye, develop within our own organisms. Despite the reluctance of the medical body and conventional, pre-established opinions,

[14] Siegfried Kracauer, *From Caligari to Hitler: A Psychological History of the German Film* (Paris: L'Âge d'homme/Flammarion, 2009) 164–5.

[15] Eric Rohmer, *L'organisation de l'espace dans le 'Faust' de Murnau* (Paris: Éditions des cahiers du cinéma, 2000) 76–9.

having his theory and research recognised allowed Pasteur to restrain a number of epizootic diseases. Thanks to the microscope and the advent of bacteriology, it scaled sight right down to the cellular level and world views changed. The microscope, with its new lens, helped the scientist to see what was once invisible – bacteria, germs – and see how they develop.

In the film, the microscope represents a symbolic tool that bridges the gap between the visible and the invisible. The generic instrument appears at every decisive moment in the film in one of two forms: either the presence of the object itself or by incorporating views seen through the magnifying lens. This presence of microbiology in the film not only works as a parallel of film theory – the camera as an eye in the unseen world – but film and microbiology share a longer history together. They had worked in concert since Jean Comandon documented bacteria in the Pathé factories in 1909 thanks to the beginnings of microcinematography.[16] These images were not a brand-new vision for William Dieterle, considering how deeply rooted scientific films were in 1910s–1920s European visual culture. About five hundred films were directed under the Weimar Republic in order to deliver medical messages to the public regarding social hygiene, sex education[17] and similar, for example by Steinach Film (1922–3).[18] In France, the government established a film library devoted to the Ministry of Social Hygiene in 1926, which owned about two hundred films one year later, and five hundred in 1930.[19]

But in *The Story of Louis Pasteur*, what makes Dieterle's microscopic views so distinguishable from what is primarily a documentary is the opposition the microscope and the views triggered. Only at the end of the first sequence does Pasteur eventually appear. But contrary to his sceptical opponents in the previous shots, his voice on the soundtrack doesn't match his face but instead accompanies a view through an optical microscope. His arguments are not based on unfounded speeches but rest upon modern scientific research, here specified through a microscopic vision. If two worlds co-habited – the visible and invisible, two opposing schools of thought also co-existed, consisting

[16] By associating a camera with a microscope, it was possible to study organisms invisible to the naked eye. In 1932, at the request of Gaston Ramon and Émile Roux, Jean Comandon returned to the Pasteur Institute as head of a cinematography laboratory.

[17] The German film industry boasted a prosperous tradition of scientific documentaries since 1917 with the Kultur-film Abteilung department of the UFA prompted films of educational value. Christian Bonah, Alexis Zimmer, « « Le calvaire du Steinach-film » (1922–23). Représentations du médecin dans le film de recherche et d'enseignement médical », *Sociétés et représentations* 2009/2 (n°28), p. 87–105. DOI 10.3917/sr.028.0087.

[18] Bonah and Zimmer, op. cit. 88.

[19] Valérie Vignaux, 'L'éducation sanitaire par le cinéma dans l'entre-deux-guerres en France', *Sociétés & Représentations* (2009/2, No. 28) 75. DOI 10.3917/sr.028.0067.

alternately of people inclined to accept the invisible and of people who resisted it and attacked such a belief.

If Pasteur's character and the European heritage it conveys chronicle a time of structuring oppositions, how William Dieterle dramatises Pasteur's positions and struggles also serves as an analogy to illustrate not only current scientific and political changes, but also the idea of new visions and of resistance. In other words, from the canvas to the film, Pasteur not only embodies a transition in identifying the new 'great men', but his microscope as new glass-medium also remodels an art of seeing as it operates on social and political conflicting relationships. But these two social interactions reveal a third one: through the microscope, Pasteur is able to see new, controversial social agents – bacteria.

II. Microbe Dramatisation: Identifying Bacteria as New Social and Fictional Adversaries

With his microscope revealing the existence of microbes, Pasteur embarks on a lonely pedagogical odyssey of parallel battles against reactionary men in power and disease. When Pasteur goes downstairs to his laboratory, he carries out his work in silence. And yet, one can hear a piercing noise on the soundtrack. Pasteur's silent disposition indicates the presence of another speaking character – bacteria.

This vivid contrast in Pasteur's double struggle has been clearly defined by Brecht in his in-depth analysis of Dieterle's films. To embrace Brecht's words, Dieterle's participation in German Exile Cinema in Hollywood must be outlined.[20] Dieterle regularly interacts with German exiles such as Max Reinhardt, Franz Werfel, Bruno Frank, Bertolt Brecht, Lion Feuchtwanger, Salka Viertel and Thomas Mann as his primary circle of friends. But beyond this socialising, he most importantly acts as a major connecting link between the exiled artists and German intellectuals. He co-founded an organisation which worked on obtaining visas and affidavits through the European Film Fund (EFF), a foundation that his wife Charlotte and Liesl Frank managed on a daily basis.[21] Brecht benefited from this fund and relied on the Dieterles' help to reach California in 1941. Afterwards,

[20] Although William Dieterle did not flee his country and does not fit the exact definition of an exile, his films and diverse forms of political involvement place him within German Exile Cinema.

[21] Larissa Schütze, *William Dieterle und die deutschsprachige Emigration in Hollywood. Antifaschistische Filmarbeit bei Warner Bros. Pictures, 1930–1940* (Stuttgart: Franz Steiner Verlag 2015). The EFF is at the core of a PhD dissertation entitled *Liesl Frank, Charlotte Dieterle and the European Film Fund* submitted by Martin Sauter in 2010 (supervised by Professor Erica Carter, Warwick University).

the two friends shared several projects, though most of them were turned down by the studios. Brecht wrote a laudatory critique of Dieterle's biopics entitled 'A Gallery of Grand-Bourgeois Figures'[22] (c. 1944):

> The element of conflict in these bourgeois biographies derives from the opposition in which the hero stands vis-à-vis the dominant opinion, i.e., vis-à-vis the dominant class. This is Ibsen's type of the enemy of the people. Society views the mere growth in productive forces as a cancer. [. . .] Pasteur is portrayed as a Galileo of medicine, he too risks jail. [. . .] Dieterle's film biographies, progressive and humanist and intelligent – which alone marks them as a kind of rebellion within the commercial movie industry in America – were also ground-breaking in a dramaturgical sense. [. . .] In Dieterle's films the historical background moved into the foreground and introduced itself as the protagonist. [. . .] Now it became among other things a matter of *dramatizing the microbes*. The hero was a hero in the struggle against them, just as he was a hero in the struggle against people.

According to Brecht, Dieterle's *Pasteur* embodies a solitary scientific voice faced with the ignorance of the Establishment and the interests of the ruling powers, railing 'against dominant opinion'. Brecht comments on two major European theatrical works: *An Enemy of the People* by Ibsen, and his own play entitled *The Life of Galileo*. Dieterle's *Pasteur* and his own *Galileo* bring closer two characters struggling against the obscurantists of their time. They both had to face severe opposition because they doubted common belief and traditional knowledge. As an advocate of heliocentrism, Galileo opposed philosophers who refused to acknowledge any diverging vision of the world and would not look through his telescope. Similarly, doctors from the Academy of Sciences, and more precisely Doctor Charbonnet, preferred to ignore Pasteur's microscope, either because they did not know, or because they did not want to know, how to look differently into the world they used to rule. And yet, if Brecht's *Galileo* retracts in front of the Inquisition whereas Pasteur keeps on fighting, the play ends on an injunction that Dieterle's film may summarise: 'You have to learn how to open your eyes', Andrea tells the young boy after crossing the Italian border.[23]

As for Ibsen's play *An Enemy of the People*, it relates the struggle of Doctor Stockmann, who shows independence of spirit by opposing corruption in the recurrent contamination of the city public baths. He is

[22] Bertolt Brecht, 'Wilhelm Dieterle's Gallery of Grand-Bourgeois Figures', 23/42-4, typescript from c. 1944, in the Wilhelm Dieterle Estate Papers, held by the Stiftung Deutsche Kinemathek, Berlin.

[23] 'Il te faut apprendre à ouvrir les yeux'. In Bertolt Brecht, *La vie de Galilée* (Paris: L'Arche, 1997) 136–7.

forced, just like Pasteur, to make himself scarce for a while and to go into exile after being judged guilty in front of the whole city.[24] With such a parallel working on the solitary struggling position, the original title – *Pasteur, An Enemy of Man* – reads differently. What's interesting to note about Ibsen's play here is that *An Enemy of the People* isn't just about changing the word 'people' to 'man'; it's more about identifying the enemy. As progressive scientific research often faces fierce opposition, laboratories turn into new battlefields. It appears in the film through the use of visual and scriptural parallels between the bellicose lexicon and a scientific imaginary, especially through the use of a warlike lexicon. The microscope reveals two kinds of opponent, one visible and one invisible. On the one hand, it highlights the traditional dominant figures that Brecht criticises in his text, that is, the men reluctant to use modern scientific tools. On the other hand, the microscope exposes the new adversaries, or rather the real enemies of humanity illustrated in the film – microorganisms. The movie sets aside the paradigms of heritage and traditional transmission by using the image of a scientist battling against contamination (germs, disease) and promoting the results of his research as he struggles to make vaccination and new ideas universally accepted.

What makes Dieterle's views through the microscope so distinct from what is primarily a documentary is the 'performance of the microorganisms' that Brecht describes. If bacteria are now characters performing in the story, you can fight against them, you can hunt them, as in De Kruif's *Microbe Hunter*, or you can dramatise them, as in Brecht's dramatising the microbes. They become actors in their own right, just like in real life and in society. According to the French historian Bruno Latour, Pasteur introduced bacteria into the social sphere. Latour argues that Pasteur turned germs into new social agents thanks to what he calls the 'theatre of the obvious'. Even though they are invisible, the existence of germs being proved means they must be socially acknowledged, which is why experiments were carried out in public. In the film, the existence of germs and the successful vaccination of sheep are

[24] As an actor in and an author of plays, William Dieterle was familiar with Ibsen's work. He was particularly interested in the Norwegian's play *An Enemy of the People*, as a 1941 letter from Paul Kohner reveals Dieterle's previous interest in acquiring the movie rights: 'Dear Mr. Dieterle: I am authorized to offer the world motion picture rights to "ENEMY OF THE PEOPLE" – as well as "DOLLS HOUSE" by Ibsen. [. . .] I believe at one time you were interested in "Enemy of the People". I wish you would please let me know if you are still interested in this property. Sincerely, Paul Kohner.' In Deutsche Kinematheke Berlin, 4.3-80/24, William Dieterle Archive, 37/54, Paul Kohner to William Dieterle, 10 April 1941.

witnessed by the onlooking crowd, who watch the outcome of the scientific experiment in Arbois. A festive atmosphere is the backdrop against which victory over microorganisms becomes a public spectacle. The new actors make it a big event. The excerpt in which young Joseph Meister writhes in pain actually represents bacteria in action. Back inside the semi-darkness of the laboratory, the camera shows a close-up of the vaccine bubbling away, in a tumultuous fight against infection. The theatrical representation of germs means they can be overcome and hunted down. Whereas in Edelfelt's painting, light predicts the discovery of a remedy, the filmic version offers a fictitious, uncertain and hypothetically dangerous battle. In the workshop, evil has not been vanquished and shadows threaten Pasteur as he faces his primary enemy – microorganisms.

Bacteria appear as the main enemy in the film. Enemies, *Erbfeind* in German, is now a term used to describe germs. When the film was screened in Germany in 1947, the translated title rather referred to Ibsen and the film's working title *Erbfeind der Menschheit*, 'An Enemy of Man'. The *Norddeutsche Zeitung* attributed the deaths of millions of people to bacteria: 'a battle that Pasteur also had to fight before finalising his theory on bacteria, which may now seem obvious, but which has prevented the deaths of millions of sufferers'.[25]

How fictional materials relay healthcare messages to the public sphere has already been at the centre of many academic studies. In the 1930s and '40s, films offered the most effective way to promote sanitary messages and carry on pedagogical missions: as the Warner motto read, 'Good movies for good citizens'. Less commonly explored in the film is that New Deal programmes had been implemented three years prior to the release of *The Story of Louis Pasteur*. The film delivers medical notions and habits like cleaning up water supplies, vaccinating the population, etc. *The Story of Louis Pasteur* follows a longer path of popularising scientific figures which started out in the US with Paul de Kruif's 1926 bestselling *Microbe Hunters*.[26] From that time, Pasteur's public notoriety, like other physicians, became good fiction material to prompt popular scientific stories and reinforce healthcare

[25] 'Passion und Triumph Louis Pasteurs – Wilhelm Dieterles Film im Cosina-Theater', 27 February 1947.

[26] Major scientific discoveries provided the Roaring Twenties with numerous stories, as *Microbe Hunters* revealed. In 1926, Paul de Kruif, a former member of the Rockefeller Institute, wrote this bestseller about the founding fathers of microbiology, of which Pasteur was one, the first in a long list of scientific novels. Less expectedly, the book paved the way for popularising these men by imagining their private lives, and by describing debates in simple vocabulary.

messages without medical jargon.[27] In Pasteur's case, the film premiere came soon after the vote on the 1935 Social Security Act that established federal funds for state and local health programmes.[28] The film starts on a pedagogical theme, delaying the arrival of its hero before finally allowing Pasteur to teach the basis of germ theory and how sterilising hands and boiling instruments can reduce puerperal fever. In his 1939 article for *Picture Show*, Edward Wood noted precisely that: 'In these days medical science makes cleanliness the most important thing in surgery, in any film that depicts a scene in hospital you will see surgeons washing their hands in sterilized water and wearing overalls that are germ-proof.'[29]

Thus does *The Story of Louis Pasteur* begin. The doctor drops his stethoscope on the ground. The camera shows the instrument being picked up and the physician blowing on it as an ironic way of cleaning and disinfecting it. The setting of the opening scene is dark. A gun, hidden behind a heavy curtain, wavers slowly in the office's background. The doctor is shot by the husband of one of his former patients and the film starts as if it were an American thriller or a dark movie, maintaining the suspense of a murder story. The fiction opens on a revenge scene, and the physician's lack of attention that caused the assassin's wife's death dwells on a parallel between bad doctors and murderers. Warner Brothers was at the time an expert in producing gangster movies. Paul Muni and Edward G. Robinson – two major Warner stars primarily noted for their performances in gangster films such as *Little Caesar* (LeRoy, 1931), *I am a Fugitive from a Chain Gang* (LeRoy, 1932) and *Scarface* (Hughes/Hawks, 1932) – left playing the bad guys to be the next Pasteur, Zola, Juarez, Ehrlich and Reuter. Even the advertisements for the biopic's

[27] So did Sidney Howard when he adapted *Microbe Hunters* into his play *Yellow Jack, a history*. It derives from the chapter on Walter Reed and the story of yellow-fever transmission. It had also been the subject of George B. Seitz's film in 1938.

[28] The popularisation of the scientist as a hero in artistic work goes along with public policies. If Theodore Roosevelt already encouraged the establishment of national health insurance in 1912, the following years and the 1920s encouraged the creation of schools or foundations to promote public healthcare programmes (1913 Conference at Rockefeller Foundation, 1915 Welch-Rose Report, 1916 creation of Johns Hopkins School of Public Health, etc.). In the 1930s, New Deal programmes prompted the delivery of medical notions through the federal art projects sponsored by the state. President Roosevelt also signed The Social Security Act on 14 August 1935. From 1935 to 1939 The New Deal Agency funded a whole range of theatre projects and productions, both professional and amateur, including Paul de Kruif's *Microbe Hunters*. These federal artistic projects were at communicating with the population – The Federal Art Project hired artists to teach in schools. The projects promoted through images or storytelling specific public health- related messages.

[29] Edward Wood, 'Putting Life into History', *Picture Show*, 9 September 1939, 9.

release enhance a link between the two genres. The design, the typography and the colours in the two posters for *The Story of Louis Pasteur*[30] and *I am a Fugitive from a Chain Gang*[31] are so similar that Pasteur may be seen less as a European scientist than as a follower of the characteristics of the American gangster. If *Pasteur*'s first scene targets American taste while playing on the popular gangster figure, Dieterle derived the pose of the scientist not only in favour of this latter gangster character, but also from a frieze on the classic settings of American film: the trial scene.

Building on a typical judiciary scene reinforces Pasteur's story turning into an American destiny. Messages on sanitation and healthcare also get wrapped into Hollywood storytelling practices with the scientist haranguing his cause in the frame of stage-encoded allocutions and verbal jousting. But the trial scene does not only acknowledge the Americanisation of European figures, it actually operates on a second level, namely, it targets the spectatorship experience. By creating visual representation of both the person delivering his arguments and of those who receive them, the film uses the power of rhetorical devices by establishing a link between the text and the images that may engage the audience in more contemporary concerns.

III. A Scientist Speaking: Re-enacting Past Trials to Meet American Current Challenges and to Address the Next Generations

Trial scenes emphasise a recurrent device in Dieterle's biopics, and generally speaking in American classical Hollywood cinema. They provide a framework that helps define the film narrative through speeches, what Stefan Machura and Stefan Ulbrich consider as a prerequisite for 1930s movies' success.[32] In *The Story of Louis Pasteur*, not only does Pasteur's name appear for the first time during a trial scene, but the film closes with an address that seems like a soliloquy. Importantly, these scenes are key moments in a classical narrative construction, putting the action into motion as speaking is the preferred way to persuade or fight for one's cause, personified through the main character's words. The trial scene creates an environment for multiple rhetorical approaches (*inventio, dispositio, elocutio*) available to Pasteur for the sake of convincing his audience or his opponents.

[30] See Fig. 4.3.
[31] See Fig. 4.4.
[32] 'A lengthy courtroom scene became almost a guarantee of a movie's success.' In Stefan Machura and Stefan Ulbrich, 'Law in Film: Globalizing the Hollywood Courtroom Drama', *Journal of Law and Society* (trans. Anglaise Francis M. Nevins and Nils Behling), Vol. 28, No. 1 (March 2001), 112.

In this light, filmed scientists became new orator-heroes[33] and appeared in the setting of legislative assemblies, tribunals or even agora. Even though *The Story of Louis Pasteur* depicts Pasteur in deliberate acts, legal proceedings and epideictic oratory, this is nothing new, for scientists were typically controversial social characters and proponents of social justice, truth and law. There is a long-established tradition of accusing scientific figures such as Newton, Copernicus and Einstein, since they opposed in print the scientific orthodoxy of their day. Alongside Galileo's or Doctor Stockmann's trials, Brecht's comments bring William Dieterle's *The Story of Louis Pasteur* closer as an example of resistance to and confrontation with the Establishment. But contrary to the two literary masterpieces, the trial scene in Dieterle's film has spatial arrangements that comply with American mise-en-scène practices. This film, as representative of this new genre, triggers the exponential increase in audience, and this new form develops from but also retains significant aspects of earlier rhetorical and theatrical genres.

Locating the scene in a courtroom or an amphitheatre here means devising a space as it would be defined by the delivery of a speech. In talkies, the spoken word is to be seen or heard, so speaking becomes a synonym of showing. It is emphasised when the mise-en-scène uses a variety of methods to portray how words have the power and ability to persuade. The actions and oppositions are built upon performances as they are displayed in their rhetorical climax leading eventually to an audience being visibly convinced. After that the Academy imputed fallacious motives to Pasteur during a hearing, he experienced his scientific research in public. The members of the Academy of Sciences are gathered in a vast amphitheatre filmed in an establishing shot. A zoom from a high-angle focuses on the Dean who embodies the role of a judge. The traditional doctors act as prosecutors, cross-examining Pasteur's future son-in-law in his capacity as witness of Pasteur's supposedly unfounded theories. What spreads from this scene is more of a general mess, a noisy tumult with the mob reacting as if they were in an open space and as if the persons speaking were plebeian orators. The opposition does not rest on scientific argument any more, the adversaries fight with rhetorical tools and Pasteur, as a great American orator, welcomes the challenge laid down by his opponents.

But Pasteur does not resent his competitors, for what matters are other more important fights, as he will elaborate in his final words. Behind a show of words, the characters actually question what science aims at, what goals it should follow. What happens in these trial scenes actually tackles scientific integrity, and the film interrogates the responsibility of scientists.

[33] I borrow the idea of a speaking hero from John Denvir's 'Through the Great Depression on Horseback'. In *Legal Reelism* (Urbana-Champaign: University of Illinois Press, 1996), 45.

Significantly, Brecht parallels Pasteur and Galileo. If Galileo finally abdicates and mopes around his betrayal of 'the only goal of Science',[34] the ending of *The life of Galileo* was rewritten three times by Brecht, each version pointing out differently the conflict between science and power and each rewrite being influenced by its latest political environment. What changed in the second version was a result of the atomic bomb. Brecht was harsher in portraying Galileo, making him carry the burden of the consequences of scientific discoveries for the contemporary world.

Similarly, Dieterle's *Pasteur* encounters a contemporaneous audience in the light of current existential challenges. As well as the microbes' occurrence, Pasteur's last words ('You young men – doctors and scientists of the future – do not let yourselves be tainted by a barren scepticism, nor discouraged by the sadness of certain hours that creep over nations'), evoke the concerns of their times, as Leslie Brewer pointed out in her 1937 review for *The Tribune*:

> Pasteur knew that a scientist had to struggle and fight against Ignorance and War [. . .]. And their battle against War? It's a much harder one but one scientists must fight. No scientist worthy of the name can tolerate a government which uses its discoveries to destroy men, women and children. Imagine what you would have felt like, last April, if you had been the inventor of the aeroplane. Your lovely, mile-eating discovery was used to wipe out Guernica, a Basque town.[35]

As Brecht's last *Galileo* contemporary perspective, Pasteur's final exhortation echoes the political climate of the 1930s and makes this character bridge and reflect upon the present time period. Even though functioning as an undercover critic, it would have been problematic to represent science and scientific instruments as politically neutral, especially at this time. Not omitting that National Socialists in Germany were spoiling scientific notions to establish their own fascist hygiene and bacteriology theories for eugenics purposes, *The Story of Louis Pasteur* and Dieterle's films in general also aim to take a European-inherited knowledge back from the Nazis. In this case, to defend the theory of spontaneous generation would advocate the idea of germs developing in organisms regardless of sex, race or gender, in complete contradiction of any genetic filiation theories.

With scientific integrity at stake, *The Story of Louis Pasteur* depicts a vision of progress and resistance that spills over into laboratories with their discourses

[34] Bertolt Brecht, op. cit. 129.
[35] Leslie Brewer, '*Louis Pasteur*, greater than *Napoleon*', *The Tribune*, London, 10 September 1937.

invading the public sphere. Thanks to these scenes in the court, everyone in society had access to Pasteur's humanist and universalist ideas, the result being the shift of responsibility from scientists alone to the wider public. Cinematographically, it often leads in films to a final camera pose. When the hero speaks according to the procedures of a trial setting, while he reaches his diegetic audience, its tribune also pragmatically penetrates the spectators' real world. Pasteur looks directly into the eyes of the spectators – the one in the fiction and the 1930s movie-goers – so his speech may engage them at a time that Hollywood was preventing any clear attempt to criticise the political crisis in Europe in compliance with the application of the Neutrality Act. The ending leads to the prospect of a troubled but challenging future and considers which message, which idea, to convey to the beacons of tomorrow:

> You young men – doctors and scientists of the future – do not let yourselves be tainted by a barren scepticism, nor discouraged by the sadness of certain hours that creep over nations. Do not become angry at your opponents, for no scientific theory has ever been accepted without opposition.

For film historian Thomas Elsaesser, the films of Dieterle established both a textual and a social mode of address.[36] While the Warner Brothers Studio strategically reversed its image for prestige films (according to the New Deal programme), Thomas Elsaesser posits that Dieterle's fictions develop a civic then universal address for their audience that he examines mainly in the trial scenes. By incorporating the words of Pasteur, Dieterle uses historical biography as a means to circumvent informal censorship, proving that cinema can convey universal political values and circulate ideas despite efforts to prevent this. The filmed allocutions become an act of speech in film, both cinematographically and politically, a particular moment that leads the film to its public platform potentialities.

For Dieterle, circulating the image and the message requires three stages: the story of Pasteur's past, his present interpretation and the call to future generations. By joining two epochs and continents, his and that of his characters, the director uses figures of the past to enhance both American social trends and his personal political commitments, while charismatically addressing the next generation to continue resisting. Not disregarding the fact that the world in 1936 was on the road to chaos, the character's final exhortations are intended for the minds of the future.

So the two figures of Pasteur – one painted, the other filmed – both have their eyes riveted on their idea, caught up in the flow of events happening in their time and in their geographical location. But once removed from

[36] Thomas Elsaesser, 'Film History as social history: The Dieterle-Warner Brother Bio-pic', *Wide Angle*, 8/2, 1986.

the artistic and cinematic context, in the same way it was removed from the laboratory or the trials, this series of 'un-framing' ensures the idea becomes extraterritorial, universal. Pasteur no longer drops his gaze; he raises his eyes and penetrates our reality. He answers Brecht, for whom 'the audience [. . .] presents itself as a protagonist of history'. The image concerns us all and circulates in different locations, in different times and according to various imaginations and implications within our collective reality. These transcontinental and transhistorical circulations not only promote universalist positions and awareness, they also lead to the questions: What can the moving picture *achieve*? More specifically, how can the portrayal of near-European scientific heritage reflect upon a dire political situation?

Conclusion

Émile Zola, another nineteenth-century French artist to whom William Dieterle dedicated his second biopic, drew in his 1898 novel *Paris* a portrait of Pasteur as a man whose 'intelligence is the most courageous, the most liberated, exclusively passionate about the truth'.[37] For Zola, the scientist is above all the 'artisan of tomorrow',[38] a perspective that unites the address to future generations and the metaphor of the scientist as an artisan, or artist of an idea. A European heritage migrates from canvas to film, but this heritage is also present within the works of the same director, who focuses mainly on emblematic humanist men and women of nineteenth-century Europe: Pasteur, Ehrlich, Nightingale for science and medicine, Reuter for technical innovation, Zola for art and politics. They all share a common vision of progress. And all of them have to move, flee, go into exile in order to exist and resist, a situation that clearly speaks to the artists of the 1930s. If, by incorporating the words of Zola or Pasteur, Dieterle condemns growing fascism in Europe, thereby circumventing the informal censorship, nineteenth-century European personalities also transpose the face of a time that bathed a world changing under the influence of ideas, of a society undergoing profound change which should be recalled and preserved. What matters is movement of a type of European heritage and knowing how to reinvest it so that it enlightens and speaks to one and all, either directly or by using the appropriate analytical tools (concepts), and continues to engage modern man in his own thoughts. Europe's legacy is the ongoing history that émigrés such as Dieterle aimed at maintaining despite the American demands to which they had to adapt.

[37] Émile Zola, *Paris*, full works, Cercle du livre précieux, t. VII, 1257.
[38] Ibid. 1566.

5

Souvenir, Fiction, Imagination: The Times of Fascism in *The Conformist*

Thibault Guichard

Involvement in the Resistance to fascism and Nazism takes a political form that is necessarily also inscribed in a practice and an ideology of violence. This has often been addressed in Europe, specifically in France, Italy and Germany, in terms of morality and politics, ethics of action, and legitimacy, if not legality. When law gives way to the undemocratic imposition of the norm, social behaviour is regulated by a form of acceptance of the existing situation, which results in a collective conformity. To avoid having to choose between adherence to a dominant ideology or its active rejection, society practices a form of accommodation. Unlike the law, which presupposes a form of knowledge of its expectations, the social norm can be interiorised. This is what interested Alberto Moravia, in his novel *The Conformist*, as well as Bernardo Bertolucci in his film adaptation of the book. But instead of summoning a collective memory, it is from their own experience that the two men worked on the novel and on the cinematographic language of its screenplay. Their experience is always situated in the present and constantly questioned, but less on the debt of the contemporary to its traumatic past than on the continuity of behaviours and imaginations. The latter are questioned from the point of view of an individual who does not develop a spontaneous but rather a constructed and theoretical relationship to the norm – no longer seen as normal but as absurd and ambiguous – and thus to fascist power and its legacy.

During the 1970s, the Italian film director Bernardo Bertolucci engaged in making *The Conformist*. Based on Alberto Moravia's eponymous novel, the film is set in the years of the fascist dictatorship and emphasises the question of time, as an object and as a narrative instrument. While for Bertolucci time means History,[1] the temporal matter of his movies also sends the viewer back

[1] Ungari, Enzo and Ranvaud, Donald, *Bertolucci par Bertolucci. Entretiens* (Paris: Calmann-Lévy, 1987) 11.

to an oneiric time, which implies a new perspective on the past. In its own way, Bertolucci's cinema offers a 'disorienting' exercise.[2]

Through this experience, spaces and images play a central and essential role. The camera travels between Paris and Rome, where the layers of sedimentation of history are numerous and visible: to evoke the Italian capital city, Bertolucci chooses places that mix its ancient past with the new history that the regime of Mussolini aspired to write. 'Marble and travertine stones'[3] formed as much an ornament as a 'real' place, a 'place of memory' (*lieu de mémoire*) that dictates its rhythm over official time. It is also, however, in the middle of events and their internal repercussions, within this monumental time, that other temporalities emerge and expand.[4] In the very first minutes of the film, a scene shows Marcello Clerici at the Place du Trocadéro in Paris, seated in a vehicle and whispering two verses,[5] while he recalls himself walking in front of the wall of the Ara Pacis in Rome. In a similar shot, Bertolucci juxtaposes the lines of the *Res Gestae Divi Augusti* with the verses that begin a poem written by another Roman emperor, Hadrian; that is, monumental and mortal time, or historical and poetic writing. The search for the character's intimacy is staged by the poetic form and through a fictional dialogue with his soul, which refers to another personal and temporal experience. Likewise, to another way of telling: the narrative is constructed from the discontinuity of reminiscence and memory.

This scene has a symbolic value that is key to interpreting Bertolucci's cinematographic inscription in comparison with Moravia's literary style, in the reconfiguration of Italy's fascist past. In a singular way, these works participate in the inaugural gesture of the figuration of history, through the inscription of a relationship to time that sheds light on how a community represents itself in a temporal configuration.[6] By considering these fictions as forms of historical experience, the historian can interpret the circulation that develops between history as a source of fiction and fiction as a mediation of a temporal experience inscribed in history.

[2] Revel, Jacques, 'Un exercice de désorientement: *Blow Up*', in De Baecque, Antoine and Delage, Christian (eds), *De l'histoire au cinéma* (Brussels: Éditions Complexe, 1998) 99–110.

[3] Bottai, Giuseppe, 'Il rinnovamento di Roma', *Les Nouvelles littéraires*, 12 February 1938. This speech is published in Bottai, Giuseppe, *Politica fascista delle arti: scritti, 1918–1943*, ed. Masi, Alessandro (Rome: Libreria dello Stato, 2009). Bottai was Minister of Corporations between 1919 and 1932, then Governor of Rome in 1936, and Minister of National Education from 1936 to 1943. He was editor of the journal *Critica fascista* from 1923 to 1943.

[4] Ricœur, Paul, *Temps et récit, t. 2. La configuration dans le récit de fiction* (Paris: Seuil, 1984).

[5] 'Animula vagula blandula, Hospes comesque corporis.'

[6] De Certeau, Michel, *L'Écriture de l'histoire* (Paris: Gallimard, 1975).

Experienced Time. Fascist Conformism according to Moravia

A Writer in his Time: A Youth in the Shadow of Fascism

Moravia, born Alberto Pincherle in 1907 in Rome, always cultivated a taste for telling and recounting himself, reconstructing his existence within the framework of narration.[7] The future writer's imagination and narrative faculties were very early nourished by two events, recognised by the author himself as the most decisive of his existence. Illness and fascism shaped him:[8] the first, by depriving him of movement and a normal education, and by forcing him into a 'solitary' childhood. In compensation, Moravia cultivated a kind of extraordinary lucidity and a capacity for observation that he was able to reinvest in narrating the present. Between 1925 and 1928, he devoted himself completely to writing his first novel, *Gli indifferenti*, while collaborating on several avant-garde cultural revues such as *Novecento*, directed by the writer Bontempelli.

As Prezzolini, his former teacher in exile in the United States, pointed out, the novel carefully avoided any allusion to politics, and even less to the new regime.[9] Indeed, indifference is the first type of relationship that Moravia maintains with the political reality of his time. Although he abhorred fascism, Moravia never intended to attack it head-on. His vocation as a novelist therefore never crossed the path of political commitment.[10] The book of the young novelist, however, provides additional reasons[11] to place him under the

[7] 'I think I had the vocation of a novelist very early, first that of a writer. In fact I just knew how to write. I already told myself about the novels I invented one day after another, taking the track back to the exact point where I had left the previous day.' This quotation is excerpted from the work of Roberto Tessari. Tessari, Roberto, *Alberto Moravia: introduzione e guida allo studio dell'opera moraviana. Storia e antologia della critica* (Milan: Mondadori, 1989) 1–3.

[8] 'I attach great importance to disease and fascism since because of disease and fascism I had to suffer, and I did things that otherwise I would never have suffered or done.' Moravia, Alberto, *Autobiografia in breve di Alberto Moravia* (Milan: Feltrinelli, 1962) 10.

[9] See Preface of Moravia, Alberto and Prezzolini, Giuseppe, *Lettere* (Milan: Rusconi, 1982).

[10] 'Politics is not and will never be, even at the time of the racial persecutions of which he is a victim, even at the time of his involvement with Pasolini, before and after his assassination, even at the time of his late activity as a Member of the European Parliament, the priority of his intellectual and personal life [. . .].' Said of Moravia by René de Ceccatty. De Ceccatty, René, *Alberto Moravia* (Paris: Flammarion, 2010) 170. For complete studies on the relationship between the writer and the fascist regime, see, in addition to Ceccatty's work, Pilitteri, Paolo, *Il conformista indifferente e il delitto Rosselli* (Milan: Bietti, 2003); Casini, Simone, 'Moravia e il fascismo: a proposito di alcune lettere a Mussolini e Ciano', in *Studi italiani* (Anno XIX, No. 2, July–December 2007, Florence: Franco Cesati Editore), 189–237.

[11] Let us recall that the writer was linked, by family ties, to Carlo Rosselli, notorious opponent of Mussolini's regime during the 1930s.

watchful eye of the political police.[12] The narrative delivers a social critique, in the tone of satire and denunciation,[13] of the Italian bourgeoisie under a triumphant fascism. The themes of this first novel – the fascism he wanted to flee rather than confront, 'bourgeois misery' and revolt against his social group – would continue to infiltrate Moravia's work for a long time. Instead of leaving the pen 'to play the role of the resistance fighter',[14] Moravia preferred to represent a conflict which he 'felt to be both victim and theatre'.

Moravia as a Portrait Painter: An Existentialist Writing

Alberto Moravia has often, and legitimately, been described as the portraitist of a society and an era. Thus, the concept of 'time', of everything that fills it and constitutes it, is decisive in his work – an observation that emerges with evident eloquence when reading the English translations of his novels.[15] By resorting to prose rather than poetry, he was aware that he had to consider an objective reality that limits writing at the same time as it is reflected in it.[16] But the Moravian work, devoid of political intention, is based on fragments of memory and contemplation which open it up to the space of the poetic.[17] The novel is woven in the intertwining of memory and imagination: in Moravia's books, writing is also nourished by fantasies – 'my books are dreams, but I have the key to them'. The key – let us understand, to open 'the door of reality' – is often sex, as in Balzac it is money, in Dostoevsky homicide and in Conrad the sea. If Moravia's work is crossed by different and dissimilar periods, there is a dominant and recurrent theme, isolated from the chaos of reality, with 'precision and plausibility'.

The theme can therefore remain the same, but the meaning changes according to the time of writing: 'I start from existence, then, without wanting to, deepening the story, I come to the meaning [. . .] I tell a case of life, and by representing it, I come to culture. [. . .] But artists have always operated in

[12] Casini, Simone, 'Moravia e il fascismo: a proposito di alcune lettere a Mussolini e Ciano', in *Studi italiani*, op. cit.

[13] His letter to Galeazzo Ciano is reproduced in its entirety in Paolo Pillitteri's book on the criticisms of and reservations about the publication of the novel and Moravia's defence. Pillitteri, Paolo, *Il conformista indifferente e il delitto Rosselli*, op. cit. 41–3.

[14] Testimony excerpted from Siciliano, Enzo, *Moravia* (Milan: Longanesi, 1971) 92.

[15] For example, *The Time of Indifference* for *Gli indifferenti* and *The Time of Desecration* for *La vita interiore*.

[16] 'I don't think it's possible to write a novel against something. Art is interiority, not exteriority.' In Moravia, Alberto, 'Ricordo de *Gli indifferenti* (1945)', *L'Uomo come fine* (Milan: Bompiani, 1962) 66.

[17] 'Where there is no memory there would be nothing but controversy, raw content and, in short, no poetry.' In the same essay, Moravia summons the Greek tradition that *mnemosin* was the mother of the muses. For the writer, the author's memory-to-things relationship ultimately reflected the highest literary style, that is, the most poetic. Ibid. 66.

this way: by telling stories that in the end prove to be in conformity with the culture of the moment.'[18] Resulting from an artistic creation more than from a single and simple observation, the novelist's work is thus capable, with Moravia, of making the writer aware of his own condition. For such a performance to be possible, literature and writing must capture something of life itself, of the real, present and past. If this is the case, one must ask to what extent the novel published in 1951, *The Conformist*, can legitimately be considered as something other than 'fiction'.

The Novel and the Reference to the Past

The author of *The Conformist* has recalled this enough times to avoid any confusion: his literary creations do not claim the ambition of historical narrative, that is, to constitute a *true* narrative. If the novelist, in this case Moravia, does not aspire to determine what reality is, he nevertheless configures an 'imaginary structure', making it possible to grasp how it is possible to represent, or to make reality present.[19] The writing here assumes a function of *mimesis*, in the sense borrowed from Aristotle by Paul Ricœur: a 'creative imitation', a 'cut that opens the fiction space', while ensuring the 'connection that establishes the status of metaphorical transposition of the practical field by the *muthos*'.[20] It will be necessary to study the configuring operation of plotting. In the immediate term, we must be attentive to the two other mimetic relationships, not the structuring activity itself but those operations by which a narrative affirms or not its claim to the truth, in the understanding of a past and the transmission of this past in the form of referential models.

Among the polemics generated by the reception of some of Moravia's works, we must count those that followed the publication of *The Conformist*, particularly in Italy.[21] At the intersection of the 'fictional experience' of the text and the 'vivid experience' of the reader, the referential regime of the novel had a significantly different scope, in Italy and abroad. The back cover of the foreign edition, composed by Moravia himself at the request of his publisher Bompiani, expressed the intentions of its author in terms rather similar to those used in a letter to Prezzolini in 1949: the reference to fascism was purely indicative; the main purpose of the book was less to evoke Mussolini's Italy than to draw 'the portrait of a character and a moral attitude characteristic

[18] Ibid. 67.

[19] Brose, Margaret, 'Moravia Alberto: Fetishism and Figuration', *Novel: A forum on Fiction*, Vol. 15, No. 1, 1981, 60–75.

[20] Ricœur, Paul, *Temps et récit, t. 1* (Paris: Seuil, 1983) 127.

[21] The novel was thus prohibited in 1952 by the Holy Office. De Ceccatty, René, op. cit. 289.

of our time: conformist and conformism [. . .] that is, the man who wants to merge, to communicate, to be the same as others'.[22] A state of mind, a contemporary attitude, a modern behaviour in relation to which the disappearance of fascism meant nothing. In Italy, however, the memory of the remote struggle between fascism and antifascism became obvious in the interpretation of the narrative.[23] With the intention of explaining Moravia's position through *The Conformist*, in the face of divergent readings of recent history, we propose to expose his narrative choices by questioning their meaning, from the point of view of their author.

Narrated Time and Narrating Time. Text, Souvenir and Image

Moravia himself evokes the literary form of tragedy several times in talking about his novel. In one letter, sent to his cousins' mother, Amelia Rosselli, he explains his choice to evoke, in a 'single' page, the murder of Carlo and Nello Rosselli. The rest of the book, he says, was about making hypotheses for himself and his readers about why and how such 'tragedies' could happen.[24] So, to express his own interpretation of the past, Moravia chose tragic art, which 'mixes the psychological element with the lyrical one' and because, in tragedy, 'there are neither bad nor good, but only characters with different destinies'.[25] The problem of becoming fascist is thus treated as an intimate question, incarnated from a totally 'imaginary and invented' point of view: 'I realised again that it was impossible to write this novel in the form of historical and realistic data.' The narrator thus chooses to endorse

[22] Moravia, Alberto and Prezzolini, Giuseppe, op. cit., 52–3.

[23] The scene of the assassination of Professor Quadri, an antifascist exile in Paris with whom the main character must enter a relationship on the orders of the political police, closely recalls the dramatic episode of the assassination of the Rosselli brothers, Carlo and Nello, Moravia's cousins, in 1937 at Bagnoles de l'Orne, in Normandy. The assassination was carried out by members of the clandestine French extreme right-wing organisation CSAR, in connection with the SIM, the foreign intelligence service of the Italian government, under the supervision of the Minister of Foreign Affairs, then Galeazzo Ciano, son-in-law of the Duce. This event subsequently gave rise to a vast literature.

[24] Moravia, Alberto, *Lettere ad Amelia Rosselli con altre lettere familiari e prime poesie (1915–1951)*, ed. Casini, Simone (Milan: Bompiani, 2010) 293. The letter quoted dates from October 1951. In another interview, with Alain Elkann, Moravia stated: '[. . .] I was very affected by this assassination to such an extent that years later I wrote a novel, *The Conformist*, in which the Rosselli affair is approached, however in an inverted way, that is to say seen from the side of the one who contributed to make them killed. In short, I wrote the novel not "for" the Rossellis, but "about" the Rossellis. And that's because I thought it should be a tragedy, even on a historical background; and not an edifying biography.' Elkann, Alain and Moravia, Alberto, *Vita di Moravia* (Milan: Bompiani, 1990) 130.

[25] Moravia, Alberto, *Lettere ad Amelia Rosselli*, op. cit. 293.

the experience of a fictional character, Marcello Clerici,[26] tormented by a fate from which he tried to escape in two different ways, first by adhering to fascism, then ultimately by his own death. The phenomenon of fascism, as such, remains unexplained: it is the dynamics of an adhesion that interest Moravia. Unlike, for example, Edmond Humeau, who in a 1934 article sought an explanation for this conformist fascist in a 'sense of honour',[27] Moravia chose to take as a witness a bourgeois assailed by the feeling of guilt, sick with the sense of abnormality. In this respect, it is important to mention an eloquent sequence in the novel in which Marcello compares himself to the fascist agent Orlando to distinguish himself better. Even if the intimate and psychological considerations of the first part of the novel are then combined with the socio-political context of the Italian 1930s, Marcello's 'original' sin is of primary importance in the story.[28]

Splitting, schizophrenia and dissociation:[29] Marcello's psychology adds complexity to the plot through which lived experience must merge into a temporal past. Ambiguity is certainly the first definitional element of this work: words are loaded with contrary meanings according to the person who takes charge of them, be it the protagonists, the narrator or even the reader. Similarly, Moravia also introduced a tension between the past of the narrative and the present of the reception. Unlike a 'militant' work, the Moravian

[26] A patronym through which we sometimes wanted to read Marcel Proust's influence on Moravia's work. In any case, this is the interpretation proposed by Yosefa Loshitzky: 'The relationship between Moravia's novel and Proust's prose poem is based primarily on an attempt by Moravia to articulate his protagonist's "data of consciousness" through a narrative technique reminiscent of that employed by Proust. However, more than imitating Proust's style, Moravia pays homage to the decadent French writer through the characters' names.' Loshitzky Yosefa, *The Radical Faces of Godard and Bertolucci* (Detroit: Wayne State University Press, 1995) 58.

[27] Humeau, Edmond, 'Le fascisme et le sens de l'honneur', *Esprit*, Vol. 2, No. 16, January 1934, 293.

[28] To Enzo Siciliano, Moravia described a 'character accented on a funereal side, as I think I do not invent others'. Siciliano, Enzo, op. cit. 90.

[29] From the beginning of the novel, the narrator introduces a little boy who feels doubly guilty: guilty of the desire to possess, guilty above all of his cruelty and of an irreconcilable passion for weapons. A double guilt that underlies his deep sense of abnormality. All the gestures, emotions and thoughts which can bring him closer to his alter ego are then perceived as reasons for satisfaction, irrefutable proofs of his normality: a feeling which will find its satisfaction in the conformation to the moral model built by fascism. Marcello's relationship to fascism is ambiguous, however. Several examples bear witness to this, as when the character learns of the events in Spain by reading the headlines in the newspapers: he finds himself sincerely satisfied with Franco's victory. Before he could repress a deep disgust for the emphatic style of official propaganda, celebrating this military information and the most venial facts of life under fascism.

novel seeks, through a tragic narrative, to create a space for reflection between what is said about the present time and its recent historical representation. However, the 'narrative identity' Moravia was trying to recompose, turning a tragic destiny into a 'general personal experience',[30] seemed too distant and unfamiliar to the temporal experience of his readers.

The Conformist *Twenty Years Later: Revisiting a Story and Recalling a Past*

In 1969, exactly twenty years since Moravia wrote the first pages of his novel, the memory of the *ventennio* evolved. With the tremendous growth of Italian cinema, the number of fictions reappraising the period of fascism increased considerably, proposing for the most part a 'pietist' vision of history, and thus absolving the common Italian from a troubled and tormented past.[31] In a few years, starting in the 1960s, the figuration of history was recomposed, partly through cinema. After the archives were opened, film production declined, while the publication of major historical research on the subject encouraged the maturation of new interpretations. Some use the past to bear witness to the present. In 1969, Bernardo Bertolucci was twenty-eight years old. That year, the filmmaker from Parma finished editing a film inspired by national history and a novel by Jorge Luis Borges (*Tema del traidor y del héroe*), *The Spider's Stratagem*. Following contact with the American distributor Paramount, he also began writing the script for *The Conformist*, adapted from Moravia's novel.

To shoot his ninth film, *The Spider's Stratagem*, the first to confront the history of antifascism and the Resistance, Bertolucci was largely inspired by the places of his childhood, an atmosphere and an environment he knew intimately. It was different with his new feature film.[32] If the two creations are based on the past and a collective memory, then the support by which events come to the surface is different. What in fact is 'memory of memory' – let us understand, memory carried by literature and cinema – compared to the memory of childhood? It seems, however, that 'memory and imagination sometimes dwell together'.[33] To make memory a true mode of knowledge the

[30] Moravia uses the expression in the author's conversation with Alain Elkann. 'Probably, *The Conformist*, so imaginary and invented, inspired me to write a novel that, although with imaginary characters and situations, would be based on a general personal experience.' Elkann, Alain and Moravia, Alberto, *Vita di Moravia*, op. cit. 229.

[31] Zinni, Maurizio, *Fascisti di celluloide. La memoria del ventennio nel cinema italiano (1945–2000)* (Venice: Marsilio, 2010).

[32] 'I remember that I kept saying at that time: *Spider's Stratagem* is influenced by life while *The Conformist* is influenced by cinema.' Ungari, Enzo and Ranvaud, Donald, *Bertolucci par Bertolucci. Entretiens* (Paris: Calmann-Lévy, 1987) 71.

[33] Appelfeld, Aharon, *Histoire d'une vie* (Paris: Éditions de l'Olivier, 2004) 7.

philosopher Paul Ricœur proposed dissociating the imagination from it, by differentiating the intentionality under each of these cognitive actions.[34] In the present case, however, memory and imagination are intrinsically linked: Bertolucci relied, in making his film, certainly, on the images of the past, but not his own images, rather those of the cinema of the 1930s. Now this one, as a fiction, did not seek 'to figure the real, but reproduced models or represented the imaginary'.[35]

Bertolucci tries to account for fascist culture, like most Italians who lived during these years, through an essentially visual approach. For example, to create 'the sensation of a fascist Rome' he decided to shoot the first part of his film in the EUR district, the futuristic area Mussolini established in the south of the capital. The iconic language, the architectural one and finally the cinematographic discourse are universal, and allowed, as such, to address various social audiences. It also helps to regain meaning over the surrounding world and reality. For many, cinema was able to represent a coherent ordering of the world around them. Nevertheless, in the light of these 'partial' images, what remains of 'the historical thickness of an era', asks Italo Calvino?[36] In this respect, we can provide some elements of answer, questioning more particularly the intentions of the director, and the relation between his cinema, history and temporal material. The narration proposed by Bertolucci is never given as a past, in its enclosure and its distance to the present: the recollection happens from it and this position is clearly assumed by the director. The link that connects the present to the past is also at another level: for the Italian filmmaker, the memory of the past occurs through a vision, some physical and intimate sensations which are not his

[34] For Ricœur, imagination is purely fictional while memory tries to reach the 'previous reality'. Ricœur. Paul, *La Mémoire, l'histoire, l'oubli* (Paris: Seuil, 2000) 5–7.

[35] Duby, Georges, 'L'historien devant le cinema', *Le Débat*, 1984/3, No. 30, 81–5. The history of Italian cinema under fascism reflects an inflection in the production and logic that governed this flourishing economy. The famous metonymy of 'white telephones', symbol of the timeless quality of this cinema and its great sophistication, has long allowed apprehending this period. At the beginning of the decade, however, an intellectual movement emerged to reorient Italian cinema towards a realistic style (the reviews *Corrente* and *Cinema* embody this movement). Initially limited to small minor circles, this idea permeates the new generation of directors, among whom we must count the figures of neo-realism, as well as the authorities. Gaetano Polverelli, Pavolini's successor at the head of the Ministry of Popular Culture, assimilated it. In either case, although in an extremely different way, reality remains mediated through a technical device or even a moral.

[36] Calvino, Italo, *Quattro film preceduti dalla Autobiografia di uno spettatore* (Turin: Einaudi, 1974) xxiii.

own, but those of his parents.[37] He reconnects with the memory of the generation that preceded him through Moravian writing, but he can only share an imagination incarnated in specific places. In *The Conformist*, read and revised from Moravia to Bertolucci, memory becomes a matter of images and spaces. Thus, things from the past come to be embodied in a time lived in the present.

Reinterpreting a Story through Images: The Conformist *in Cinema*[38]

The Conformist by Bertolucci is a film about the national past, inspired by an artificial memory produced by the cinema of the 1930s: the spectator will therefore not find there the traces of a personal memory but those of a public memory generated in particular by the film industry.[39] Its penetration of a large public was thus encouraged, in accordance with Bertolucci's intentions. *The Conformist* was a commercial success, which enabled the accession of its author to a cinema of 'communication'.[40] Making films intended for the wider public forced Bertolucci to relate to the collective memory about fascism, by integrating some references from it.[41] The need to conform the text or image to a reality expected by the public – and not simply to the 'real past' – therefore leads to the shaping of 'clichés'.[42]

[37] 'Moravia allowed me to look at Italy in the thirties, my parents' Italy, to live it, to feel it. In an unusual way, what can those who loved *The Conformist* understand, for someone who was born in the forties like me. It was precisely Alberto, his atmospheres, his words in low relief, in 20th-century architecture, that inspired me. One could film one of his pages, make a travelling in the middle of his words, as in a street of Parioli or Eur.' Bertolucci, Bernardo, *Mon obsession magnifique. Écrits, souvenirs, interventions (1962–2010)* (Paris: Seuil, 2014) 146.

[38] A whole series of books deals with the transfer between fiction writing and film writing, part of which is more particularly interested in the relationship between narrative and cinema. Among the works consulted are: Brunetta, Gian Piero, *Letteratura e cinema* (Bologna: Zanichelli, 1976); Tinazzi, Giorgio, *La scrittura e lo sguardo: cinema e letteratura* (Venice: Marsilio, 2010); Cortellazzo, Sara and Tomasi, Dario, *Letteratura e cinema* (Rome: Laterza, 1998). The confrontation between the interpretations proposed by Roland Barthes (published in Italian in 'Principi e scopi dell'analisi strutturale', *Nuovi argomenti*, No. 2, 1966) and Pier Paolo Pasolini ('Il cinema di poesia', *Empirismo eretico* (Milan: Garzanti, 1972)) was of great inspiration.

[39] The film is thus described as 'artificial and stylistic' by Loshitzky. Loshitzky, Yosefa, op. cit. 62.

[40] '*Partner* was built entirely on the oppositions that exist between "spectacle" and "distance", images and sounds, cinema and theatre, film and the spectator. *The Conformist* was my first show-film; it was a journey into the centre of the desire to entertain.' Ungari, Enzo and Ranvaud, Donald, *Bertolucci par Bertolucci. Entretiens*, op. cit. 89.

[41] Ricœur, Paul, *Temps et récit, t. 1*, op. cit. 146.

[42] Deleuze, Gilles, *Cinéma 2. L'image-temps* (Paris: Éditions de Minuit, 1985) 31–3.

Instead of soliciting memory, fiction thus ends up presenting, by means of fabulous stories, a kind of 'amnesia'.[43] Bertolucci, however, refused this model of truth. He turned it around, subverted it and finally arrived at an almost inverted schema: it is no longer fiction that asserts itself as truth (a cinema of truth) but a 'cinema-vérité' that ends up in fiction (the truth of cinema).[44] Although the shooting of the film plunged him into a major production, Bertolucci did not give up his role of 'author'.[45]

There is a personal poetic in Bertolucci's cinema. His early years with his father formed the kind of relationships that Bertolucci engaged with men, feelings and the world. His father, the poet Attilio Bertolucci, introduced his son to his art, but also to cinema, before Bernardo first used a 16 mm camera at the age of seventeen.[46] These two forms of expression co-existed with him for a long time and influenced him during the making of his first films. Like his friend Pier Paolo Pasolini, Bertolucci was attentive to the singularity of a language that shares, with the world of memory and dreams, the specificity of expressing itself in and communicating through images.[47] His expressive technique wanted to be open to the irrational, to visual memory and dreams. Like a poem, the unity of the film relies on an extralinguistic factor, which is foreign to narrative language:[48] in this case, the image of visual reality refers to that of memory – another image – thus creating a new way of looking at the past.

By making a film about fascism, Bertolucci finally proposed a singular and original perception of time,[49] intimate and collective, and past – the

[43] Sand, Shlomo, *Le XXème siècle à l'écran* (Paris: Seuil, 2004) 14.

[44] 'I accept to the end the principle that, whatever fiction I intend to stage, the camera will always film as if it were cinema truth. Finally, improvisation is nothing other than the combination, skillfully conducted or assisted, between fiction and documentary.' Ungari, Enzo and Ranvaud, Donald, op. cit. 216. In another interview given to Pierre Pitiot, he states: 'I think I come to this fiction through the path of cinema vérité. I feel like a documentary filmmaker who ends up with a fiction.' Mirabella, Jean-Claude and Pitiot, Pierre, *Sur Bertolucci* (Milan: Éditions Climat, 1991) 80.

[45] Prono, Franco, *Bernardo Bertolucci. Il Conformista* (Turin: Lindau, 1998) 19–23.

[46] In an interview given to Laure Adler in 2013, in the programme *Hors-Champ*, broadcast on France Culture, Bernardo Bertolucci recounted his first cinematographic memories, in the company of his father: 'We went to this film club [created by Attilio Bertolucci, in Parma, where films by Griffith, Chaplin, Keaton, Eisenstein, etc. were shown] as we could have gone to Mass [on Sunday morning].' His father questioned the shots, the film sequences, to reveal their poetic dimension: in the manner of Pier Paolo Pasolini, as Bernardo tells it, for Attilio 'things were poetic or not poetic'.

[47] Pasolini, Pier Paolo, 'Il cinema di poesia', *Empirismo eretico* (Milan: Garzanti, 1972) 175.

[48] 'The unity of a poem is the unity of a mood.' Northrop Frye quoted in Ricœur, Paul, *La Métaphore vive* (Paris: Seuil, 1975) 285.

[49] Dalle Vacche, Angela, *The Body in the Mirror: Shapes of History in Italian Cinema* (Princeton: Princeton University Press, 1992).

past as an image that reveals itself in superimposition in the background of memory. Indeed, it is not the past that Bertolucci films but the present:[50] the cinematographic images are not images of the past but memories imagined and made present, actualised. What the filmmaker deals with above all is the present of memory, what he calls a 'historicisation of the present'.[51]

Time Regained. Bertolucci facing History

The Temporal Experience and the Dream: An Oneiric Cinema

There is a homology between the narrative form and a certain idea of life. The time that is organised in narrative, Jean-Paul Sartre exposes, is a time that seems to 'flow in the same direction as the reader's time, informing and accompanying it'.[52] This concordance, on the other hand, seems to vanish when reading a poem: poetry, Sartre continues, is like 'a kind of haemorrhage of duration, painful, uncomfortable, out of phase'.[53] The feeling of loss, the discomfort is here motivated by the singular form of the poem, which shakes our relationship to meaning. Comparing the poem with the icon rather than with the sign, Paul Ricœur maintains that the fusion of meaning and sensibility, this 'flow of evoked or excited images', is open to the imagination and to 'all the sensory impressions evoked in the memory'.[54] It is this flow of images that makes virtual experience possible – 'illusion' – associated with reading a poetic work. This feeling of loss is also found in Sartre as a spectator of the city of the Doges: facing the Venetian landscape, the sense that time is getting lost is linked to a loss of movement. Reading a poem and looking out from his balcony, the writer thinks of himself as a 'snail in a labyrinth', and the straight line that is supposed to symbolise the force of time is transformed into a line that forks and forks: many presents confront and mingle with contradictory pasts. The truth regime of the story collapses and the reader witnesses its 'falsification'.

[50] Bernardo Bertolucci took up on his own account a theory which he attributed to Renoir and which he himself had entitled the 'open door' theory: 'When you shoot a film, you always have to leave a door open to the place where you shoot, because you don't know who or what can suddenly appear when no one expects it. It's these unpredictable entries that will make the film more beautiful.' Ungari, Enzo and Ranvaud, Donald, op. cit. 179.

[51] The expression appears in the interview given to Jean Gili. Gili, Jean, *Le Cinéma italien. Entretiens avec Marco Bellocchio, Bernardo Bertolucci, Mauro Bolognini, Luigi Comencini* (Paris: Union générale d'éditions, 1978) 371.

[52] Sartre, Jean-Paul, 'La reine Albemarle ou le dernier touriste', *Les Mots et autres écrits autobiographiques*, 2010, 689.

[53] Ibid. 372.

[54] Ricœur, Paul, *La Métaphore vive*, op. cit. 273–321.

It is the same in some of Bertolucci's films: certain sequences of a story not yet past must be read as utopias, anticipations or 'the dream of a thing'.[55] His cinema was made of a 'very raw material' but 'woven on a dream loom'. To understand the meaning of a sequence and read one of his films correctly, he recalled, you had to know how to 'surrender to emotion'. Emotion, that is an inner vibration, a personal and intimate expression of our deep self. It is indeed useful to keep in mind that Bertolucci's film practice took place in parallel with his 'psychoanalytical career', as he said, which began in 1969 during the shooting of *The Spider's Stratagem*. This experience also continued during the making of *The Conformist*. His cinematographic adaptation of the Moravian text thus proposes a real rewriting of the original work. The filmmaker stages a subjective story, unfolded from the interiority of the main character. 'Spectator of his own life, of his own acts',[56] Marcello Clerici puts himself back in the life of the dream and loses interest in effective action to access his history. On a journey by car, his soul 'becomes distended', caught in time in a broken present.

The Status of the Cinematographic Image: A Present Loaded with History

It is through the detour of dream and imagination that memory, in Bertolucci's cinema, gives itself and makes itself accessible to our consciousness.[57] That's why sets are so important. On the one hand, they are determined to recreate an imagination, the fascist conception of time and space. Re-elaborated, reinvented and finally transfigured, they are also charged with a fantastic dimension, close to surrealism.[58]

Historical imprecision and falsehood are balanced here by an excess of symbolic expressiveness: Bertolucci chooses to film time and history by bringing his viewer into these empty and monumental places. He has never used the expression 'historical film' to describe his works. However, as a filmmaker he liked to say that he 'used' history rather than 'making' it. 'Cinema

[55] Gili, Jean, *Le Cinéma italien. Entretiens avec Marco Bellocchio, Bernardo Bertolucci, Mauro Bolognini, Luigi Comencini*, op. cit. 231.

[56] Magny, Joël, 'Dimension politique de l'œuvre de Bernardo Bertolucci de *Prima della Rivoluzione à Novecento*', in 'Bernardo Bertolucci', *Études cinématographiques*, Lettres modernes, 1979, 49–76.

[57] 'But if our past remains almost entirely hidden from us because it is inhibited by the needs of present action, it will find the strength to cross the threshold of consciousness in all cases where we lose interest in effective action to place ourselves, in a way, in the life of dreams.' Bergson, Henri), *Matière et mémoire* (Paris: Presses Universitaires de France, 1990) 171.

[58] This artistic movement, very important during the first half of the twentieth century, inspired Bertolucci. He compared some shots in his films to Giorgio de Chirico's works, for example those in which individuals are quite alone in monumental and empty spaces.

Figure 5.1 In some shots, Bertolucci is inspired by Giorgio de Chirico's works.

knows only one conjugation, he said, the present time.'[59] The representation
of time can only be done indirectly, through editing, a stage in the making
of the film that has acquired for Bertolucci a new dimension, starting from
when he directed *The Conformist*. In contact with Franco 'Kim' Arcalli, who
later became the editor and screenwriter of his final films, he quickly became
aware of the artistic richness of this phase and no longer considered it as the
place where the gap with reality widened.

How do images become perspectives on time? First, let's introduce the
most obvious technique in this area – flashback. Contrary to Moravia's nar-
rative schema, Bertolucci indeed draws a narrative rhythmed by the memory
of the protagonist, his comings and goings in his past. Instead of the linear
chronology of the novel, the film substitutes an imperfectly circular canvas,
extended in the last moments of the film by a postlude. The use of flashback
may seem classic and conventional, particularly in the way in which this tech-
nique is integrated into the narrative process, here in a causal and linear sense,
a somewhat destiny-driven form. However, the order of events is upset by the
complexity of the reconstruction and this creates internal relations between the

[59] Gili, Jean, op. cit., 372.

different levels of the past.[60] Bertolucci refused Moravia's schema of destiny for his film – absence of a straight line and absence of a looping circle – leaving the adaptation of its end orphaned.[61] Further steps backwards can be convened, indefinitely, to answer this enigma that comes from the past.

The film does not deploy a longitudinal vision[62] of the story: we progress in the film by travelling in the 'circles of memory'[63] of the protagonist. As we delve into Marcello's memories, we reach deeper layers of his reality. Memory is always present, but it simply expands to reflect on the perception of souvenir-images that allow the embodiment and actualisation of the past. The scenes that take place in Rome, then in Ventimiglia and finally in Paris, are souvenir-images that Marcello exhumes from his past. The first story – that is, the receptacle of the story – is the journey by car, initially in Paris, and then mostly in an unknown, empty and snow-covered space. This type of place is an invitation to remembrance. The scenes of the journey put before our eyes 'pure optical and sound images'[64] that assume a temporal function. Symbolically, Bertolucci chooses the metaphor of physical movement to evoke a displacement in time.[65] The film is filled with these shots, suspended, even strange, which represent a direct image of time, trying to make it sensitive. In the final sequence, for example, a child grabs an apple placed high on a piece of furniture; the camera stops for a few seconds and films the fruits

[60] Kidney, Peggy, 'Bertolucci's *The Conformist*: A Study of the Flashbacks in the Narrative Strategy of the Film', *Carte Italiane*, 1 (7), 1986, 47–56.

[61] 'It seemed to me that there was this *deus ex machina* that was making out the characters and then I wondered maybe it would be even stronger, even for the character, that suddenly, that night of July 25, Marcello also have a revelation. He realizes from those few things he sees around him and especially the reappearance of a minor character in the story but very important in the life of Marcello, that homosexual driver [. . .] and realizes that he felt different, a murderer had led him to try to be like everyone else [. . .] and perhaps his diversity and a more sexual diversity, deeper than that of having been, whether or not we know, a murderer.' Bertolucci, Bernardo, *Il Conformista*, 1971; 2013, Raro Video, DVD.

[62] 'History is essentially longitudinal, memory is essentially vertical', writes Charles Péguy. Péguy, Charles, *Clio. Dialogue de l'histoire et de l'âme païenne*, III, *Œuvres en prose completes* (Paris: Gallimard, 1987–92) 1177.

[63] Bergson, Henri, *Matière et mémoire*, op. cit. 115.

[64] Deleuze, Gilles, *Cinéma 2. L'image-temps*, op. cit. 13.

[65] The connection between car travel and time travel is all the more eloquent as Marcello, on several occasions, is chased by a chauffeur: successively, following the order of appearance of the sequences in the film, in Rome in 1938 by the driver and agent of the OVRA who will then accompany him on his journey to Paris and Savoy; in parallel, in Rome but in 1917 when he is a child and followed by the driver who tries to abuse him; and on the journey between Paris and the Alps. Finally, in the streets of Paris, when Marcello and his wife leave their hotel to visit the apartment where Professor Quadri is staying; again, their predator is agent Manganiello. The comparison between car travel and time travel is made by Bertolucci and reported in Ungari, Enzo and Ranvaud, Donald, op. cit. 73.

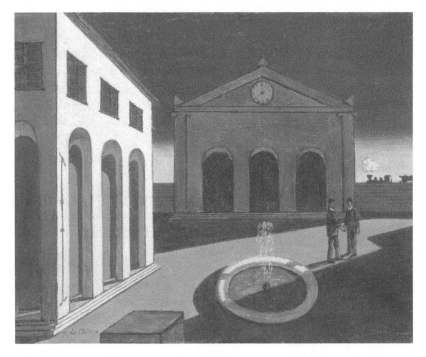

Figure 5.2 Giorgio de Chirico, *L'addio dell'amico che parte all'amico che rimane* (The farewell of the friend who leaves to the friend who remains), 1950, oil on canvas painting, 40x50 cm.

Figure 5.3 Bertolucci constructs a contemporaneity between two temporalities, present time and past time.

scattered in the foreground, against a heavenly background. The duration of this image – pictorial in its form – could be, as Deleuze had already analysed in the Japanese cinema of Yasujirō Ozu, 'the representation of what remains, through the succession of changing states'.[66] A feeling of duration, made both of continuity and multiplicity, is suggested here, demonstrating that present time, 'the only conjugation of the film' to quote Bertolucci, exists only as an 'infinitely contracted past which is constituted at the extreme point of the *déjà-là*'.[67]

Aesthetics of Time Regained: The Present of Memory

The director of *The Conformist* sought to represent the temporality of an interior life, through which the public would be led to perceive and remember a lived time. Sometimes subject to negative criticism, Bertolucci's work has also been appreciated for its ability to bring the viewer closer to a period, to 'bring him into it',[68] although it is a dreamed and imagined past rather than anything really lived. The film, aesthetically accomplished, articulates several shots which we could therefore call, following Deleuze, 'pure optical images'. These images elicit an 'attentive recognition'[69] of what is perceived on the screen and solicit the appearance of an image-souvenir whose virtual nature is sometimes underlined by the director. The virtual redoubling is assumed by shots that reflect and envelop Marcello's memory: when the character arrives at Ventimiglia, the filmed sequence seems, for example, to capture the pictorial effect of René Magritte's painting *La Belle captive*. The spectator then witnesses a third-degree redoubling as the virtual image resulting from a memory of the protagonist undergoes, in its turn, a double movement of capture and liberation.

The phenomena of double perception inhabit the film: the first narrative, in the present, is repeatedly doubled by memories that provoke impressions of déjà vu or, as in Bergson, of 'false recognition'.[70] A priori, we could believe in a *true* recognition: the similarity between the past and the present within their very difference is easily discernible. However, Marcello *believes* he is witnessing two identical scenes, which are called each to the other in his memory: he is attending to 'the same sensations, the same concerns'. He finds

[66] Deleuze, Gilles, *Cinéma 2. L'image-temps*, op. cit. 27–9.

[67] Ibid. 130–1.

[68] Kael, Pauline, 'The Poetry of Images', *The New Yorker*, 27 March 1971.

[69] Bergson, Henri, *Matière et mémoire*, op. cit. 107.

[70] Bergson, Henri), 'Le souvenir du présent et la fausse reconnaissance', *L'Energie spirituelle* (Paris: Presses Universitaires de France, 1990) 110–53.

Figure 5.4 Is 'image-souvenir' real or fictional?

himself at the same moment, where he was then in his story. He is a prisoner of his past and of a circular time. He repeats rather than remembers.[71] Usually, a perception calls up a souvenir insofar as it can help to understand the present, in order possibly to anticipate the immediate future and thus become a 'guide to action'. False recognition, on the other hand, leaves an impression of dream: reality is transposed onto a dream. Bertolucci expresses it through the voice of his character himself.[72] The story of his dream diverges from what is projected on the screen, but how can the viewer discern the true from the false? The real and the imagination never cease to bypass each other, so that the objectivity of one and the subjectivity of the other remain strictly indistinguishable.[73]

In Bergson, the coalescence of the virtual and the actual, the subjective and the objective, takes the form of a virtual image – 'pure souvenir' – defined according to the actual present of which it is the past, both absolutely and simultaneously, and which does not exist in any consciousness, but only in

[71] Freud, Sigmund, 'Remémoration, répétition et perlaboration', *Libres cahiers pour la psychanalyse*, 2004/1, No. 9, 13–22.

[72] On the way by car, in one of the last sequences, Marcello tells the fascist assassin who drives them through snowy landscapes, that he had a dream.

[73] '[. . .] the world that Bertolucci presents to us, like a mirror stretched to an elusive reality'. Mirabella, Jean-Claude and Pitiot, Pierre, op. cit. 38.

time.[74] Is this time, however, accessible to us? So that an image can take us back in time, it must emerge from the past: we cannot reach it otherwise, if we do not place ourselves in it right away. *The Conformist*, on the other hand, is 'in the present', a present attached to its actuality and 'dressed in the costume of the past'. In several interviews, Bertolucci explains his decision to make this film to respond to a form of nostalgia, widespread and *omni-present*,[75] towards the fascist past in Italian society during the 1970s.[76] From his point of view, the relationship between the two periods was more about repetition than recollection. In doing so, his intention was not to create a souvenir but to make oblivion[77] possible, one which allows memory to rest but also recollects by revealing an unconscious, the 'unnoticed nature of the perseverance of the souvenir'.[78]

Several times in the film, Marcello's face is reflected in mirrors, windows: these sequences, until the last scene of the film, in which the protagonist looks at the camera, are like instantaneous moments of self-analysis and knowledge. These scenes are also the *mises en abyme* of our situation as spectators: we retain the same apprehension – perception and memory – of fascism that the prisoners of the myth of the cave have of their environment: that is, some representations projected to us by the apparatus of cinematographic technique. The reference to the famous myth, underlined in a scene in the film, highlights Bertolucci's vision: by bringing to our consciousness

[74] It is a confrontation of the Deleuzian and Ricœurian readings of Henri Bergson's text that allowed us to take up the theses exposed in *Matière et mémoire* on how the subject accesses his memories. Ricœur, for example, in *La Mémoire, l'histoire, l'oubli*, exposes the psychological antithesis that runs in the essay between the recognition and the survival of images: 'pure' memory exists by itself, it is marked by 'impotence and unconsciousness'. Ricœur, Paul, *La Mémoire, l'histoire, l'oubli*, op. cit. 562. For Deleuze, this unconscious is time; indeed, rather than insisting on the thesis of duration as the sole subjectivity, constitutive of the interior life, Bergson maintains the following: 'the only subjectivity is the time seized in its foundation and it is we who are interior to time'. Deleuze, Gilles, *Cinéma 2. L'image-temps*, op. cit. 131.

[75] See the discussion between Marilyn Goldin and Bernardo Bertolucci: 'There is still some nostalgia in Italy for the Fascist period, isn't there? – Yes! That's why I say *The Conformist* is a film on the present.' The previous quotation is taken from an answer given to Joan Mellen: '*The Conformist* is also in the present, but it's the present dressed as the past.' Both are cited in Loshitzky, Yosefa, op. cit. 67.

[76] 'When I shot *The Conformist* I wasn't really thinking about the Thirties but about the Italy I had around me, the one I shot in 1969–70, with terrorism and the strategy of tension.' Socci, Stefano, *Bernardo Bertolucci* (Milan: Il Castoro cinema, 2003) 42–9.

[77] 'Movies are made to forget, not to remember.' In Socci, Stefano, op. cit. 42–9.

[78] This oblivion makes memory possible; see Heidegger's *Gewesenheit*, which Ricœur uses to evoke 'the immemorial resource and not the inexorable destruction'. Ricœur, Paul, *La Mémoire, l'histoire, l'oubli*, op. cit. 573.

memories of fascism, the filmmaker wanted to open the horizon to another memory of this period.

Let us draw a first conclusion from our peregrination through the novel and cinematographic forms of narrative: each work, fictional or not, has its source in the intimacy of its creator. It is thus linked to a personal experience, which nevertheless has the vocation of testifying and representing more than the singular identity of its author. Cinema, in its capacity of figuration and compression of time, as does the novel, certainly makes it possible to give meaning to an otherwise unintelligible world. In this case, the relationship to a social and political reality such as that of fascism was retained at the centre of the creative act. In the two examples, this link implied a confrontation between the past and the present, singular and unique, that constitutes a temporality.

Aristotle wrote: 'Memory *is* past.' For Moravia, it also generates the artist and his art. Art is always a memory of things that have happened. Thus the novelist, with *The Conformist*, wishes to tell a personal drama, as a 'testimony of what we do and what we are in life'. The following sequence matters: things that are important in personal life are not those that we intentionally wish to achieve but those that circumstances constrain us to undertake. We should not see any determinism in this observation but rather the conscious expression that man is necessarily in the world and that the limits imposed on him are always lived by a subjectivity, forced to choose an attitude.[79] In search of a truth of lived experience, reconstituted in present time, Moravia elaborates a classical plotting, deployed on an extended duration from a beginning (the prologue) to an end (the epilogue). *The Conformist*'s narrative also has a broader ambition than the reconstitution of a personal identity, since it opens on the possible homology between intimate and collective times.

Bernardo Bertolucci's film adaptation exploded this linear structure of Moravia's work. He gave up following its chronological course, and modified its end to finally deconstruct the deductive mechanics of time, the reciprocal implication within time. Bertolucci tried to represent the past by putting it into images. His representation was constructed from the present, with a specific intentionality.[80] More than the past itself, it is a 'feeling' of the past that he tries to capture with a film in which the hero is more a spectator than an

[79] This is the lesson Lino, the pedophile driver Marcello believes he murdered as a child, gives to the hero at the end of Moravia's novel: 'But all of us, Marcello, have been innocent . . . was I also not innocent at one time? And we all lose our innocence, one way or the other . . . this is normality.' Moravia, Alberto, *Il Conformista*, in *Opere/3. Romanzi e racconti 1950–1959*, Vol. I (Milan: Bompiani, 2004) 324.

[80] 'I've always had it clear that films about the past, if they don't have a strong link with the present, are only more or less successful illustrations of the period.' In Socci, Stefano, op. cit. 42–9.

actor. It then imposes a de-structuring of the history and chronological order of events through a spatial and imaginary order where recollection occurs through the impression on the memory of places and images. This experience of disorientation finally conditions the possibility of conceiving the present without allusion to the past and of discerning this one without calling upon that one.

Made both of erasure and conservation,[81] memory must reach the recognition of an experience as past. Bertolucci, during the 1970s, attended to or believed to attend to a rehearsal of history. His intention, however, was not to predict the return of fascism but to oppose and prevent a form of 'nostalgia' for the past. The film shows a character whose temporal experience is confused, chaotic; he seems to be experiencing a regret. For Bertolucci, Italian society was in a similar state of desire,[82] experiencing a painful aspiration to a past regretted and transfigured by imagination. By showing a 'past that was not before',[83] he gave expression to a contemporary perception of time and a new relationship to history and memory of fascism in Italy.

[81] Todorov, Tzvetan, *Les abus de la mémoire* (Paris, Arléa, 1995), quoted by Dosse, François, 'Entre histoire et mémoire: une histoire sociale de la mémoire', *Raison présente* (September 1998) 5–24. 'Memory is in no way opposed to oblivion. The two contrasting terms are erasure (oblivion) and preservation; memory is, always and necessarily, an interaction of the two.'

[82] Dika, Vera, *Recycled Culture in Contemporary Art and Film. The Uses of Nostalgia* (Cambridge: Cambridge University Press, 2003) 98.

[83] Morreale, Emiliano, *Il Conformista*, in Aprà, Adriano, *Bernardo Bertolucci. Il cinema e I film* (Venice: Marsilio, 2011, 197). 'The decisive element is a new way of looking at the past, something that would later be called postmodern and that still plays the role of the retro. The past, with *The Conformist*, is something that wasn't before.'

6

The Law of the Father and the Order of Time: Charles Laughton's *The Night of the Hunter*

Christian Delage*

Charles Laughton's only film as a director, *The Night of the Hunter*, did not meet with success when it was released in 1955. Then it was gradually considered as a masterpiece, a film, however, understood to be out of historical time, a film noir, certainly, but a fable, a tale. What was undoubtedly badly accepted at the time, and then abandoned, was the complex relationship that the film had with the law, that is, the borderline between good and evil, the tradition that is imposed, the rules of social life. The film features determinations that weigh on the protagonists, but not to the point of imposing a fate on them. It is not part of a tragic vein, because if the social context acts on the harmony of the family unit, situations of internalisation, transgression or conflict resolution that threaten it open up a 'horizon of expectation'.[1]

If we move from the reception of the film to its conception, the reasons for an evolutionary understanding of its meaning become clearer, if not simpler. The links between scriptwriter James Agee and director Charles Laughton – their complicated relationship to Christian faith and their interest in the original myths of the creation of the United States of America – are fuelled by a questioning of the order of social relations, sexuality and the power of money. Thus the film leads us to wonder about what, in the transition from childhood to manhood, allows us to enter into the order of time, freeing ourselves from the law of the father.

It all began with a meeting between Laughton and Agee. Laughton asked Agee to write a screenplay based on Davis Grubb's novel of 1953, which had

* Translated by Glenn Naumovitz
1 Reinhart Koselleck, *Futures Past. On the Semantics of Historical Time*, translated and with an introduction by Keith Tribe (New York: Columbia University Press, 2004).

made a deep impression on both. Their collaboration is noteworthy less for how they addressed the issues that interested them – the birth of the American nation and the mythological or religious foundations of its identity – than how they brought them to the screen. *The Night of the Hunter* proceeds from and attests to that tension. Laughton was inspired by fragments and expressions drawn not just from history, literature, painting, music and Holy Scripture, but also cinema, leaving visible traces of an imaginary world based on myths, great narrative constructions and stories in circulation. The film's aesthetic quality and historical nature are successfully intertwined with that mosaic, forming a coherent text expressing the author's thoughts. Laughton mediated his work through his relationships with the film crew, with whom he shared a common experience. As Hollywood reached the peak of its classic aesthetic, the director experimented with a sort of 'collaborating system' harking back to early American filmmaking while fully embracing the modernity of his vision.

The Night of the Hunter has an explicit relationship to American history, in particular the social history of the Great Depression. But Laughton's main aim was to show how a boy comes of age by printing an internal archive based on the figure of Moses and the law of the father.

Commencement, Commandment

In the opening scene, two children, John and Pearl Harper, are playing in the front yard of the family farmhouse on the banks of the Ohio River. Suddenly, they hear a car. Surmising that his father is inside, John runs over to the vehicle, which screeches to a halt. His wounded father, Ben, tells him to stash $10,000. Ben kneels down to speak to John, who suddenly looks taller. He asks him to swear that he will never tell anybody, including his mother, where the money is hidden and to always look after Pearl. Then a group of policemen surrounds Ben, ordering him to put his hands up and lie on the ground.

Clearly upset, John presses his hands on his belly and grimaces with emotional pain. He begs the policemen to stop, but they walk his father to the squad car. John freezes. His mother, Willa, and Pearl arrive. The police cars drive off. Willa hugs Pearl. Motionless, John glances at his mother, spins around and makes a dash for the trees. Willa stares at him, then at the police cars pulling away.

What can be observed in this scene? A *commencement*: the children are playing in an almost idyllic setting introduced by a downward tracking shot starting with bird's-eye views of the Ohio Valley and coming to rest on

the Harper family home.[2] The prairie is a sort of Garden of Eden naturally enclosed by trees; a white picket fence delineates an area comparable to the clearing Georges Duby mentioned when he wrote of Cistercian abbeys.[3] Flowers neatly arranged on the riverbank suggest the harmony of an original paradise, the perfection of an ideal embodied by the children's union with primal nature, a wilderness that had existed before humanity, society and the film – a place that the earliest settlers arriving on the *Mayflower* in 1620 believed was still virgin, traces of which may still have been seen in the 1930s.[4] Was that the America Laughton had dreamed of (re)discovering while crossing the Atlantic in 1931 after being asked to perform on Broadway?[5] Directing *The Night of the Hunter* in Hollywood twenty years later, he could only have been more aware of the temporal distance from the pioneers. What turned out to be the hardest? Understanding individuals and social groups he felt close to because they lived in the same century, or travelling back in time by re-enacting the journey of the Pilgrim Fathers? The rural America in *The Night of the Hunter*, often described as being outside history,[6] plunged its roots in the seminal texts,

[2] Davis Grubb, author of the novel upon which the film is based, described the choice of decor: 'Today, my Aunt Mary sent me old, crumbling daguerreotypes of the original Cresap's Landing houses. One of them is exactly the house and tree arrangement I see for the Harper home. A fine, typical river bottomlands farm house in exquisite American rural primitive style – before the gingerbread and frippery of the nineties set in' (Letter from Davis Grubb to Charles Laughton, 19 April 1954, Laughton's Papers, No. 74, Library of Congress, Washington, DC, 3). In this letter, Grubb alludes to the drawings Laughton had asked him to make before writing the screenplay to help him decide on sets and locations (collection of 119 sketches at the Margaret Herrick Library, Los Angeles). Grubb was born in Moundsville, West Virginia, a small town on the Ohio River where his grandfather's steamboat called on a regular basis in the 1880s. See the short biography his brother Louis wrote in 1989 as a foreword to Grubb's *You Never Believe Me and Other Stories* (New York: A. Thomas Dunne Books, St Martin's Press, 1989).

[3] Georges Duby, *Saint Bernard. L'art cistercien* (Paris: Arts et Métiers Graphiques, 1976).

[4] In the work of Philip Freneau, America's first great poet, Élise Marienstras observes that instead of explaining the national idea as an entrance into history, there is 'the sense of a-historical creation that goes along very well with the pastoral image [. . .]. Not even Atlantis, to which he alludes, is satisfactory; he manufactures a past outside myth itself, without referring to any culture, but set in a landscape both wild and benevolent where communing with nature allows men to live in peace and prosperity.' *Les mythes fondateurs de la nation américaine. Essai sur le discours idéologique aux États-Unis à l'époque de l'Indépendance (1763–1800)* (Brussels: Complexe, 1992) 83: 1st edn, Paris: Maspero, 1976.

[5] Laughton named the production company he and Erich Pommer founded in 1937 the Mayflower Pictures Corporation.

[6] Bertrand Tavernier and Jean-Pierre Coursodon describe it as 'a timeless provincial and rural America'. *50 ans de cinéma américain* (Paris: Nathan, 1991) 594.

poems, stories and speeches where Freneau, Jefferson and Crèvecoeur voiced their 'mistrust of cities, industry and commerce, hatred of destructive culture and dream of a society in harmony with nature, far from the sullied societies that have chosen industrialization and a history where men kill one another'.[7]

A *commandment*: rather than naïvely resuscitate Paradise, Laughton set the film in the troubled 1930s. The Great Depression leads Harper to commit a robbery and kill two people. In jail, he explains his motives to his cellmate, Harry Powell:[8]

> Preacher (gravely): You killed two men, Ben Harper.
> Ben: That's right, Preacher. I robbed that bank because I got tired of seein' children roamin' the woodlands without food, children roamin' the highways in this year of Depression; children sleepin' in old abandoned car bodies on junkheaps; and I promised myself I'd never see the day when my youngins'd want.

In 1933, James Mickel Williams carried out a survey of children's living conditions:[9] 'Thousands of boys (one estimate places the number at two hundred thousand), with a scattering of girls, are wandering over the United States, some of whom have no homes, but most of whom have left homes which unemployment had made unbearable. [. . .] The boys are, of course, half starved, often sick from eating bad food, exhausted, hunted and demoralized.'[10] During the New Deal, the federal government implemented a policy to reactivate the national memory. The Works Progress Administration's Federal Writers' Project published historical guidebooks encouraging awareness and knowledge of the past, particularly in Ohio.[11] On 8 July 1938, President Roosevelt himself made a speech launching 'Start Westward of the Nation' in Marietta, near some of the same locations

[7] Élise Marienstras, *Les mythes fondateurs de la nation américaine*, op. cit. 85.

[8] Laughton began a spoken-word performance of his film for a phonograph record by saying, 'Let me tell you a tale of two children, of all children. Once upon an evil time of hunger and depression in our Land, they lived with their mother Willa and their father Ben Harper in a house by the river.' (Charles Laughton in a reading of *The Night of The Hunter* by Davis Grubb, music by Walter Schumann, RCA Victor High Fidelity Recording, 1995.)

[9] In 1931, the Red Cross refused to come to the aid of striking miners and their families in West Virginia on the grounds that their hardships were not caused by a natural disaster. Children bore the brunt of the labour struggles, which were very long. See William Stott, *Documentary Expression and Thirties America* (New York: Oxford University Press, 1973) 27.

[10] James Mickel Williams, *Human Aspects of Unemployed and Relief, with Special Reference to the Effects of the Depression on Children* (Chapel Hill: University of North Carolina Press, 1933) 84–5.

[11] Participating in the rise of the welfare state, the Civil Works Administration was set up in February 1934 and became the Works Progress Administration (WPA) a year later. With the National Youth Administration, it focused on giving young people work.

where Laughton shot *The Night of the Hunter* almost twenty years later. The states and the federal government officially acknowledged the importance of preserving traditions, until then often sacrificed in the name of industrial and economic 'progress', to offset the damage to the American Dream wrought by the Great Depression. In the meantime, calls for a critical review of the nation's founding myths often fell on deaf ears in the regional centres of an overwhelmingly provincial society that cared for little more than preserving the local heritage. In December 1937, a caravan set out from Ipswich, Massachusetts on a months-long trek following the original route settlers of European stock took to Marietta. The State of Ohio gave historical re-enactors in the six states of what had been the old Northwest the following instructions:

> A hundred and fifty years ago, the text books were written by men in the settled communities along the Atlantic seaboard from whom the old northwest territory which later became the present states of Ohio, Indiana, Michigan, Illinois, Wisconsin and a part of Minnesota was farther away to them than Siberia is to us today.
>
> The men and women who carried the nation toward the western ocean were *makers* of history rather than *writers* of it. They knew more of the long rifle and the woodsman's axe than of quill and parchment; and their days were too full of action for writing or recording.[12]

Makers rather than *writers* of history? In 1804, Meriwether Lewis and William Clark set out on the first crossing of the North American continent, reaching the Pacific coast two years later. Their goals were both scientific and commercial. President Thomas Jefferson commissioned the expedition, asking Congress for funding in a secret message. Lewis and Clark's journal is considered a seminal text of American literature. But Michael Kammen observed, surprised, how little the expedition inspired American artists.[13] Perhaps, after a period of popularising the pioneers' adventures based on academic histories or official accounts, retrospectively Hollywood was the best way to turn traces of the past into historical facts.

[12] 'Freedom on the March', an eight-part historical re-enactment by O. K. Reames, Northwest Territory Celebration Commission of Minnesota Papers, quoted by Michael Kammen, *Mystic Chords of Memory. The Transformation of Tradition in American Culture* (New York: Alfred A. Knopf, Inc., 1991) 458.

[13] *Meadows of Memory. Images of Time and Tradition in American Art and Culture* (Austin: University of Texas Press, 1992) 67. See Charles M. Russell's depictions of the Lewis and Clark expedition in Peter H. Hassrick, *Charles M. Russell* (New York: Harry N. Abrams, Inc., Publishers, in association with The National Museum of American Art, Smithsonian Institution, 1989).

Printing an Internal Archive

Ben Harper makes his son swear an oath (Figs 6.1 and 6.2). Aware that he will be sentenced to death, his commandment involves transmitting a material and moral legacy: the loot is made heavier by the crime committed to obtain it. Before the police hustle his father off to jail, John swears to look after Pearl and keep the money's hiding place a secret, including from his mother, because she's 'got no common sense'. It will be his and Pearl's when they come of age.

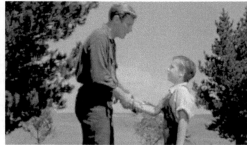

Figures 6.1–6.2 *The Night of the Hunter*: John, the son of Ben Harper, swearing an oath.

An internal *archive* is being *printed*: the policemen's brutal arrest shifts the father's guilt to his son. When Harper is pinned down, John presses his hands on his belly twice, evincing the pain of losing his innocence and his refusal to accept his father's fate. 'Don't!' he shouts, followed by a second, more emphatic cry and a plaintive 'Dad!', so upset that he is nearly prostrate and no longer paying any attention to his mother or sister (Figs 6.3 and 6.4).

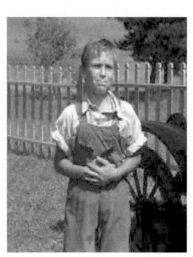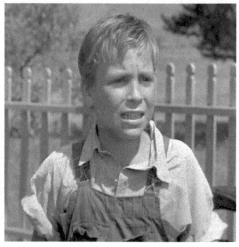

Figures 6.3–6.4 *The Night of the Hunter*: John crying 'Dad'.

The directing, especially the acting and choice of shots, suggests the shift from father to son and shows a *mal d'archive*.[14] Laughton stressed this pathological state in his instructions to Billy Chapin, the actor who plays John:

Charles Laughton: Look at me with a sickness smile.
Billy Chapin: Don't!
Charles Laughton: Shout it!
Billy Chapin: Don't!
Charles Laughton: Shout at me. And you say: Dad!
Billy Chapin: Don't!
Charles Laughton: No. Not like this. This is a guy you've known all this time.[15]

Now let us compare this scene with the sequence of Powell's arrest near the film's end. An old woman, Miss Rachel, has taken John and Pearl under her wing. In relentless pursuit of the children, Powell besieges the house where they have found refuge. Miss Rachel calls the police, who arrive in a speeding squad car, sirens wailing. At first, the scene is filmed from John's viewpoint:

A Trooper: Is that him, Ma'am?
Rachel (*shouting*): Yes! Mind where you shoot, boys! There are children here!
Trooper: Harry Powell, you're under arrest for the murder of Willa Harper!
Standing in the doorway of the barn opposite the house, Powell puts up his hands.
Trooper: Drop that knife, Powell.
John grips his belly as the officers twist Powell's arm to make him drop the knife (Fig. 6.5):
John (*shouting*): Don't!
Powell is thrown to the ground and handcuffed.
John (*shouting louder*): Don't!

[14] 'The *trouble de l'archive* stems from a *mal d'archive*. We are *en mal d'archive*: in need of archives. Listening to the French idiom, and in it the attribute "*en mal de*," to be *en mal d'archive* can mean something else than to suffer from a sickness, from a trouble or from what the noun "*mal*" might name. It is to burn with a passion. It is never to rest, interminably, from searching for the archive right where it slips away. It is to run after the archive, even if there's too much of it, right where something in it unarchives itself. It is to have a compulsive, repetitive, and nostalgic desire for the archive, an irrepressible desire to return to the origin, a homesickness, a nostalgia for the return to the most archaic place of absolute commencement.' 'Archive Fever: A Freudian Impression', *Diacritics*, Vol. 25, No. 2 (Summer 1995), The Johns Hopkins University Press, 57.

[15] Rushes of *The Night of the Hunter*, UCLA Film and Television Archive, continuity established by Inès Gil, postgraduate thesis in Film and Audiovisual Studies, Université de Paris-VIII, 1996, 64.

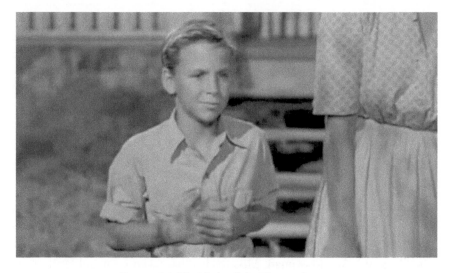

Figure 6.5 *The Night of the Hunter*: Angst.

John grabs the doll where the money is hidden and runs over to Powell as Miss Rachel anxiously watches. The doll bursts open and the banknotes scatter (Figs 6.6 to 6.8). Miss Rachel leans towards him:

> John: Here! Here! Take it back, Dad! Take it back! I don't want it, Dad! It's too much! Here! Here!

Miss Rachel scoops John up in her arms and whisks him away. Only the sound of birds can be heard.

This scene recalls the one at the start of the film by showing the repetition of the *mal d'archive*. The Preacher's arrest reminds John of the police leading his father away. Earlier, he had refused to acknowledge Powell as his father despite the latter's urgent pleas. Now, he feels the same physical malaise he did for his real father. The difference is that he shouts 'Don't!' three times instead of two[16] and runs over to Powell instead of lying down. Freed from his sense of guilt, technically he does not break his oath because Pearl, to save his life, has already confessed that the loot was hidden in her doll. But the dependency in which the oath had imprisoned John *is* broken; what ends is the lull in his family novel, opening up a rush of repressed feelings and the possibility of release.

[16] While directing the film, Laughton told Billy Chapin, 'Now, listen Billy. It is a recognition, somebody came back from the dead like a ghost.' Rushes of *The Night of the Hunter*, continuity established by Inès Gil, op.cit. 82.

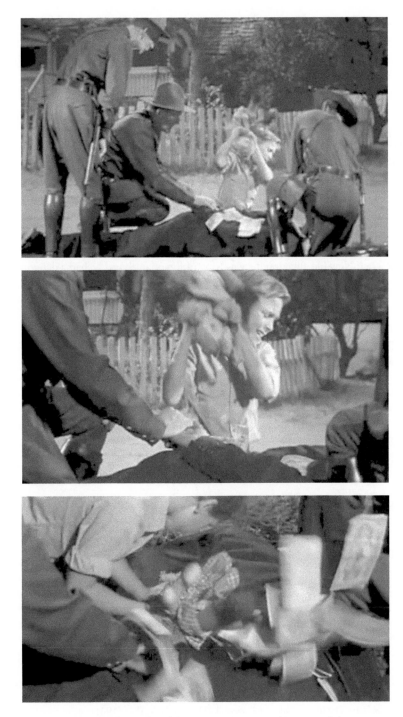

Figures 6.6–6.8 *The Night of the Hunter*: Arrest and return of the money.

John gradually moves ahead in mastering time by making the shift from a natural to a historical order. What good are myth and religion to him? Does he subconsciously use them to invent a memory and accede to the dignity of the temporal, of history?

Laughton's choice of Lillian Gish for the part of Miss Rachel, who tells the Old Testament stories, recalls cinema's earliest days and primeval roots. But Laughton did not cast her for nostalgia's sake or as a sort of monument to the past. While gauging the distance separating her from the 1910s – especially *Broken Blossoms* (D. W. Griffith, 1919), in which her frail character finds fleeting protection in a Chinese doll's cradle – she also embodies the durability of a deeply American yet at the same time universal cinematic language.[17] At night, Miss Rachel tells the children a story. They all sit around her, but John remains conspicuously aloof on the porch:[18]

> Rachel: Now old Pharaoh, he was King of Egyptland! And he had a daughter, and once upon a time, she was walkin' along by the riverbank and she seen somethin' bumpin' and scrapin' along on a sand bar down under the willows. And you know what it was, children?
> Ruby, Clary, Mary: No!
> Pearl: No!
> Rachel (*still loud*): Now, it was a skiff, washed up on the bar. And who do you reckon was in it?
> Ruby (*confidently*): Pearl and John!
> Rachel (*still loud*): Not this time! There was only one young'un – a little boy babe. And you know who he was, children?
> Ruby, Mary, Clary, Pearl: No!
> Rachel (*very quietly*): It was Moses! – A King of men. Moses, children.
> *John slowly turns around, enters the house and walks past Miss Rachel without stopping.*
> Rachel (*commandingly*): John, get me an apple. And get one for yourself, too.
> *John comes back and puts an apple in her lap. He tries to catch her gaze, but she carries on without looking up from her needlepoint.*
> Rachel (*suddenly*): John, where are your folks?

[17] Laughton asked the Museum of Modern Art film library in New York to show him the masterpieces Griffith had made with his favourite actress: 'He felt that Griffith would provide him with the visual inspiration he needed to direct a film with an American pastoral setting, and now he knew he had been right. Griffith's exquisitely sensitive and poetic response to landscape, which he invested with almost mystical properties, his disposition of figures in the frame, his miraculously fluid cutting, all were marvelous and enthralling.' Charles Higham, *Charles Laughton, An Intimate Biography*, op. cit. 187. Laughton also watched five films by René Clair: *Un chapeau de paille d'Italie* (1927), *Les Deux Timides* (1929), *Sous les toits de Paris* (1930), *À Nous La Liberté* (1931) and *Le Million* (1931).

[18] Legend has it that Miss Rachel is based on Exodus: 1 and 2.

John (*plainly*): Dead.

Rachel: Dead. (*She nods with finality.*) Where are you from?

John: Upriver.

Rachel (*finally looking at John, but almost condescendingly*): I didn't figure you'd rowed that skiff all the way up from Parkersburg?

John looks down. There is a pause. He takes Miss Rachel's hand.

John (*very curious*): Tell me that story again.

Rachel: Story? What Story, Honey?

John: About them Kings. And the queen found down on the sand bar that time in the skiff.

Rachel: Kings? Why, there was only one king, honey.

John: I mind you said there was two.

Rachel: Well, shoot now! Maybe there was!

Throughout the scene, Miss Rachel avoids John despite her fondness for him. She has a son, but the reasons for his absence or possible indifference towards her are unknown. Instead of transferring the maternal affection she needs to express to her adopted children, Miss Rachel distributes her stories – and, therefore, the archives, giving them an archiving power – depending on the closeness or distance between legend and reality, by mixing mythical tales and real situations, especially John's.[19] John mixes up two kings, which Miss Rachel pretends not to notice at first. Later, she tells the children another story:

Rachel: Now, there was this sneakin', no-account, ornery King Herod, and when he heard of little Jesus growin' up, he figured: 'Well, shoot! There won't be room for the both of us! I'll just nip this in the bud.' But he wasn't sure which of all them babies in the land was King Jesus. So that cruel old King Herod figured if he was to kill all the babies in the land, he'd be sure and get little Jesus. And when little King Jesus' Ma and Pa heard about this plan, what do you reckon they went and done?

Clary: They hid in a broom closet!

Mary: They hid under the porch!

John: No, they went a-runnin'.

Rachel: Well now, John, you're right. That's just what they done! Little King Jesus' Ma and Pa saddled a mule and they rode all the way down into Egypt land.

[19] John's attitude must not be mistaken. What he takes issue with is not with the Bible but its apparent trivialisation, the predetermination of its narration: on the contrary, he tries to relate to the story Miss Rachel tells. Laughton asked Gish to repeat this scene:

Gish: Now, there was this . . .

Laughton: Do it again, Lily. That wasn't quite beginning a story. Any story. I don't want you to know the story at all.

Rushes of *The Night of the Hunter*, continuity established by Inès Gil, op. cit. 81.

John: Yeah, and that's where the queen found them in the bulrushes.
Rachel: Oh no, that wasn't the same story. That was little King Moses. But just the same, it did seem like it was a plague time for little ones. Them olden days. Them hard, hard times.

Mixing up the stories of two kings, Pharaoh and Herod, is not the result of John's imagination alone. The other children draw parallels between his boat ride and that of Moses. For the French art historian Émile Mâle, 'Si Moïse sauvé des eaux a été si fréquemment peint, c'est qu'on admettait encore au temps de la Contre-Réforme que Moïse sauvé au berceau était une figure de l'Enfant échappant à la persécution d'Hérode.[20] Quant à l'exégèse chrétienne, elle a toujours utilisé l'Ancien Testament comme préfiguration du Nouveau. La représentation courante de Moïse est d'ailleurs partagée entre celle de l'enfant sauvé des eaux et celle de gardien des Tables de la loi.' ('If Moses saved from the waters was so frequently painted, it is because in the time of the Counter-Reformation it was still admitted that Moses saved from the cradle was a figure of the Child escaping the persecution of Herod. As for Christian exegesis, it has always used the Old Testament as a prefiguration of the New Testament. The common representation of Moses is moreover divided between that of the child saved from the waters and that of the bearer of the tablets of the Law.')

The film shows the need to have one's own stories told by others as a way of reappropriating them, however true or untrue they may be, and to find the bearings of a personal and collective identity.[21] On Christmas Eve 1856, David Stevenson asked his children and nephews to compete in a contest to write a better Moses story. The story six-year-old Robert Louis dictated to his mother won first prize, a Bible. According to his mother, who claimed she helped him only by reading the Bible aloud to refresh his memory, the young Stevenson said that was the moment he wanted to become a writer with all his heart. In a watercolour of the flight out of Egypt he made to accompany the text, Stevenson depicted the characters as members of the aristocratic society to which the family belonged: the Hebrews wear top hats; some smoke pipes; Moses nonchalantly crosses the Red Sea, his coat trailing in the water, his bundle on his shoulder.

Myth, says Jean-Pierre Vernant, must be understood not as something in the distant past, traces of which might persist here or there, but as a facet of religious experience, its verbal component combined with its ritual and metaphorical dimensions. If that is the case, myth can no longer be defined

[20] Émile Mâle, *L'Art religieux après le Concile de Trente. Étude sur l'iconographie de la fin du XVIe du XVIIe, du XVIIIe siècle Italie-France-Espagne-Flandres* (Paris: 1932) 342.

[21] See Robert Louis Stevenson, *The History of Moses*, privately printed, A. Edward Newton, Oak Knoll, Daylesford, PA, 1919 (New York Public Library, Manuscript Department).

negatively, by absence, by what is missing: non-rational, non-logical, non-realistic and infantile. On the contrary, the problem is to find it a meaning or, rather, to learn how to recognise the meanings it has.[22] The Bible's strong presence – visible in the movie posters and, in particular, the Mosaic figure[23] – evokes the collective myths resurrected by the American Republic's young citizens: the new Jerusalem.[24] The project was complex: despite their Puritanism, the settlers sought to create a 'national collective separate from the Church'.[25] To escape old Europe and the burden of its legacy, they believed that religious feeling, their community's oldest heritage, could recast history. This allowed them to return to the roots of a faith free of all dogma and, despite its original determination, to face an open future.

In what was a passage from Europe to America for him as well, did Laughton project the renewed commandment of Mosaic Law onto John's character? At the heart of this search for an identity shared between the collective and the individual, how can the obsession with divine figures during and even after childhood, and the attempt to depict their symbolic omnipotence throughout the film, be interpreted?

The Mosaic Figure: Ethics and Aesthetics

Laughton does not rely on the Moses figure alone to symbolise John's fate. He is rescued from the river by a 'princess' who would bring him back to his mother to nurse him before adopting him as her son. The water is not hostile; on the contrary, it is almost a maternal womb, a sweet refuge. John and Pearl cannot return to their mother because she is dead. However, they need protection from their false 'adoptive' father. When he shows up with a Bible in one hand and a rifle in the other, they unmask him as an imposter.

[22] 'Frontières du mythe'. In Stella Georgoudi and Jean-Pierre Vernant (eds), *Mythes grecs au figuré. De l'antiquité au baroque* (Paris: Gallimard, Le Temps des images, 1996) 26.

[23] As André S. Labarthe noted in his review of the film when it came out in France: 'Harry Powell, a strange pastor with the words LOVE and HATE tattooed on the knuckles of each hand, is the Old Testament God, the "celestial bandit" in *Les Chants de Maldoror*, "the strongest whose wrath is terrible"'. Like the people of Moses, John and Pearl tremble with fear and respect before him. 'Their repressed feelings of hostility towards him gradually surface in the 10,000 dollars they hide in Pearl's doll, which becomes the symbol of an act they did not commit (Ben Harper's death). The ultimate parricide, the Jewish people *lynching* (as in the film) their God, gives meaning to their guilt, which until then had not had an actual focus, making it *real*. The symbol of the 10,000 dollars, now useless, is destroyed.' *Cahiers du cinéma*, 60, June 1956, 42.

[24] A close-up of a little girl in the crowd of Hebrews fleeing Egypt for the Promised Land in *The Ten Commandments* (Cecil B. DeMille, 1923) seems to have inspired the shot of Pearl and her doll.

[25] Élise Marienstras, *Les mythes fondateurs de la nation américaine*, op. cit. 85.

Floating in the river, Willa's body seems to possess a grace in death that it had lost in life. John's last words to his father – 'Dad, it's too much!' – underscore the intensity of the paternal presence beyond death: in *The Night of the Hunter*, the living are not at the bedside of the dying. After losing both their parents, the children are not confronted with the symbolism of their burials. In *A Death in the Family*, the novel Agee finished in 1955 – the year *The Night of the Hunter* came out and shortly before his own death – he described two children, Rufus and Catherine, finding their recently deceased father's body:

> . . . Rufus turned his eyes from the hand and looked towards his father's face and, seeing the blue-dented chin thrust upward, and the way the flesh was sunken behind the bones of the jaw, first recognized in its specific weight the word, *dead*. He looked quickly away, and solemn wonder tolled in him like the shuddering of a prodigious bell, and he heard his mother's snowy lips with wonder and with a desire that she should never suffer sorrow, and gazed once again at the hand, whose casual majesty was unaltered.[26]

Anticipation of their own deaths releases John and Pearl from a Church doctrine that would tend to guide their nascent conscience or potential for belief. Yet, as Hans-Georg Gadamer says, 'men are the only living beings known to bury their dead, which means they try to preserve them after death, worshipping them in the cult of those they keep in their memories'.[27]

In the twentieth century, cinema seemed to have the uncanny ability to channel the passions that had previously been the monopoly of theatre or the religious experience and to contain the painful awareness of life's evanescence and the struggle between good and evil in a night alternating between terror and tranquility.[28] *The Birth of a Nation* (1915), one of the films Laughton watched before directing *The Night of the Hunter*, has this intertitle:

> We do demand, as a right, the liberty to show the dark side of wrong, that we may illuminate the bright side of virtue – the same liberty that is conceded to the art of the written word – the art to which we owe the Bible and the works of Shakespeare.

[26] James Agee, *A Death in the Family* (New York: McDowell, Obolensky, 1957) 311.

[27] 'We have the sense', Gadamer says, 'that the message that emerged victorious in our cultural area, that of the sacrificial death of the Son of Man and the Son of God, sought to impose itself as a veritable Redemption and still wins out over all other promises.' 'Dialogues de Capri'. In Jacques Derrida and Gianni Vattimo (eds), *La Religion* (Paris: Seuil, 1996) 228–30.

[28] For Leo Braudy, Laughton's film can only be understood as the passage from Mitchum to Gish, 'from morbid antisexuality to reasonable and moral antisexuality, from a violent Old Testament religion to a calming New Testament'. *The World in Frame. What We See in Films* (New York: Anchor Press/Doubleday, 1976) 234.

Laughton, if only through the Preacher's brutality, simultaneously confronts American society and the cinema it spawned. He uses the classic codes of Hollywood violence to show the contradiction, never openly expressed, between puritanical morals and often indulgent production. For him, the issue was less what message to put across than how the story can show, without 'illustrating', something about the order of transmission, legacy and shared time. That is why the Moses figure is so important: it allows Laughton to draw a connection between ethics and aesthetics, history and stories, reality and film.

Michelet considered Moses 'the law incarnated, alive, ruthless. He alone gave Michelangelo pure satisfaction of spirit. It is said that, forty years later, when he was dragged into the church where he was to sit, his father, who walked in front of him, was outraged to see him go so slowly, turned around and threw his hammer at him, saying with tenderness: "Hey! What are you doing? Is that why you're not alive?'[29] Accompanied by his brother, Alexander, Sigmund Freud made his first journey to Rome in 1901. Walking into the Church of San Pietro in Vincoli, Michelangelo's statue of Moses stopped him in his tracks.[30] Yosef Hayim Yerushalmi considers Freud's attitude an expression of his guilt feelings over ignoring his father Jakob's pleas to start reading the Bible again.[31] On Sigmund's thirty-fifth birthday, in 1891, the elder Freud, for the second time, gave him a copy of Ludwig Philippsohn's illustrated bilingual edition of the Bible that the boy had pored over in his

[29] *Histoire de France*, Vol. 7, 'La Renaissance', 310–11.

[30] 'No piece of statuary', he wrote later, 'has ever made a stronger impression on me than this. How often have I mounted the steep steps from the unlovely Corso Cavour to the lonely piazza where the deserted church stands, and have essayed to support the angry scorn of the hero's glance! Sometimes I have crept cautiously out of the half-gloom of the interior, as though I myself belonged to the mob upon whom his eye is turned – the mob which can hold fast no conviction, which has neither faith nor patience, and which rejoices when it has regained its illusory idols.' Sigmund Freud, 'The Moses of Michelangelo', published anonymously in 1914 in *Imago*. Reprinted in *The Standard Edition of the Complete Psychological Works of Sigmund Freud*, translated from the German under the general editorship of James Strachey, Vol. 8 (1914–16) (London: The Hogarth Press and the Institute of Psycho-Analysis, 1955) 213.

[31] *Freud's Moses. Judaism Terminable and Interminable* (New Haven: Yale University Press, 1991) 71. Although it also involves his relationship to his father and religion, Franz Kafka's family experience is almost the opposite of Freud's: 'Your life', he wrote to his father, 'was essentially governed by your unequivocal belief in the opinions of a particular class of Jewish society and, since these opinions were a part of your identity, you came to believe unequivocally in yourself. Here too, there was enough Judaism, but it was too little to be handed down to a child. It seeped away even as you passed it on.' *Dearest Father*, translated from the German by Hannah and Richard Stokes (Richmond: Oneworld Classics, 2008) 59: 1st edn, 1953.

childhood.[32] It had a new leather binding and a dedication in Hebrew entirely written in *melitzah*, a mosaic of fragments and expressions from the Bible or rabbinical literature woven together to form a coherent text reflecting the author's thoughts.[33]

Freud started his self-analysis in 1896, between his father's death and his first journey to Rome. Two seminal events focused his attention on Moses. One, personal – seeing Michelangelo's statue for the first time – led him to publish *The Moses of Michelangelo* in 1914.[34] The other, political – the Nazis' rise to power and persecution of the Jews – prompted him to write *Moses and Monotheism*, which he began in 1934 and published in its final form just weeks before his death in 1939.[35] This was another *commencement* and *commandment*, where the main issue on Freud's mind – the relationship to the Law – might seem to contradict the idea of its figuration. 'Among the precepts of Mosaic religion is one that has more significance than is first obvious,' he wrote. 'It is the prohibition against making an image of God, which means the compulsion to worship an invisible God.'[36] But Michelangelo chose the precise moment when Moses brought down the Tables of the Law, one of which forbids graven images or likenesses of God. In his analysis, Freud suggests that, unlike the depictions of Moses in paintings,[37] here he holds back his anger against his people after catching them worshipping the Golden Calf. His restraint de-sacralises divine power while at the same time lending it more gravitas. Whether in the precepts Moses laid down on the radical otherness of the Hebrew God, or in how Freud interpreted the artwork, an almost abstract spirituality must triumph over the primitiveness

[32] For Jews of central Europe, this birthday marks the coming of adulthood. On Philippsohn's Bible, see Théo Pfrimmer, *Freud lecteur de la Bible* (Paris: PUF, 1982) 215–78.

[33] 'Son who is dear to me, Shelomoh. In the seventh year of the days of your life the Spirit of the Lord began to move you and spoke within you: Go, read in my Book that I have written and there will burst open for you the wellsprings of understanding, knowledge and wisdom . . . Jakob, son of R. Shelomoh Freud.' Quoted by Yerushalmi, *Freud's Moses*, op. cit. 139–40.

[34] See Jean-Joseph Goux, 'Moïse, Freud, la prescription iconoclaste', *Les iconoclastes* (Paris, Seuil, 1978); Sarah Kofman, 'Un autre Moses ou la Force de la loi', *L'imposture de la beauté* (Paris: Galilée, 1995) 51–73; Jackie Pigeaud, *L'art et le vivant* (Paris: Essais Gallimard) 324–43.

[35] In a letter to Arnold Zweig on 30 September 1934, Freud wrote that, in the face of new persecution, he again wondered how the Jew had become what he was and why he attracted eternal hatred. He soon found the answer. Moses created the Jew, and he entitled his work *The Man Moses, a Historical Novel*.

[36] *Moses and Monotheism* (New York: Vintage Books, 1939), 144.

[37] Such as Rembrandt's *Moses*, of which Freud owned a print: see *Sigmund Freud's Jewish Heritage* (Binghamton: State University of New York, and London: Freud Museum, 1991).

of the senses or instincts. Michelangelo's *Moses* met with criticism for being too sensual. In response, he defended the idea of 'seizing by the eye', *oculi captare*. Using the sculpture's meaning to make it intelligible, Freud was not insensitive to images and their archiving function. Before he could read, he grew obsessed with one of them: Philippe de Champaigne's engraving clearly depicting Moses as a Hebrew.[38]

In *Moses and Monotheism*, Freud tried to put the myth into its historical context. In his view, Moses was no Hebrew but an Egyptian. After Ikhnaton adopted monotheism, according to Freud, he attempted to give the Hebrews the new religion, but they rebelled and killed him. The memory of his murder was repressed but remained latent in their collective unconscious. Although a heavy burden, it also allowed them to reactivate Moses' teachings.[39] Freud's hypotheses about Moses' Egyptian-ness and the conclusions he reached must be taken with a grain of salt, but his initial approach reveals a keen awareness of the contradictions between historiography and psychoanalysis. Concern for truth led him to reject the traditional path of the 'historical novel', but the lack of sources did not hold him back. Freud filled in the gaps with his imagination: there is a tension between tangible historical proof and psychoanalytical intuition. In his first, unpublished, introduction to *Moses*, Freud defined the methodology of the 'character sketch' he had initially planned to write:

> A character study requires reliable material as its basis, but nothing available to us concerning Moses can be called trustworthy. It is a tradition coming from one source, not confirmed by any other, fixed in writing only in a later period, in itself contradictory, revised several times and distorted under the influence of new tendencies, while closely interwoven with the religious and the national myths of a people.[40]

[38] In March 1933, Freud analysed Hilda Doolittle. The American poet told him that 'before knowing how to read, she looked at Gustave Doré's illustrations of the Bible, lying flat on the floor. She identified alternately with the Egyptian princess, the baby Moses and his sister Miriam. Her dreams were full of classical and Biblical imagery [. . .] Near the end of the first series of sessions, Freud asked her if she was the child Miriam who, in Doré's engraving, remained half-hidden in the bulrushes, watching the newborn who was going to become the leader of a captive people and the founder of a new religion. The main themes Freud developed in *The Man Moses* are present in these sessions.' Théo Pfrimmer, *Freud lecteur de la Bible*, op. cit. 11.

[39] Terming this historical re-enactment a 'scenario', Yerushalmi said that 'the past not only subjugates; it also nourishes'. *Freud's Moses*, op. cit. 78.

[40] *Der Mann Moses: Ein historischer Roman*, manuscript dated 8 September 1934 (Freud Archives, Library of Congress, Washington, DC) 2, quoted by Yerushalmi, *Freud's Moses*, op. cit. 17.

At the end of *Moses and Monotheism*, Freud makes an analogy between Judaism and Christianity and 'the ancient ambivalence in the father-son relationship' to explain the meaning of Moses' murder by the Jews.[41]

The Mediation of History

There are three trial scenes in *The Night of the Hunter*. Like the repetition of the scenes of the two 'fathers'[42] being arrested and of John mixing up the Pharaoh and Herod stories, they are quite unsettling. In the first, a judge, enthroned beneath Lincoln's stern portrait, sentences Harper. In the second, Powell is sentenced in the same courtroom. In the third, John accuses Powell of murdering his mother. This scene is shot along the same sightlines as the previous two, but neither Powell nor the judge is visible. Lincoln's portrait[43] occupies his spot, as though positioned to sentence Powell – and perhaps, through him, his own father. But when asked to identify the defendant, John clams up in a forced yet voluntary silence. There are really no discrepancies or contradictions between religion and

[41] 'Its main doctrine, to be sure, was the reconciliation with God the Father, the expiation of the crime committed against him; but the other side of the relationship manifested itself in the Son, who had taken the guilt on his shoulders, becoming God himself beside the Father, and in truth in place of the Father. Originally a Father-religion, Christianity became a Son-religion. It could not escape the fate of having to displace the Father.' *Moses and Monotheism*, op. cit.175. Paul Ricoeur sees a function of consolation in the Freudian interpretation of religion: 'This is where the relationship between religion and desire is most evident. Everything centers around the paternal nucleus, the longing for the father. Religion is biologically grounded in the condition of dependency and helplessness peculiar to human childhood. The neurosis that now serves as the point of reference is the one through which the child passes and which is subsequently revived in the adult after a period of latency. So, too, religion is the revival of a distressing memory, which the ethnological explanation proceeds to link with a primal killing that would be to primeval mankind what the Oedipus complex is to the childhood of the individual.' *Freud and Philosophy: An Essay on Interpretation*, translated by Denis Savage (New Haven: Yale University Press, 1970) 532.

[42] Among the families Walker Evans photographed for *Famous Men*, J. A. Ward finds similarities between two fathers and a mother holding a child in her arms, comparing it to sculptures of the Virgin and Child. *American Silences. The Realism of James Agee, Walker Evans and Edward Hopper* (Baton Rouge and London: Louisiana State University Press, 1985) 152–7.

[43] On the use of images of Lincoln in the American public memory and their religious significance, see Nick Browne, 'Relire *Young Mister Lincoln*'. In Raymond Bellour (ed.), *Le cinéma américain. Analyse de films* (Paris: Flammarion, 1980), Vol. 1, and, by the same author, 'Politique de la forme narrative', *Revoir Hollywood, la nouvelle critique américaine*, introduction by Noël Burch (Paris: Nathan, 1993) 77–86: 1st edn, *Wide Angle*, Vol. 3, No. 3, 1980.

justice: an abundance of stories in one case, a lack of them in the other, challenges the word's 'authority' each time.[44] John's silence reveals the emergence, in a fictional character's consciousness, of truth soon given form by the mediation of history.

John also remains silent in the scene in which he submits to his father's authority. But sometimes the opposite happens: playing with Pearl, he gives the orders, and he is chosen to swear a lifelong oath. Their complicity foreshadows the future casting of roles: John feels responsible for his sister even before his father asks him to be. He helps Pearl put on her doll's shoes, but above all he helps her speak:

John: Hold Miss Jenny still!
Pearl: Stand still, Miss Jenny!

Shortly after their father leaves, as they are getting ready to sleep in the same bed, Pearl, already tucked in, speaks to her brother: 'Tell me a story, John.' John hesitates a moment before weaving together the threads of a story hardly different from what has just happened to him:

John: Well, once upon a time, there was a rich king who had himself a son and a daughter. They all lived in a castle over in Africa. Then, one day, this king got taken away by some bad men. And before he got took off, he told his son to kill anyone who tried to steal his gold . . .

Then, standing in front of the bedroom wall on which the streetlamp's shadow is cast, he spots another imposing shadow overlaying his own. It is the Preacher, leaning on the fence in front of the house. The children have not met him yet. The shadow looms ominously, though at first the character himself seems quite harmless:

John: Just a man!

However, the secret of the stolen money's hiding place is increasingly hard to keep. In the jail cell they shared, the Preacher heard Ben Harper mention a hidden treasure while talking in his sleep and tried – unsuccessfully – to make

[44] Pondering changes in the relationship between historians and their readers, Paul Veyne writes, 'historians did not invent the custom of citing sources, scholarly annotation. It comes from theological controversies and legal practice, where Scripture, the Pandects or trial evidence were lightened.' *Les Grecs ont-ils cru à leurs mythes?* (Paris: Seuil, Points Essais, 1983) 23.

him reveal its whereabouts. He knows the children know. One night he tries to lure them into a trap, first by singing, then by speaking:

> Powell (*singing*): Leaning . . .
> Powell (*speaking*): Chil-dren!

John refuses to speak and runs away from home. He seems quite capable of taking responsibility in his parents' absence, but this is harder than it seems at first. Pearl complains of feeling cold and hungry. John knows they must leave but cannot say why:

> John: If we stay here, somethin' awful'll happen to us.
> Pearl: Won't Daddy Powell take care of us?
> John: No. That's just it. No.
> Pearl: Where are we going, John?
> John: Somewhere. I don't know yet.

He runs away to his Uncle Birdie's, only to find him drunk and guilt-stricken over Willa's violent death. Suddenly, John remembers that several weeks earlier he had talked him into repairing his father's long-abandoned boat moored next to the old dock where Birdie lives in his floating house. Like the cabin, the boat is a vestige, a remnant of a past – the days when Birdie piloted one of the steamboats sailing down the Ohio River – that is gone forever. The boats now bypass Cresap's Landing, but their baleful whistles can still be heard in the distance.[45] At first Pearl is too afraid to leave but, too sleepy to resist, she lets John bring her down to the riverbank. On the boat, the roles are temporarily reversed: John dozes off and Pearl starts singing: 'Once upon a time there was a pretty fly . . .'[46]

Why does John relinquish his seat, voice and song to Pearl? Do singing and speaking play different, interchangeable roles on the road to adulthood? Does Powell's awful bellowing when the children slip through his grasp induce a sort of torpor-like state in John? Why is John so reluctant to testify in court at the end of the film?[47] Questions about both 'fathers' can also be asked. Harper

[45] In a letter to Laughton (Letter from Davis Grubb to Charles Laughton, 19 April 1954, op. cit.), Davis Grubb wrote extensively on the steamboat whistle's importance.

[46] On the music in *The Night of the Hunter*, see Jean-Pierre Berthomé's beautiful article, 'Deux voix dans la nuit', *Positif*, 389/390, July/August 1993, 148–53.

[47] This going back and forth between singing and speaking also reveals a stage in the development of John's sexuality, between narcissism and discovery of the other. It can be assumed that he will emerge emancipated, unlike most of the adult characters: Grubb describes Willa as feeling guilty about her sexuality ('The whole Christian ethic is woven thusly – the gold thread of the spirit and the scarlet thread of the flesh.' Letter to Charles Laughton, op. cit. 2). As for the Preacher, his manifest impotence is combined – thanks to Robert Mitchum – with great powers of seduction.

speaks to his son a long while before the police arrest him. What are his words worth? What about the words of Powell, a 'preacher' who knows only hymns but no Scripture? He starts singing *Leaning* in front of Miss Rachel's house: the tune is so catchy that Rachel joins in, their voices creepily mingling with and responding to one another.[48] With regard to the film's 'father', what can be made of the theatrical mask behind which Laughton's voice is hidden when he reads the Bible, not just on the radio, but also in church?[49] Comparing Freud's *Moses* to Schönberg's *Moses und Aron*, Yerushalmi observes that in the opera, which is entirely based on the conflict between the two brothers, Moses is a spoken part, Aaron a singing one. The spoken word becomes 'the symbolic equivalent of the incapacity of expression'.[50]

The distribution of roles between John and Pearl suggests an imaginary world divided between male and female, patriarchy and matriarchy. In their relationship, the need to reappropriate stories about their own lives and those that have been passed on to them – Uncle Birdie's memories or Miss Rachel's tales – spawns a tension between song and speech. This enables them to tell their story in front of another, to grow aware of the distance and gap that language allows. Childhood is precisely when we believe the stories told to us without questioning their truthfulness or even the authority of the bodies that construct or disseminate them. Agee, whose father died when he was six, found a form of consolation and openness to the world in the religious word. He seems to have very quickly memorised the Scriptures he heard while serving Mass at St Andrew's School.[51] Indeed, the title of his and Walker Evans'

[48] Carole Desbarats: 'The weapon Lillian Gish chooses to protect John and the other children is respect for the sacred: while the hunter cast a spell on the children and viewers with a sensual tune, *Leaning, Leaning . . .*, she sings a different text to the same melody, *Leaning on Jesus*, before joining in unison the man she reveals, after these two bars, to be a preacher or, if you will, a heretic.' 'Au cinéma, la nuit, le mal', *Question de*, 105, 1996, 236. Unlike *Bringing in the Sheaves* or *Waiting for the Harvest*, *Leaning on the Everlasting Arms* is still popular in Harlem's Baptist churches, where it is sung after the Sunday service.

[49] During the filming of *Captain Kidd* (1945), Laughton agreed to do Bible readings, in particular at Dr Remsen D. Bird's, the president of Occidental College in Eagle Rock: 'We ministers', as Rev. Dr Graham Hunter, of Fullerton, California, said, 'have made a fetish of the Bible. You make it the solid, earthy tales of a people, and show how they are directly related to daily life.' Laughton said, 'Jesus Christ was no sissy, and the Word of God is not namby-pamby stuff, but strong meat for strong men!' Florabel Muir, 'An Actor Discovers The Bible', *Saturday Evening Post*, 24 November 1945, Vol. 218, 11 and 47.

[50] Yosef Hayim Yerushalmi, 'Freud's Moses and Schönberg's Moses. Words, Idolatry and Psychoanalysis', 41st conference in homage to Sigmund Freud at the Academy of Medicine, 16 April 1991, before the New York Psychoanalytic Institute, *Le Débat*, 73, January/February 1993, 43.

[51] See Ross Spears and Jude Cassidy (eds), *Agee, His Life Remembered*, with a narrative by Robert Coles (New York: Holt, Rinehart and Winston, 1985) 28.

book is taken from Ecclesiastes: 'Let us now praise famous men, and our fathers that begat us.'[52]

It is helpful to repeat, depict and show stories, myths or religious texts before gaining distance from them. Laughton knew that when the Pilgrims reached America they could not completely shed the attitudes, behaviours and cultural systems inherited from the Old World, despite being driven by the pioneering will to build a new society.[53] Likewise, European and American references (*Caligari*, Murnau, Griffith)[54] abound in Laughton's film, prompting François Truffaut's scathing critique. *The Night of the Hunter*, he wrote, 'flounders between the Scandinavian and the German styles, touching on Expressionism but forgetting to keep on Griffith's track'.[55] Did Laughton merely cobble together a sort of collage, borrowing its constituent parts from various sources?

The *melitzah* of *The Night of the Hunter*

In *Mourning and Melancholia*, Freud defines mourning as the need to come to terms with losing a beloved object.[56] Since history cannot negotiate with memories, the question is to know where the boundary is between too much and not enough, between satisfaction or, on the contrary, flight. The answer

[52] Ecclesiastes 44. This chapter expounds the idea that 'the righteousness of merciful men' cannot be forgotten:
But these were merciful men, whose righteousness hath not been forgotten.
With their seed shall continually remain a good inheritance, and their children are within the covenant.

[53] Actually, Charles Laughton emigrated to the US in the 1930s and didn't become an American citizen until 1950 (translator's note).

[54] The polarity between song and speech can also be understood as the tension between silent film, from which music was not absent, and the arrival of sound. Laughton remembered how Murnau 'showed' his characters' feelings in *Sunrise* or how Cecil B. DeMille tried to find visual equivalents to the Bible's text in *The Ten Commandments*.

[55] *Arts*, 23 May 1956. 'I do not understand', wrote Serge Daney, 'how the *Cahiers* could have missed it at the time, how Truffaut was unable to see anything [. . .]. Laughton's film is of a profound strangeness. Innocence does not yet exist there because, it seems, we are *before* the birth of good and evil. The Lillian Gish character is neither a mother nor even a grandmother; she is content with keeping watch. She is like the pre-generic of a still-suffering species: man. For the second time (the first was with Griffith), Lillian Gish is at the start of something. There is a cosmogony in the film: man has not been completed. Neither has woman. She floats between two waters, 'the children'. That is still said too soon: the little girl is absolutely not the little boy. Nothing is final. It must be seen what the result is. And the result is a lot.' *Devant la recrudescence des vols de sacs à main* (Lyon: Aléa Éditeur, 1991) 135.

[56] 'Mourning is regularly the reaction to the loss of a loved person, or to the loss of some abstraction which has taken place of one, such as one's country, liberty, an ideal, and so on.' Sigmund Freud, *Mourning and Melancholia*, written in 1915, published posthumously in 1946. Edition consulted: *The Standard Edition of the Complete Psychological*

lies in the story's structure, which can play with the repetition and/or reconstruction aspect and, above all, puts viewers or readers in a specific place. The children's many adventures shape their identities, while at the same time they are assembled into a film. Laughton *repeats* stories that are a part of humanity's shared legacy while *reconstructing* them in a coherent, original narrative. The emotions felt watching his film are inextricable from his plot construction, which can even lead to reflective, rational thought by revealing its texture with marks of historicity. As representation, the film cannot establish a *fact*, like a historian can. But the director's tools, in both their materiality and signification, nevertheless have a great heuristic potential.

In the film's *melitzah*, the story's coherence stems from how respect for and distance from religion are mixed and opposed to each other. In Grubb's sketches, Powell resembles a Christ in Majesty, a hieratic figure recalling the stiffness of Romanesque sculpture. Then, foreshadowing his fall from grace, Powell's de-sacralisation plunges him into a secular world, giving nearly human accents to the expression of terror stripped of any actual power.

Handcuffs, the dirty blow knocking Powell down and blood evoke Christ's Passion, Crucifixion and Deposition from the Cross. How can the sight of Miss Rachel holding the unconscious John in her arms fail to bring Michelangelo's *Pietà* to mind?[57]

In the spring of 1923, Agee had a similar experience during a spiritual crisis marking the end of his obsessive identification with Christ. It was Maundy Thursday at St Andrew's, where the pupils would keep vigil all night contemplating the question Jesus asked his disciples: 'What, could ye not watch with me one hour?' Awaking at a quarter to four in the morning, he 'went to the chapel to pray and fast, but when he took his place he found that he no longer believed in the ritual. Try as he might to concentrate on the death and resurrection of Jesus, he felt overcome by an irresistible urge to cast off the cloak of religion and morality. Burning candles seemed to consume all the air in the tiny chapel; he was suffocating. When his turn in the vigil finally ended, he found it a great relief to walk down the sandstone steps into the cool morning atmosphere and to inhale deeply of the

Works of Sigmund Freud, translated from the German under the general editorship of James Strachey, Vol. 14 (1914–16) (London, The Hogarth Press and the Institute of Psycho-Analysis, 1957) 243. Paul Ricoeur finds similarities between this and another text of Freud's, *Remembering, Repeating and Working Through*, to underscore the difference between memory – repetition – and history – reconstruction.

57 Such references to religious iconography are rare in American cinema, even where they are least expected: in *The Roaring Twenties* (Raoul Walsh, 1939), a First World War hero becomes a bootlegger and is ruined by the 1929 stock market crash. His death in his mistress's arms is filmed like a pietà. The young Martin Scorsese recalled the scene in one of his earliest films, *It's Not Just You Murray* (1964).

profane world.'[58] Agee wrote about the event in *The Morning Watch*, a story in which his alter ego, Richard, crucifies himself.[59]

Grubb, Laughton and Agee shared a fertile preoccupation with how the secular and the sacred interacted in the century of cinema, with coming-of-age stories and with the idea of America. For Laughton and Agee, isn't religion the best – and at the same time the most contradictory – place to assume a double requirement of transcendence and rationality? This is where the criss-crossing references to Moses and Christianity might be found. One is aesthetic – the shift from iconoclasm to icon, non-figuration to transfiguration – the other historic – the opposing time frames of Judaism and Christianity, the prophetic and the contemplative.[60]

In one of the film's most beautiful scenes, when John and Pearl are gliding down the river, viewers are swept away by magical fantasy: the starry sky, still water and drifting boat constitute a sort of cinematographic fairy tale. But sometimes, reality rudely intrudes. Hunger drives John and Pearl to a house where a woman wearily hands out potatoes to starving children. 'Where are your folks?' she asks John.

John: Ain't got none.
The woman: Oh, go away, go away.

Later, sitting on the edge of the boat, John hungrily eyes creatures on the riverbanks – an owl, a crawling turtle: 'They make soup out of them, but I wouldn't know how to go about getting him open.'

At night, the children stop to find shelter. John says, 'We're going to spend the night on land.' The place they find to sleep is a highly stylised barn where broken lines and the interplay of light and shadow are borrowed from Expressionism. At the same time, it looks quite natural inside: an astonishing shot

[58] *James Agee: A Life* (New York: E. P. Dutton Inc., 1984) 28–9.

[59] 'It was during one of these protracted and uncomfortable sojourns on his knees that his mind, uneasily strained between its own wanderings and efforts at disciplined meditation, had become absorbed in grateful and overwhelmed imagination of Christ Crucified, and had without warning brought to its surface the possibility of his own crucifixion. He had wondered with all of a sincere heart how ever he might do enough for the Son of God who had done so much for him when suddenly, supplanting Christ's image, he saw his own body nailed to the Cross, and, in the same image, himself looked down from the Cross and felt his weight upon the nails, and the splintered wood against the whole length of his scourged back.' James Agee, *The Morning Watch*, in *Stories of Modern America*, edited by Herbert Gold and David L. Stevenson (New York: St Martin's Press, 1961) 404.

[60] 'Unlike the prophetic times of Judaism, a vectorized time of history, an orientated time when a nation's earthly vicissitudes and a people impelled by messianic hope and the conquest of the Promised Land, Christianity maintains the yearning for an essential verticality; it encourages the contemplative, mystical temptation to escape the tumult of the century to immediately accede to a beginning of transfiguration.' Jean-Joseph Goux, *Les Iconoclastes*, op. cit. 29.

with cow udders in the foreground tracks the children as they move through the barn.[61] The film's miracle lies in the ability of its language to depict everyday life as though it were something out of our imaginations. As in real life, the plainest expressions of existence co-exist with the deepest wellsprings of hope.

The Order of Time

In his analysis of *The Night of the Hunter*, Gilles Deleuze develops the idea of 'stretching time'. In his deconstruction, it is not John and Pearl who react to the 'visual and sound situation' around and above them, but 'a movement of the world' that offsets the characters' lack of movement.[62] In our opinion, this 'stretching' effect occurs when the children simultaneously undergo a primal experience and put it into words. However, once they are safe inside Miss Rachel's home, between the lure of the city and the Christmas ritual, the secular and the sacred, John snaps out of his stillness and replaces the movement of nature or the world with his own. This is no longer the subjective time of his consciousness, but not yet the distanced time of his being-in-the-world. The boat no longer glides along on its own, and John finds a place that does not confine him, like most of the grown-ups around him, in simplistic alternatives: love and hate (the Preacher), pleasure and sin (Willa), Puritanism and perversity (the shopkeeper couple, Walt and Icey Spoon), wistfulness and self-destruction (Uncle Birdie).[63] The ghosts of the past must appear in dreams again in order to vanquish the anxiety of the cosmic time of night and benefit from the radiant daylight of calendar time. After his father's death, a gleaming object in a second-hand shop window catches John's eye: it is a pocket watch amid a jumble of old objects. Noticing him staring, Pearl asks, 'Are you going to buy it, John?' He does not answer. after the Preacher's trial, the judge tells John he can go home. Off screen, he can be heard asking him, almost indirectly: 'And what's Santa Claus going to bring you for Christmas,

[61] As Jean-Pierre Berthomé rightly points out, when the children stop "to listen to an invisible mother sing her child to sleep before taking shelter in the welcoming stable amongst cows with milk-gorged udders, the lullaby at the beginning of the film is heard again (*Dream, little one, dream*). However, the mother behind the window no longer sings about dreaming but prudence: *Hush, little one, hush*. Two voices in the night." Op. cit. 149.

[62] 'The only film by Laughton, *Night of the Hunter*, shows us the great pursuit of the children by the preacher; but the latter is dispossessed of his own movement of pursuit in favor of his silhouette as shadow theatre, whilst the whole of nature takes on the responsibility of the children's movement of flight, and the boat where they take refuge seems itself a motionless shelter on a floating island or a conveyor belt.' *L'Image-temps* (Paris: Minuit, 1985) 80–1.

[63] Very subtly, Laughton does not have John look *visibly* older by the end of the film. After he takes possession of the watch, the director merely creates a slight distance in the space he occupies in the world of adulthood – the kitchen where Miss Rachel is busying about – and the world of childhood – upstairs, where the girls have gone to unwrap their gifts.

little man?' Before John can react and look at him, Miss Rachel gestures to the judge, putting her wrist up to her ear to suggest a watch.

In the film's last scene, the children are together at Christmas. From the kitchen, where she is busy cooking, Miss Rachel observes John, alone in front of the Christmas tree. He looks at his gift, a watch similar to the one in the window, and puts it up to his ear to hear it ticking. Then he proudly smiles and glances her way. However, he does not go over to Miss Rachel to thank her but walks behind her. Visibly moved, she addresses him almost indirectly, without their gazes really meeting: 'That watch sure is a fine loud ticker.'

After all, it is a Christmas present and, even at his age, around twelve, John can very well take it as such: without an identifiable giver or first owner, the watch looks brand new. Miss Rachel stresses the holiday's religious aspect. Facing the camera, she complains to the Lord about the widening gap between its sweet, gentle tradition and the harshness of the Great Depression. She gives one of the girls, Ruby, the jewellery she has been dreaming of but does not do the same for John, who is walking towards the stairs: 'Be nice to have someone round the house who can give me the right time of day!' John stops on a step, rubs the watch glass with his sweater to shine it and looks at Rachel:

John: This watch is the nicest watch I ever had.
Rachel: Well, a fella just can't go around with run-down, busted watches!

John nods. But in Agee and Laughton's first draft of the screenplay, he is more explicit:[64]

John: I ain't afraid no more! I got a watch that ticks! I got a watch that shines in the dark![65]

John's awareness and, later, command of passing time marks his transition to adulthood in the repression of the night and a time frame that mixes up the

[64] In the novel, Grubb makes a direct connection between possessing the watch and transforming the work of memory into the work of mourning: 'There was no sleep for John for a long, ticking time that night. Crouched beneath the bright, heaped quilts he stared at the watch on the string [. . .]. Then he heeded some secret and forgotten bidding of his memory and looked at the place where, on the ancient, flowered wallpaper of the bedroom, the moon cast its square of pale light through the windowpane. [. . .] Silently John slipped from beneath the covers into the icy air and stole shivering across the cold floor to the windowsill. Then he saw that the black shape had, indeed, returned, standing as it had before, as he had known it would be. John lifted an arm and the specter did the same. He twisted his body that way and this and lifted his arms above his head and wiggled his hands and the shadow mimicked every finger, every nodding lock of bushy hair. Then John felt the cold watch pressing against his naked breast.' Davis Grubb, *The Night of the Hunter* (New York: Zebra Books, Kensington Publishing Corp., 1953) 237–8.

[65] James Agee, *Agee On Film*, Vol. 2, 'The Night of the Hunter' (London: Peter Owen, 1965) 354.

rhythms of nature and history. Privacy and isolation during a long journey allow John to unburden himself of a heavy legacy and (re)discover the meaning, if not the reality, of his family novel. 'A sense of good and evil, justice and injustice and other things of that nature sets humans apart from other living beings,' says Giorgio Agamben, 'and the communality (*koinomia*) of these things is what makes the home (*oikia*) and the city (*polis*).'[66] When John takes ownership of the watch, a vague sense of a new freedom erasing the lack of a real family legacy comes over him. The link between generations bolsters his awareness that he must take responsibility in his new home and find his place in the community. The acquisition can be the measure of his emancipation: the gift holds out the promise of entering the order of time. It is not just a piece of jewellery, like Ruby's gift; its (relative) anonymity does not make him dependent on the giver. It is more a symbol of John's hard-won autonomy, the vector of a sociability that begins to emerge, prompted by acknowledgement from others, from the *other*, of his existence in the world and his social identity. There is a sort of invisible distribution of the sacred and the secular, Christmas and New Year's Day. Perhaps it is a 'good omen gift'?

John stands face-to-face with America at a specific moment in its history – the 1930s – and, at the same time, with the universal categories of myth, religion and coming of age. At one point in the film, the hunter – on foot, horseback, even by train, with John wondering if he ever sleeps – loses track of them after they start travelling by river, vanishing into a natural world disconnected from a historical order. But Powell has a cognitive memory: like Carlo Ginzburg's hunter, he is the first to *tell a story* because only he can read the silent, if not imperceptible, trail his prey leaves behind as a series of coherent events.[67]

In *The Night of the Hunter*, the only film Charles Laughton directed, cinema is used to experience history, and the archive fever it produces. Whether based on facts already established by historians – adding an additional layer of interpretation to already existing ones and transforming them in the collective memory – or preceding the historian in uncharted territory, it attempts to approach places and times where the interiority of memory meets the process of socialisation.

[66] *Enfance et histoire. Destruction de l'expérience et origine de l'histoire*, translated from the Italian by Yves Hersant (Paris: Payot, 'Critique de la politique', 1989) 13: 1st edn, Giulio Einaudi, 1978.

[67] 'Signes, traces, pistes. Racines du paradigme de l'indice', *Le Débat*, No. 6, November 1980, 14. Referring to *The Moses of Michelangelo*, Ginzburg mentions what Morelli's writings may have meant for the young Freud: '. . . the idea of a method of interpretation based on waste, on marginal data considered revealing. Thus, details usually looked down upon as unimportant, if not outright trivial and "low", provide the keys to access the loftiest products of the human spirit.' Ibid., 11–12.

7

The Litigating Dead: Zombie Jurisprudence in Contemporary Popular Culture

William MacNeil

Capitalism, Catastrophe and the Critical Cry for 'Fresh Brains': The Zombie as Juridico-political Metaphor

'Fresh brains': that *could* be the cry of any number of zombified undead which seem, of late, to have overrun popular culture.[1] It *is*, in fact, the tart riposte of one of the mid-twentieth century's most well-known analysands to his eminently distinguished analyst – the latter being, here, famous Freudian

[1] This chapter was first delivered as a lecture (March 2016) to my intensive 'Speculative Legalism' class while I was visiting the Interdisciplinary Centre, Herzliya, Israel: my thanks to the students in attendance (especially Ms Michal Finkelstein) for their feedback, as well as to my IDC colleagues, Dr Anat Rosenberg (IDC) and Professor Lior Barshack (IDC), for their gracious hospitality. Subsequently, this chapter was further developed and delivered at the 'West of Everything' Symposium at Cardozo Law School, NYC (August 2016), Southern Cross University's School of Justice Work-in-Progress Seminar (November 2016), the Hong Kong Conference of the Law, Literature and Humanities Association of Australasia (December 2016), the Conference of the Association for the Study of Law, Culture and the Humanities at the Stanford Law School (March 2016) and the TC Beirne School of Law Seminar Series (March 2016) at the University of Queensland, Brisbane, Australia. My thanks to the following organisers, interlocutors and auditors: Associate Professor Marco Wan (HKU), Professor Christian Delage (Paris), Professor Peter Goodrich (Cardozo), Dr Cristy Clark (SCU), Professor Bee Chen Goh (SCU), Associate Professor John Page (SCU), Dr Alessandro Pelizzon (SCU), Associate Professor Jennifer Nielsen (SCU), Dr Rohan Price (SCU), Dr Nicole Rogers (SCU), Ms Helen Walsh (SCU), Professor Scott Veitch (HKU), Mr Edward Epstein (Shanghai & Hong Kong), Professor Bernadette Meyler (Stanford), Dr Karen Crawley (Griffith), Professor Brad Sherman (UQ), Professor Simon Bronitt (UQ), Mr Lee Aitken (UQ), Dr Allison Fish (UQ), Dean Sarah Derrington (UQ), Dr Monica Lopez Lerma (Reed) and Dr Julen Etxabe (Helsinki/Portland). An earlier version of this chapter appeared in the online journal *No Foundations: An Interdisciplinary Journal of Law and Justice* (William P. MacNeil, 'The Litigating Dead: Zombie Jurisprudence in Popular Culture', 2017 *NoFo* 14) and I am grateful to the journal's editors for their permission to republish.

rival Ernst Kris.[2] In this case (see Kris 1951/1975, 237–51), Kris's analysand was a university lecturer who suffered from a block: he could neither publish his academic work nor, eventually, write up his scholarly findings, all owing to his obsessive fear of putative plagiarism (Kris, 1951/1975, 244). Even when Kris pointed out to him – after conducting his own extensive library research – that, far from being plagiarised, his work was highly original (Kris, 1951/1975, 244), the analysand remained unconvinced, clinging to his fantasy of scholarly theft. When Kris further explained, in full-blown psychoanalytic fashion, that this (mis)appropriative fantasy may have been founded on an infantile wish for a successful father (Kris, 1951/1975, 245), the analysand responded that, after each therapy session, he would wander along a nearby street full of attractive restaurants and bistros in New York, scrutinising their menus for his favouritie dish: 'fresh brains' (Kris 1951/1975, 245). For subsequent critics of Kris and his school – such as, most notably, French Freudian, Jacques Lacan – this encephalic vignette served, perfectly, to expose the poverty of a certain kind of psychotherapy:[3] namely, that of ego psychology which, with all its normalising imperatives, entirely missed the point of this, admittedly, cryptic but vividly vivisected reply. From Lacan's vantage, 'fresh brains' was a powerful sign of the analysand's desire, signalling his rejection of Kris' facile reality checks, all the while calling for a new perspective, a different approach: in short, another way of *thinking* about his case, hitherto unexplored by the standard course of treatment (Fink 2004, 52–62; Nobus 2002, 168–71).

Why start with this vignette from psychoanalysis[4] when the topic of this article, as its title indicates, is 'the litigating dead' – that is, zombies? Aside, of course, from the obvious fact that the principal players in each storyline are very much linked by a mutual desire; more than anything else, zombies, as much as Kris' analysand, yearn for 'fresh brains'. That desire, however, is not only literal (for cranial sustenance) but also figural (for new forms of analysis). Consequently, this article's central argument is as follows: whether they be on page or screen – and whether that screen be big (cinema) or small

[2] Ernst Kris (1900–57) was an art historian and psychoanalyst. Born in Vienna, his early career included a working relationship with Freud. In 1938, he fled to England and, in 1940, he moved to New York. In both places, he continued to work in psychoanalysis and art/art history, including as a training analyst at the London School of Psychoanalysis and as a lecturer at the New York Psychoanalytic Institute.

[3] Lacan discussed Kris' article twice in his seminars (1953–4, 52–61; 1955–6, 73–88) and returned to it twice in his writings (1966, 318–33, 489–542).

[4] For a superb application of this vignette to the field of law, policy and jurisprudence, see Maria Aristodemou's masterful 'A Constant Craving for Fresh Brains and a Taste for Decaffeinated Neighbours' (2014).

(television) – what popular culture's current crop of the 'walking dead' call forth, on our part, is a different sort of hermeneutic, an alternative interpretation. That is, a critical perspective capable of parsing the (re)animating tropes of zombie fictions which figure, both metaphorically and metonymically, varying approaches to ordering and organising, indeed governing, the world as we know it. In making this claim, this article differs markedly from prominent Lacanian-Marxist philosopher Slavoj Žižek, who sees in this pervasive 'undead' phenomenon an attitude of resignation, even an abdication of ethical responsibility: 'It's easier to imagine the end of the world', said Žižek, 'than it is to imagine the end of capitalism.'[5] Extrapolating from this bleak observation, Žižek's reading would hold that there are no other options to our present institutional arrangements – runaway globalisation, pitiless neo-liberalism, growing inequality, geopolitical instability – *unless* it is the *degree zero* of zombie apocalypse. So, here, zombies come to signify two stark choices: either Capitalism or catastrophe.

While there is much to recommend the position taken by Žižek and innumerable others of his persuasion (Shaviro, 2002; Newitz, 2006; McNally, 2012; Lauro & Embry, 2008; Zimbardo, 2014), this article would take the opposite tack. That is, in their relentless pursuit of 'fresh brains', zombies evince an overarching *desire* that goes well beyond the imaginative limits of Capital's compulsively repetitive drives, one which emboldens us to reconceive the juridical bottom line organising not only its methods of exchange (contract, property), but its modes of governance (representation, rights and rationality): to wit, a *desire* for a reconfigured *law*, as much as a *law* of revitalised *desire*. What is this 'law of desire' – that, in turn, desires law above all else – but a radical rethinking of the intersubjective tie; specifically, the way in which 'the One' (the self, the subject) is connected to 'the Many' (the Other, the socio-Symbolic). To resituate this problematic in terms of historical political theory, that of Hobbes, Locke and Rousseau: how is the social contract formed? What are its terms and conditions? Who is negotiating it? And, most important of all, to what end?

The generically diverse zombie fictions privileged by this article – principally, comic book and TV series *The Walking Dead*,[6] with asides to

[5] Žižek has repeated this claim in a number of books, articles and interviews. See, for example, the documentary film *Žižek!* (D. Astra Taylor, 2005). As is also well known, the claim is first attributed to Fredric Jameson (1996, 2003).

[6] *The Walking Dead* television series (October 2010–ongoing, Season 8 forthcoming at the time of writing). This series is based on the comic book series by Robert Kirkman (w); Charlie Adlard et al. (a), Berkeley, CA: Image Comics, 2003–ongoing.

[7] *The Rising* is the first in a series of zombie horror novels written by Brian Keene. It was published in 2003. In 2004, it was optioned for film and video-game adaptation. A sequel was also published in 2005: *City of the Dead* (Keene, 2005).

trailblazing pulp fiction *The Rising*[7] and, on both big screen and page, *World War Z*[8] – stage for their respective audiences a dark socio-legal allegory of what Freud would call 'the group and its psychology' by speculating on how juridico-political authority, indeed, leadership (be it charismatic, traditional or bureaucratic[9]) is legitimated and maintained. This article will trace and track these forms of leadership, and the juridical nature of the societies which they lead, linking regimes of property, personality and process with specific kinds of governance: dictatorial, paterfamilial, conciliar. The fact, however, that each of these regimes not only fails, but fails spectacularly, should by no means be read as a symptom of the situation's hopelessness. On the contrary and counter-intuitively, quite the reverse: here, govern-mentality's serial combustions – of the individual and the collective, of the miraculous and the rational – are tremendously productive, the disastrous sum total of each effectively clearing a space for an encounter between zombie and human which is neither antagonistic nor identitarian. As *entre deux morts* – or, between two deaths[10] – this encounter models, relationally, an 'ethics of the Real' which, in sidestepping the genre's false dichotomies (for example, neo-liberal status quo vs. zombie apocalypse) points a way forward beyond the fundamental fantasy that the zombie, as political, economic and juridical metaphor, at once occludes but also discloses: specifically, Capital-ism-*as*-catastrophe.

Know Thy Zombie: The Prisoner's Dilemma, Decision-making and the Indeterminacy of Human Identity

Before, however, exploring any further the juridico-political economic the-matics of leadership, governmentality and an 'ethics of the Real' beyond Capital, this article will address, as a core philosophical issue and its ontic condition precedent, the depiction of the basic human bond's emergence in zombie fictions. Simply put: in the wake of an apocalypse, how do we tell the difference between a human friend and a zombie enemy? The former is, of course, a potential subject of the socio-Symbolic, in fact its core relational agent; while the latter, by definition, is inimical to that very subjectivity, it being destructive not only of the socio-Symbolic writ large, but the self which is its basic building block. *The Walking Dead* proffers grounds for such a deci-sion that are epistemologically surprising, even confounding of our normal

[8] *World War Z* is an apocalyptic horror novel by Max Brooks. Published in 2006, it was also published as an (abridged) audiobook and released as a film (of the same name): *World War Z* (D. Marc Foster), USA: Paramount, 2013.

[9] This template of authority is, of course, Weberian, and is drawn from 'The Three Types of Legitimate Authority' in *Economy and Society* (Weber, 1922/1978), 215–16.

[10] For a more developed definition of this term of psychoanalytic art, please see note 23 of this article.

expectations. I say so because, in terms of *knowing* each other, zombies clearly have the upper hand over humans: they recognise each other almost immediately – by sight, by shuffle, but above all by smell – while humans remain uncertain, doubting whether the other is one of us (human), one of them (zombie), or somewhere in between (one of the infected).

To put it in slightly different terms: zombies *know* and *act*, while humans *hesitate* and *decide*. Of course, this is not to suggest that while we're perpetually paralysed, zombies are always proactive, knowing exactly what to do and when to do it. This is because, as the series shows time and again, zombies can be *fooled*. Much is made of this in *The Walking Dead*, many of its episodes containing a scene in which Rick and his band, in an effort to infiltrate zombie-dominated territory, disguise themselves as the 'Walking Dead' ('Guts', Ep.2, S.1, *TWD*), smear their clothes and skin with blood ('No Sanctuary', Ep.1, S.5 'Start to Finish', Ep. 8, S.6, *TWD*), drape themselves with body parts and, otherwise, stink of rot ('Guts', Ep.2, S.1, *TWD*). And the ruse often succeeds, at least initially and for a time; however, it can never be sustained, a fresh wind blowing away the stink as well as the body parts, or a downpour of rain washing away the blood stains ('Guts', Ep.2, S.1, *TWD*), leaving each metaphorically naked in his or her humanity – which, naturally, the zombie senses instantly and seizes upon, pouncing on its victim like an animal instinctively devouring its prey. Humans, however, operate very differently: instead of an immediate affective response, dependent upon one's own senses, their reaction is cognitive, evaluating, weighing and judging the reactions of others before rendering a decision as to whether one is a friend or enemy, human or zombie.

Knowledge, then, for humans comes from outside the self and is dependent on context. This is clearly the case in the 'prisoner's dilemma' hypothetical beloved of management consultants, philosophers and psychologists (Kuhn, 2017). In its psychoanalytic version – that of Jacques Lacan[11] – three people are assembled in a room, each with an affixed marker – either black or white – which none can see of their own, but only of the others (Lacan, 2006, 161–2). The test, here, is who can work out the colour of their own marker and, presumably, go free by judging the reactions of the other two (Lacan, 2006, 162, 167–9). For, of course, the other two are the only ones who *know* what one's marker's colour is and, in order to access that knowledge, one must 'read' the others' gestures, parse their attitude, analyse their behaviours because the usual grounds for certitude here (Lacan, 2006, 167–9), such as the senses (for example, 'seeing is believing'), are conspicuously absent in this case. Such a situation would seem to put humans at a tremendous disadvantage. While we agonise over decision-making, they – the zombies – simply

[11] See Lacan's discussion of the prisoner's dilemma in his key chapter, 'Logical time and the assertion of anticipated certainty', in his *Écrits* (Lacan, 2006), 161–75.

get on with what they do best: devouring fresh brains and, in the process, massifying their numbers to such an exponential extent that they threaten the social contract, as much as its contracting, rights-bearing subjects. Yet what seems to be, initially, a human weakness (uncertainty, hesitation) can in fact be a source of strength. For doubt, indeed contingency, is necessary for judgment, decision-making and leadership (Lacan, 2006, 170–1) as well as, by extension, the formation of the *socius* through the foundational legality of its social contract.

Post-apocalyptic Social Contracts: Zombie Fictions' Competing Communities of Property, Personality and Process

Consider the increasing fragility, indeed vulnerability, of those societies, the leaders of which would neutralise uncertainty, even abolish difference. The case of Alexandria in *The Walking Dead*'s Season 5 is instructive here. With its impregnable walls, its well-networked power sources and its ample stockpiles of food and ammunition, it appears to be – and is – the safest of safe havens ('Remember', Ep.12, S.5, *TWD*), enabling the illusion of pre-apocalyptic *bourgeois* suburban life to continue: of book clubs and cocktail parties ('Forget', Ep.13, S.5, *TWD*), of manicured lawns and extramarital affairs ('Forget', Ep.13, S.5; 'Try', Ep.16, S.5, *TWD*). There is, however, a fatal flaw in Alexandria's Stepford-style world. Like the contemporary 'gated community' which it so clearly stands for, Alexandria screens its applicants, recruiting only those candidates, shortlisted by various scouting missions, that it deems suitable ('The Distance', Ep.11, S.5, *TWD*), all the while rejecting or expelling the unsuitable ('Remember', Ep.12, S.5, *TWD*) – something like a parody of elite school/university admissions or, better yet, exclusive club or secret society initiation ('Try', Ep.15, S.5, *TWD*). So Alexandria, and its leadership (Deanna, Aaron et al.), *know* precisely the kind of person they want: principally, someone who will respect, uphold and defend their values of possessive individualism, euphemised as 'sustainability' ('Remember', Ep.12, S.5, *TWD*). Within the universe of *The Walking Dead*, Alexandria is *the* neo-Lockean community of property *par excellence*, one where every inhabitant is, seemingly, safe and secure in their own possessory beds, and each enjoys an autonomy that renders his or her sense of selfhood separate and distinct: a community, effectively, of strangers. No wonder, then, so many of the ills that afflict today's mainstream culture – alcoholism ('Spend', Ep.16, S.5, *TWD*), domestic violence ('Spend', Ep.16, S.5; 'Try', Ep. 15, S.5, *TWD*), mental illness ('Start to Finish', Ep.8, S.6, *TWD*) – persist in Alexandria, and are tacitly tolerated as long as these problems remain private and behind closed doors ('Try', Ep.16, S.5, *TWD*), such as the open secret of Dr Peter Anderson's spousal abuse of wife Jessica ('Spend', Ep.14, S.5, *TWD*). It is so because, in this society, every man's home is still his castle – even if that castle contains, for some, a *dungeon*.

Contrast Alexandria's attitudes here with Rick's ragtag-and-bobtail group. While the Alexandrians are in deep denial about the precariousness of their context – not only looking the other way when confronted with local problems ('Try', Ep.16, S.5, *TWD*), but, even more, remaining absolutely convinced about who does and does not belong ('Try', Ep.16, S.5, *TWD*) –Rick and his fellow travellers are so indifferent to any sort of selective filter that they come to incarnate, in their composition, *difference* itself. For Rick's cohort are not only diverse in terms of race, class and gender; indeed, they span a capacious range of skill sets, as much as varied personality types, ranging from the utterly useless (for example, Fr. Gabriel, Eugene) to the absolutely effective (for example, Abraham, Sasha, Maggie and Glenn), with the remainder equivocating between these two poles – and, more often than not, holding diametrically opposed views which, at times, erupt into open conflict: recall the fiercely fought Carol/Morgan disagreement over the sanctity of human life ('Start to Finish', Ep.8, S.6, *TWD*).

Despite such storms and stresses, this group of stragglers and misfits, hangers-on and survivors always manages to rise above their internal tensions, and coalesce into something far more intimate than Alexandria's *faux* community of alienated and atomised individuals. For what Rick's group instantiates is nothing less than what the ancient Greeks would call a *nostos*;[12] that is, a household to call home, as much as home to come back to, at the very heart of which is a *family* ('Remember', Ep.12, S.5, *TWD*) that even the most self-absorbed narcissists of Alexandria would see as unique, special and worthy of emulation. The question that arises, however, is whether there is an appropriate *nomos* – that is, law – by which to order and organise this *nostos* (Sage Heinzelman, 2010, xi–xiv) into a community that encompasses, through the founding legality of social contract, the self and the Other, the individual and the group. Certainly, the principal candidate for this role of nomic law-giver, this figure of legitimate authority is former sheriff ('Days Gone Bye', Ep.1, S.1, *TWD*) Rick Grimes himself, who already functions as the group's *paterfamilias*; that is, its father figure, prescribing its norms, setting its guidelines and otherwise laying down, as psychoanalysis would have it, the 'Law of the Father's Name' (Evans, 1996, 62–4, 101–2, 122, 140–1).

If, though, Rick is that law-bearing Father, then he is a peculiarly vacillating, even ambiguous, one. For no clear patriarchal command – the 'No' of the

[12] For the path-breaking revival and redeployment in cultural legal studies of this ancient term – and concept – please see Susan Sage Heinzelman's law-and-literature classic, *Riding the Black Ram: Law, Literature and Gender* (Sage Heinzelman, 2010), xi–xiv.

Nom du Père, as French Freudians' version of Oedipus would have it (Evans, 1996, 122) – issues from him. Instead, Rick oscillates back and forth, sometimes taking on the mantle of paternal leadership (as he does in Seasons 1 and 2), sometimes rejecting it (as he does in Season 3), then doing both (in Seasons 4 and 5). In short, Rick *wavers*, even questions his phallic authority, doubting his claims to legality as much as paternity. Compare Rick's uncertain attitude and shifting status with that of his obscene counterpart, the monstrously Leviathanic Phillip Blake, *aka* The Governor – the group's key antagonist in Seasons 3 and 4 – who runs his fiefdom, Woodbury, like something out of a Mad Max film[13] – though one seemingly co-directed by Thomas Hobbes as much as George Miller. With its highly contrived (and rigged) gladiatorial games ('Say the Word', Ep.5, S.3, *TWD*) between chained zombies and armed human praetorians (*omnium bellum contra omnes?*[14]), Woodbury could *easily* be a televisual equivalent of Auntie's Bartertown from *Beyond Thunderdome*, both being awash in pleasure-in-pain. So, unlike Rick, the Entity-like Governor sends an unequivocal and unambiguous message: 'Enjoy!' By 'Enjoy!', I mean 'enjoyment' in the sense of that dark and driving force of a disturbing *eros*; that is, a perverse sexuality that the Lacanians and the post-Lacanians call *jouissance* (Evans, 1996, 91–2; Wright, 1992, 185–7), tinctured with all manner of paraphilia, especially sadism.

This is precisely the Governor's psycho-sexual/social position, because he urges us to give vent to our desire for retribution and enjoy our bloodlust. In this role, the Governor assumes a paternal function that Slavoj Žižek might call the 'anal' father (Žižek 1991, 53–7; 1992 passim), an inversion of Rick's phallic fatherhood. While the latter is always puzzling through the Law, tentatively, even painfully trying to reach the right decision, the former is, unequivocally, laying down the 'Law to Enjoy'. As the Žižekian Father-Enjoyment, the Governor never wavers and, certainly, never doubts. This is, of course, his fundamental problem – *and* pathology: unlike Rick, forever debating his judgment, the Governor never questions his decisions. In so doing, the Governor not only marks himself as an authoritarian personality – the Fascist Master (Evans, 1996, 105–6) – but as a psychotic (Evans, 1996, 155–7). For the psychotic has complete faith in his fantasy, the delusions of which he misapprehends (Evans, 1996, 33–4, 77), with the full strength of his deranged convictions, as the real. Think how easily the

[13] *Mad Max*, D. George Miller, P. Byron Kennedy (Australia: Kennedy Miller Productions, 1979). *Mad Max* was followed by *Mad Max 2* (1981); *Mad Max Beyond Thunderdome* (1985) and *Mad Max: Fury Road* (2015).

[14] Literally, the 'war of all against all', characterising the state of nature in Hobbes' *Leviathan* (Freeman, 2008, 142).

Governor mistakes the dead for the living, misrecognising his own zombi-
fied daughter, Penny ('Say the Word', Ep.5, S.3, *TWD*), for the person
of the young girl she previously was ('Walk With Me', Ep.3, S.3, *TWD*),
and insisting that is who, ontologically, she still is by keeping her with
him, secreted away, chained in his office cupboard ('Made to Suffer', Ep.8,
S.3, *TWD*). Not that Penny is the only (un)dead curio here, the Governor
displaying such ghoulish trophies as the severed heads of his victims, as
well as other corporeal bits and bobs, in what amounts to a chamber of
horrors ('Walk With Me', Ep.3, S.3, *TWD*). With this fetishism of the
'body in . . . pieces' (Wright, 1992, 36) – the Lacanian *corps morcélé* – the
Governor looks to be something like a 'Bluebeard' figure from Grimm's
(and grim) fairy tales, a nightmare 'Daddy' who, in his strong associations
with death and decay, seems to have stepped straight out of Gothic fiction.

No wonder, in Series 3, Rick abdicates paternal leadership of the group,
especially if this is where it leads: from the Symbolic Phallic Father who
says 'No!' to the Real Anal Father, urging a deranged 'Enjoy!', the two
being flipsides of the same coin. This is why those Series 3 and 4 episodes
set in the abandoned prison that Rick and his group take over, with the
aid and assistance of some remaining inmates, are crucial. Because this
storyline models a leaderless mode of governance ('This Sorrowful Life',
Ep.15, S.3, *TWD*); namely, an acephalic sovereignty in which authority is
disseminated from the One (Rick-as-Rousseau) to the Many (the group-
as-'General Will'). How, though, is this dissemination effected? What is
the governing modality that replaces Rick's patriarchal autocracy? Nothing
less than through a supreme 'council' ('30 Days Without An Accident',
Ep.1, S.4, *TWD*), which operates along such strictly democratic centralist
lines that even Lenin himself (or Jodi Dean herself)[15] would be satisfied;
specifically, attend the meeting, vote, abide by the majority decision. End
of story: no subsequent debate, no follow-up discussion and, certainly, no
breakaway splits or deviations. Here, then, is rule by the party and, espe-
cially, its central committee, the processes and procedures of which dis-
place, and indeed do away with, any sort of singular authority – despite the
prison location, even the panoptic gaze of the warden, ordinarily watchful.
The irony of which is that, even if the prison residents are no longer them-
selves watching, then someone else certainly is; specifically, the Governor
and his minions, not only watching ('Internment', Ep.5, S.4, *TWD*), but

[15] For Dean's uncompromising rehabilitation of what some might think as the least palatable
aspect of Marxist-Leninist praxis – the vanguard party – see her now germinal *Crowds and
Party* (Dean, 2016).

waiting – for what? Simply, to storm the prison, exact their revenge and release the zombie hordes ('Welcome to the Tombs', Ep.16, S.3; 'Too Far Gone', Ep.8, S.4, *TWD*).

This drives home the need for a mode of leadership that has its source *in*, and is in turn a source *of*, liberal-legal *law*-giving, as much as Schmittian-political theological *decision*-making (Schmitt, 1985, *passim*). By this, I mean a leader who, through his or her decisional authority, will not only ensure security but who, through his or her commitment to Rule of Law imperatives, will respect democratic process, at once representing yet also bringing into dialogue the individual and the group. This is not only a key challenge confronting *The Walking Dead*'s fictional universe; it is our world's central issue as well. Given such global crises as climate change, financial mayhem, geopolitical uncertainty, the key question facing the world is what form of governance will deliver it from this parlous state of affairs. Certainly not the dysfunctional options on offer from the current law/politics nexus as imaged in the series: for example, Alexandria's precarious model of possessive individualism, desperately clinging to its things (a metaphor for the neo-liberal West); or the prison's vulnerable template of process and procedure, perilously distributing leadership among a bureaucratised managerialism that strains responsibility and leaves decision-making compromised (a figure for the old socialist East, its 'revolution betrayed' by party *nomenklatura*); finally, the truly scarifying blueprint of the charismatic 'cult of personality', where the 'great helmsman' of the ship of state turns out to be a psychotic demagogue (an allegory of Clive Palmer in Australia,[16] Nigel Farage in the UK[17] and, of course, Donald Trump in America[18]), one who will save us from ourselves even if it means killing us all.

Miracles, Marxism and Monsters: Towards a Zombie Jurisprudence of Critique

So, the stakes are high in zombie fiction because, *contra* Žižek and others, they force us to rethink our *nomos* but also our *nostos*, our law *and* society. Here, narratives such as *World War Z* (Brooks, 2006; *WWZ*, 2013) are instructive,

[16] Queensland-based mining magnate and maverick Australian politician with a penchant for the eccentric bordering on the bizarre (for example, one of his current pet projects is building a replica of the *Titanic*), Palmer is the founder of the populist Palmer United Party.

[17] As the leader of the anti-EU, anti-immigrant UK Independence Party (UKIP), Nigel Farage was, until recently, Britain's leading Eurosceptic, having paved the way – ironically for a sitting MEP – for 2016's Brexit vote.

[18] Famously, the 45th and current president of the United States and widely known – and decried – as a populist, protectionist and *Volk*-ish nationalist.

especially in the radically discrepant logics proposed by its respective cine-matic and textual versions as a response to the zombie crisis. For the former, filmic solution, the proposal turns on what might be called 'the miraculous'. Now miracles are, usually, theological; that is, a sign from God recorded in many faiths' sacred scriptures, including the Upanishads, the Koran, and the Old and New Testaments. It is precisely that theological miracle informs one of the first of the present wave of zombie fictions, Brian Keene's *The Rising* Series, where blessed release from a zombie apocalypse – who themselves are demons, rebel angels from another dimension, Hell – comes in the form of an afterlife, presided over and protected by God (Keene, 2005, Epilogue, 355–7). That theistic plot twist, however, is not the miracle of the film *World War Z*; instead, it is scientific rather than religious, a 'Eureka' moment on the part of UN investigator Gerry Lane, who observes, during the heart-stopping fall of Jerusalem (*WWZ*, Sc.9), how the highly mobile zombie swarms sidestep and ignore the terminally ill: in this case, a cancerous child (*WWZ*, Sc.9). This fieldwork insight leads to Lane's Jonas Salk-like discovery, later at a belea-guered British research institute (*WWZ*, Scs.13–15): the inoculating effects of deadly (but curable) pathogens, the presence of which, in the body, will repel the zombies and, possibly, save humanity (*WWZ*, Scs.15, 16).

What is interesting here is how much *World War Z*, the film, departs from *World War Z*, the book. At first blush, the most glaring departure appears to be in terms of narrative structure, the former being focalised by one character, Gerry Lane being a star vehicle for Hollywood 'himbo' Brad Pitt;[19] whereas the latter is told, in the manner of a Studs Terkel-style oral history 'from below',[20] being vocalised in the multiple viewpoints of those who lived through and triumphed over, eventually, the zombie apoc-alypse. That formal-narratological departure is, however, upstaged and, ultimately, overwhelmed by a substantive-thematic one: specifically, when Max Brooks' book flatly rejects the miracle of intervention, scientific, theo-logical and otherwise; and plumps, instead, for a solution to the crisis that is collective rather than individual, involving as it does full mobilisation of the material and mental resources of global humanity (Brooks, 137–86, 187–269) in order to prosecute a 'total war' against the zombie apocalypse (Brooks, 270–327). In so doing, according to Brooks' *World War Z*, global

[19] It was Pitt's production company, Plan B Entertainment, which secured the screen rights for the film. Pitt is also one of the producers of the film (with Dede Gardner, Jeremy Kleiner and Ian Bryce).

[20] See, for example, Studs Terkel's oral histories of the Great Depression (Terkel, 1970) and Second World War (Terkel, 1984).

society must undergo a radical restructuring by installing, surprisingly for an American text, a version of the old 'communist idea'[21] – 'from each according to their abilities, to each according to their needs' (Marx, 1978, 531) – that would put the now-defunct command economies of the passé Soviet bloc to shame.

The problem, though, with *World War Z*'s two solutions to the zombie apocalypse is that each repeats rather than reconciles the divide between the individual (the 'Eureka' moment of the film) and the collective (the 'communist idea' of the text). By way of contrast, *The Walking Dead* opts for, at least I maintain, a solution that encompasses both the individual and the collective, and all the other antinomies for which this binary stands: security/democracy, decision-making/dissemination, leadership/consensus. But what will bring these sets of opposition together? Naturally, the solution must involve the law, that great mediator between right and utility, the individual and the common good. Yet what kind of law is it? I would argue that it is a law that takes ethics seriously, putting it, squarely, front row and centre. Namely, a legality that valorises an ethical care and concern for, as Levinas would put it, 'the Other' (Levinas, 1998), the duty to whom we can never resile from, can never disavow, can never give up on, no matter what the consequences. Given this definition, surely the most ethical figure in Western jurisprudence is Antigone,[22] Oedipus' celebrated daughter, who refused to obey the order of her uncle, Creon, King of Thebes.[23] For Creon, infamously, barred any citizen from properly burying, according to the rites and rituals of the gods, his nephew, Polynices, recently dead from having taken up arms against Thebes (Sophocles, 1984: *Antigone*, ll. 26–30, 215–31). In performing what amounts to a burial –sprinkling dust over Polynices' body (Sophocles, 1984: *Antigone*, ll. 277–81, 417–89) – Antigone not only honours her brother but the gods themselves, following their 'higher' law instead of that posited by the state through the 'command of the sovereign' (Sophocles, 1984: *Antigone*, ll. 499–524).

[21] Of which everything old is new again, the 'communist idea' being brushed off, put on display and recirculated as a viable political option, a branding process amply attested to by trailblazing collections such as Costas Douzinas' and Slavoj Žižek's *The Idea of Communism* (Douzinas and Žižek, 2010) and Jodi Dean's provocative *The Communist Horizon* (Dean, 2012).

[22] For the definitive reading of Antigone as the *ur*-figure of jurisprudence, see Julen Etxabe's superb *The Experience of Tragic Judgment* (2014).

[23] *Antigone* is one of the three Theban plays (and Oedipal dramas) by Sophocles, following on in terms of plot from *Oedipus the King* and *Oedipus at Colonus* (Sophocles, 1984). It was written and performed first, however, around 450 BC.

My Zombie, (Not) My Self: The 'Ethics of the Real' as Laying The Living Dead To Rest

Something like Antigone's Sophoclean drama is played out in Series 5 of *The Walking Dead* when Sasha, a female character of great Antigone-like resolve and determination who, after losing, dispatching and burying her dead brother Tyrese ('What's Happened and What's Going On', Ep.9, S.5, *TWD*), symbolically joins him by lying down in a shallow mass grave of disposed and truly dead zombie cadavers, identifying with each ('Conquer', Ep.16, S.5, *TWD*). Why do I say identifying? Because, in so doing, Sasha knowingly honours the zombies, as well as the memory of her brother, elevating all of them to the dignity of the dead 'Thing',[24] to be put to rest, buried ritually, even prayed over. Is this not the ethical moment of the series: an ethics, as Alenka Zupancic might put it, of 'the Real'? (Zupancic, 2000, *passim*). That is, an ethics where we identify with 'the Real' of the zombie, not in order to become one of them – this is the fatal mistake of the Terminus cannibals (Seasons 4 and 5) or the roving Wolves (Seasons 5 and 6), who misrecognise the 'Walking Dead' as living subjects to be mimicked, that is, *Imitatio Zombii* – but to end, mercifully, an existence that is well and truly '*entre-deux-morts*', between two deaths.[25] After all, when all is said and done, we are all zombies, at least potentially. We know this because, as Rick later reveals ('Beside the Dying Fire', Ep.13, S.2, *TWD*), Dr Jenner whispered to him, in the final, intense scenes set at the end of Series 1 in Atlanta's Centre for Disease Control, that all of humanity had been infected with the virus ('TS-19', Ep.6, S.1, *TWD*).

This startling revelation is recalled *in*, and makes sense *of*, Rick's despairing lament in Series 5 that 'we are all the "Walking Dead"' ('Them', Ep.10, S.5, *TWD*). But one should not necessarily read this utterance as fatalist resignation, quiescently accepting one's inevitable fate; that is, ceding dominion

[24] Borrowing from Lacan (Lacan, 1959–60, 21, 42, 80, 98, 151), via Žižek (Žižek, 1999, 263; 2000, 95), Zupancic equates *das Ding*, 'the Thing', with 'the Real' and, as such, as affording access to the ethical event, rearranging the coordinates of our existence: 'The Real Happens to us (as we encounter it) *as impossible*, as the "impossible thing" that turns our symbolic universe upside down' (Zupancic, 2000, 235).

[25] That of the body's biological (Real) death and its ceremonial (Symbolic) death, thereby opening up the space in which the death drive prevails, evacuated of desire, but animated by a demand – the emblematic literary example is the ghost of Hamlet's father, who, as neither fully dead nor as one of the living, haunts his son with a demand for vengeance. The terminology is, of course, Lacanian (Lacan, 1959–60, 248; Evans, 1996, 32–3) and the point Žižekian (1992, 23), which has been picked up in and disseminated widely in the critical literature (for example, Dima, 2016; Sigurdson, 2013; Mullen, 2014; Larson, 2010).

of the planet to the zombie hordes by becoming one of them. On the contrary, the presence of the virus in all of us presents us with a *free choice*: we can either join the dead, participating – like the current subjects of global capital – in their never-ending and iterative loop of consumption, metaphorised cinematically in the 'fresh brains' demanded in innumerable zombie flicks; or we can make a conscious effort, like Kris' analysand impliedly invited in his nosological anecdote of 'fresh brains' (Kris, 1951/1975, 245), to break with this chain of consumption by embracing our uncertainty, hesitation, difference to become an alternative version of humanity, one that would challenge the hegemony of the 'Walking Dead', calling them into question, putting them on trial, judging them and finding them wanting. To that political, ethical and, above all, *juridical* end, *The Walking Dead* invites us to become nothing less than 'The Litigating Dead'.

Bibliography

Aristodemou, Maria, 'A Constant Craving for Fresh Brains and a Taste for Decaffeinated Neighbours' (2014), 25 *European Journal of International Law* 1, 35–58.

Brooks, Max, *World War Z: An Oral History of the Zombie War*, New York: Random House, Inc., 2006.

Dima, Vlad, 'You Only Die Thrice: Zombies Revisited in *The Walking Dead*' (2016) 8 *International Journal of Žižek Studies* 2, 1–22.

Douzinas, Costas and Slavoj Žižek, *The Idea of Communism*, London: Verso, 2010.

Etxabe, Julen, *The Experience of Tragic Judgment*, London: Routledge, 2014.

Evans, Dylan, *An Introductory Dictionary of Lacanian Psychoanalysis*, London and New York: Routledge, 1996.

Fink, Bruce, *Lacan to the Letter: Reading Écrits Closely*, Minneapolis: University of Minnesota Press, 2004.

Freeman, Michael (ed.), *Lloyd's Introduction to Jurisprudence*, 8th edn, London: Sweet & Maxwell, 2008.

Jameson, Fredric, *Seeds of Time*, New York: Columbia University Press, 1994.

Jameson, Fredric, 'Future City' 21 (11) *New Left Review* (2003) 65–79.

Keene, Brian, *The Rising*, USA: Delirium Books, 2003.

Keene, Brian, *City of the Dead*, USA: Delirium Books, 2005.

Kris, Ernst, 'Ego psychology and interpretation in psychoanalytic therapy' 20 *The Psychoanalytic Quarterly* (1951) 15–30. [Republished in L. M. Newman (ed.), *Selected Papers of Ernst Kris*, New Haven: Yale University Press, 1975, 237–51.]

Lacan, Jacques (1953–4), *The Seminar of Jacques Lacan, Book I: Freud's Paper on Technique 1953–1954*, in J. A. Miller (ed.), J. Forrester (trans.), New York: W. W. Norton, 1988.

Lacan, Jacques (1955–6): *The Seminar of Jacques Lacan, Book III: The psychoses 1955–1956*, in J. A. Miller (ed.), R. Grigg (trans.), New York: W. W. Norton, 1993.

Lacan, Jacques (1959–60), *The Seminar of Jacques Lacan, Book VII: The Ethics of Psychoanalysis 1959–1960*, in D. Porter (trans.), Dennis Porter (notes), London: Routledge, 1992.

Lacan, Jacques (1966), *Écrits: The first complete edition in English*, B. Fink and H. Fink (eds), R. Grigg (trans.), New York: W. W. Norton, 2006.

Lauro, Sarah Juliet & Karen Embry, 'A Zombie Manifesto: The Nonhuman Condition in the Era of Advanced Capitalism' (2008) 35 *boundary 2* 1, 85–108.

Levinas, Emmanuel, *Entre Nous: on thinking-of-the-Other*, Michael B. Smith, New York: Columbia University Press, 1998.

Marx, Karl, 'Critique of the Gotha Program', *The Marx-Engels Reader*, R. Tucker (ed.), 2nd edn, New York: W. W. Norton, 1978, 525–41.

Mullen, Gary A., 'Adorno, Žižek and the Zombie: Representing Mortality in the Age of Mass Killing' (2014) 13 *Journal for Cultural and Religious Studies* 2, 48–57.

Newitz, Annalee, *Pretend We're Dead: Capitalist Monsters in American Pop Culture* (Durham, NC: Duke University Press, 2006).

Nobus, Dany, *Jacques Lacan and the Freudian Practice of Psychoanalysis*, London: Routledge 2000 [Taylor & Francis e-Library, 2002].

Shaviro, Steven, 'Capitalist Monsters' (2002) 10 *Historical Materialism* 4, 281–90.

Sigurdson, Ole, 'Slavoj Žižek, the Death Drive and Zombies: A Theological Account' (2013) 29 *Modern Theology* 3, 361–80.

Sophocles, *Antigone* in *The Three Theban Plays: Antigone; Oedipus the King; Oedipus at Colonus*, Robert Fagles (trans.), Bernard Knox (intro. and notes), London and New York: Penguin Books, 33–128.

Terkel, Studs, *Hard Times: An Oral History of the Great Depression*, New York: Pantheon Books, 1970.

Terkel, Studs, *The Good War: An Oral History of World War II*, New York: Pantheon Books, 1984.

Weber, Max, 'The Three Types of Legitimate Rule', in Guenther Roth and Claus Wittich (eds), *Economy and Society* (1922), Berkeley: University of California Press, 1978.

Wright, Elizabeth (ed.), *Feminism and Psychoanalysis: A Critical Dictionary*, Oxford: Basil Blackwell, 1992.

Zimbardo, Zara, 'It is Easier to Imagine the Zombie Apocalypse than to Imagine the End of Capital', in Andy Lee Roth, Mickey Huff (eds) with Project Censored, *Censored 2015: Inspiring We the People – The Top Censored Stories and Media Analysis of 2013–2014*, Ralph Nader (foreword), Khalie Bendib (cartoons), New York and Oakland: Seven Stories Press, 2014.

Žižek, Slavoj, 'Grimaces of the Real, or When the Phallus Appears' (1991) 58 *October*, 53–7.

Žižek, Slavoj, *Looking Awry: An Introduction to Jacques Lacan through Popular Culture*, Cambridge, MA: MIT Press, 1992a.

Žižek, Slavoj, *Enjoy Your Symptom!: Jacques Lacan In Hollywood and Out*, London: Routledge, 1992b.

Žižek, Slavoj, *The Ticklish Subject: The Absent Centre of Political Ontology*, New York and London: Verso, 1999.

Žižek, Slavoj, *The Fragile Absolute: Or, Why is the Christian Legacy Worth Fighting For?* London: Verso, 2000.

Zupancic, Alenka, *Ethics of the Real: Kant and Lacan*, London: Verso, 2000.

Comic Book Series

The Walking Dead: Robert Kirkman (w); Charlie Adlard et al. (a), Berkeley, CA: Image Comics, 2003–ongoing.

Filmography

Mad Max, D. George Miller, P. Byron Kennedy (Australia: Kennedy Miller Productions, 1979).

Mad Max 2, D. George Miller, P. Byron Kennedy (Australia: Kennedy Miller Productions, 1981).

Mad Max Beyond Thunderdome, D. George Miller, P. Terry Hayes, George Miller and Doug Mitchell (Australia: Kennedy Miller Productions, 1985).

Mad Max: Fury Road, D. George Miller, P. George Miller, Doug Mitchell and P. J. Voeten (Australia: Village Roadshow Pictures, Kennedy Miller Mitchel and RatPac Dune Entertainment, 2015).

World War Z, D. Marc Foster (USA: Paramount, 2013).

Žižek!, D. Astra Taylor and P. Lawrence Konner (USA and Canada: Zeitgeist Films, 2005).

Television Series

The Walking Dead

- Season 1: Frank Darabont, Robert Kirkman, David Alpert, Charles H. Eglee and Gale Anne Hurd (executive producers), *The Walking Dead: Season 1* (USA: AMC Studios, 2010) [TV Programme, DVD, Blu-Ray].
 - 'Days Gone By', Episode 1: Frank Darabont, writer; Frank Darabont, director.
 - 'Guts', Episode 2: Frank Darabont, writer; Michelle McLaren, director.
 - 'TS-19', Episode 6: Adam Fierro, Frank Darabont, writers; Guy Ferland, director.
- Season 2: Frank Darabont, Robert Kirkman, Glen Mazzara, David Alpert and Gale Anne Hurd (executive producers), *The Walking Dead: Season 2* (USA: AMC Studios, 2011) [TV Programme, DVD, Blu-Ray].
 - 'Beside the Dying Fire', Episode 13: Robert Kirkman, Glen Mazzara, writers; Ernest Dickerson, director.

- Season 3: Robert Kirkman, Glen Mazzara, David Alpert and Gale Anne Hurd (executive producers), *The Walking Dead: Season 3* (USA: AMC Studios, 2012) [TV Programme, DVD, Blu-Ray].
 - 'Say The Word', Episode 5: Angela Kang, writer; Greg Nicotero, director.
 - 'Made to Suffer', Episode 8: Robert Kirkham, writer; Billy Gierhart, director.
 - 'Welcome to the Tombs', Episode 16: Glenn Mazzara, writer; Ernest Dickerson, director.
- Season 4: Robert Kirkman, David Alpert, Scott M. Gimple, Greg Nicotero, Tom Luse and Gale Anne Hurd (executive producers), *The Walking Dead: Season 4* (USA: AMC Studios, 2013) [TV Programme, DVD, Blu-Ray].
 - '30 Days Without an Accident', Episode 1: Scott Gimple, writer; Greg Nicotero, director.
 - 'Internment', Episode 5: Channing Powell, writer; David Boyle, director.
 - 'This Sorrowful Life', Episode 15: Scott Gimple, writer; Greg Nicotero, director.
 - 'Too Far Gone', Episode 8: Seth Hoffman, writer; Ernest Dickerson, director.
- Season 5: Robert Kirkman, David Alpert, Greg Nicotero, Tom Luse and Gale Anne Hurd, Exec Prods., *The Walking Dead: Season 5* (USA: AMC Studios, 2014) [TV Programme, DVD, Blu-Ray].
 - 'What's Happened and What's Going On', Episode 9: Scott Gimple, writer; Greg Nicotero, director.
 - 'Them', Episode 10: Heather Benson, writer; Julius Ramsay, director.
 - 'The Distance', Episode 11: Seth Hoffman, writer; Larysa Kondracki, director.
 - 'Remember', Episode 12: Channing Powell, writer; Greg Nicotero, director.
 - 'Forget', Episode 13: Corey Reed, writer; David Boyd, director.
 - 'Spend', Episode 14: Matt Negrete, writer; Jennifer Lynch, director.
 - 'Try', Episode 15: Angela Kang, writer; Michael Satrezepis, director.
 - 'Conquer', Episode 16: Scott Gimple, writer; Greg Nicotero, director.
 - 'No Sanctuary', Episode 17: Scott Gimple, writer; Greg Nicotero, director
- Season 6: Robert Kirkman, David Alpert, Scott M. Gimple, Greg Nicotero, Tom Luse and Gale Anne Hurd (executive producers), *The Walking Dead: Season 6* (USA: AMC Studios, 2015) [TV Programme, DVD, Blu-Ray].
 - 'Now', Episode 5: Corey Reed, writer; Avi Youabiam, director.
 - 'Start to Finish', Episode 08: Matt Negrete, writer; Michael E. Satrazemis, director.

- Season 7: Robert Kirkman, David Alpert, Scott M. Gimple, Greg Nicotero, Tom Luse and Gale Anne Hurd (executive producers), *The Walking Dead: Season 7* (USA: AMC Studios, 2014) [TV Programme, DVD, Blu-Ray].

Digital Resources

Kuhn, Steven, 'Prisoner's Dilemma' (first pub., 4 September 1997; rev. 29 August 2014), in *The Stanford Encyclopedia of Philosophy*, ed. Edward N. Zalta. Spring 2017. https://plato.stanford.edu/archives/spr2017/entries/prisoner's dilemma. Accessed 26 June 2017.

Larson, Lars Bang, 'Zombies of Immaterial Labour: The Modern Monster and the Death of Death' (2010) 15 *E-Flux Journal* 1.

McNally, David, 'Zombies: Apocalypse or Rebellion?', *Jacobin*, 23 October 2012. https://www.jacobinmag.com/2013/10/zombies-apocalyse-or-rebellion. Accessed 26 June 2017.

8

Form of Life: How the Law Became an Image

Emanuele Coccia

Introduction

Everybody knows Adorno's story about Benjamin portrayed as a young romantic philosopher flirting with the idea of publishing a book consisting only of citations 'in order to build theory that doesn't need interpretation'. This tremendously successful urban legend had an enormous and pretty tragic impact on several generations of freshmen in human and social sciences. And still, the reasons for such an enduring fascination are one of the most obscure glorious mysteries of the history of humanities: there is nothing more trivial than a book consisting only of quotes. This extremely common literary genre, called, for centuries, *compilation*, is the main form of almost the totality of academic production since at least the thirteenth century – that is, since the birth of universities. More importantly, *compilation* was and is the main and most important form of expression of the two most normative sciences of the West: *theology* and *law*. The first legal monument – or, to be more precise, the only legal *book* we have from Roman Antiquity – the *Corpus Iuris*, is a compilation, a book consisting only of quotes; and the most influential theological book even in a secret way is not a theological treatise of Aquinas, but the *Liber Sententiarum* of Pietro Lombardo, the compilation which was used as a textbook in European universities for centuries.[1] Compilation is the language of law. And since I have to speak about law and theology, I have weighed up at great length the possibility of giving a talk consisting only of quotes. It would have been perfect: first, a complaint about the time, so I Corinthians 7:29: 'What I mean, brothers and sisters, is that time is short', and then directly to my purpose: how law, which was at the beginning a word or a set of words, became an iconic or a visual entity. And the quotations for this would sound more or less like this: 'In the beginning was the Word. And the Word was with God,

[1] Catherine Darbo-Peschanski (éd.), *La citation dans l'Antiquité* (Paris: Jérome Million, 2005).

and the Word was God. Through him all things were made; without him nothing was made that has been made. And in the Word was life, and life was the light of men. And then the Word was made Flesh and dwelt among us (and we beheld his glory), full of grace and truth.' And the story would be done: *ite missa est*. Law, as Plato repeatedly said, is the product of the logic of brachylogy: that's why quotation is its main device. Already in quotation, law becomes an image: something that makes a similarity between two materially different realities exist.

In order to fill up the short 'time that remains' I will try to do what law and theology do once they have quoted their source: *comment* on them. My paper will be a commentary on the first lines of the Gospel of John: I will try to show in which sense the phrase 'the Word was made Flesh' can be interpreted as a synonym of 'the Law was made image'. I would like to show something extremely paradoxical: the fact that a legal system that has notoriously always affirmed and defended the purely *verbal* and *linguistic* nature of the law and condemned any idea of iconic normativity as pure idolatry, has ended up letting the word and the law have the status and form of an image.

The Judeo-Christian Legal Tradition

It is no accident that one could speak about the process of what could be called the *iconification* of law in Western societies using words from the New Testament. We tend to forget that the Gospels and the Pauline Letters, and more generally the Jewish *Tanakh*, are not only legal documents, but some of the first law books that Western Greek-Latin civilisation ever saw and read.[2] We tend to forget that awareness of the legal nature of those documents (that we insist on considering religious documents) was a pretty trivial fact in ancient Greek literature: the famous *Letter of Aristea*, for instance, is nothing but the mise-en-scène of the translation into Greek of the Bible as the most ancient and the most perfect law book of the world.

[2] See above all the works of Raymond Westbrook (Hg), *A History of Ancient Near Eastern Law*, Handbuch der Orientalistik 71/1–2 (Leiden and Boston: Brill, 2003); see too *Law from the Tigris to the Tiber: The Writings of Raymond Westbrook* (Winona Lake, IN: Eisenbrauns 2009) (Vol. 1 *The shared tradition*; Vol. 2 *Cuneiform and biblical sources*). On the same questions, see Cohen, Boaz, *Jewish and Roman Law: A Comparative Study* (New York: The Jewish Theological Seminary of America, 1966); W. Bacher, *Die exegetische Terminologie der Jüdischen Tradition* (Leipzig: J. C. Hinrichs, 1899–1905); R. Yaron, *Gift in Contemplation of Death in Jewish und Roman Law* (Oxford: Clarendon Press, 1960); A. Watson, *Jesus and the Law* (Athens and London: University of Georgia Press, 1995); and *Collected Works of David Daube*, ed. by C. Carmichael, Vol. 3, Biblical Law and Literature (Berkeley: Robbins Collection, 2003).

The *Letter* designates the Bible always as 'the collection of books of the law of the Jews' [*tou noumou tôn ioudaikôn biblia /hoi nomoi tôn iudaikôn*].[3] With the *Septuaginta* translation, the Bible becomes, even before the Justinian code, the first example of a 'legal book' in the Greek-Latin world. The *Letter* describes this juridical code as the most divine (*theioteron*), the most philosophical (*philosophôtera*) and the purest (*akeraion*).[4] And it is also the most complete, because the legislator has not limited itself to regulating a particular aspect of human existence but has produced a law that governs human life *kata panta*, or in all its aspects (*bios kubernatai kata panta*).[5] 'Nothing of the secret actions of men on earth can escape them.'[6]

This opinion is also shared by Flavius Josephus, the famous Roman historian of Jewish origin, of Greek language of the first century who, in his *Contra Apionem*, sketches a kind of comparative treatise on law. According to Flavius Josephus, the Bible is not simply a legal code alongside the others, but the oldest legal code that humanity has conceived (*phêmi ton êmeteron nomothetên tôn opoudêpotoun mnêmoneuménôn nomothetôn proagein archaiotêti*), drafted, he writes, when the word itself (*nomos*) did not yet exist in Greek [*hopou ge mêd'auto tounoma palai egignôsketo tou nomou para tois hellesin*]. Proof of this is the fact that Homer never uses this word (*kai martys homêros udamou tês poiêseôs autô chrêsamenos*): at this time, writes Josephus, the peoples were not governed by laws or regal commandments (*prostagmasi tôn basileôn*) but through maxims (*gnômais*). The Bible, continues Josephus, is not only a collection of legal texts, it is the text that introduced and made life in law possible in the world (*nomimôs zên*):[7] if there is an origin of law and law in the world then, according to Josephus, it is not to be found in Rome or Athens, but in Jerusalem. This kind of opinion didn't correspond to a purely philosophical position: it corresponded to the specific legal situation of the Jews of Alexandria. Meleze-Modrzejewski's studies have shown that even after the end of the Jewish state, the Bible was considered a law not only in the metaphorical sense of the term: in Greco-Roman Egypt, the *nomos* of Jewish minorities (except for taxation) was still the *Tanakh* and its interpretation.[8]

[3] *Lettre d'Aristée à Philocrate*, ed. A. Pellettier (Sources Chrétiennes n. 89), Paris 1962, IV, 30, p. 118.
[4] Ibid., IV, 31, p. 120.
[5] Ibid., XI, 251, p. 212.
[6] Ibid., IX, 132, p. 168.
[7] Flavius Joseph, *Contre Apion*, ed. T. Reinach and L. Blum (Paris: Les Belles Lettres 2003), l. II, § 154, p. 84.
[8] J. Mélèze-Modrzejewski, *Le statut des hellenes dans l'Égypte Lagide*. In *Revue des études grecques*, 96 (1983) 241–68; J. Mélèze-Modrzejewski, *Note sur la législation royale des Lagides*. In *Mélanges d'Histoire Ancienne Offerts à William Seston* (Paris, 1974) 365–80; J. Mélèze-Modrzejewski, *La règle de droit dans l'Égypte ptolémaique. État des questions et perspectives de recherches*. In *Essays in Honor of C: Bradford Welles* (New Haven, 1966) 125–73.

The difficulty we have in recognising the legal nature of these documents depends primarily on their formal nature. Eckhart Otto stressed, on the one hand, that because of the very special relationship between law and religion in the legal cultures of the Ancient East, the legal collections present forms of legal legitimacy that are very different from those of the contexts of the Western Mediterranean; on the other hand, he often recalled how biblical law constitutes a sort of *Fremdkörper*, a true intruder in the Ancient Eastern legal history, unlike any form of local common law.[9] Compared with other legal traditions, the *Tanakh*, and even more intensively the New Testament, have indeed very peculiar traits: first of all, they all are *stateless law codes*: not only are they not the emanation of a state,[10] but, as is explicitly mentioned in the *Letter of Aristeas*, the *normative perfection* of those laws somehow *depends* on their 'lack of royal power' (*pronoia basilikê*).[11]

In this case, the separation between law and government or state is not only a historical fact. There is in the *Tanakh* what has been called a *Staatsferne*, a form of distance from the state, a criticism of every form of state institutionalisation of the law, and it is this same distance that is expressed in the prophets' criticism of the monarchical institution. The condition of exile sanctions something deeper, a tendency of the right to the a priori limitation of all forms of state obedience.

This non-territorial dimension of law is an essentially *legal dimension*, which for example C. Schmitt completely ruled out when, in *The Nomos of the Earth*, he stressed the earthly aspect of law. The 'iconification of law' is, in my opinion, profoundly linked to this 'non-territorial' nature. It is because of the fact that the law cannot refer (if not in a very metaphorical way) to the earth, that its first substratum has to be life. Property cannot be in this case its first expression. *The iconic nature is in this sense, the form that law has to assume in order to apply to life*: only as image can law become a form of life.

This absolutisation of the law, a law without territory, which can only live in the people who keep it in their own bodies, is important to understanding what happens in Christianity. Indeed, Christianity only exacerbates this same movement: at its centre is the political myth of an *heir to the throne*, the royal anointed (Christos, Masshiach), who came to save his own people and was killed by his people. The tragedy staged in the Gospels is that of a divinised

[9] Eckart Otto, 'Recht ohne Religion. Zur "Romanisierung" der altorientalistischen Rechtsgeschichte im "Handbuch der Orientalistik". In Eckart Otto, *Altorientalische und biblische Rechtsgeschichte* (Wiesbaden: Gesammelte Studien, Harrassowitz Verlag, 2008) 185–91.

[10] See especially Mario Liverani, *Israel's History and the History of Israel* (London and New York: Routledge, 2014).

[11] *Lettre d'Aristée à Philocrate*, ed. A. Pellettier (Sources Chrétiennes n. 89), Paris 1962, IV, 30, pp. 118–20.

king who speaks about law, kingdom, salvation: 'the King of the Jews' is put to death by his own nation, allied with the Roman power. 'The god was killed. The king of Israel [*ho basileus tês Israêl*] was murdered by the right hand of an Israeli,' cried Melito of Sardi.[12] The law is now the *staging* of the assassination of the sovereign. Christianity is a political community which transformed the death of its king in its political myth and made out of the *life* of this king (described in the Gospels) its own law.

A New Legal Poetics

Because of this distance from state and government, and because of the fact that its object is life and not land, law corresponds here to a totally different experience of justice. This conceptual difference is firstly expressed in the textual and rhetorical particularities that make it incomparable with any other form of legislation produced in the Greek or Roman world. One of the most interesting points of comparison is the relationship between morals and law. In Hellenistic law this tension was expressed in the very practised and theorised rhetorical separation between the *preambula legis*, the prologues of the law (the introductory part, with an exhorting and persuasive purpose [*peistikos nomos*]), in which the legislator enunciated the moral principles that inspired the norm, and the actual body of the norm, the 'pure law' (*akratos nomos*), which contained, so to speak, the purely legal element.[13] Starting from the long reflection on prologues, the Platonic tradition had led scholars to think of the relationship between morals and law as a rhetorical and not a natural difference. According to Lycurgus, for example, a pupil of Plato and Isocrates, the distance between legal norms and moral education, between prescription and persuasion, is above all a question of *brevitas*: 'laws in fact, in their conciseness do not teach but prescribe the conduct to be held, while poets, imitating human life and choosing the most beautiful episodes, persuade spirits to develop their reasons and illustrate them through examples'.[14] The law would therefore be nothing more than an abbreviated form of moral teaching,[15] and

[12] Melito of Sardi, *On pascha and Fragments*, ed. Stuart George Hall (Oxford: Clarendon Press, 1979) 54. The text continues as follows: 'O unprecedented crime, or new injustice [*adikia*]. The sovereign [*despotês*] has been made unrecognisable by his naked body.'

[13] G. R. Ries, *Prolog und Epilog in Gesetzen des Altertums* (Munich, 1983); H. Hunger, *Prooimion. Elemente der byzantinischen Kaiseridee in den Arengen der Urkunden* (Vienna, 1964); M.-T. Fögen, *Das Lied vom Gesetz* (Munich, 2008).

[14] Lycurgue, *Contre Léocrate*, § 102 (Lycurgue, *Contre Léocrate Fragments*, ed. F. Durrbach (Paris, 1971) 67).

[15] Platon, *Nomoi* 721 a : 'il faut toujours préferer la brévité [*ta brachutera*]'. [Platon, *Œuvres complètes*, Vol. XI. 2nd edn, Les lois Livres III–VI, ed. Éd. des Places, Paris, 1951, p. 74].

its mandatory character would be both the symptom and the consequence of this necessary rapidity of expression.

Now it is on the basis of a different way of thinking about the relationship between morality and law that Alexandrian Judaism has developed a legal poetics that denies any possible identification between norm and precept. The law is not expressed simply through the commandment, but knows other rhetorical genres, such as history, biography, the story etc. 'The oracles of which the prophet Moses was the instrument', writes Philo of Alexandria, 'are of three kinds [*ideai*]: the first concerns creation, the other is historical, the third is instead more properly normative [. . .] The historical part is the account of virtuous and evil lives [*anagraphê bion esti spoudaiôn kai ponêrôn*], with the penalties and rewards that have sanctioned the one and the other in every generation.'[16]

Developing a similar idea, Josephus had noted that 'every moral teaching can be done in two ways: through the commandments given or through the exercise of morals [*dia tês askêseôs tôn ethôn*]. The other legislators had different opinions, each choosing the manner that suited them and neglecting the other. For example, the Lacedemoni and Cretans educated citizens through the exercise of customs, not through precepts. The Athenians, on the other hand, and almost all the Greeks, prescribed by law what had to be done or avoided, but they did not bother to produce habit through action. Our legislator has endeavoured to reconcile these two ways.'[17]

The plurality of registers and the overcoming of the simple form of the commandment do not express a lack of law or a defect in its legal nature. On the contrary, they mark the perfection and superiority of Jewish law over any

[16] Philo of Alexandria, *De praemiis et poenis*, § 1–2 (Philon d'Alexandrie, *De praemiis et poenis*, ed. A. Beckaert (Paris, 1961) 42).

[17] Flavius Josèphe, *Contre Apion*, cap. XVI, §§ 170–1, pp. 86–8. The text continues as follows: 'He did not leave the practice of morals without explanation, nor did he suffer that the text of the law was without effect; starting with everyone's first education and domestic life, he left nothing, not even the slightest detail, to the initiative and imagination of the subjects. Even the food from which we must abstain or which we can eat, the people we can allow to share our lives, the application at work and inversely the rest, he himself delimited and regulated all this for them by his law, so that living under it as subject to a father and a master, we sinned in nothing either voluntarily or by ignorance. For he has not left the excuse of ignorance either; he has proclaimed the law the most beautiful and necessary teaching [*kai kalliston kai anagkaiotaton apeidexe paideuma thy nomon*]; it is not once, nor twice, nor several times that it should be heard: but he has ordered that every week, abandoning all other work, one should gather to hear the law and learn it exactly by heart. This is what all legislators seem to have neglected' (Ibid., cap XVII, § 173–5, pp. 88–90).

other normative form. Developing ideas already formulated in the Platonic *Nomoi* (719b–723e), Philo considers the linguistic and rhetorical coincidence between law and morals, between exhortation and command, as the sign of the absolute perfection of a legislator:

> Among the legislators, some immediately established a list of what to do and not to do and set the penalties for transgressors; the others, thinking they were superior, did not start from this, but having first founded and established a city through reasoning, through the creation of laws they adapted to the city the constitution they considered most suitable. Moses considered that the first attitude, which is to command without encouragement, as if one were addressing slaves and not free men, is the act of a tyrant and a despot (which it is in fact); and on the other hand he considered that the second, although appropriate to its object, had not been fully approved by all the judges. He therefore adopted a different attitude in both areas.
>
> On the one hand, in his orders and prohibitions he suggests and encourages rather than commands by trying to accompany with introductions and conclusions most of the indispensable instructions he gives to move through consensus and not violence. On the other hand, thinking that it is inferior to the dignity of laws to begin with the founding of a city made of human hands, considering the greatness and beauty of the whole code thanks to the precise gaze of his intelligence and thinking that it was too powerful and too divine to be limited within the earthly limits, he began with the Genesis of the great city, thinking that laws were the most similar image of the constitution of the universe.[18]

It is precisely this poetic richness of the law that pushes Christianity to make biography the privileged formal register of the norm.

What is a Biography?

With his classic monograph *Die griechisch-römische Biographie nach ihrer literarischen Form*, Fritz Leo set out to offer the most profound reflection on the genesis, form and history of biography in Antiquity.[19] After his investigations, the scholars – especially Arnaldo Momigliano –have corrected the false historical data and proposed a new arrangement, but they have not left the principles set by him; nor have they achieved the depth of their analysis.[20] Leo affirms that the biography owes its birth to the new 'interest in human

[18] Philo of Alexandria, *De vita Mosis*, II, § 49–53 (Philon d'Alexandrie, *De vita Mosis*, ed. R. Arnaldiz, C. Mondésert, J. Pouilloux and P. Savinel (Paris, 1967) 213–15.

[19] Friedrich Leo, *Die griechisch-römische Biographie nach ihrer litterarischen Form* (Leipzig: Teubner, 1901).

[20] Arnaldo Momigliano, *The Development of Greek Biography. Four Lectures* (Cambridge, MA: Cambridge University Press, 1971); A. Momigliano, 'L'idea di biografia nel pensiero greco'. In *Quaderni urbinati di cultura classica*, 27 (1978) 7–27; A. Momigliano, *Storia e biografia*

individuality as an object worthy of observation, of study, of representation'.[21] He was, above all, the first to notice the influence of Aristotle's moral reflections and his school on the way of conceiving individual life. According to Aristotle, '*êthos* is generated from ethos, morality [*Sittlichkeit*] from custom to moral action'.[22] 'In an Aristotelian sense', then, 'the *bios* cannot be represented through the enumeration of qualities, but one has to present man's actions, so that his character and essence can emerge from them. [. . .] The task of the writer was not only to narrate a life, but also to give an image of the personality in the narration of life'.[23]

According to Leo, it is this attention to personality rather than events that defines the novelty of the Plutarchical biographical narrative and what separates it from a simple narrative of history. And for that very reason, for the fact that 'the narration of the *praxeis* serves in the *bios* only [. . .] to the extent that it is useful for the illustration of the *êthos*',[24] that a style of chronicle is replaced with a freer narrative, in the attempt to draw out the way of life of an individual [*eidos tou biou*]. Introducing the exemplary lives of Alexander and Caesar, Plutarch warns and begs 'readers that if we do not refer to all the exploits [*me panta mede kath'hekaston*], we do not even stop too tidily at each of the most celebrated, but we cut and suppress a large part, not for this are we to be censored and reprimanded'. 'We do not write stories, but lives [*oute gar historias gràphomen alla bious*],' he adds,

> nor is it in the noisiest actions that virtue or vice are manifested, but many times a fact of a moment, a sharp saying and a childhood serve more to paint a character than battles in which thousands of men die, numerous armies and sites of cities. Therefore, just as painters take, in order to portray the similarities of the

nel pensiero antico (Rome and Bari: Laterza, 1983); A. Momigliano, 'Ancient Biography and the Study of Religion in the Roman Empire'. In *Ottavo contributo*, 239–59; Albrecht Dihle, *Studien zur griechischen Biographie* (Göttingen: Vandenhoeck u. Ruprecht, 1970); A. Dihle, *Die Entstehung der historischen Biographie* (Heidelberg, Winter, 1987); Michael Erler and Stefan Schorn, *Die griechische Biographie in hellenistischer Zeit* (Berlin: De Gruyter, 2007); Widu Wolfgang Ehlers (ed.), *La Biographie antique. Entretiens sur l'antiquité classique*, 44 (Vandoeuvres and Geneva, Fondation Hard, 1998); Italo Gallo, *La biografia greca: profilo storico e breve antologia di testi* (Salerno: Rubbettino, 2005).

21 Leo, *Die griechisch-römische Biographie*, 316.

22 Ibid., 188. The Plutarchian model is, according to Leo, the maximum expression of Aristotelian influence. See p. 190: 'The biography, whose method and nature could be reconstructed in this way from Aristotelian ethics, exists purely in the Plutarchic form of the biography. *Physis* and *paideia* are referred to in the introduction; from the time when di hexis des reported on these, so as to gradually appear his image and be rounded off in the narrative of his deeds. The conclusion is that "in Plutarch's *bioi* we have the direct descendant of the ancient peripatetic biography".'

23 Ibid., 189.

24 Ibid., 147.

face, those factions in which the nature and the character are most manifested, taking little care of everything else, in the same way we should be granted to pay more attention to the signs of the spirit, and for them to draw the life of each one [*eidopoien ton ekaston bion*], leaving to others the facts of great scope and the combats.[25]

In another masterpiece of ancient biography, even Suetonius admits the need to abandon the strictly chronological (*per tempora*) order of the story in order to concentrate on the *species*, the form and to draw with more precision the customs and the face of the individual.[26] In a certain sense the biography is born from this obsession and this urgency to understand a life not as an infinite catalogue of *erga* and *praxeis* but as a way of life, like *tropos biou or biou diagogé*.

Biography has not History as its model, but painting: its object is not time, but the form of someone's life. It is a rhetorical form in which it is necessary to compose words to produce images, to treat language as if it were a visual instrument. Any law that makes biography its own language will therefore become more similar to painting than to writing.

The Law as a Biography

There is a great deal of evidence, rhetorical, literary, cultural and especially theological, on the biographical nature of evangelical texts, which not only *are* biographies, but *must* also be biographies.[27] From a purely literary point of view, they have in fact all the rhetorical elements that characterise ancient biography. First of all, there is the proximity but also the distance from the historiographical genre.[28] Secondly, as in Plutarch or Suetonius, there is also

[25] Plutarchus, *Vitae parallelae*, II, 2, *Alexandros kai Kaisar*, ed. K. Ziegler (Stuttgart and Leipzig, 1994), 152.

[26] Svetonius, *De vita Caesarum Libri VIII*, ed. M. Ihm (Stuttgart and Leipzig, 1993), *Divus Augustus* § 9, p. 50: 'Proposita vitae eius velut suma parte singillatim neque per tempora *sed per species* exequar qua distinctius demonstrari cognoscique possit'; *Divus Iulius*, § 44, pp. 22–3: 'talia agentem atque meditantem mors praevenit. De qua prius quam dicam ea quae *ad formam* et habitum et cultum et mores nec minus quam ad civilia et bellica eius studia pertineant, non alienum erit summatim exponere'.

[27] Charles H. Talbert, *What is a Gospel? The Genre of the Canonical Gospels* (Philadelphia: Fortress Press, 1977); C. H. Talbert, *Biographies of Philosophers and Rulers as Instruments of Religious Propaganda in Mediterranean Antiquity*. In ANRW II, 16.2, 1978, 1619–51; Detlev Dormeyer, *Evangelium als literarische und theologische Gattung* (Darmstadt: Wissenschaftliche Buchgesellschaft, 1989); Richard A. Burridge, *What Are The Gospels? A Comparison with Graeco-Roman Biography* (Grand Rapids, MI: William B. Eerdmans Publishing Company, 2004).

[28] Cornelius Nepote, *Pelopidas* 16,1,16 : *vereor . . . ne non vitam eius enarrem sed historiam videar scribere*.

an effort in the Gospels to take out and reproduce a way of life without being limited to writing a chronicle of events. For the Gospels, it is valid as Wilamowitz had remarked about Plutarch: that the idea of the *bios* in the ancient world was not a *Lebenslauf*, a *curriculum vitae*, nor what happens to someone, but the way he lives.[29] In the Gospels there are the *apophtegmata*, the gnomic forms, which bring them closer to the literary genre of the *chriae*, the examples (*paradeigmata*) which bring them closer to moral or parenetic works but also commendable elements, which are characteristic of the tradition of *laudatio* (one thinks of Tacitus' *Agricola*). In them one can also find how in the genre of the *exitus illustrium virorum* particular attention is given to death, and to its phenomenology. There is also an essential relationship with anecdotes, which was for example very typical in the *bios* of philosophers and sages. But the strongest proof of the biographical nature of the Gospels is precisely of a legal nature.

In his two biographical writings, *De Josepho* and *De Abrahamo*, Philo sketches a theory of legal biography. He explains that biography is the examination of 'the archetypes of the law', that is to say, 'those among men who have an irreproachable and perfect life, whose virtues are consequently recorded [*esteliteusthai*] in the holy writings for their illustration [*epainon*] but also to stimulate readers and induce them to the same zeal'. According to Philo, the Torah, the law, is the biographical account of 'these men' who, he adds, 'are the living laws, in effect, the laws endowed with reason [*hoi gar empsuchoi kai logikoi nomoi*]'.[30] In this sense, Philo continues, 'the established laws are nothing but commentaries on the life of the ancients, the archaeology of their works and the words they have used [*hypomnêmata einai biou tôn palaion, archaiologountas erga kai logous hois echrêsanto*]'.[31] Laws are *commentaries* [*hypomnêmata*] of the life of ancient men: if every norm has to exist as life before becoming letter and mandate, the law itself has to be a biography. The law itself becomes the image of those lives and transforms those lives into icons of the law.

[29] Ulrich von Wilamowitz, *Plutarch als Biograph*, in *Reden un Vorträgen*. 2. Band (Berlin: Weidmann, 1926) 264: '*Der Bios eines Menschen ist durchaus nicht sein Lebenslauf, nicht was er erlebt, sondern wie er lebt.*'

[30] Philo of Alexandria, *De abrahamo* § 3-6 (Paris: Éditions du Cerf, 1966) 23–5. Cf. also Philo of Alexandria, *De decalogo* (Paris: Éditions du Cerf, 1965) 38, where Philo speaks of 'the wise men, who founded our people and whom the Holy Scriptures designate as unwritten laws'. It is, as is well known, a theme of Platonic origin (Pol. 292 sq.). See also *De migratione abrahamo*, § 130 (Paris: Éditions du Cerf, 1965) 176: 'the words of God are the actions of the wise' [*tous tou theou logous praxeis einai tou sophou*].

[31] Ibid.

Conclusion

It has been shown that the incipit of the Gospel of John is a commentary on the incipit of Genesis.[32] Trying to submit to a further comment on the incipit of John, I think it is possible to think of the development of the Judeo-Christian juridical tradition as a radicalisation of an iconic logic of the law.

Already as a Word, God is capable of producing images of himself: he duplicates his reality in the world he created. The law is therefore an archetypal image of the world: it is in the image of the law that the world was created. Law is at the same time what allows us to make the world a simple image of the creator and vice versa – the image of all that exists. By becoming flesh, the law (the word) radicalises this logic. In fact, it forces every subject to relate to the law as to his own image, to establish with it a relationship of similarity rather than obedience.

The institution of the world and its legal order are produced by the same matter, the Word. The coincidence between the legislator and the creator is based on the fact that in both cases it is the Word. And the book that testifies of both (creation and legislation) is the same.

[32] Daniel Boyarin, 'The Gospel of the Memra: Jewish Binitarianism and the Prologue to John'. In *The Harvard Theological Review*, Vol. 94, No. 3 (July 2001), 243–84.

Part 2

New Frontiers of Jurisprudence

9

Virtual Judges in Immigrant Detention: The Mise-en-scène of No-show Justice

Michelle Castañeda[1]

Introduction

In the political asylum hearing I attended in a courtroom inside a for-profit prison built for Central American mothers and children in Dilley, Texas, the judge was a 'no show'. He was not there. His torso was actually in Miami, present by video chat on a large screen that they had installed in the customary place of the judicial bench in the little trailer dressed up as a courtroom next to the trailers they'd dressed up as houses next to the trailers they'd dressed up as schools. Also present in the two-dimensional image of no-show justice: this shiny spot on a bald head (the government prosecutor), this left arm and profile (the language interpreter), this bushy hair and back-of-a-computer-screen-for-a-face (the law clerk), a map that is a little blurry but appears to depict Central America, a clock set to 10:45 am (it is 8:45 in Texas where we sit in court) and, in the top right corner of the screen, the image that these people in Miami could see of us. You know what that reverse gaze is like from Skype calls. That's me in the corner sitting silently, drawing a picture of the courtroom. That's Sandra, my friend, a lawyer, who has been told not to speak. That's Yesenia, my friend, a detained asylum seeker who sits next to Sandra and says to the image of the judge in the screen, 'I'm nervous.'[2] She is about to be ordered deported and, as of this writing, continues to suffer the consequences of what happened in that courtroom.

[1] The images in this chapter were created by Sam Sundius, a New York-based artist and activist in the Sanctuary movement for immigration justice, as part of a collaboration with the author. They are a response to the scenes and themes described in the chapter, and are part of a larger project to visually render the legal violence she has witnessed. samsundius@gmail.com

[2] Personal information has been changed to protect confidentiality.

I offer the phrase 'No-Show Justice' to consider the theatricality of court-room appearance under conditions of disappearance. Those interested in the ritual, aesthetics and theatricality of law have a certain dignified solemnity in mind when they consider a courtroom appearance. Increasing use of video technology for remote participants in courtrooms has prompted a re-evaluation of how such technologies alter law's symbolic processes, potentially distorting what it means to 'appear'. If having one's 'day in court' is deeply associated with the right to have rights, then the virtualisation of that process potentially bears important implications. Some scholars have specifically explored the use of remote video technology in prisons, where imprisoned defendants are broadcast into distant courtrooms through videolinks. In her study of Australian prisons, Carolyn McKay argues that this set-up turns the '*symbolic* isolation of the defendant in a courtroom dock" into a "*literal* expulsion from the courtroom, with appearance from behind prison walls' (2015: 21, original italics). Taking seriously how such a design extends the punitive function of imprisonment, she argues that rather than view videolinks 'as a *courtroom* technology' – seemingly one which allows prisoners, despite physical distance, to appear in court – she treats them as 'an emergent *prison* technology' – in other words, as a technology of punishment that casts imprisoned defendants out of the sensory environment of their own trials (McKay 2015: 2).

In this chapter I discuss a courtroom scene inside a prison where remote video technology not only distorted many of our assumptions about the symbolic meaning of a courtroom appearance, but also rendered that scene continuous with a broader phenomenon of state violence – namely, the disappearance of Central American migrants in the United States. When I speak of 'disappearance', I am referring to the 'severity revolution' in US immigration policy, which, since the mid-1990s, has criminalised many groups of racialised non-citizens (Coleman 2011). These groups are often detained – that is, incarcerated – 'in a manner that has no strict juridical status' and in which they are denied 'recourse to the formalities of any due process of law: no actual charges leveled, evidence presented, or legal "rights" stipulated' (De Genova 2016: 2). Alongside black, Muslim, Arabic and Mexican non-citizens, all of whom have been criminalised and detained through targeted policies during this period, the US Immigration Industrial Complex took specific aim at Central American migrants arriving on the US–Mexico border in the early 2000s, when, with the introduction of a 'Catch and Remove' policy initiative, the Department of Homeland Security (DHS) directed agents to prioritise 'Other Than Mexicans' and to funnel Central Americans into both existing and newly constructed, primarily for-profit, detention centres, and into

a particular legal formation of rightlessness known as 'Expedited Removal'.[3] In considering this phenomenon under the framework of 'disappearance', I invoke a term currently gathering force among migrant justice movements and scholars that centres on the perspective of migrants themselves. Those employing this term, like Loyd, Mitchelson and Burridge (2013), Hallett (2017), Bernstein (2017) and Lykes et al. (2015), observe many reminiscences between current US immigration policy and the range of tactics deployed by US-sponsored military dictatorships in the so-called Dirty Wars of the mid- to late twentieth century: unmarked vans kidnapping people in the middle of the night, people held captive in unknown locations, fear of inquiring about a relative's whereabouts lest one come to the attention of the authorities, and the official obfuscation of deaths in detention centres and on the US–Mexico border. When those affected say that a detained relative was 'disappeared', they indicate that a system of state kidnapping under conditions of extortion and invisibility echoes and extends deeper histories of colonial and neo-colonial violence. Indeed, some Central American migrants who experienced the disappearance of relatives during the era of US-sponsored military dictatorships speak of contemporary US immigration enforcement practices as a 'second war' that makes the wounds of that generation 'burn anew' (Lykes et al. 2015: 207). Taking this insight seriously means heeding lessons from those histories for what they might indicate about the workings of the interwoven judicial, military and carceral systems that administer immigration law. After all, 'disappearance' was not a condition that magically befell thousands of people in the Americas living under US-sponsored military dictatorships; rather, it was a condition planned, executed and arranged to appear as what had not been planned, executed or arranged. When relatives of the disappeared invoked that term, they meant to indicate precisely that their family members had not, in fact, disappeared, but had been taken to a particular place, by particular people, at a particular time, under particular orders, which included the particular steps required to create the impression that those people had simply vanished. In other words, the invocation of the term, in its very inaccuracy, calls out the systematic production of false consciousness; it points the finger at a particularly hideous form of state theatre which compounds the loss of

[3] As described by Lauren Martin in *Catch and remove* (2012a: 322); original citation: Department of Homeland Security, 'Remarks by Homeland Security Secretary Michael Chertoff, Border Patrol Chief David Aguilar and Acting Director of Detention and Removal Operations John Torres at an Operational Briefing on the Secure Border Initiative' (9 February 2006). Available at http://www.dhs. gov/xnews/releases/press_release_0852.shtm, accessed 20 December 2009.

life with the loss of reality. Disappearance not only involves the removal of people from their worlds, but also the attempted destruction of the factuality of those events. Disappearance denatures the event, generating a split between the phenomena and the terms used to define them, between personal and official memory, between what everyone knows and what they can safely discuss. Those who analyse regimes of disappearance in the Latin American context explain that these features tend to generate a sense of a public sphere shot through with inverted realities, open secrets and coerced participation. In this chapter, I explore how similar dynamics occur within the bureaucratic spaces of immigration enforcement, including those that seemingly safeguard the right to courtroom appearance.

Those familiar with the migration routes that run from the Northern Triangle (Guatemala, El Salvador, Honduras) through Mexico and into the United States, speak of 'the disappearances and disposability of populations as an ongoing, money-making, transnational event' (Taylor 2015). Diana Taylor's reference to a 'transnational event' must be understood vis-à-vis the co-ordinated militarisation of multiple borders, the intentional deflection of migrants into more and more deadly routes, and the US and Mexican policies that eclipse pathways for safe, authorised migration and travel (Rosas 2006; Chávez 2012). 'Money-making event' refers to the manner in which this managed violence and enforced precarisation of migrating Central Americans sustains profitable schemes operated by both licit and illicit economic actors. As Wendy Vogt has studied, the 'presence of absented people' (Coutin 2005: 196) is commodified at every stage along the Corridor of Death, as the trajectory from the Northern Triangle to the United States interior has come to be known: from transnational gangs that demand extortion payments from small business owners and recruit and sexually abuse young boys and girls, to criminal networks, transportation industries and police networks in Mexico that kidnap and extort money from Central American migrants, to agricultural and export-processing industries that recruit indebted migrants into exploitative arrangements, to US Border Patrol and paramilitary groups that interfere with life-saving attempts and conceal deaths in the borderlands, to US detention centres run for profit which charge exorbitant prices for basic necessities and impossibly high bond fees for release. Given the way, from the perspective of migrants, there is a kind of sameness among these sites of disappearance, given the way one finds oneself kidnapped and paying ransom *again*, suggests the need for a radical abolitionist rethinking of detention centres, including those that have absorbed humanitarian logics, those that seemingly safeguard a right to appear.

Some US detention centres, such as the one I visited, have absorbed such logics in their efforts to stay in business following mounting legal pressure to close. If a series of lawsuits had successfully argued that the 'prison-like' settings of earlier detention centres were inappropriate for families, the new models incorporated 'home-like' details, calling for 'welcoming architecture', 'gabled roofs' and 'toddler play areas' (Martin 2012b: 881).[4] If critics argued that previous arrangements denied migrants' rights to apply for asylum, the new prisons were narrated by the DHS as merely administrative, non-punitive processing centres with a permanent built-in judicial apparatus from which detainees could apply for asylum.[5] These reforms set the stage for scenes of No-Show Justice, with immigration courts 'co-located' in prisons and detention centres. The re-juridicalised, ambiguously humanitarian model of family detention, in particular, created a pathway for the DHS and its corporate affiliates to continue to incarcerate this population once the penal model of criminalisation and rightlessness had become politically unviable. While the construction of courtrooms inside detention centres would seem to imply a reversal of the conditions of rightlessness formerly operating inside them, it is helpful to remember that, for Central Americans, asylum law has frequently functioned as an accessory to state violence. In the 1980s, Salvadorans and Guatemalans fleeing US-sponsored genocidal and counterinsurgent violence sought asylum in the US. Prior to the 1980 Refugee Act, asylum was primarily awarded to applicants from Communist Bloc countries and the Middle East – in other words, it functioned as a kind of ideological point scored against countries cast as national enemies. To admit the cases of Central American asylum seekers, in sharp contrast to that earlier premise, would have entailed conceding the massive violence committed by military dictatorships supported by the US. It would have required admitting the targeting of indigenous lands for transnational capital projects, the propagation of sexual violence as a genocidal tactic, and the kidnapping and torture of students, activists, peasant leaders and intellectuals by regimes supported by the US. The Reagan administration therefore moved to systematically deny

[4] Lauren Martin obtained these descriptions from a 2008 ICE document outlining the parameters for new detention centres: US Immigration and Customs Enforcement, 'Family Residential Standards' (copy available from Lauren Martin). Regarding lawsuits denouncing the 'prison-like' conditions of previously operative detention centres, see American Civil Liberties Union, 'Legal Documents in the ACLU's Challenge to the Hutto Detention Center', www.aclu.org/hutto

[5] Johnson, J. C., Secretary of Homeland Security, 'Statement On Family Residential Centers', 24 June 2015, www.dhs.gov/news/2015/06/24/statement-secretary-jeh-c-johnson-family-residential-centers

these claims (at a rate of 97 and 99 per cent for Salvadorans and Guatemalans, respectively). Yet, as anthropologist Susan Coutin explains, 'the politically neutral language of the 1980 Refugee Act demanded politically neutral rationales for denials' (Coutin 2011: 576). Thus, these claims were denied not through a blanket policy directive, but rather through a series of neutral-seeming devices deployed by individual judges in individual asylum hearings, including

> challenging witnesses' credibility, requiring nonexistent or dangerous documentation (such as copies of death threats), delinking the decision to emigrate from the experience of violence, treating individual experiences as instances of generalized suffering, defining violence as criminal rather than political in nature, and defining 'indirect' threats, such as the assassination of neighbors or family members, as not rising to the level of persecution. (Coutin 2011: 576)

The serial enactment of the asylum hearing thus worked, *as if through careful parsing of the specific merits of each individual case*, to not only systematically deny thousands a pathway to authorised status, but also to suppress historical memory of US involvement in Central America. In other words, the adjudication of asylum hearings in the US formed one component of a transnational project of disappearance. These asylum decisions, while seemingly based in the individualising logic of the courtroom appearance, worked on a population-based level to cover up and distort official memory of US covert operations in Central America. If such juridical distortions in the 1980s worked in tandem with more obvious forms of disappearance, then we can likewise ask what knowledge, in our contemporary moment, asylum appearances produce and erase relative to the current phase of transnational disappearances. The legacy of the 1980s instructs us to pay attention to what is being hidden even as individual migrants recover the right to appear in court.

When I pursue this line of inquiry, I do so informed by several years working in solidarity with primarily Mexican and Central American migrants and their relatives as they navigate US bureaucracies, locate missing relatives, seek release from detention centres, apply for asylum, resist deportation, establish spaces of sanctuary, mobilise campaigns of protest, and spiritually resist what is widely interpreted as a racist attack on their survival. To attempt to bear witness to these experiences requires me to suspend what I used to assume about the meaning of a 'prison' or a 'court', and also to linger in what I would rather not – namely, the thick sensation of a kind of psychological torture which I have personally witnessed inside bureaucratic spaces of immigration law, and which those I know navigating these systems commonly describe. The courtroom scene I call 'No Show Justice' was a particularly keen example

because it nested the symbolism of a ritual of justice within layers of dissimu-
lation and denial, including through the apparition-like figure of a virtual
judge. My argument is thus not solely concerned with the mediatised court-
room, with the fact that the judge was present via a screen. But in the con-
text of a broader scenario of disappearance, the videolinked presence inside a
prison of the supposed arbiter of justice came to represent yet another bitter
layer. My argument is that an analysis of the theatrical dynamics of such a
scene can illuminate logics that are not as easily grasped at the macroscopic
levels, and in which it becomes difficult to discern whether disappearance
and appearance collude or collide.

The Theatricality of Disappearance and Appearance

The theatricality of disappearance is, perhaps, a surprising concept. The term
'theatricality' is typically associated with an excess of visuality, an exaggerated
display or showiness. The state project of disappearing its citizens, on the
other hand, is marked precisely by the fact that the events in question occur
in a political *ob-scene*, or offstage. Performance theorist Diana Taylor, in her
work theorising this question in the context of Argentina's Dirty War, writes:

> [It] is important to realize that dealing in disappearance and making the visible
> invisible are also profoundly theatrical. Only in the theatre can the audience
> believe that those who walk offstage have vanished into limbo. So the theatrical-
> ity of torture and terror, capable of inverting and fictionalizing the world, does
> not necessarily lie in its visibility, but rather in its potential to transform, to
> recreate, to make the visible invisible, the real unreal. (1997: 132).

The notion that 'things are not what they seem to be' is, of course, a hall-
mark of theatre. But the particular inversions Taylor describes are neither
associated with the topsy-turvy play of the subaltern carnivalesque nor with
the existential predicament of the theatre of the absurd. The theatre of disap-
pearance may share elements with both these forms, but its specificity lies in
the way such inversions reflect and propagate state-authored violence. Disap-
pearance, as a state project, refers not only to the disappearance of a person
from their world; it also refers to the attempted destruction of the factuality
of the event, which can mean removal of the means of getting at the truth,
the destruction of records, the hiding of bodies, censorship and the dissemina-
tion of official lies. Because loss of life is officially denied, the state project of
disappearance seems to 'fix' memories, per Michael Taussig's analysis, in the
'fear-numbing and crazy-making fastness of the individual mind' (1992: 28).
In other words, by making the events of state violence into hallucinatory non-
events, the state moves torture and murder from the seeming objectivity of a
collective reality to the seeming fantasy of an internalised reality.

If a primary mode of disappearance denatures the history of violence, a corollary mode targets the public, who, within a regime of disappearance, is expected and coerced to participate in these inverted realities. As Taylor describes, the military junta in Argentina – as in other dictatorial regimes throughout the Americas in the late twentieth century – did not simply remove people from their social worlds, but also required those connected to the disappeared, and the public at large, to behave as if those bodies had simply vanished. While individual acts of violence occurred in the shadows, the disappearing state acquired consent for that violence by publicly broadcasting its logics. Taylor writes, 'As if by magic, people disappeared into thin air. Then, just as suddenly, the bodies of disappeared people showed up all over the country – on sidewalks, in trash cans – as messages to the population' (98). The US Immigration and Customs Agency (ICE), echoing these tactics, likewise combines secretive locations of state violence with public spectacles of threat, as in the highly spectacular event of the ICE Raid. Such scenes involve 'showing ourselves to ourselves', in anthropologist Victor Turner's phrase, the means by which societies hold their values up for observation, rendering otherwise abstract processes visual and concrete (1980: 156). Yet by showing ourselves disappearance, disappearance becomes, paradoxically, tethered to spectacle. The spectacle serves as a warning to un-know and un-see what the people know and see. Within regimes of disappearance, one finds oneself attempting to deny what one knows in order not to become a target – a type of sensory retraining that Taylor calls 'percepticide' (1997). In a sense, then, while the theatre of disappearance is authored by the state, it is also a form in which the state transfers the burden to its victims, and to the populace at large, to maintain a collective false consciousness. The intention of the illusion, in this sense, is not necessarily to persuade the public that the disappeared have vanished. The regime knows that the populace knows where the people have gone. The intention of the 'as if' is to coerce the public to become performers in the show.

It is at this level that we can begin to glimpse a possible affinity between the state theatre of disappearance and the genre of courtroom appearance that is the asylum hearing. Seemingly, the two should not go together. If a state project of disappearance destroys records of the lives it destroys, then judicial appearance implies the institutional recording of life: to testify in the judicial mode is to speak the personal on the plane of the historical, to register one's narrative at the 'point of conflation between a text and a life' (Felman and Laub 1992: 2). If the current era of detention was ushered in through the invention of legal categories like 'Expedited Removal' – which construct a class of people with no right to see a judge – then to win one's right to appear in court represents not only a pathway against deportation

but potentially also a more fundamental recuperation of political person-hood. Finally, if we consider the shadowy operation of detention centres in remote locales, distanced from migrants' communities and potential legal supporters, then the presence of a courtroom would seem to introduce quite the opposite spatial premise. The Roman notion of trials as *res publicae*, public events, has been emphatically affirmed within the Anglo-American legal tradition, from Jeremy Bentham's notion of 'publicity' as the foundation of justice to US jury trial stipulations for open court (Resnik and Curtis: 293). To win the right to appear in court, especially when this right has been stripped, thus cannot but function as a proper site of struggle, as what detained migrants and their supporters 'cannot not want'.[6]

The desire for a right to trial is thus both procedural and ritual. It is a pathway out of a deportation machine, and more symbolically an opportunity for legal recognition, which, in Judith Butler's terms, reflects 'a certain desire to be beheld by and perhaps also to behold the face of authority' (1997: 112). Such desire is anticipated by the liturgical structure of the courtroom, whose roots lie in the twinned juridical-ecclesiastical authority of medieval courtrooms. If courts have since come to resemble rather more 'secular cathedrals', they are still structured as a theatre of deferred access to the face and voice of authority (Mulcahy 2008: 476).[7] Entering a courtroom, one passes through a series of thresholds: thresholds demarcate the court building from the rest of the built environment, the entry door from the courtroom, the observation area from the trial area, the trial area from the bench, the bench from the judge, the judge's adornments from his person, and his person from his 'inner chambers'. These successive frames, alongside codified forms of silence, gesture and speech, all serve to elevate the figure granting legal recognition, and to place the act of recognition on an ambiguously juridical and sacred plane.

When this theatre of deferral and recognition is reproduced in the particular genre of the asylum hearing, its liturgical structure begins to take on certain geopolitical and racial inflections. As many who have witnessed asylum hearings observe, the asylum hearing seems to stage a kind of confession, or avowal (Noll 2005). Such a structure, for instance, is implied by former immigration lawyer Jawziya Zaman, who writes: 'In virtually every case involving defense against deportation, the law insisted that I reinforce tired stereotypes about the global South and force clients to undergo a ritual flagellation before they could be granted the privilege of remaining in the country' (Zaman 2017). Asylum law requires proof that one has been persecuted, and fears further persecution, on behalf of one of several protected

[6] Here I appropriate Spivak's well-known phrase (1994: 278).
[7] See Evans (1999) theorising the Inns of Court in terms of a theatre of deferral.

grounds: 'race, religion, nationality, political opinion, or membership in a particular social group'. While some individuals in the US request asylum 'affirmatively' – that is, spontaneously presenting themselves to immigration authorities – many do so after having been placed in deportation proceedings and/or detention centres. In this situation, asylum becomes the principal avenue by which their right to remain in the country, or their right to release from detention, might be recovered. The asylum seeker thus enters the hearing already condemned vis-à-vis the law, already cast in a position of aberration relative to the system of nation-states. She enters the courtroom having been deemed 'removable' or 'inadmissible' – a fact she must ceremonially concede at the start of the hearing. Against the campaigns that have cast her as a national enemy, and the policies of disposability and disappearance emanating from that accusation, she has to rely on her trauma as the mysterious vehicle that moves the face of authority to show its other face. She must prostrate herself before the grace of the adjudicator, who concludes the ritual by reintegrating her into the system of nation-states, either by legalising her status in the US or expelling her to her country of origin (Noll 2005). In this scenario, she maintains a 'wounded attachment' to the state or to the system that rejects her; she is asked to identify with trauma (or traumatise identity) in order to win recognition and its corollary benefits.[8] As Lauren Berlant writes on the politics of subaltern trauma, 'if the pain is at the juncture of you and the stereotype that represents you, you know that you are hurt not because of your relation to history but because of *someone else's* relation to it' (original italics). Your pain becomes 'a public form because its outcome is to make you readable, for others' (2002: 122).

From the perspective of someone who has been criminalised and subjected to various forms of state violence, this premise that her trauma shall earn her redemption is riddled with irony. She might be moved to say, 'Of course I am traumatised. You know I am traumatised because why else would I be here? You have heard one thousand stories like mine. You know I am traumatised because you yourself have traumatised me. So why is it that if I reveal my trauma in *this* way at *this* time in *this* room you will suddenly embrace me?' The riddle of this question takes us to the mystery of avowal as a juridical-liturgical form. 'I avow that I am this' is a seemingly unitary statement that in fact breaks down into a series. To say 'I avow that I am this' contains 'I stand before you', and 'I am this', and 'You hate this', and 'I see myself through your eyes', and therefore 'I hate that I am this', and therefore 'I am not this anymore', and therefore 'I am yours'. Avowal stages a drama of disambiguation, of proving through your suffering that you no

[8] See Wendy Brown (1995) theorising 'wounded attachments'.

longer pertain to a maligned identity because you have stood before the Law and confessed that you do, and through this action modified your relationship both to yourself and to the Law (Foucault 2014). In such a ritual, the affective labour of suffering functions as phenomenal evidence of an inner transformation, the proof that you have passed through the series of shifts carrying you all the way from sinner to penitent, from 'I am this' to 'I am not this'. I am not a criminal. I am an asylum seeker. I am not here to invade. I am here seeking protection. I came from a terrible culture and I want to be part of yours. I will be a good citizen. I am not the Other. I am just a child. I am just a woman. I am innocent.

You apologise for the very colonial optics that have marked your body as dangerous and disposable. You avow race itself. You boil down your mobility into a Manichean story by which you were victimised by your pathological culture and seek protection from a superior one. But as a member of the culture in question, you are, in the words of Juana María Rodríguez, 'simultaneously a part of and apart from the "they" that are invoked' (2003: 97). So you, your supporters and your legal advocates must continuously rehearse tropes of purity and innocence to disambiguate you from the image of barbaric criminality with which you are always already marked, and which you have been required to rehearse in court in order to figure yourself as its victim. Those of us in the field frame these parameters almost as a matter of course, as in descriptions like the following from a refugee advocate who interviewed Central American asylum seekers in Panama: 'I heard story after story, told by men and women with tears running down their faces, about how innocent families had been targeted by gangs and forced to flee their countries' (Hetfield 2016). Our advocacy narratives tend to gravitate to such schematic binaries, pitting a unidimensional victim against an equally unidimensional aggressor, because a frank discussion of asylum seekers as complex political actors living in complex political circumstances does not set the terms for a successful avowal. As anthropologist Miriam Ticktin has argued, humanitarian assistance historically relies upon the capacity to depict an idealised and impossible form of innocence. She argues that such innocence is also 'captured' by the ones that attribute it through formal acts of recognition – for instance, the volunteers, advocates, judges and journalists who work to characterise individuals or groups as proper recipients of asylum. Innocence, she writes,

> creates a savior class or subject, and they too make claims to innocence. If the people one is saving are understood as innocent, outside time and place, and one is intervening only to stop the suffering, how can this not be considered innocent too? This refers back to the meaning of explicit not-knowing in the concept of innocence: *in-noscere*, 'not to know'. (2017: 583)

If we think about the transnational co-operation in disappearing Central American migrants, if we think about a deportation and detention regime that kidnaps people, profits from this kidnapping, separates families, and eclipses peaceful modes of mobility, then we are talking about an overwhelmingly violent system in which there is much at stake in 'not-knowing'. As the drama of avowal plays out in the liturgical set-up of the individual hearing or the spotlight of public debate, we easily forget that this drama is not driven by a spontaneous request for protection by a figure situated exterior to the US nation, but rather as an intervention by the US in processes of mobility that could easily take other forms. For many Central Americans living in the US, protracted undocumentedness and displacement across generations has spurred formations of political belonging that honour diasporic identities, embrace itinerant and transnational families, and transcend fixed notions of the nation-state. Some migrant justice movements argue for transnational suffrage, and others for a right to 'live, love, and work wherever we please' (Fernandez and Olsen 2011; Hallett and Baker-Cristales 2010). Many diasporic Central Americans' experience of political violence – as well as their experience of political belonging – trace complex cartographies across this transnational region.

Yet when they apply for asylum, they must rehearse a rigid cartographic imagination, where the criminalised mark which they carry from *there* can be expunged through the affective labour of trauma and innocence, and then redeemed through the benevolence of a transcendent authority situated *here*. The violence was *there*. Desire (for freedom, protection, inclusion) is *here*. There is no room to speak to a form of violence that is both *here* and *there*, like the transnational character of the state project of disappearance, or the *right here right now* violence of the detention centre in which one finds oneself. There is no room to speak to a situational need to be *here* mixed with a hope to return to *there*, no room for the idea that the asylum seeker could 'loathe [her country] and long for it at the same time' (Zaman 2017). These narratives emerge in the repetition and intimacy of enduring neo-colonial relations that nevertheless are framed as if the violence in question inhered in the Otherness of the colonised. As anthropologist Sherene Razack notes, asylum reproduces the 'epistemological cornerstone of imperialism: the colonized possess a series of knowable characteristics that can be studied, known, and managed accordingly by the colonizers whose own complicity remains masked'(Razack 1998: 10).

Perhaps, thinking back to the theatricality of disappearance, part of the effect of asylum appearances is precisely to mask this complicity, to construct the parameters of a scene of address in which US imperial violence is structurally prohibited from entering the record. Figured this way, we can no longer

imagine the scene as a dyadic encounter, in which the suffering of the asylum seeker is pre-given and hers, and the dramatic tension revolves around whether that suffering will be properly recognised or improperly refused. We can no longer conceive in a vacuum the drama of avowal, whether asylum seekers have proven themselves innocent of the stain of their disparaged cultures, whether humanitarian principles have been affirmed by these acts, whether the face of authority has shined upon particular subjects, and what we need to do to make the judge and the public feel more. Rather, the scene can be reconceived relative to a broader trauma produced *across* neo-colonial histories that is refigured and reimagined by that scene. In other words, I refer to the knowledge about those histories that is produced – and erased – through the serial staging of the asylum appearance. Sometimes, when you zoom out from the hearing, you find that there would have been no need for this hearing had you and your family gained the recognition entitled to you a generation ago. Sometimes, when you zoom out from the asylum hearing – as we will do later in this chapter – you find that the courtroom is nested inside a prison, that you have been disappeared into this prison and stripped of your rights, and that participation in the ritual of avowal is your only way out. To this extent, the asylum appearance becomes an eraser, erecting a scene in which not only the deeper histories of US imperialism, but also the immediate circumstances coercing the encounter cannot be spoken.

The house of law will make sure that what should not be said will not be said. Think of its scenographic arrangement, the arrangement of the court-room appearance. Think of the supplicant standing before the bench. The neutrality and semi-sacredness of the figure of the judge adopting a posture of impartial contemplation relative to violence in Central America. Think of him poised up there *as if* he were not deeply familiar and deeply complicit with the violence in question. Think of the ceremony of justice figuring the asylum seeker as supplicant, *as if* her appearance were not materially coerced. What will it mean that, in the midst of a transnational regime of disappearance, the judge is allowed to situate himself in a centred, neutral position, from this position contemplate a version of violence in Central America rendered anthropological and aloof, and for the representatives of those countries to 'concede inadmissibility' and then to plead – *as if motivated not by the urgency of release from captivity but by their own spontaneous desire* – for mercy, forgiveness and inclusion on the basis of the unliveability of their pathological cultures? And for the volunteers, lawyers and others who have cajoled the grace of the judge to be affirmed in their humanitarian commitments by virtue of such recognition. Asylum in this sense becomes a theatre of erasure, of '*in-noscere*, not to know'. With asylum, we refuse to know the transnational character of both violence and desire.

The predilection for erasure that is structural to asylum's terms is the fundamental distortion that begets other kinds. If the form can manufacture innocence of the history of US interference in Central America, innocence of the histories of criminalisation that coerce the encounter, then we are more prepared to consider the particular spatial configuration of a courtroom offering asylum and refuge from within a detention centre. This configuration stretches innocence to its absurd extreme, posing the question whether the asylum hearing can even stage innocence of its very surroundings, as if the courtroom ritual could be embedded in a space of kidnapping and yet retain its customary meaning. Asylum's predilection for distortion helps us understand how a courtroom appearance, while seemingly the antithesis of a state project of disappearance, can fold into the logic of the latter, working to make the 'visible invisible, the real unreal'.

South Texas Family Residential Center, Winter 2016

I had flown down to the South Texas Family Residential Center from New York with Sandra, an immigration lawyer, to join the team of lawyers and other advocates who had set up a permanent base near the prison. Its remote desert location neighbored another prison and an oilfield. Its arid unpunctuated surround seemed to do to space what indefinite detention does to time. There was not a contour or curve in sight. In the parking lot, Sandra and I were prohibited from taking pictures, though we were tempted to take one of the series of flags at the entry way, which unabashedly proclaimed a neo-liberal sovereign trinity: the Corrections Corporation of America flag, the Texas flag and the US flag. Before arrival we had been advised to bring bottled water because the local water was thought to be polluted from fracking. To visit prison is not to know prison. From the get-go I was inoculating myself against the toxic water that the detainees daily imbibed. The security procedures and the strict control of movement (for both detainees and visitors) made us abundantly aware we were in a prison. Yet, inside the network of trailers that make up the prison complex, there were vaguely school-like murals of rainbows on some of the walls (and further into the complex, though I was not allowed inside, different segments had apparently been given summer camp-like names: 'the brown bear neighborhood' or the 'green turtle neighborhood') (Gómez Cervantes, Menjívar and Staples: 279).

My responsibility, like many volunteers who arrive in a weekly circuit, was to spend all day in the 'visitation trailer' of the prison and work in teams of lawyers and translators to help individual women prepare for their 'Credible Fear Interviews' – a kind of precursor to potentially winning political asylum. At the time of my visit, women who passed these interviews were then eligible for release from the prison on bond or by electronic monitoring to pursue

their asylum claims outside the prison. Many of the women that we worked with succeeded and were released. Their experiences more than qualified them for the required standard of fear, and the presence of the advocacy organisation, as a constant watch over this prison, aided immeasurably in pressuring the adjudicatory apparatus to adhere to its own standards. One of the first women we met with asked me, 'Am I in prison? When we arrived they told us it was a family centre but it definitely seems like we're in prison.' I had no idea how to answer her question in the moment, charged as it was with the responsibility to define a reality that I was not myself living. To say 'yes' was to seize her reality completely, effectively imprisoning her in the moment of the utterance. To say 'no' was to collude with the prison industry's euphemisation that insulted her ability to apprehend the fact of her own captivity.

All day we spent meeting women like her, framing for them the parameters of their upcoming asylum appearance. We explained that asylum exists to protect people who fear persecution if returned to their countries, and asked them why they decided to leave. If our interlocutors tended to narrate collective realities as such – framing their own experiences in terms of escalating violence in their countries – we learned to steer their narratives away from such statements. To this end, we asked, 'Why did they chose *you* and not others?', 'What is it about *you* that made them target you specifically?' We encouraged their recollections into the mould of a narrative arc: 'What was the first moment the violence started, the worst moment, and the moment that made you decide to leave?' In asking these questions, we were also acclimatising detained women to the practice of answering questions about traumatic incidents on demand, in preparation for their eventual court appearance inside the prison. If they did not expose themselves and discuss everything they had been through, their narrative would lack authenticity and veracity in the eyes of the adjudicators.

One of the women I met in the visitation trailer, Ana, was visibly shaking when we approached her to conduct the interview preparation. We asked her what had happened and she explained that when she presented herself to the Border Patrol at the US–Mexico border, she was asked what right she had to enter the country, and she told the officers she had no visa or documents but that she had come to the US to reunite with her husband in Virginia. Upon hearing her response, they shackled her, and in sadistic mocking told her they would take her all the way to Virginia to meet him. On the van ride from the border to the 'Family Residential Center', she believed that she and her children were being kidnapped. She explained that she pleaded with the officers to tell her where they were really bound but they only laughed at her and repeated, 'We're going to see your husband.' After she had told this story and caught her breath, Sandra and I tried to reassure her that she was safe, that

she was not kidnapped and that she had legal rights, and then proceeded to give the standard orientation we had learned to give to others. We explained that she had the option to apply for political asylum, and that asylum exists to protect those whose governments cannot or will not protect them from persecution.

It was our job, in other words, to help caged people feel relaxed and secure enough to talk about traumatic events to officials in the same prison into which they had been kidnapped and in which they were held captive. We encouraged women to trust in this process, to see the courtroom appearance as their 'opportunity' to tell their story. We reassured them that the asylum officers and immigration judges adjudicating their cases were institutionally separate from the officers who monitored their every movement and underfed their children. Our labour as volunteers, in other words, involved smoothing the gaps and contradictions wrought by the marriage of necro-political and humanitarian forms. It was as if, sweeping our hands out across that miserable campus, we were to say, 'Here's a captivity trailer, another captivity trailer, a captivity trailer, and then the trailer of impartiality, confidentiality and justice.' In producing this image, I felt co-opted into the hallucinatory structure of the space, in some sense exacerbating the hallucination in order to help people, one by one, escape it. In order to navigate such a space, in order to get a foothold into the structure, I had to become complicit in a type of theatricality that involved repairing, eliding, denying and otherwise participating in a web of contradictions.

Because while I tried to tell detained women like Ana that they were safe, the truth was that they had indeed been kidnapped and were not safe. I had to lie about their current reality in order to help them get released, and in the process, my lies merged with a general quality of tortuous inversions characterising that space. The truth, in Ana's case, was that agents of the US government, far from protecting her from persecution, had embroiled her in a terrifying, sadistic form of disappearance. The Border Patrol punished Ana's desire to see her husband by disappearing her and her children – strangely, disappearing her into a space in which she was now invited to formally request protection. As we prepared Ana for her asylum hearing, I hoped that she would not mention to the judge her desire to see her husband, because I knew it would call into question her pure motivations as an asylum seeker. I also hoped she would heed our explanation that when asked during her hearing about whether she was afraid, that she only speak to the fear she had of returning to Guatemala, rather than the more immediate fear she felt imprisoned in the detention centre after having been kidnapped by the Border Patrol. Thinking of Ana, it is clear that by steering her towards the parameters of asylum, I was also participating in a

process of erasure – in this case, erasing disappearance itself from the legal record. The juridical and humanitarian scene of Ana's eventual petition for asylum would enable the conversion of a transnational form of terror into an arrangement in which she could give testimony only to forms of terror operating *there*. The fact that Ana was kidnapped at the time of her court-room appearance would not appear in the legal record. To quote Maria Saldaña-Portillo in a related context, the parameters of asylum had made the cartographic imaginary of state terror 'stop abruptly, but reassuringly, on the US–Mexico border' (2016: 6).

Back in the parking lot after a day of interviews, Sandra and I ask each other, 'Does that bus really have tinted windows?' The bus driver casually informs us he deports residents to Guatemala. All day we had spent inform-ing detained people about their legal rights, about their 'opportunity' to tell their story in court, only to be suddenly, brutally reminded of the stakes of that appearance. If they did not successfully mobilise their suffering in the manner required of them, they would be placed behind a layer of invisibility in a tinted deportation van. Here was the actual instrument of banishment. This was seeing it 'up close'. But the windows were tinted so to see it up close, to see it in person, was to continue not to see it. The tinted bus com-municates to the public that the bodies inside are undesirable, forsaken lives and that they are behind darkness because our world is better without them. The tinted bus is paradoxically turned out, in that sense, towards the public, even though it hides its prisoners. The scene publicly announces a project of removal, asking us to consent to disappearance by giving us something to see. Indeed, the tinted bus announces a correlation between perceptual and physical removal, making the former a kind of rehearsal for the latter. It thus functions as the visual correlate to the disappearance fantasy contained in terms like 'detention' and 'expedited removal' – that is, that of a frictionless erasure of people from the nation. The tinting lays the basis for that fantasy; it does the theatrical work of making prisoners seem 'as if vanished'.

The tinted bus says 'These people do not exist', because we just covered them with an opaque screen. As an openly illusionary mechanism it invites us to suspend disbelief, to concede to the power of props and to suspend aware-ness, too, that it is the scenography, the act of tinting, rather than the bodies themselves, which generate the fear from which we purportedly require pro-tection. In other words, the tinted bus calls attention to itself only to reroute that attention to the mythical alterity of its captors, or, perhaps, to that very alchemy where the imprisoning violence of the state turns into the mythic deviance of the criminal and back again. Part of disappearance's theatricality, as Taylor argues, is the way it takes advantage of a psychological substrate of infantile images of cavernous spaces and darkness to create the impression

Figure 9.1 Sam Sundius, 'Deportation bus', 2018. Graphite on paper. Artist's collection.

that there is an unstoppable, diabolical or indeed magical force separating us from the people targeted for disappearance. To this extent, the windows act like a magic line separating us from the interior – a solidarity inhibitor, making it seem as if it were not possible, if we possessed the will, to open the doors of this bus.

If the tinted windows have a mystifying effect for those outside, it will tend to have a concretising one for those inside. To be inside a tinted bus is to perceive with absolute clarity the purposefulness and immediacy of an attack. To be placed where no one can see you is a threat of what is to come. It introduces a space where sovereignty becomes capillary and intimate, in which ICE attempts to substitute the fullness of your social being with a single direct relation to what Judith Butler, in *Precarious Life*, might call its 'petty sovereigns' (2006: 65). Intended to dull perception for those outside, inside, I imagine, the bus can only sharpen it. Inside, on a trip from Texas to Guatemala, the process of deportation would involve seeing hundreds of

people who cannot see you back, or rather who look in your direction but cannot register your face. Imprisoned the whole way through, it would give the lie to the supposed geographic localisation of prison. Instead, transported in a mobile prison across apparent national boundaries, you would understand the collusion of multiple nations in manufacturing your disappearance. Although I cannot speculate on what it feels like to be inside that bus, friends I know who have been deported say that in these moments they focused on the connections that matter most. They concentrated on loved ones, on those prepared to fight for them, on those whose persistent allegiance proves that a violent attempt to separate them from others can never entirely succeed. The same tinted window that will function as an invitation to some to turn away, for others will represent the urgency of relation.

Courtroom Appearance

I only entered once into the 'courtroom' inside this prison. For the most part, volunteers are strictly limited to the visitation trailer, but on this occasion Sandra and I were escorted by guards to the courtroom, which from the outside was just another in a series of identical trailers, but from the inside was designed to look like a courtroom. The reason I was allowed in was that another one of the women Sandra and I assisted, Yesenia, had failed her preliminary hearing with an asylum officer, and was now preparing to appeal that decision to a higher official, the immigration judge. If we had spent the week assisting women's case preparations in the 'visitation trailer', preparing them to appear in court, it was at this point that Sandra and I would be allowed to see, as others in our position had not, the actual 'courtroom' in which the petition for asylum would take place.

The preparation for Yesenia's case was not going well. We asked her the standard questions about why she feared returning to Honduras, and her answers did not 'rise to the level of persecution' that qualifies individuals for asylum. Her story was not specific or traumatic enough, and no matter how many questions we asked, or who asked them, her answers remained brief and equivocal. From her fearful demeanour we sensed – and many months down the road, she explained to one member of our team – that she had in fact experienced horrific persecution in Honduras that she did not feel comfortable sharing in that prison. She had been threatened that she would be killed if she spoke about the conditions that required her to flee, and here she was in a prison being told that if she did not tell the full truth she would be deported. The mirroring of a single threat by two nations traced a regional zone of state terror: all parties demanded that she shut up and speak. Beyond the immediate insight that it was the very extent of this terrorisation that

made it impossible to mobilise her suffering in the manner expected of her, her silence also functioned to pierce the hallucinatory structure of the space. The gaps in her story pointed to the gaps in ours. They brought the fact of her captivity to the fore. In the very way in which her body, her voice and her pausing narrative spoke the ongoingness of terror, Yesenia laid bare the 'as if' quality of the labour required of her: suspend consciousness of imprisonment, perform as legal subject while imprisoned under false terms, appeal to the US government as protector from violence in your country of origin while it has set up an institution specifically to extend and financially profit from that violence.

Thinking of this moment now, I wonder what it could have meant to respect her reality, what it would have meant to collectivise the truth contained in those gaps and insist upon her right to a freedom of movement without any corresponding obligation. I imagine now what it would have meant to perceive the connection between ICE's surveillance and the surveillance of the humanitarian apparatus that insistently violated her privacy. What would need to change in order to honour her right to make decisions without her having to account for, prostrate or expose herself to anyone?

But at the moment, I was not thinking along these lines. I was simply more and more afraid for her. We wanted her to feel safe in the trailer-courtroom because we knew she would be deported if she did not divulge everything that had happened. So we emphasised that this judge was there to listen to her, that he would not reveal anything to ICE nor to those who threatened her in her country. We told her we would be right there with her, that she could take as much time as she wanted, that we were sorry she had to go through all this stress, that we were rooting for her, that everything was going to go well. In other words, we lent our good intentions to the carceral scene of judicial appearance. In doing so, we were no doubt influenced by the customary imaginary of what a courtroom appearance represents: the impartiality, publicity and fairness attributed to the 'secular cathedral'. We rehearsed normative assumptions about a kind of inbuilt legitimacy of what it means to appear in a court of law even as we knew we were headed not to a proper courtroom in the way we imagined it but rather to a trailer a few feet away.

On the day of Yesenia's hearing, she, Sandra and I were escorted separately by guards to the trailer-courtroom. If the courtroom is traditionally set apart from its surround by a series of thresholds, this courtroom was cited/sited in a grid of trailers, placing the traditional form in mocking, mobile quotation marks. The thin plastic walls of the trailer, symbols of impermanence, transience, seriality and poverty, ushered us in to the courtroom as if announcing

the cheaply illusory way we were about to rehearse the ritual of justice. They said, 'Get ready to feign'.

Inside the courtroom trailer, as we watched other detained women's cases and waited for Yesenia to be brought in, we had time to take stock of the surround. We were surprised to find some customs indeed preserved. In spite of its remoteness, the scene of justice in its most ob-*scene* iteration still attended to the scenographic. It still put the threshold in the place you would expect it. There were rows of pews and a gate separating us from the giant screen connecting us to the judge, court clerk, government prosecutor and language interpreter, all stationed somewhere in Miami. The giant screen stood in the architectural place of the judicial bench. Both screen and bench represent a point in the room that is simultaneously beyond it. Both have that property of beckoning and forbidding your approach. In both cases you sense that by comparison you have been reduced to singularity, to a mere here and now. Yet in this case that little room somewhere in Miami had the sense of transcendence only because it represented the freedom of movement denied to the detained families. The buzzing, wired surface transmitting faces from distant places teased them with

Figure 9.2 Sam Sundius, 'Immigration court trailer', 2018. Graphite on paper. Artist's collection.

a tether to the world outside prison. It seemed remote not because it housed the 'mystical foundation' of law but because it was a place people could freely leave. The placement of geographic space in the structural position of a metaphysical beyond seemed to place life outside prison in the position of a desired but ultimately inaccessible remove.

Like a 'real court', the trailer-courtroom had rows of pews and a gate separating spectators seated in the pews from the participants in the proceedings. But – 'haha' – these rows of pews existed to welcome an imaginary audience: the hypothetical public that would attend this trial and, by attending, oversee the activities of justice in the grand tradition of open court, was, of course, absolutely prohibited from entering the premises, because we were inside a prison. So the pews became no-one-is-coming displays, reminders that no one's eyes bear witness. There we were, seated respectfully, looking up at the image of these body regions, these torsos called Miami, looking up at the image of ourselves framed in the upper-right corner of the screen, viewing the image of what would be the judge's 'view from the bench' and adopting the posture of respectful subjects relative to that projected view. But – 'haha' – there was no actual principle of elevation here. The image from 'on high' was an effect of the technology, the judge was actually gazing at a computer screen that might very well have been placed at his eye-level. Nevertheless, we watched ourselves framed in that screen performing submission to a concocted elevation. The scene invited us to lock eyes with Law, stimulating that 'desire to be beheld by and perhaps also to behold the face of authority' (Butler 1997: 112). Yet – 'haha' – we were beheld by a face we could unplug. If we did so, the thin film of static would go flat, 3D would turn 2D, colour would turn grey, and the room would have become that much more of the prison that it was. The very flimsiness of the connection to justice was on display. And the display held a mirror back up to our participation as if in mocking. It held a mirror to our belief; in one corner of the screen, we watched our own fearful, respectful faces reflected back at us. We watched ourselves injecting belief into a process no one believed, yet in which Yesenia had no choice but to participate.

In such a scenario of coerced participation, to identify the 'fake' is not necessarily to materially resist these parameters. It would be quite easy to turn the 'haha' back around and reply, 'No, what you have shown us here is neither a family centre nor a courtroom.' But it is far more difficult to determine how to reassert one's truth without that act inciting further violence. If I were to stand up and say, 'This is not a court', the consequences would be felt by the organisation with which I volunteered, and ultimately by the detainees themselves. If detained people refused to 'appear' before a screen, if they protested

the conditions by which they had been invited to exercise legal rights, then they would be vulnerable to arbitrary acts of retribution.

Sandra leans over to me and whispers, 'Your honour, may I approach the fax machine?' The rough juncture between disappearance and appearance has put us in that ironic mood. The 'gabled roofs' above the prison trailers, the pathetic swing set in the middle of the prison desert, the mock-summer camp tone of the 'Green Turtle neighborhood', and the 'haha'-like inversions of that courtroom – they all seemed to form part of a continuous ironic aesthetic. We could say, given the history of family detention's evolution, that this aesthetic is euphemistic. But if it is a euphemism it is cheaply so, as if the prison were overtly advertising the very unimportance of carrying the euphemism all the way through. If the ritual of courtroom appearance seems minimally feigned, it wasn't to persuade detainees and their advocates that this prison had truly been converted into a benign humanitarian centre for processing asylum claims. The very flimsiness of their attempts – the way they left the euphemism conspicuously half-finished – constituted a type of artifice whose intent was less to convince than to terrorise. Recalling Taylor's analysis of state regimes of disappearance, she describes the apparent contradiction between the fact that such states go to great lengths to conceal their operations and occasionally air traces of those operations publicly. Such moments of spectacle take on a taunting character; they accrue power to the state by demonstrating its capacity to coerce the public, under threat of further violence, to un-see and un-know what they see and know. If the 'show' of disappearance, then, tends to devolve from state actors to its victims, then the trailer-courtroom in the South Texas Family Residential Center likewise seemed to transfer the burden onto the detainees themselves to perform 'court behaviour' across an abyss of absurdity. Judges and other courtroom officials are customarily responsible for manifesting an atmosphere of solemnity and semi-sacredness, propping up the eventfulness of the ritual of courtroom appearance. In the trailer-courtroom, the court officials and their technological supports had done almost nothing to produce such an atmosphere. The trailer was not holding up the event. The screen was not holding up the event. The detainees and their advocates, on the other hand, were doing a great deal to sustain the eventfulness of the event, seated respectfully, preparing tirelessly, and injecting their own belief and hope into the possibility of judicial recognition.

As I observed our reflection in the judge's screen, I noticed how narrow a slice of our reality appeared within his frame. From the perspective of the judge, our half of the courtroom looked like any other court. His monitor showed him rows of respectful subjects in a room that could be anywhere.

The view from his monitor bore no indication that this was a trailer or that this was a prison. To that extent, the basic fact of the detainees' captivity had been rendered visually non-salient for this judge. If he could have seen the entire scene – what is the entire scene? – how large would the frame have to have been extended to capture the fact that the women presented to him as courtroom defendants actually appeared from within a state of captivity? There is no reason to assume that how a room looks to someone who can freely leave it corresponds to how it looks to someone trapped in that room. The screen allowed him to adjudicate asylum cases without his having to pack his bottled water, cross the desert, hear the echoes of those missing there, do a double-take at the tinted bus, surrender his things to the security guards, pass the 'Green Turtle neighborhood', and then open the trailer door leading to the 'court' where he seemingly 'presides'. In other words, if asylum appearances tend to manufacture innocence of US imperialism, this particular form facilitated such forgetting by allowing the judge to administer asylum while entirely ignorant of the spatial parameters of his own courtroom.

When Yesenia arrives in the courtroom, my contemplation dissolves. Yesenia is immersed and very afraid. The judge begins by asking her questions about the transcript of her earlier hearing. He says he does not see anything in her testimony to support a well-founded fear of persecution. He asks if she has anything to add and she says 'No', but her 'no' comes out like a scream behind barbed wire. I glance at the security guard who has this whole time been positioned in the right side of the room. I have just noticed him because of the twitch in his face, and he looks down in what I perceive to be shame. He speaks English and Spanish. I imagine that, like me, he feels himself to be straddling the vertigo of the event. Sandra is still not allowed to speak, and I can see the taut muscles of her face muffling her speech. Our half of the courtroom is in a state of suspended panic.

The judge asks another question and Yesenia responds, 'I am nervous.' To claim nervousness in response to another question is to disrupt the expectation of her response, to disrupt the regulated turn-taking of courtroom speech, and to assert that she cannot answer the questions posed to her without addressing the conditions within which they are asked – namely, the fact that this scene, described to her as a courtroom appearance, in fact excludes, ridicules and disappears her. The judge immediately proceeds to confirm those conditions, joking, 'Well I have a dentist appointment today so no one is more nervous than I am.' 'Indeed,' his comment seems to suggest, 'You should be nervous. While this society has collectivised responsibility for the care of my body, it has collectivised responsibility for the disposal of yours. The fear I have about others helping me live is more profound than your fear of others letting you die.'

The scream is not penetrating the screen. I am two feet away from her but I feel like she is actively being dropped out of the room. I feel like her removal from the shared world is not making a hole in the world because she has already been perceptually cut out of its fabric. Or we are, in that moment, enacting that cut.

And then this particular judge momentarily loses his internet connection. He peers closer into the camera (I'm assuming this because his face gets larger on the screen) and he says, 'We're beginning to lose our picture here . . . it looks like every colour of the rainbow . . . oh never mind, it's coming back now . . . I've lost my train of thought.' His 'train of thought', the tether to law's semi-sacred source, snaps when the visual field blurs; the law releases its hold on the body. Sudden awareness of the fragility of the medium, a flickering that is a faulty cable rather than a fluttering robe. The judicial pores fill up with blackheads instead of time immemorial, pus instead of communion. His face gets larger and he says we have been reduced to pixels and it has scrambled his mind.

The judge says he is sending the case to ICE to 'do what they will do' (presumably because he doesn't want to put his mouth around the word 'deport'). Yesenia is crying. Sandra and I are still not allowed to speak. I am picturing Yesenia on that tinted bus driving down to Honduras with her three kids. The judge cites 'Matter of Sanchez and Escobar' in explaining his decision, a 1980s asylum case holding that 'widespread conditions of indiscriminate violence' are insufficient grounds for asylum.[9] Sanchez and Escobar was written in the generation of US-sponsored counter-insurgency operations, when immigration judges were directed to find neutral rationales for denying Central American cases, including by characterising that violence as random and untargeted. How convenient this judicial precedent is that you can reuse the neutral devices of previous eras of disappearance without having to cite the conditions of their emergence. How layered the memory of undeclared wars.

Conclusion

We have ended without resolving many things, including Yesenia's story. I would rather not continue it because the point of this article was not to make her appear in narrative form. The point was to show how appearance mingles with disappearance, the coerced and contradictory conditions in which migrants are asked to 'tell their story'. I tried to turn the camera in the other direction, towards the state, which is currently at work constructing little

[9] Matter of Sanchez and Escobar, 20 I&N Dec. 2996 (BIA 1985).

theatres that intend to make people seem 'as if vanished'. To turn the camera to the state is inevitably to risk lending it more power. When we look upon a tinted bus, we are in danger of making the current operations of disappearance seem magical and permanent. It is only a thin film. It is only theatre. It can change.

We might wish it would be enough to mobilise resistance on the principle that no one should be surveilled, criminalised or incarcerated as punishment for locomotion, but instead the migrant is increasingly made to perform her suffering for others in order for those others to decide whether she deserves redemption from forms of punishment imposed and not recognised as forms of punishment. Her basic safety and her right to have rights are subordinate to others' feelings and her capacity to elicit them. The compassion we feel for Yesenia, or Ana, or any individual subject is therefore not enough. It feels more urgent to accompany them into the rooms where scenes of compassion serve to legitimise state terror, and then to place our imaginations in service of the alternative. Imagine, with Luis Fernandez and Joel Olsen (2011), living, loving and working wherever you please. Imagine not having to tell your story. Imagine no prisons.

Bibliography

Berlant, L. (2002): 'The Subject of True Feeling', *Left Legalism/Left Critique*, Durham, NC: Duke University Press.

Bernstein, N. (2017): '1. Waging accountability: why investigative journalism is both necessary and insufficient to transforming immigration detention', *Challenging Immigration Detention: Academics, Activists and Policy-makers*, 11.

Brown, W. (1995): *States of Injury: Power and Freedom in Late Modernity*, Princeton: Princeton University Press.

Butler, J. (1997): *The Psychic Life of Power: Theories in Subjection*, Stanford: Stanford University Press.

Butler, J. (2006): *Precarious Life: The Powers of Mourning and Violence*, London: Verso.

Chávez, K. R. (2012): 'The Need to Shift from a Rhetoric of Security to a Rhetoric of Militarization', *Border Rhetorics: Citizenship and Identity on the US–Mexico Frontier*, 48–62.

Coleman, M. and Kocher, A. (2011): 'Detention, deportation, devolution and immigrant incapacitation in the US, post 9/11', *The Geographical Journal*, 177(3), 228–37.

Coutin, S. B. (2005): 'Being en route', *American Anthropologist*, 107(2), 195–206.

Coutin, S. B. (2011): 'Falling outside: Excavating the history of Central American asylum seekers', *Law & Social Inquiry*, 36(3), 569–96.

De Genova, N. (2016): 'Detention, deportation, and waiting: Toward a theory of migrant detainability', *Global Detention*.

Evans, D. (1999): 'Theatre of Deferral: The Image of the Law and the Architecture of the Inns of Court', *Law and Critique*, 10(1), 1–25.

Felman, S. and Laub, D. (1992): 'Introduction', *Testimony: Crises of Witnessing in Literature, Psychoanalysis, and History*, Abingdon: Routledge.

Fernandez, L. and Olson, J. (2011): 'To live, love and work anywhere you please', *Contemporary Political Theory*, 10(3), 412–19.

Foucault, M. (2014): *Wrong-doing, Truth-telling: The Function of Avowal in Justice*, Chicago: University of Chicago Press.

Gómez Cervantes, A., Menjívar, C. and Staples, W. G. (2017): '"Humane" Immigration Enforcement and Latina Immigrants in the Detention Complex', *Feminist Criminology*, 12(3), 269–92.

Hallett, M. C. and Baker-Cristales, B. (2010): 'Diasporic Suffrage: Rights Claims and State Agency in the Salvadoran Trans-Nation', *Urban Anthropology and Studies of Cultural Systems and World Economic Development*, 175–211.

Hallett, M. C. (2017): 'The New Disappeared: Illegality, the Deportation Regime, and the Resurrection of State Violence', *The Social Practice of Human Rights: Charting the Frontiers of Research and Advocacy*, 1.

Hetfield, M. (18 August 2016): 'The US Is Failing Central American Refugees', *Time Magazine*. Retrieved from http://time.com/4457748/central-american-refugees/

Loyd, J. M., Mitchelson, M. and Burridge, A. (eds) (2013): *Beyond Walls and Cages: Prisons, Borders, and Global Crisis* (Vol. 14), Athens: University of Georgia Press.

Lykes, M. B., Sibley, E., Brabeck, K. M., Hunter, C. and Johansen-Méndez, Y. (2015): 'Participatory Action Research with Transnational and Mixed-Status Families', *The New Deportations Delirium: Interdisciplinary Responses*.

Martin, L. L. (2012): '"Catch and remove": Detention, deterrence, and discipline in US noncitizen family detention practice', *Geopolitics*, 17(2), 312–34.

Martin, L. L. (2012): 'Governing through the family: Struggles over US noncitizen family detention policy', *Environment and Planning A*, 44(4), 866–88.

Mulcahy, L. (2008): 'The Unbearable Lightness of Being? Shifts Towards the Virtual Trial', *Journal of Law & Society*, 35(4), 464–89.

McKay, C. (2015): 'Video Links from Prison: Court "Appearance" within Carceral Space', *Law, Culture and the Humanities*.

Noll, G. (2005): 'Salvation by the grace of state? Explaining credibility assessment in the asylum procedure', *Proof, Evidentiary Assessment and Credibility in Asylum Procedures*, Leiden: Martinus Nijhoff Publishers, 197–214.

Razack, S. (1998): *Looking White People in the Eye: Gender, Race, and Culture in Courtrooms and Classrooms*, Toronto: University of Toronto Press.

Resnik, J. and Curtis, D. E. (2011): *Representing Justice: Invention, Controversy, and Rights in City-states and Democratic Courtrooms*, Yale University Press.

Rodríguez, J. M. (2003): *Queer Latinidad: Identity Practices, Discursive Spaces*, New York: NYU Press.

Rosas, G. (2006): 'The managed violences of the borderlands: Treacherous geographies, policeability, and the politics of race', *Latino Studies*, 4(4), 401–18.

Saldaña-Portillo, M. J. (2016): *Indian Given: Racial Geographies across Mexico and the United States*, Durham, NC: Duke University Press.

Spivak, G. (1994): 'Bonding in difference', *An Other Tongue: Nation and Ethnicity in the Linguistic Borderlands*, Durham, NC: Duke University Press, 273–85.

Taussig, M. (1992): *The Nervous System*, Abingdon: Routledge.

Taylor, D. (1997): *Disappearing Acts: Spectacles of Gender and Nationalism in Argentina's 'Dirty War'*, Durham, NC: Duke University Press.

Taylor, D. (13 March 2013): Frontera Sur/Souther Border. *Crossing Mexico Conference.* Retrieved from: https://vimeo.com/channels/migrationhemi/123127551

Ticktin, M. (2017): 'A world without innocence', *American Ethnologist*, 44(4), 577–90.

Turner, V. (1980): 'Social dramas and stories about them', *Critical Inquiry*, 7(1), 141–68.

Vogt, W. A. (2013): 'Crossing Mexico: Structural violence and the commodification of undocumented Central American migrants', *American Ethnologist*, 40(4), 764–80.

Zaman, J. F. (12 July 2017): 'Why I Left Immigration Law', *Dissent Magazine*. Retrieved from https://www.dissentmagazine.org/online_articles/left-immigration-law

10

Comity, Facebook and the (Legal) Personality of Animals

Christopher Hutton[1]

Introduction

This chapter contextualises the motif of the comity of animals, that is, an imagined state of harmony existing between human beings and animals, and among different animal species, within jurisprudential discussion of animal legal personality. This 'new legal frontier', animal personhood, enacts in novel form law's perpetual entanglement with conflicts among parties (lions and lambs) whose interests are fundamentally incompatible. The evocation of animal comity is not in itself innovative or surprising, but the contemporary proliferation of images and tropes through social media is unprecedented. Images of animal comity represent a substantial portion of the huge number of animal-related postings served up daily on Facebook and other social media as 'click-bait' to a global audience. Animals are held up for admiration in virtue of possessing desirable human qualities, such as friendship, altruism, compassion, intelligence, humour, loyalty, grief, empathy, joy, love: 'It's almost like the internet was built for anthropomorphizing animals' (anthropologist Holly Dunsworth, cited in Milman 2016). However, Riederer (2016) points to academics who reject the label of anthropomorphism, such as the primatologist Frans de Waal. De Waal sees human beings as being in 'anthropodenial' in relation to the similarities between human beings and other animals (de Waal 2016). The naturalist Sy Montgomery concluded after many years of studying octopuses: 'If I have a soul – and I think I do – an octopus has a soul too' (Montgomery 2016: 226). These two authors form part of an intellectual turn against notions of a radical species divide (see Safina 2015).

[1] The author would like to thank the organisers of West of Everything: New Media, Visual Culture and Law, Cardozo School of Law, 28–9 August 2016. This work forms part of a project funded through a Hong Kong RGC Humanities and Social Sciences Prestigious Fellowship Scheme award: 'Defining Fundamental Concepts: The Legal Personhood of Animals' (2014–15).

Animal rights advocacy is intrinsic to this turn, with the assertion that animals can be 'subjects-of-a-life' (Regan 2003: 80ff).

In animal personhood advocacy, animals are portrayed as having legitimate interests that are not reducible to human concerns, and law is presented, paradoxically, as a potential tool for giving expression to the nonhuman point of view. The motif of 'giving voice' is common to a wide range of writing, art and activism on behalf of nonhuman animals. In popular culture, one can point to films such as Nick Park's claymation film *Creature Comforts*,[2] in which zoo animals give their considered views on life in captivity (Malamud 2017). In *What Would Animals Say If We Asked the Right Questions?*, Despret evokes Jakob von Uexküll's notion of *Umwelt* to explain that 'animals, endowed with sensory organs different from our own, do not perceive the same world' (Despret 2016: 161). Bruno Latour, in the foreword to Despret's book, argues that 'to understand what animals have to say, all the resources of science and of the humanities have to be put to work' (Latour 2016: vii).

Giving Voice to Animals

The motif of 'giving voice to the voiceless' is widespread, displaying a strong analogy with discourses about marginal human groups and identities. A guide to talking about animals in the media, 'a style guide for giving voice to the voiceless', offers 'concrete guidance for how to cover and represent nonhuman animals in a fair, honest, and respectful manner in accordance with professional ethical principles'.[3] Yet some reject the implications: 'You've seen the phrase on T-shirts, tattoos, memes, and in social media bios. Those making this proclamation are typically vegans who care deeply about animals. But where do we draw the line between effective advocacy and human savior complex?' (see Houdeschell 2017).

In the controversy concerning Cecil the lion, shot by a US dentist during a hunting expedition on 1 July 2015, the claim to representativity was central: 'Cecil the Lion – how social media is giving a voice to the voiceless' (Croon 2015). Cecil (2002–13) was a resident of Hwange National Park in Matabeleland North, Zimbabwe. He was being monitored by Oxford's Wildlife Conservation Research Unit (WildCRU). News of his death 'spread across the globe like wildfire', according to the blurb of *Cecil's Pride: The True Story of a Lion King* (Hatkoff 2016), 'raising questions to an unprecedented level about our relationship to animals and the planet'. According to the site Know Your Meme, on 28 April 'the hashtag #CecilTheLion rose to the top of the trending topics list on Twitter in the United States; according to

[2] Aardman Animations, Channel 4 Films, UK, 1989.
[3] www.animalsandmedia.org/main

Topsy Analytics, #CecilTheLion was mentioned over 127,000 times within the first 24 hours'.[4] WildCRU commissioned Meltwater ('We spot the trends before they're trending')[5] to track the spread of the story. A torrent of hate was directed at the hunter, 'the most hated dentist in America' (Kass 2015). One estimate gave the peak response on 29 July as consisting of around 12,000 mainstream media articles mentioning Cecil, with social media activity likewise peaking at nearly 90,000 posts (see Goldman 2016, MacDonald et al. 2016). A Facebook page was also created on behalf of Cecil.[6] The interplay between *The Lion King* (1994) and Cecil, a 'true' lion king, culminated in a Disney animator, Aaron Blaise, who had worked on *The Lion King* and other Disney animations, creating 'images of Cecil in the heavens watched by his Earthbound descendants' (Child 2015).

The social media response itself was, one might argue, a form of 'cartoon thinking', where a complex set of issues was reduced to a good versus evil narrative drawn in bright colours. By some estimates, trophy hunters kill 70,000 animals a year (Schweig 2015). One figure given by animal rights activists for the number of farm animals killed annually is 58 billion, a figure which excludes fish and other sea creatures.[7] On the day that Cecil met his untimely end, Boko Haram militants killed ninety-seven people in the village of Kukawa, in Borno State, Nigeria, and murdered forty-eight further victims the following day.[8] One widely shared satirical post pointed out that Cecil the Lion was himself 'no choirboy' and went on to mock the anthropomorphism of the story:

> Photos have surfaced of Cecil in the act of killing and eating Gary the Gazelle. Gary was a favorite of both locals and visitors at Zimbabwe's Hwange National Park, where he delighted onlookers with his trademark leap, while clicking his heels. Gary was 12 years old and leaves his beloved wife, Greta Gazelle, and their 8 (unnamed) offspring.[9]

A strikingly popular feature of Facebook postings featuring animals is the trope of unlikely animal friendships: 'Maybe the only thing more popular online than a video of a kitten is a video of a kitten with a buddy. Or instead of just a monkey, a monkey riding a pig' (Webley 2011). A 2015 advertising campaign for Google Android was promoted under the title

[4] knowyourmeme.com/memes/events/cecil-the-lion-s-death
[5] www.meltwater.com
[6] www.facebook.com/CeciltheLion.org
[7] www.animalequality.net/food, accessed 28 February 2018. On the number of fish killed annually for food, see fishcount.org.uk
[8] 'Nigeria Boko Haram crisis: Militants "kill 150"', BBC online, 2 July 2015, available at: www.bbc.com/news/world-africa-33369713
[9] Facebook post by Lynn Sadler (www.facebook.com/lynn.sadler.98), 2 August 2015.

of Friends Furever. It celebrated 'unlikely animal friendships' and 'adorable pairings', featuring 'a dog and a dolphin swimming, an elephant and sheep digging dirt and a bear and a tiger nuzzling'.[10] Such friendships may occur between humans and animals (for example, where a human is shown playing around with a lion or other predator) or between two or more animals not normally regarded as compatible. Human–animal friendships are featured widely on YouTube, for example '17 Amazing Human Animal Friendships'[11] and 'Top 10 Human and Animal Friendships That will Melt your Heart – Bond between animal and Humans'.[12] Encounters between humans and animals tap 'into one of our culture's most enduring collective fantasies: the power of communion with other animals' (Gold 2017).[13] YouTube offers for viewing 'Unbelievable Unlikely Animal Friendships Compilation 2017'.[14] On Instagram there is a page entitled 'interspecies friendships' with thousands of pictures. The site Mental Floss likewise lists '20 of the Animal Kingdom's Most Surprising Friendships'.[15] BuzzFeed has a story entitled 'The 21 Most Touching Interspecies Friendships You Never Thought Possible'.[16] In other media, the National Geographic channel has a series entitled 'Unlikely Animal Friends'.[17] A writer for the series published *Unlikely Friendships: 47 Remarkable Stories from the Animal Kingdom* (Holland 2011). The book has as an epigraph a quotation from Ecclesiastes 4:11: 'If two lie together, then they have warmth; how can one be warm alone?'.

One common motif in social media commentary is that human beings can learn peaceful co-existence from these friendships, or that they at least provide grounds for optimism: 'if these guys can all get along, perhaps there's still hope for us humans'.[18] On a site where Instagram friendship pictures are ranked by viewers, we read: 'Unlike humans in US politics, odd animal couples somehow manage to find common ground. Perhaps the rest of us

[10] dogwithblog.in/unlikely-animal-friendships

[11] www.youtube.com/watch?v=tORyXbx3tUs, accessed 28 February 2018.

[12] www.youtube.com/watch?v=-zNqRIcFFzM, accessed 28 February 2018.

[13] Of course, Facebook and other social media are also a forum for organised animal rights activism, for example, People for the Ethical Treatment of Animals (PETA), Animal Rights Activist, Animals Rights Watch, etc.

[14] www.youtube.com/watch?v=_NPOD92a78I, accessed 28 February 2018.

[15] mentalfloss.com/article/59967/13-unlikely-adorable-animal-friendships, accessed 28 February 2018.

[16] www.buzzfeed.com, accessed February 28, 2018.

[17] channel.nationalgeographic.com/wild/unlikely-animal-friends/

[18] community.lovenature.com/news/18-life-affirming-gifs-of-adorable-and-unlikely-animal-friendships, accessed 28 February 2018.

should take a page from their book.'[19] In social media, frequent reference is made to the line attributed to Isaiah 11:6: 'and the lion will lie down with the lamb'. In fact, the text reads as follows (Isaiah 11:6–8):

> The wolf also shall dwell with the lamb, and the leopard shall lie down with the kid; and the calf and the young lion and the fatling together; and a little child shall lead them. And the cow and the bear shall feed; their young ones shall lie down together: and the lion shall eat straw like the ox. And the sucking child shall play on the hole of the asp, and the weaned child shall put his hand on the cockatrice's den.

An editor for Our Daily Bread Ministries, noting that her Facebook friends 'often post endearing videos of unlikely animal friendships, such as a recent video I watched of an inseparable pup and pig, another of a deer and cat, and yet another of an orangutan mothering several tiger cubs', relates this to the Garden of Eden, where God gave Adam and Eve plants for food, and 'I imagine even the animals lived peacefully together'. After the Fall, 'in both human relationships and the creation, we see constant struggle and conflict', yet the prophet Isaiah offers the reassurance that an era of peace will come in a 'renewed earth'.[20]

Animal Comity in the Western Tradition

In the history of Western iconography we find peaceful gatherings of disparate animals depicted in relation to Orpheus, who can charm wild animals with his music,[21] as well as Dionysus, under whose influence wild animals play and walk together.[22] In Christian iconography, frequent motifs include Adam naming the beasts in Genesis,[23] the entry of the animals onto Noah's Ark and the text of Isaiah.[24] English nonconformist writings of the late sixteenth and seventeenth centuries make constant reference to the motif of the lion lying down with the lamb, and other variants of the text of Isaiah.[25] The

[19] www.ranker.com/list/instagram-animal-friendships/mariel-loveland

[20] Alyson Kieda, odb.org/2018/02/09/unlikely-friends

[21] Josias Murer (1564–1630), *Orpheus Charming the Animals*, c. 1600, see www.gettyart.edu; Frans Snyders (1579–1657), *Orpheus and the Animals*, 1636, see commons.wikimedia.org

[22] Sarcophagus with triumph of Dionysos, AD 215–225, see www.mfa.org

[23] *Adam Naming the Animals*, etching by G. Scotin and J. Cole after H. Gravelot and J. B. Chatelain, 1743, see catalogue.wellcomelibrary.org; William Blake (1757–1827), *Adam Naming the Beasts*, 1810, see artuk.org

[24] Jan Brueghel the Elder (1568–1625), *The Entry of the Animals into Noah's Ark*, 1613, see commons.wikimedia.org

[25] See, for example, Bassett (1683: 16).

early advocate of vegetarianism, Thomas Tryon (1634–1703), who envisaged a universal religion incorporating Neoplatonic mysticism, Hinduism and Christianity, saw meat-eating as reflecting the violent or bestial in human beings (1691: 105):

> A time shall come when the Lyon shall eat Hay with the Ox, and the Wolf lye down with the Lamb, that is, the fierce savage beastial Nature in Man, shall be thorough shined and bowed before the Divine Principle, or Lamb-like Spirit; and whosoever comes to know that time, will be contented with innocent Herbs, Bread, and the like harmless Foods.

It was the 'Wolfish Dog Nature' which predominated, creating longing after 'the Flesh and Blood of Beasts'; but if a peaceable principle was dominant, then a person would 'desire Food suitable thereunto' (Tryon 1691: 105). Similarly, the tension between the brute reality of animal existence and the ideal of comity between creatures is powerfully present in the interweaving of text and imagery in Blake's *Songs of Innocence* (1789), notably in the poem 'Night'.[26] In the nineteenth century, in continuation of the nonconformist tradition, multiple representations of the prophecy of Isaiah are found in the primitivist paintings of the American Quaker Edward Hicks (1780–1849), for example *The Peaceable Kingdom* (1826) and *A Peaceable Kingdom with Quakers Bearing Banners* (1829–30).[27]

Evolutionary Psychology and its Critics

Common to both the pagan and the Christian visions of comity among animals or between animals and human beings is the idea that a special power or divine force has suspended, or at the end of days will dissolve, the conflicts intrinsic to nature. The rise of evolutionary science in the nineteenth century suggested that there could be no definitive salvation from the eternal struggle for existence, as the principles of nature applied everywhere to all natural systems, including human beings. Nature in time could not and would not be transcended. Darwinism by implication located in each species, and thereby in each member of a species, a dynamic drive that represented self-interested struggle, even if 'from the war of nature, from famine and death, the most exalted object which we are capable of conceiving, namely, the production of the higher animals, directly follows' (Darwin 1859: 490). For Herbert Spencer (1820–1903) the 'struggle for existence' implied '[t]hat the carnivore may live herbivores

[26] For reproductions of Blake's poems, see www.blakearchive.org
[27] See Tatham (1981).

must die; and that its young may be reared the young of weaker creatures must be orphaned' (1882: 17). Nonetheless, the highest stage of evolution would be not attrition and struggle, but a state of peace which enabled mutually adjusted and non-contradictory ends (1882: 19): 'For beyond so behaving that each achieves his ends without preventing others from achieving their ends, the members of a society may give mutual help in the achievement of ends.'

For the discipline of evolutionary psychology, which developed in the second half of the twentieth century as a way of applying Darwinian theory to the human mind, altruism creates a complex puzzle precisely because of this baseline assumption of this instinctual drive to self-preservation and propagation (Okasha 2013).[28] Today there is an intellectual reaction underway against this form of evolutionary thinking, grounded in a revised understanding of animals in nature, rather than an imagined mystical elevation of humans and animals above it. This involves a rejection not only of the Cartesian understanding of animals as complex organic machines,[29] but also of behaviourism, behavioural ethology (associated with figures such as Konrad Lorenz, Karl von Frisch and Nikolaas Tinbergen), sociobiology (Wilson 1975) and evolutionary psychology. Sociobiology applies a form of reductionism to human beings, in that they are seen as being as much the creatures of their biology as other nonhuman animals. 'Humanistic' ideas of soul, the autonomous self, mind, friendship, love, morality are understood as fictional projections of deeper instinctual processes (Sabloff 2001: 179).

Animal rights discourse sees both humans and nonhuman animals as genuinely vested with these attributes. Roughgarden (2009: 5), rejecting Darwin's theory of sexual selection, offers this summation: 'I find that competitive tooth-and-claw narratives about nature have been greatly exaggerated, that all sorts of friendships occur among animals, many mediated by sexuality, and that many social roles are signaled by gendered bodily symbols.' Social constructionism identifies a set of frameworks, assumptions and metaphors drawn from culture and ideology that underlie essentialising assertions about nature (Fine 2010, 2017). The social media displays of animal comity, together with these broader intellectual trends, offer reassurance that animals, including humans, are not condemned by species-specific instincts to perpetual conflict and violence.

[28] For two accessible overviews of the altruism debate, see Connor (2014) and Orr (2015), discussing E. O. Wilson (2014) and David Wilson (2004). For an annotated bibliography, see Post et al. (2003).

[29] For an account of early modern debates about animal souls and human souls, see Thomson (2010).

The philosopher Bruno Latour has observed that many natural scientists profoundly distrust the 'folk anthropomorphism' of lay accounts of animal behaviour. But this leads to a paradox, whereby in order to avoid anthropomorphic explanations, scientists resort to laboratory research. The logic is that 'only by creating the highly artificial conditions of laboratory experimentation will you be able to detect what animals are really up to when freed from any artificial imposition of human values and beliefs onto them' (Latour 2016: viii). Nonetheless, noting that '[f]ew things seem to capture the public imagination more reliably than friendly interactions between different species', Goode (2015) reported that the phenomenon of 'unlikely animal pairs romping or snuggling' had now drawn the attention of mainstream scientists, especially those interested in questions such as how this topic could 'add to an understanding of how species communicate, what propels certain animals to connect across species lines and the degree to which some animals can adopt the behaviors of other species'. Goode cites a range of scientific opinion, from the sceptical to the enthusiastic. According to Clive Wynne of Arizona State University, these interactions all take place 'in a human-controlled environment'. On the other hand, Barbara Smuts had used the word 'friendship' in her book, *Sex and Friendship in Baboons* (1985). Other scholars cited include Barbara King, the author of *Being with Animals* (2010), who argues for 'a rigorous definition of what constitutes a "friendship" between members of different species', and Marc Bekoff, author of *The Emotional Lives of Animals* (2007).

One key locus for these disparate intellectual trends is Latour's attempt to break down the symbolic boundaries between objects, nature and people, or, put another way, between nature and society (Latour 1993). The question arising for law is whether the popular embrace of the comity of animals, and the contemporary intellectual attack on anthropocentric models of nature, can shift law's own anthropocentrism. Law not only structures the polis, it operates as the gatekeeper, dividing the polis from the lawless wilderness beyond. In the traditional legal taxonomy, animals are either *ferae natura* or *domitae naturae* or *mansuetae naturae* (see Ingham 1900). Thus, they are brought into purview of the polis as chattels only, though they may live wild within the geographic boundaries of the polis and in complex symbiosis with it (Sabloff 2011, Donaldson and Kymlicka 2011). One fundamental principle of law is that human beings are its ultimate rationale, and other forms of relationships, for example, between people and things, are reducible to, or evaluated in terms of, relationships between people. Whatever entities, processes and controls that law posits, these are ultimately fictional proxies for the rights, interests and duties of human beings. This is true of the corporation, which stands as a proxy for a range of individual and collective human interests. To the Roman jurist Gaius is attributed the phrase *hominum*

causa omne ius constitutum, that 'each law has been established for the sake of mankind'. While law makes 'the epistemic division into persona/res/acta' (Lamalle 2014: 305), there are not three branches of law, and there is no way to conceive of law 'without persons' (Kelly 1911: 576). This anthropocentric understanding of law is concretely realised in the rules of standing or *locus standi*, that is, the need to show sufficient connection to or direct interest in a cause of action. Issues of standing in animal cases ultimately raise the question of anthropocentrism, that is, whether there must be a direct, proximate and clearly identifiable human interest in the litigation ('injury-in-fact', see *Data Processing Svc. Orgs. v. Camp*),[30] or whether a species, an ecosystem or an individual animal can be understood to have an autonomous interest at stake recognised by law.

A Non-anthropocentric Law?

In line with the intellectual trends discussed above, a range of positions advocating a non-anthropocentric law have emerged (Deckha 2013). For Francione (2006), the key is that no animals, higher primate or not, should be classified as property. There are arguments presenting animals as enslaved,[31] as potential citizens (Kymlicka and Donaldson 2014)[32] or as the holders of a form of legal personhood such that they are protected by *habeas corpus*.[33] Law, so the argument goes, evolves by expanding its recognition of, and protection afforded to, hitherto objectified, marginalised or exploited classes of being such as slaves, children and women (Wise 2002, Stone 2010, Boyle 2016).

Human–animal and animal–animal comity as viewed on Facebook suggest that it is nature itself that can provide for Spencer's mutually adjusted goals. A related, jurisphobic view suggests that law, rather than nature, is a cause, or at least a symptom, of conflict (Gilmore 1997: 111):

> The better the society, the less law there will be. In Heaven there will be no law, and the lion will lie down with the lamb. The values of an unjust society will reflect themselves in an unjust law. The worse the society, the more law there will be. In Hell there will be nothing but law, and due process will be meticulously observed.

[30] 397 U.S. 150 (1970).

[31] *Tilikum et al. v. Sea World Parks & Entertainment Inc.*, 842 F. Supp. 2d 1259 (S.D. Cal. 2012).

[32] The authors propose a tripartite distinction between domesticated animals which would enjoy a kind of membership or citizenship in society, wilderness animals with sovereign rights to territory, and liminal animals (that is, 'urban wildlife'), which would acquire a kind of denizenship.

[33] For details of litigation to date, see www.nonhumanrights.org

The inverse, more jurisphilic view, is the belief that conflict resides in the natural order of things, including human society, and law mitigates it as far as reasonably possible. In seeking recognition of animal rights and legal personhood, activists are expressing faith in law's expanding role as a protective shield over the oppressed and the marginal. However, for the sceptic, this mitigation cannot bring comity to the animal kingdom (Epstein 2002):

> Do we have it in our power to arbitrate the differences among animals? Do we train the lion to lie down with the lamb, or do we let the lion consume the lamb in order to maintain his traditional folkways? Do we ask chimpanzees to forgo eating monkeys? It is odd to intervene in nature to forestall some deadly encounters, especially if our enforced nonaggression could lead to the extermination of predator species.

Conclusion

The argument for animal personhood operates in two contradictory directions: law as artifice versus law as the mirror of nature. In the first view, it is law's artifice that enables it to breathe life symbolically into a corporation, and this demonstrates that there is no necessary and sufficient set of criteria required to qualify for personhood, such as status as a human being. Yet, secondly, it is urged that it is law's duty to recognise facts about the natural order of creation, in particular, that higher primates have a whole range of attributes and abilities (notably sentience, but also moral sensibilities) which they share with human beings. It follows that advocacy of animal personhood represents simultaneously a non-anthropocentric and an anthropocentric approach to legal personhood: it is both anti-humanist (or post-humanist) and humanist, and at the same time non-realist and realist (naturalist). One deeply non-anthropocentric model of human social order is that of the systems theorist Niklas Luhmann. For Luhmann, 'humans are not part of social systems' and 'human actors cannot be the components of social systems' (Fuchs and Hofkirchner 2009: 112, Luhmann 1984). If we take Luhmann seriously, humans cannot, by acts of will or through the instrumentality of legal personhood, call a non-anthropocentric law into existence: the notion that human agency can achieve this is deeply paradoxical. At the other extreme, the imagery of animal comity in popular culture is uniformly anthropocentric, speaking to a cartoonish fantasy that animals can be elevated without any corresponding downgrading of humanity: having one's animal friends and eating them too.

Bibliography

Bassett, William (1683): *Unity Stated the only Means to it Assign'd and Argu'd, Together with the Motives Pressing it*, London: Davis.
Bekoff, Marc (2007): *The Emotional Lives of Animals: A Leading Scientist Explores Animal Joy, Sorrow, and Empathy – and Why They Matter*, Novato: New World Library.

Boyle, Becky (2016): 'Free Tilly: legal personhood for animals and the intersectionality of the civil and animal rights movements', *Indiana Journal of Law and Social Inequality* 4, 169–92.

Child, Ben (2015): 'Cecil the lion tribute created by Lion King animator', *The Guardian*, 5 August 2015, available at: www.theguardian.com

Connor, Steve (2014): 'Why Richard Dawkins "is not a scientist", the survival of the least selfish, and what ants tell us about humans', *The Independent*, 10 November 2014, available at: www.independent.co.uk

Croon, Judy (2015): 'Cecil the lion – how social media is giving a voice to the voiceless' *Dogstarz*, 11 August 2015, available at: dogstarz.ca

Darwin, Charles (1859): *On Origin of Species*, London: Murray.

De Waal, Frans (2016): *Are We Smart Enough to Know How Smart Animals Are?*, New York: W. W. Norton.

Deckha, Maneesha (2013): 'Initiating a non-anthropocentric jurisprudence: the rule of law and animal vulnerability under a property paradigm', *Alberta Law Review* 50, 783–814.

Despret, Vinciane (2016): *What Would Animals Say If We Asked the Right Questions?*, Minneapolis: University of Minnesota Press.

Donaldson, Sue and Will Kymlicka (2011): *Zoopolis: A Political Theory of Animal Rights*, Oxford: Oxford University Press.

Epstein, R. A. (2002): Animals as Objects, or Subjects, of Rights, Law & Economics Working Paper No. 171, Chicago.

Fine, Cordelia (2010): *Delusions of Gender: The Real Science Behind Sex Differences*, New York: W. W. Norton.

Fine, Cordelia (2017): *Testosterone Rex: Unmaking the Myths of Our Gendered Minds*, New York: W. W. Norton.

Francione, Gary (2006): 'Taking sentience seriously', *Journal of Animal Law and Ethics* 1, 1–20.

Fuchs, Christian and Wolfgang Hofkirchner (2009): 'Autopoiesis and critical social systems theory'. In Rodrigo Magalhaes and Ron Sanchez (eds), *Autopoiesis in Organization Theory and Practice*, Bingley, Alberta: Emerald, 111–29.

Gilmore, Grant (1977): *The Ages of American Law*, New Haven: Yale University Press.

Gold, Sarah (2017): 'Step away from the lion: romping with wildlife does not actually help protect it', *Slate*, 3 January 2017, available at: www.slate.com

Goldman, Jason (2016): 'Why did the death of Cecil the lion cause such an uproar?', *The Guardian*, 5 May 2016, available at: www.theguardian.com

Goode, Erica (2015): 'Learning From Animal Friendships', *New York Times*, 26 January 2015, available at: www.nytimes.com

Hatkoff, Craig (2016): *Cecil's Pride: The True Story of a Lion King*, New York: Scholastic.

Holland, Jennifer (2011): *Unlikely Friendships: 47 Remarkable Stories from the Animal Kingdom*, New York: Workman.

Houdeschell, Amanda (2017): 'You aren't a voice for the voiceless', *Species Revolution*, 27 October 2017, available at: www.speciesrevolution.org

Ingham, John (1900): *The Law of Animals: A Treatise on Property in Animals Wild and Domestic*, Philadelphia: Johnson.

Kass, John (2015): 'Cecil the Lion and the most hated dentist in America', *Chicago Tribune*, 29 July 2015, available at: www.chicagotribune.com

Kelly, Joseph (1911): 'Gaian fragment', *Illinois Law Review* 6, 561–78.

King, Barbara (2010): *Being with Animals: Why We Are Obsessed with the Furry, Scaly, Feathered Creatures Who Populate Our World*, New York: Doubleday.

Kymlicka, Will and Donaldson, Sue (2014): 'Animals and the frontiers of citizenship', *Oxford Journal of Legal Studies* 34, 201–19.

Lamalle, Sandy (2014): 'Multilevel translation analysis of a key legal concept: persona juris and legal pluralism.' In Cheng Le, Sin King Kui and Anne Wagner (eds), *The Ashgate Handbook of Legal Translation*, Farnham, UK: Ashgate, 299–312.

Latour, Bruno (1993): *We Have Never Been Modern*, Cambridge, MA: Harvard University Press.

Latour, Bruno (2016): Foreword to *What Would Animals Say If We Asked the Right Questions?*, Minneapolis: University of Minnesota Press, vii–xiv.

Luhmann, Niklas (1984): *Soziale Systeme*, Frankfurt/Main: Suhrkamp.

Macdonald, D. W., Jacobsen, K. S., Burnham, D., Johnson, P. J. and Loveridge, A. J. (2016): 'Cecil: A Moment or a Movement? Analysis of Media Coverage of the Death of a Lion, Panthera leo', *Animals* 6(5), 26. DOI: 10.3390/ani6050026.

Malamud, Randy (2017): '"Creature Comforts": Crafting a Common Language Across the Species Divide'. In Dominik Ohrem and Roman Bartosch (eds), *Animating Creaturely Life: Ontology and Ethics Beyond Anthropocentrism*, London: Palgrave, 77–94.

Milman, Oliver (2016): 'Anthropomorphism: how much humans and animals share is still contested', *The Guardian*, 15 January 2016, available at: www.theguardian.com

Montgomery, Sy (2016): *The Soul of an Octopus: A Surprising Exploration into the Wonder of Consciousness*, New York: Simon and Schuster.

Okasha, Samir (2013): 'Biological Altruism'. In Edward N. Zalta (ed.), *The Stanford Encyclopedia of Philosophy* (Fall 2013 edition), plato.stanford.edu/archives/fall2013/entries/altruism-biological/

Orr, H. Allen (2015): 'How the altruism gene passes from one generation to the next', *Financial Review*, 2 April 2015, available at: www.afr.com

Post, Stephen, Johnson, Byron, McCullough, Michael E. and Schloss, Jeffrey P. (eds) (2003): *Altruism & Love: An Annotated Bibliography of Major Studies in Psychology, Sociology, Evolutionary Biology, and Theology*, Philadelphia: Temple Foundation Press.

Regan, Tom (2003): *Animal Rights, Human Wrongs*, Oxford: Roman and Littlefield.

Riederer, Rachel (2016): 'Inky the octopus and the upsides of anthropomorphism', *The New Yorker*, 26 April 2016, available at: www.newyorker.com

Roughgarden, Joan (2009): *Evolution's Rainbow: Diversity, Gender, and Sexuality in Nature and People*, Berkeley: University of California Press.

Sabloff, Annabelle (2001): *Reordering the Natural World: Humans and Animals in the Sablof*, Toronto: University of Toronto Press.

Safina, Carl (2015): *Beyond Words: What Animals Think and Feel*, New York: Henry Holt.

Schweig, Sarah (2015): 'Trophy hunters are killing 70,000 animals ever year', *Business Insider*, 22 November 2015, available at: www.businessinsider.com

Singer, Peter (1981): *The Expanding Circle: Ethics and Sociobiology*, New York: Meridian.

Smuts, Barbara (1985): *Sex and Friendship in Baboons*, Abingdon: Routledge.

Spencer, Herbert (1882): *The Data of Ethics*, New York: Appleton.

Stone, Christopher (2010): *Should Trees Have Standing?: Law, Morality, and the Environment*, Oxford: Oxford University Press.

Tatham, David (1981): 'Edward Hicks, Elias Hicks and John Comly: perspectives on the peaceable kingdom theme', *The American Art Journal* 13, 36–50.

Thomson, Ann (2010): 'Animals, humans, machines and thinking matter, 1690–1707', *Early Science and Medicine* 15, 3–37.

Tryon, Thomas (1691): *All Foods Proceeding from the Vegetable Kingdom are Innocent*, London: Salusbury.

Webley, Kayla (2011): 'The adorable dozen: bizarre animal friendships', *Time Magazine*, 19 April 2011, available at: content.time.com

Wilson, David Sloan (2004): *Does Altruism Exist?: Culture, Genes, and the Welfare of Others*, New Haven: Yale University Press.

Wilson, Edward O. (1975): *Sociobiology: The New Synthesis*, Cambridge, MA: Harvard University Press.

Wilson, Edward O. (2014): *The Meaning of Human Existence*, New York: Liveright.

Wise, Steven (2002): *Drawing the Line: Science and the Case for Animal Rights*, Cambridge, MA: Perseus.

11

Moral Choices and Ethical Systems in Videogames

Antoine Rocipon

'Sometimes we like to refer to videogames as "interactive entertainment" to clarify that they require direct engagement and dialogue, versus passive media that simply require attention and consumption', writes Leigh Alexander.[1] Her ambivalent choice of words – 'Sometimes we like to', 'to clarify' – tends to show that there is indecision here, which is surprising considering that it comes from a relatively well-known author and journalist specialising in the history and analysis of videogames, and that she has already written four self-published books on these themes.

That uncertainty is in fact an indication of the complexity of apprehending videogames as a medium. Aesthetic scholars have insisted too much on the importance of interpretation and active attention to let us consider cinema, television and any other kind of moving images as only 'passive media'. On the other hand, some people in the videogames industry have been trying for quite some time now to go further than just producing objects of 'entertainment'. This has left us with the idea of 'interactivity', but what exactly is interactivity? What does it mean in terms of media analysis? How can it help us understand how videogames have radically changed our society?

To answer these questions, at least in part, I will first focus on the idea of interactivity and ask why it is so important. By then focusing on videogames which contain what I would call 'moral choices' and 'moral systems', I will try to show that some videogames may offer players a new way of questioning human nature, because they completely change our relation to ethics.

Interactivity and Narrative

Videogames are probably the only medium that force the observer/player to have a systematic reaction. Filmic experience is about interpretation,

[1] Leigh Alexander, 'Gamer's Paradise: The Evolving Relationship Between Film and Games', thecreatorsproject.vice.com, 2012.

which can lead to an emotional response, but if a film scene fails to make you feel empathy for the main character the narrative will go on anyway. Videogames often don't offer that possibility: if the fear of dying doesn't lead me to hide behind that desk or to dodge that bullet, I'll lose a life and have to play the level/game again. In videogames the player is constantly asked to make choices, and those choices always lead to a different narrative. Almost everybody played *Tetris*, and yet no one saw the same *Tetris* narrative, because no one finished the game or a level in the exact same way, in the exact same amount of time. If two people are watching a movie in a movie theatre, the narrative that has been offered to them is the same, even if their experience of the narrative could be different. This equivalence doesn't exist when it comes to videogames. In videogames the players' choices lead to the construction of a narrative that is every time unique in every way.

We cannot emphasise this idea too much, because this is what makes videogames so appealing, and this is what makes them different from other narrative media. The idea of interactivity as the essence of videogames wasn't - and maybe still isn't – in evidence. For a long time the part of the industry that was looking for legitimacy suffered from comparison with cinema and television, and tried to produce videogames with strong aesthetics and narratives (and, as a consequence, a more minimalistic gameplay). Games such as *Iko* (2001), *Shadow of the Colossus* (2005) and *Okami* (2006) are good examples of the direction that was taken by people who wanted to produce artistic videogames in the 2000s. Those three games have a positive reputation in the gaming community. However, I think they suffer from what seems to be an insurmountable obstacle:

> There is an inherent conflict between the now of the interaction and the past or 'prior' of the narrative. You can't have narration and interactivity at the same time; there is no such thing as a continuously interactive story. The relations between reader/story and player/game are completely different – the player inhabits a twilight zone where he/she is both an empirical subject outside the game and undertakes the role inside the game.[2]

That's why I decided to focus on games which tried to go in the opposite direction, by valorising what appears to me the most extreme and interesting use of interactivity in videogames: the possibility of making moral or ethical choices that are supposed to change the narrative. In *Fallout 3*, for example, at some point in the game (depending on how she plays and

[2] Jesper Juul, 'Games Telling Stories – A brief note on games and narratives', gamestudies. com, 2001.

where she is going) the player has to either activate or defuse a nuclear bomb around which a city has been built. These kinds of choices are particularly interesting because they are neither purely mechanical (jumping on a platform, using your sword to kill an enemy . . .) nor part of the outside world (turning off the console, saving the programme . . .). They force the player to become involved not only in the game, but in its narrative. Even if, as we will see, these choices sometimes don't change anything in terms of what happens next to the character, they change everything in terms of how the player experiences what happens to his avatar. As I said, every videogame narrative is determined by players' choices, and moral or ethical choices are the most extreme ones, because they force the player to consciously change the narrative he is building for himself.

Moral System without Moral (Fable)

The videogame developer and programmer who most consistently introduced and worked on morality in videogames is Peter Molyneux. The *Black & White* series (two games: 2001 and 2005) and the *Fable* series (2004, 2008 and 2014 for the three main games) both offer a moral system that has huge importance in the gameplay and the aesthetic of the game. In *Fable* you play a character that has multiple options for good or bad actions in relation to the narrative, but also with the open world that is offered to him (punching villagers without any reason gives you 'bad points' while offering them gifts gives you 'good points'). Your character's appearance slowly changes according to their morality level: if you act like an evil entity, horns will soon grow on his head, while he will obtain a halo if he acts as a good Samaritan.

The moral system offered here is however problematic: good and bad are defined in relation to our own biblical cultural background. The physical changes of *Fable* are of course representative of that background. Therefore, I feel like the pre-existing system in which the player is supposed to act doesn't imply a consequent moral involvement from him. He will probably make his choices according to what the rewards are (if good = better sword and bad = better armour, he will pick according to what he thinks he needs for his character), to aesthetic changes (I personally used to like having horns and red eyes), or maybe just to what he enjoys the most (killing everyone and reigning by fear, or being beloved all around the world and maybe even marrying a villager). Therefore, games based on this kind of moral system seem always to suffer from the same two problems: first, the game rewards you for following an archetype (pure good or pure evil) with really obvious choices. Then, the story told by the game remains the same: you end up doing the same quests,

fighting the same bosses, and most of the time saving the world. As Brandon Perdue points out:

> The gameplay context tends to overwhelm the moral concepts at play; meters like *Mass Effect*'s[3], or even out-of-game achievements, 'invariably guide players to push to one extreme', as Louis Castle observed. Even just tying the morals to the gameplay tends to boil game morality down to using violence or using more violence. But a fully dramatic context is largely impractical; the execution alone adds huge costs in time and money to the development of an average contemporary game release.[4]

So we have two major flaws: archetypal good and evil related to a cultural construction, and a story that remains the same or almost the same. Today it is impossible for the industry to develop a videogame which offers the player the opportunity to make any choice he wants (what if instead of killing or saving the bad guy I decide to run away from my responsibilities?), and to change the story told by the game according to those choices (any choice made would create a new branch of the story, leading to an infinite number of possible stories). However, in the following paragraphs I will try to show that despite financial and technical impossibility, some developers have tried to go further than Peter Molineux's games in the direction of questioning morality.

Predefined Moral Systems and Grey-area Ethics: 'If this was to happen?': *This War of Mine*

I selected one game as an example, which I think offers an answer to the problem of archetypal good and archetypal evil. A game with a predefined moral system in which the player has to implicate himself and think 'if this was to happen'.[5]

In *This War of Mine* (2014), the player takes control of a group trying to survive in a city at war. He controls several characters (each with a quick biography) and has to look in the buildings around to gather food, water and tools, in order to survive as long as possible. In some locations, events will occur: the character controlled by the player at that moment will meet new people: some will try to rob or kill him, some will sell him goods, some will help or even join him, etc. What's interesting is that some of these events

[3] In terms of moral system and moral evaluation, *Mass Effect* is very close to *Fable*.
[4] Brandon Perdue, gamasutra.com, 2011.
[5] The expression was coined by Ben-Shaul Nitzan in *Hyper-Narrative Interactive Cinema* (Amsterdam: Rodopi, 2008).

imply the making of tough choices: for example, you can decide to steal or not to steal the remaining food of an old couple. However, stealing can lead your character to have feelings of remorse and therefore be less efficient in their quest for survival. Here again, the notions of 'good' and 'bad' are predefined by the game developers (and, again, by Christian morality). However, it is sometimes impossible to survive, and to actually play the game, if you don't choose the 'bad' option. Of course, this grey area is built on purpose by the game developers, the game clearly aiming to give an 'experience of war from an entirely new angle', which is the official subtitle of the game. Pawel Miechowski, one of the game's developers, says:

> During the development we were thinking that in movies and books you are a spectator but if they're good stories you are able to feel empathy, love, hate with characters. With games you can do something that will make you feel remorse over what you did. So this is uncomfortable.[6]

As a matter of fact, in many interviews Miechowski uses the same kind of argument (it might not be consciously): he refers to the classical narrative medium (maybe because of the quest for legitimacy we pointed out earlier) and then adds a mention of what's different with games:

> When I'm in a certain mood I watch action shoot-outs, like in *Rambo* or Schwarzenegger films, but from time to time, something inside me pushes me to watch war dramas like *The Pianist* or *Schindler's List*, and I cry like a baby when the film ends. That's catharsis for me. And I firmly believe games can do the same – games can be adrenaline-pumped action and they can deliver that for you when you feel like playing such action, but games can also tackle serious topics or comment on reality and the human condition via properly structured gameplay.[7]

Part of this 'properly structured gameplay' he mentions are those tough choices the player has to make. Sometimes he has to do what seems wrong, most of the time because he can't do otherwise to keep on surviving, and to keep on playing. One of the video trailers for the game is particularly interesting: the video shows one of the main characters watching through a door and seeing that a woman is about to get raped and killed by a man, then two choices linked to two other videos appear on the screen: 'Help the girl' or 'Do nothing'. In the game, if the player has a weapon (which is not always the case) he can save her by killing the guy who assaults her. But that's

[6] Pawel Miechowski, interview for Rockpapershotgun.com
[7] Pawel Miechowski, interview for Existentialgame.com

not what the video shows: if you click on the link 'Save the girl', the girl runs away while the character supposedly controlled by a player just opens the door and gets killed. If you click on the link 'Do nothing', the girl dies. Miechowski and his team knew what they were doing when they advertised the game, because the whole point of the game is to make the player understand that in wartime the moral system can't be the same as in 'normal' life. By accepting that, we understand that our own vision of morality, the one that appears in a game like *Fable*, is constructed and not definitive. 'If you do something the player isn't programmed for, he or she doesn't know what to do and starts to act more subconsciously. Emotions are raised there, in this subconscious,' says Miechowski.[8] With *This War of Mine* we have an example of a predefined moral system in which bad and good actions don't always lead to bad and good consequences in terms of gameplay and narrative, and, as Silcox and Cogburn underline, 'One thing we can't stress strongly enough is that great art can't just always show "bad" acts, which lead to "bad" consequences. Real life isn't always that way, nor is great art.'[9]

I believe *This War of Mine* is representative of the current approach to morality among videogame developers: a focus on grey-area ethical decisions and a predetermined moral system. The game forces the player to think 'if this was to happen' and asks the player to control predetermined characters: a group of people trying to survive. Paradoxically, this leads to an identification that might be even stronger than with games played in the first person. Here are some of the top YouTube comments on the 'Gameplay Trailer' for *This War of Mine*: 'In my first game, I couldn't save Katia . . . Literally fucking cried . . .' (Mustang Rider, 54 upvoters); 'See, I don't know why – but I feel like I have way more empathy than a normal human should. When it comes to even moral choices in just this game, no matter how desperate my group was for food, I could never bring myself to steal or murder' (Just Another, 44 upvoters). One of the main criticisms of the well-known Trolley Problem (and other related problems) is that it is not realistic nor conceivable for the human mind, because this kind of situation never happens. However, it seems that videogames are able to force the player to conceive these kinds of problems, or at least to force him to make a decision. Of course, he is not really the one making the choices, his avatar is, and there are far fewer consequences, but it doesn't change the fact that he actually had to try to imagine the situation and acted as a consequence of pressing a button. He had to make a choice.

8 Pawel Miechowski, interview for Techtimes.com
9 Silcox and Cogburn, quoted by Laura Parker in 'Why are moral choices in games so black and white?', gamespot.com, 2009.

Ethical Negotiation in Role-playing Games: *Fallout*

The second type of game I want to focus on is the Role Playing Game (RPG), mostly because these offer the player the possibility of creating his own avatar and playing in a vast open world with few restrictions. In this area, Bethesda is one of the most popular studios, and that's why I decided to talk about the two last games of its well-known RPG series: *Fallout* (1997, 1998, 2008, 2015).

At the beginning of each of these games you create your character: on the screen you choose his skin colour, his characteristics, his class, his skills, etc. But there is something else you choose mostly off-screen: his personality and his morality. Because when you know your character is going to act in a world as big as Bethesda's open worlds, you know you will have to make a lot of choices in terms of what you're going to answer to a Non-Playing Character (NPC) which quests you're going to attempt, which side you're going to pick (*Fallout 4* offers the possibility of joining different groups or factions, each with a different game ending). Most of the time these games offer very limited background on the character you play (you have been arrested without any obvious reason, or you just have amnesia, for example), because the developers know that the player is going to imagine this background himself. When you create your character you also create his personality to match what you want to do with him later and how you want to play him, because you know that in this kind of game you will have a lot of choices to make and a lot of dialogue options (cynical, naive, aggressive; some character skills are even related to these options). What happens in this character creation screen on which role-playing gamers spend so much time is what Massimo Maietti calls 'ethical negotiation':[10] the player chooses what ethical and moral system his character will follow, and this ethical system is both part of the player (because that's who and what he wants to play) and an abstraction. We can see the whole process of this negotiation in an article written by Emanuel Maiberg (videogame journalist for Motherboard.com) called 'I Just Said Yes to All the Drugs in *Fallout 4*':

> As I imagined it, Bill already had a drug problem, probably due to extensive self-medicating to treat an undiagnosed case of PTSD from his time in the army. He was a functioning alcoholic and father before the events that kick off *Fallout 4*, but when the atomic bombs dropped, the world ended, and Bill lost his wife and kid, he spiraled.

[10] Massimo Maietti, 'Player in Fabula: Ethics of Interaction as Semiotic Negotiation Between Authorship and Readership'. In Andres Jahn-Sudmann and Ralf Stockmann (eds), *Computer Games as a Sociocultural Phenomenon* (Basingstoke: Palgrave Macmillan, 2008) 101.

In *Fallout 4*, some players emerge from the vault trying to make the world a little better. Some strive to become great villains, accruing power and wealth. Others like to wander the wasteland aimlessly, helping or acting selfishly where they see fit. I, as Bill, had a much clearer sense of purpose. I knew as soon as I emerged from the vault what my goal was: get wasted in the wasteland. Simply find and abuse any substance I could find as much as I can.[11]

In *Fallout 4* you play a man who was in the army and saw his wife being killed by someone he doesn't know. We see here how Maiberg uses this not-so-minimal background (compared to other RPGs) to fit what he wants to play: a selfish and cynical junky (*Fallout 4* offers the possibility of taking different types of drugs, those drugs can help you in the short term, but you also risk becoming an addict). However, as Maiberg points out, it's not so easy to decide to play this kind of character:

> Experimenting with chems in *Fallout 4* mostly taught me that there's no prac-tical reason not to, unless you don't want to role-play a dirtbag. I've never used them in previous *Fallout* games, and now that I think about it, the only reason I didn't is out of some vague notion that drugs are bad. When I play games, and deep role-playing games like *Fallout* specifically, I like being the ultimate good guy, and getting drunk and high all the time just didn't seem to me like something a hero would do.

What Maiberg's article shows is that your own morality and moral system often influence the process of the ethical negotiation. Most people can't play a complete asshole without at least creating a background for him that would justify his actions. I personally noticed that I now have a really hard time playing a 'bad' character, which was not the case when I was younger (maybe because I don't now play videogames much and therefore don't see them as 'just games' anymore, or maybe because as I grew up my moral convictions became stronger). The ethical negotiation is the dialogue between the pre-existing moral convictions of the player and what character he wants to play according to what the videogame world and gameplay offer him.

Maiberg here also points out the importance of 'being role-play', which is a really fundamental concept in the gaming community. Why is role-playing so important? Because that's the tool needed by the player to create his own narrative. There are tons of ways of 'being role-play'. Sometimes it means that you're always going to try to be the 'good guy' when you're confronted with choices related to the narrative (and therefore actually programmed by the game developers), but most of the time it's completely up to the player to

[11] Emanuel Maiberg, 'I Just Said Yes to All the Drugs in *Fallout 4*', Motherboard.vice.com

decide. Let's say you start playing *Fallout* and you decide that your character hates guns. Then, even if the game doesn't mind at all if you use a gun from time to time, you can decide to play the whole game only fighting with your bare hands and never break that rule. We see that the initial ethical negotiation leads to the creation of a moral system specific to the character you're currently playing. Most of the time, RPGs will offer different storylines related to your choices (but still, as I said earlier, they can't offer an infinite number of storylines), but most important is that the player, particularly when he is 'role-playing', also creates his own narrative in relation to those storylines, and how he sees and experiences what's happening to his character:

> Event, in computer games, takes place through the presence of the user, whose role is not to merely actualize a single predetermined narrative, but rather to act within certain boundaries of performative freedom.[12]

In this respect, RPGs are getting closer to their sources of inspiration – tabletop role-playing games – and we could draw the same conclusion for videogames as Michelle Nephew does for tabletop games:

> Because the player is empowered to do more than just interpret the 'text' of a role-playing game – because the player has a hand in shaping his character and the game's narrative based on his own experience and desires – he becomes an active manipulator of the text.[13]

'Being role-play' while playing a RPG has become part of what we could call the 'gamer ethic', which forces players to create a moral system specific to their character and to stick to it. By doing this, gamers try to develop their own compelling and satisfying narrative.

Rethinking Human Nature through Videogames

Why have I taken so much time trying to understand the evolution of videogames in terms of moral and ethical issues? Why is it important and interesting to see what videogames currently propose, and what is happening when I play different types of games that involve moral choices? Because I think the processes and mechanisms I described: (1) grey-area choices and 'if this was to happen'; and (2) ethical negotiation and the relation between role-playing and narrative, allow the player to (re)think his own ethics and his own moral system.

[12] Massimo Maietti, op. cit. 99.
[13] Michelle Nephew, 'Playing with identity: Unconscious Desire and Role-Playing Games'. In J. Patrick Williams, Sean Q. Hendricks and W. Keith Winkler, *Gaming As Culture* (Jefferson: McFarland and Co., 2006) 120.

To understand this more clearly it is necessary to connect what I said about videogames to a philosophical approach to the topic of morality and ethics. Moral philosophy still owes a lot to Spinoza: here are, in brief outline, some propositions he made about good and evil:

– nature has nothing in 'excess', or doesn't 'lack' anything, nature just is, therefore 'good' and 'evil' are notions created by men to judge nature and their own creations in relation to their needs and expectations: 'As far as good and evil are concerned, they also indicate nothing positive in things, considered in themselves, nor are they anything other than modes of thinking, or notions we form because we compare things to one another.'[14]

– However we must not get rid of those notions, we must just accept that they are only comparative tools men use to try to live as freely as they can. I here use the term free as it is used by Spinoza: the accomplishment of human nature by the knowledge of the causes that determine him. The free man is the one who acknowledges that what is good is what leads one to the accomplishment of the human nature and what is bad is what restrains the self from it. This man would have the 'true knowledge of good and evil'. Men created the concept of 'good' and 'evil' because they weren't born free.

– The problem is that 'true knowledge of good and evil' is weak compared to human passions, and human passions are always restraining men from accomplishing their nature: 'he who is led by fear, and does good in order to escape evil, is not led by reason'[15] (being led by reason also being part of this accomplishment according to Spinoza).

By connecting these ideas to what I said earlier about videogames, we can see that videogames might be a powerful medium for questioning human conceptions of good and evil. Games with grey-area choices like *This War of Mine*, for example, allow the player to acknowledge how his moral system is pre-constructed by a cultural background, while role-playing games force the player to an 'ethical negotiation' that involves an acknowledgement of his own conception of good and evil, but also offer him the possibility to partially get rid of it (and therefore maybe get him closer to the 'true knowledge of good and evil'). We can also assume without taking too much risk that by creating an ethic for a character and sticking to it, a RPG player takes a step forward in the direction of understanding determinism. In the article about *Fallout 4* I mentioned earlier, for example, the author creates by himself a connection between past experience (War, PTSD, murder of his wife) and current behaviour and choices (selfish junky). I could also emphasise the idea that since a videogame is by definition programmed (for now), any event

[14] Baruch Spinoza, *Ethics*, Part IV, Preface.
[15] Baruch Spinoza, ibid., Prop. LXVIII.

(bug excepted) is necessarily predetermined.[16] Videogames also can directly aim at a better understanding of human nature: *This War of Mine*, for example, forces the player to reconsider what is good and what is evil, and tries to make him feel remorse, but the game also helps him acknowledge that 'good' and 'evil' change according to circumstances. Therefore, either by being confronted with a coercive moral system, or by themselves producing a system by negotiating with their own vision of good and evil, videogame players are definitely getting closer to this true knowledge of good and evil that Spinoza talks about.

Videogames, moreover, also offer something that appears completely new to me: the possibility of making (virtual) moral choices without being led by passions, or at least in a situation where human passions have less impact in the process of decision-making. In most videogames you can play again and make another choice, you can reload a previous save, you can die and retry. 'A free man thinks of death least of all things; and his wisdom is a meditation not of death but of life,' writes Spinoza.[17] In Spinoza's philosophy, the free man is a hypothesis: he can't really exist since he would have to be completely omniscient of all the causes that determine him. But maybe this free man lies there, on the screen of a computer or a TV: every videogame character is a 'free man', because each videogame's character is programmed and knows he is, the game program knows that his choices are predetermined, and he knows what's going to happen. The player can of course never completely incarnate the avatar he is playing, but by imagining this character story, by being the one giving him consciousness, by being in contact with him for so long, by feeling the remorse he feels and actually dealing with them in the game, he certainly can learn a thing or two, and maybe use his reason more often than usual.

By linking some aspects of videogaming to some propositions made by Spinoza, I have tried to show that videogames have probably changed a lot of things about our relation to ethics and morality. Videogames are maybe the only place where you can make a choice that has no consequences for the self (but in the end, hasn't it really?). I do think that the games I focused on (and many others) put the player in contact with his human essence (in these cases, in terms of morality and ethics), and maybe allow him to think about this. This appears to me to be a first fundamental step in the direction of art videogames.

In conclusion I want to talk about a paradox I discovered while re-reading this article: even if I started by saying that videogames are all about choices,

[16] I am of course not talking here about multiplayer video games; all the games I mention are one-player games.
[17] Baruch Spinoza, *Ethics*, Prop. LXVII.

in the development of the argument I couldn't stop myself using the verb 'force' and the vocabulary of obligation. And it's true that videogames force you to have a reaction, they force you to make tough choices you don't want to make, they force you to play a specific character, and when they don't, they force you to pick a class, a race, to choose between a finite number of faces. In role-playing games you think you can play everything – a warrior, a mage, an archer, a villain or a hero – but most of the time you can't be a random peasant minding his own business, or an accountant. If you want to have a good experience, you probably shouldn't do all the quests available, which means you will have to play several characters if you want to play the whole game. In videogames, you're not free of your interpretations. You think you're creating your own narrative, but in the end it is predetermined, and you're only participating in the creation of an experience or a different version of a narrative, which, as I have tried to show, is already something really important. One has to admit that, for now, videogames only give you the illusion of choice. If they didn't, they probably wouldn't be games anymore.

12

Reading Law: A Beginner's Guide to the Manual of How to Read the Book of Law Yet to Come

Daniela Gandorfer

Reading Books: Yet to Come

How to start reading a book still to come? At the beginning of *Cannibal Metaphysics*, Eduardo Viveiros de Castro reveals that he had originally planned to write a book as an homage to Gilles Deleuze and Félix Guattari. He would have written it from the point of view of his discipline, anthropology, and he would have called it *Anti-Narcissus: Anthropology as Minor Science*. Somehow, however, he sensed that this endeavour might be too unsettling, too contradictory, perhaps even too daring to be undertaken by him – especially by him alone. Instead of writing the book himself, he decided to write about it 'as if others had written it'; he decided to write a beginner's guide to the endlessly imagined book, which 'ended up not existing – unless in the pages to follow'.[1] This imagined book – written by not only one, but more than one, an homage to Deleuze's and Guattari's work, appeared only in the beginner's guide offered by de Castro (that is, it did not exist except somewhere and somehow 'in the pages that follow') – prompts us to rethink what we mean when we speak of reading and writing. If writing about concepts, to whom or what should or can we remain faithful? Whose thoughts are we thinking, and who is thinking our thoughts? To whom or what are we owing our past and current thoughts, as well as our thoughts to come? With whom are we thinking, and what is the responsibility that arises in relation to this thinking-with across time and space? And in terms of reading: How are we supposed to read this beginner's guide; a text that not only refers to, quotes and invokes a book not yet written, but presumes even to introduce it, which

[1] Castro, Eduardo Viveiros de, and Peter Skafish, *Cannibal Metaphysics: For a Post-structural Anthropology* (Minneapolis: Univocal, 2014) 39.

means that it claims to only exist because of and in relation to what does not yet exist, and what, in fact, might never come into being?

The fact that de Castro imagines a book similar to the work of Deleuze and Guattari is of course no coincidence. Even though his own work is rooted in *Anti-Oedipus* and *A Thousand Plateaus*, it is in fact Deleuze's works to which he refers more frequently, and which he quotes in order to articulate his concepts in *Cannibal Metaphysics*. Despite the textual references, the citations in footnotes and the listings in the bibliography, this beginner's guide – *Cannibal Metaphysics* – cites differently, since what is at stake in *Anti-Oedipus* and *A Thousand Plateaus* can neither be expressed by a written text, nor referenced as a written text, let alone contained in a footnote or an endnote. What's more, *A Thousand Plateaus* foreshadows a mode of reading that might – at the time it was written - not have been as feasible as it is today with the emergence of digital humanities, social networks, media technologies and platforms that connect people across different places, different time zones and different spaces. It is a book that cannot be read in isolation, somewhere in a library, or a closed room, in an attempt to *understand* what it is about. Neither is it a book that offers a fixed structure, a chronology of chapters, or a well-presented object that can be set into dialogue with another interpretation or articulation of that object. This is precisely why an homage to this work has less to do with a rigorous application of concepts, with an adaptation of the title, the structure or the language, but rather with the performativity of what is presented, with how it operates, links and unlinks, harkens back to written texts that precede it, evokes forms to come, and reaches out to the material dimensions of their concept-assemblages. It is in this sense that the beginner's guide coincides, presupposes and is simultaneously made possible by both that to which it serves as an homage, and what is imagined and unfolds only when we find a mode of reading it in its multidimensionality and multimediality. In that respect, I like fantasising about a beginner's guide to a book *of* and *by* law that hovers between reading and writing, referring and being referred to, a book that exists only in and as becoming, shaped by actions that precede it and follow from it, because it would not only shift what we understand as reading, but also the ethical, political and aesthetic implications of such a mode of inventive reading. This curiosity also coincides with my firm belief that every attempt to rethink or reimagine law (its forms, subjects, materiality, spatiality and temporality, forces, etc.) has to be preceded by a theoretical inquiry on what it means to *read* law. It is crucial that such an inquiry leads us to question both what it means to 'read' and what we understand as 'law'. I would even claim that – taking our cues from literary theory, that is, developing an alternative mode of reading – it is primarily 'law' that loses its defined contours, its fixed references and its alleged grounded-ness. In other words: once we find a way to *read* law in its materiality and multimediality,

what we used to understand as law cannot be law anymore, and what we have not considered as law might be law after all. The question of what reading means, or rather, what it could mean, is by no means a novel concern of literary theory. While it has been addressed from so many different angles and with so many different approaches in mind, I do think that in regard to what I wish to demonstrate – namely, the need to develop an alternative mode of reading law – *A Thousand Plateaus* allows us to break through a number of brick walls that need to be torn down if we want to perform a different mode of reading: one that defies dichotomies like inside/outside, subject/object, mind/matter, or form/content and conceptualising/perceiving. It helps us to figure a mode of *reading* that transforms and embodies the book, leaves and breathes the text. It allows us to imagine the potentiality of reading as something that cannot be severed from perceiving and being perceived, from its images, sounds, material entanglements, conceptual complicities and thus from the response-ability that arises in the course of this creative activity. In what follows, I wish to hint at some thoughts and concerns that stand at the very beginning of what might become a draft of a beginner's guide to a manual on how to read law in its materiality and multimediality, that is, to a manual on how to approach a different, an altered notion of the book *of* and *by* law.

Reading: Sensing Assemblages and Sensate Assemblies

Reading

In the introduction to their book, Deleuze and Guattari attest that 'writing has nothing to do with signifying', but 'with surveying, mapping, even realms that are yet to come'. The book is introduced as an 'assemblage', which is 'as such unattributable', an indeterminate multiplicity, without definable borders and exceeding its own form, and thereby bracingly rejecting subject and object alike. One looks in vain for a consensus about the content or object of the book. This is precisely what is at stake with the form of reading Deleuze and Guattari introduce, or at least adumbrate, for it links and connects, reaches out towards the yet to come and seeks to provide an open space of difference that can be co-habited without necessarily presupposing consensus. Consensus, Erin Manning writes, is 'the silencing of disagreement, the impossibility of disagreement'. It is 'precarious precisely because it rests on the injunction not to err', since it 'ignores the fragility of an erring movement: it pretends that its displacements are always known in advance', and thus lends itself too easily to acts of exclusion.[2] The readers of *A Thousand Plateaus* do

[2] Manning, Erin, *Politics of Touch: Sense, Movement, Sovereignty* (Minneapolis and London: University of Minnesota Press, 2007) 15, 48, 70.

not need to consent *to*, they need to read *with* – with whoever else is reading, with whatever is read. If '[a] book exists only through the outside and on the outside',[3] and if our focus should not remain on the question of finding the most probable, the most convincing, the most agreeable, the *one* interpretation, the one that is most likely to reach consensus, but rather on 'what it functions with', on 'other multiplicities' into which 'its own are inserted and metamorphosed',[4] we can no longer hold onto what we used to understand as *reading*. Indeed, in his foreword to the English translation of *Mille Plateaux*, Brian Massumi suggests imagining the text as a record to which the reader is invited to lend an ear. The best way to 'read' *A Thousand Plateaus*, he writes, is by reading it as a 'challenge', for the question is not 'is it true? But: does it work? What new thoughts does it make it possible to think?' and '[w]hat new sensations and perceptions does it open in the body?' In this account, reading also means *perceiving* and *sensing*, where to sense, according to Manning, is 'to world in all directions at once', and 'to challenge the interstices between insides and outsides, spaces and times'.[5]

Similar to Deleuze's and Guattari's call to forego subject and object distinctions,[6] Judith Butler, in her reading of Whitehead in *On This Occasion*, makes an interesting claim about the alleged one-directional understanding of the reader/text relation. Butler describes the relation between subject and object not in hierarchical terms, but rather as a curious 'interaction'. Both 'are animated in relation to one another . . . and in this sense the aliveness of each is dependent on a certain provocation coming from the other'. Since this consequently 'raises the question of non-human modes of acting or . . . [of] acting on', she suggests that 'such non-human modes of acting and being acted on characterize the object – in this case, the text – and me'.[7] Accordingly, what traditional grammar calls an object and, analogously, the text, the non-human, the book, what is subordinated and always only thought to exist in reference to the subject is in fact also acting upon and helping create subjects and, in this context, the readers. *Reading*, then, becomes a multidirectional movement between two bodies of texts – the reader and the written – which cannot always be clearly distinguished from *perceiving* and which dissolves the notion of an inside and an outside. At the same time, this also breaks with the assumption

[3] Deleuze, Gilles and Guattari, Félix, *A Thousand Plateaus: Capitalism and Schizophrenia*. Translated by Brian Massumi (Minneapolis and London: University of Minnesota Press, 2014) 4.

[4] Ibid.

[5] Manning, *Politics of Touch* 155.

[6] Deleuze and Guattari, *A Thousand Plateaus* 3.

[7] Butler, Judith, 'On This Occasion'. In Roland Faber, Michael Halewood and Deena Lin (eds), *Butler on Whitehead: On the Occasion* (Lanham, MD: Lexington Books, 2012) 4.

that the reader is a passive consumer of whatever the respective authority writes and thus produces. Michel de Certeau renders this 'theory of consumption' – as well as the subsequent hierarchisation of writing (as the production of a text) over reading as the reception of it from someone else, 'without putting one's own mark on it, without remaking it' – utterly 'unacceptable'.[8] According to de Certeau, 'one cannot maintain the division separating the readable text (a book, image, etc.) from the act of reading'.[9] To *read* means to travel, and the reader's place 'is not here or there, one or the other, but neither the one nor the other, simultaneously inside and outside, dissolving both by mixing them together'.[10]

If that is the case, and if we, as a consequence, cannot rely on the sub-ject/object, producer/consumer distinction anymore, and if consequently the book is an assemblage of material and immaterial traces of thought and mat-ter, Henri Bergson's *Matter and Memory* has a lot to contribute towards a theory of perceptual reading, especially in relation to the links it establishes between making sense and perceiving, between interiority and exteriority, part and whole, and in relation to what Bergson understands as a body. For Bergson, the body – understood as the image at the centre of an assemblage of infinite images and to which we refer all other images – is the 'place of passage of the movements received and thrown back, a hyphen, a connect-ing link between the things which act upon me and the things upon which I act'.[11] Thus, a body, 'in the aggregate of the material world', is 'an image which acts like other images, receiving and giving back movement', which is to say that *every* image, at *every* given moment, is simultaneously the subject and object of movement. The distinction between interiority and exterior-ity is 'merely the distinction between my body and other bodies', and thus between 'the part and the whole'. Accordingly, the separation between a thing and its environment 'cannot be absolutely definite and clear-cut', since 'the perpetuality of their reciprocal actions and reactions is sufficient to prove that they have not the precise limits which we attribute to them'.[12] It is perception that outlines their form and it does so according to bodies, bodies carved out from all the other bodies, with which they can enter into relations 'as if with persons'. If read analogically, the book and the reader become images among an infinite number of images. This allows us to imagine a reading that transcends words, pages and books, and applies to a critical perception of

[8] Certeau, Michel de, *The Practice of Everyday Life* (Berkeley: University of California Press, 1988) 165, 169.
[9] Certeau, *The Practice* 170.
[10] Certeau, *The Practice*.
[11] Bergson, Henri, Palmer, W. Scott and Paul, Nancy Margaret, *Matter and Memory* (Cambridge, MA: MIT Press, 1991) 151–2.
[12] Bergson, *Matter and Memory* 209.

matter and matters alike. For Bergson, perception is always oriented towards action. It is a moving towards, a reaching out and a setting into motion of images and bodies that are about to touch and be touched; '[d]irection but not goal-directed', an 'affirmation of a movement toward',[13] sensing and thereby paving the way for what Manning imagines as a 'politics of touch', 'the incommensurability of sense', and thus a synaesthetic reading of matter.[14] It is crucial to point to the critical implications we can infer from a theory of reading as always also sensing and perceiving, for it necessarily also requires an 'education of the senses' that would be able to overcome the gaps in our perception, since 'between sounds, between odors, between tastes, there are gaps', 'there are intervals of silence'.[15] Taking our point of departure from all of these texts – as well as from the *Anti-Narcissus*[16] and the book that would finally break through stern legal forms and patterns – we can already sense a mode of reading that we can try to make useful for legal theory, too.

Sensing Assemblages and Sensate Assemblies

Many of the theoretical (and practical) approaches that took hold in the last ten to fifteen years responded to what numerous scholars have experienced as a too narrow and strict focus on language. Karen Barad caused a stir in academic circles by beginning her essay *Posthumanist Performativity* with the claim that '[l]anguage has been granted too much power', '[t]he linguistic turn, the semiotic turn, the interpretative turn, the cultural turn', in fact 'every turn lately' has turned everything, 'even materiality', into 'a matter of language or some other form of cultural representation'.[17] Barad, like many other contemporary thinkers, including Donna Haraway, Rosi Braidotti and Eyal Weizman, tries to bring back – meaning: after the linguistic turn, and thus informed by what the linguistic turn and its methods have taught us – materiality into philosophical thinking. There are, of course, major differences even among those who feel drawn to a more materialist approach, which makes it impossible to summarise their thoughts and methods as 'new materialism'. However, there are similarities in what they try to achieve; namely, the dissolution of dichotomies and the reaching out towards what is not generally considered a text, a subject or an actor, that is to say, something that is not only perceived and interpreted but that also gives back something

[13] Manning, *Politics of Touch* 155.
[14] Ibid.
[15] Bergson, *Matter and Memory* 49.
[16] *Anti-Narcissus: Anthropology as Minor Science* (forthcoming).
[17] Barad, Karen, 'Posthumanist Performativity: Toward an Understanding of How Matter Comes to Matter'. In *Signs*, Vol. 28, No. 3, Gender and Science: New Issues (Spring 2003) 801.

material and something that affects. It is in this sense that they all – in one way or the other – refer to what is also at stake in Deleuze's and Guattari's work, or perhaps especially to the unknown but still imagined *Anti-Narcissus*. Each of their methods can show us how the act of reading leaves what we have considered the text or the book, and how its patterns of forms find their (differential) repetition in material assemblages. What is often misunderstood as an attack not only on more traditional approaches to language and literary theory, but also on post-structuralism and critical studies, is actually an attempt to broaden our reading and writing skills, to push them to their (and our) limits. And what is often misunderstood as apolitical or unconcerned with ethics bears strong political and ethical implications. In fact, it aims to introduce both different forms of expression and performative forms of activism that are only made possible by a stronger focus on materiality and which, in turn, require sharpened abilities to sense and perceive material and immaterial forms differently.

This can be seen in Butler's book, *Notes Toward a Performative Theory of Assembly*. At one point, speaking of demonstrations against violent and criminal actions committed by the police – demonstrations that allow for the possibility of overcoming police power precisely because the assemblies become at once too large, too diffuse and too mobile to be contained by it – Butler adumbrates a different understanding of law and the emergence of its legal forms. These 'anarchist moments or anarchist passages', she writes, 'when the legitimacy of a regime or its laws is called into question, but when no new legal regimen has yet arrived to take its place', create an interval that opens itself up for the execution of the 'performative power to lay claim to the public in a way that is not yet codified into law and that can never be fully codified into law'.[18] This performativity not only involves speech, but also 'bodily action, gesture, movement, congregation, persistence, and exposure to possible violence', and urges us to understand this acting together, which 'lays claim to materiality, leans into its supports, and draws from its material and technical dimensions to rework their functions'.[19] In other words, what is at stake here – in relation to law – is a reading of legal forms that emerge outside of written legal texts, and not only involve, but are even predicated on, the interaction of bodies, matter and movement.

In relation to contemporary political challenges and conflicts, the increased attention to matter and materiality in academic thought as a means to respond to these challenges has contributed to what is now termed the

[18] Butler, Judith, *Notes Toward a Performative Theory of Assembly* (Cambridge, MA: Harvard University Press, 2015) 74–5.

[19] Ibid., 75.

forensic turn. Although this turn affects various disciplines, I want to point to the London-based research-agency Forensic Architecture and their wide-ranging publication, *Forensis. The Architecture of Public Truth*, because it brings together a variety of forensic modes, that is, modes of sensing and reading across materiality, which are performed with a strong political and ethical imperative in mind. In the introduction, Eyal Weizman – an architect and himself strongly influenced by Deleuze's work as well as by Deleuze's collaborations with Guattari – describes the 'forensic turn' as 'an emergent sensibility attuned to material investigation' that hold s the potential to invert the current direction of the forensic gaze applied by states or police.[20] The commitment to this reversal is legible in the effort to turn 'forensics into a counter-hegemonic practice able to invert the relation between individuals and states', and 'to challenge and resist state and corporate violence and the tyranny of their truth'. This form of 'transformative politics', Weizman claims, 'must begin with material issues'.[21] In his work, Weizman repeatedly states the close relationship between forensic architecture – as method and practice – with law, legal procedures, legal forums and force(s). The main reason is that this practice – investigative aesthetics, as he calls it in *Forensic Architecture* – 'seeks to devise new modes of narration and the articulation of truth claims', and in so doing has to operate with and within legal frameworks.[22] Build-ings and the built environment – the objects and subjects Weizman uses to articulate an alternative and activist method and practice of aesthetics – function as media since they are storage and inscription devices, while they also interact and affect the very process they record.[23] Buildings – matter in general – sense and thus have to be read as technological, material, political and historical assemblages. This form of reading – one that involves digital and analogue data, and relies on other sensors, too – must not pretend to be objective, but take credit for its own political and activist necessity.[24] What is required is thus a 'critical forensic practice' based on a different understand-ing of aesthetics, namely as 'sensorial capacity of matter itself', and thus 'the way in which matter can detect, register, and respond not only to contact and impact, but to influences in its environment and to remote presence'. What Weizman terms *material aesthetics* 'captures the way in which matter absorbs or *prehends* its environment', how matter relates and affects, and is thus both

[20] Forensic Architecture, *Forensis: The Architecture of Public Truth* (Berlin: Sternberg Press, 2014) 10.

[21] Ibid., 11.

[22] Weizman, Eyal, *Forensic Architecture: Violence at the Threshold of Detectability* (New York: Zone Books, 2017) 94.

[23] Weizman, *Forensic Architecture*, 53.

[24] Ibid., 74.

'prior and primary to human perception, apprehension, and judgement'.[25] In this account of reading, subject and object, reader (architect) and text (material interrelations and assemblages) switch back and forth, and thereby constantly affect and influence each other. The political dimension, then, results from the articulation of a multimaterial reading, since forensic aesthetics 'is not only the heightened sensitivity for matter or of the field', but, Weizman cautions, 'relies on these material findings brought into a forum'.[26] This is not far from Butler's claim. Although she formulates her argument in relation to Hannah Arendt and thus speaks of spaces of appearance (of bodies and, as a consequence, political subjects) instead of forums 'where matter becomes a political agent',[27] Butler nevertheless takes the materiality of field, space and bodies into consideration. While Weizman speaks of a sensitivity towards matter that can invert political hegemonies, Butler states that assembling bodies in the street can 'redeploy the space of appearance in order to contest and negate existing forms of political legitimacy', and 'as they fill or take over public space the material history of those structures works also on them, becoming part of their very action, remarking a history in the midst of its most concrete and sedimented artifices'.[28] Both Butler and Weizman suggest that materiality and matter cannot be separated from sensing human subjects, and that a performative reading that exceeds the written text and its structural properties precedes political – even legal – actions that are then able to rewrite the hegemonic texts of law and state, as well as the respective regimes of truth applied by them.

In *New Directions in Law and Literature*, Peter Brooks reminds us of the value of understanding detective stories and their mode of narration for legal practice.[29] Picking up on the detective story, we can say that the forensic turn resulted simultaneously in the dissolution, dissemination and multiplication of the detective, while the material turn led to the scattering of clues which became agents themselves, sensing and sensing back at the multiplicity of detective-assemblages which continuously record, narrate and counter-narrate. In *A Thousand Plateaus*, Deleuze and Guattari dedicate a long section to the novella. Perhaps, in a book still to come, in a book *of* and *by* law that will unsettle legal thought, it will indeed be the detective story

[25] Weizman, *Forensic Architecture*, 94–5.

[26] Forensic Architecture, *Forensis*, 15.

[27] Ibid.

[28] Butler, *Notes* 85.

[29] Brooks, Peter, 'Retrospective Prophecies: Legal Narrative Constructions'. In Elizabeth S. Anker and Bernadette Meyler (eds), *New Directions in Law and Literature* (Oxford: Oxford University Press, 2017) 92–108.

that helps us develop forms of engaging with the law's material, rhizomatic and performatively (un)structured narrations.

Reading Law: The Book that Matters and Matters of Legal Form(s)

Reading law

Similar to what Deleuze and Guattari term 'book', the law too cannot be restricted to a single form, or a collection of fixed forms; it takes on various material and immaterial shapes, it acts on bodies and is enacted by bodies, it produces excess and simultaneously reproduces itself as this very excess – an excess that goes far beyond the written, and that nevertheless needs to be recognised as belonging to the law's text. While it is, by now, already broadly accepted that the text of law exceeds its written dimensions, its papers, documents, court decisions, law codes and constitutions, the skills we need to *read* and *perceive* the law's *texture* remain neglected.

If law is understood as both multimedial and multisensual, the question of its perceptibility must be raised. This perceptibility is not necessarily restricted to the human senses, but points to the law's materiality – the often overseen, overheard, untouched, forgotten or ignored parts of law. Andreas Philippopoulos-Mihalopoulos describes what is at stake when he warns that '[i]n the legal system, the withdrawal of matter is an everyday occurrence', because 'law presents itself as immaterial, abstract, universal, non-geographical'.[30] As a consequence, it is important to realise that 'the law is not just the text, the decision, even the courtroom. Law is the pavement, the traffic light, the hood in the shopping mall, the veil in the school, the cell in Guantanamo, the seating arrangement at a meeting, the risotto at the restaurant.'[31] Law, for that matter, 'does not dwell on the textual (that too) but expands on the space and bodies that incorporate it and act it out'.[32] We have to challenge a law that 'is quite comfortable with fiction, fabrication, abstraction, and an entirely relational dynamics'.[33] We must rethink what it means to read the law in its multidimensionality, because what gets lost, what gets dispossessed, deprived, contaminated, hurt and even killed, erased, effaced, is by no means just fiction,

[30] Philippopoulos-Mihalopoulos, Andreas, 'Critical Autopoiesis and the Materiality of Law', *International Journal for the Semiotics of Law – Revue internationale de Sémiotique juridique* 27, No. 2 (2014) 410.

[31] Ibid.

[32] Philippopoulos-Mihalopoulos, Andreas, *Spatial Justice: Body, Lawscape, Atmosphere* (London: Routledge, 2015) 3.

[33] Davies, Margaret, 'The Consciousness of Trees', *Law and Literature*, Vol. 27, No. 2 (2015) 231.

abstraction, words, texts and concepts, but bodies (whether human or non-human), organisms and environments.

It goes without saying that the claim that law is also material, and thus transcends what we are used to term the (written) legal text, the book of law, does not free us from raising the question of form – quite the opposite. In order to read law across its materiality it is necessary to pay attention to how this alternative understanding of law might affect its forms and, even more so, their reproducibility. Law, as it is commonly conceptualised, strives for generality and for the ability to create forms that are broadly applicable by subsuming multiplicities, singularities and assemblages of an infinite number of details under a common term or a static scenario. The creation of common forms in general, and of the forms of law in particular, consists of two crucial steps. First, any form of movement has to be interrupted, and similar to a cut-out, a freezing of time and space relations, a separation of parts from an (imagined or real) whole has to be performed in order to create the illusion of stasis, which allows for the second step, namely the proclamation of generality by means of the comparability of separated parts.[34] We can conceive of this step as the creation of a legal case, or, even more so, the issuing of a single law. In order to speak of a complex of interrelated, entangled events, perspectives and details as a 'case', or a 'law', particular parts, namely those which fit well into the larger structure of legal forms (the legal order), have to be isolated and analysed. This of course involves an act of selection that cannot account for the singularity of the case or law. Moreover, it has to forget and suppress more than it can contain by means of – and this is the second step – producing sameness and comparability. In *Creative Evolution*, Bergson outlines the limits of a way of thinking, perceiving and analysing – he is speaking mostly of science, but what he says is also applicable to contemporary legal thinking – that aims for the general predictability of forms. It is indeed, Bergson states, the 'unforseeability of forms' that makes the intellect – always in the service of science and logical reasoning – revolt, since it 'selects in a given situation whatever is like something already known', and it seeks it out 'in order that it may apply its principle that "like produces like"'. This separation of parts, this breaking down of it into 'elements and aspects, which are approximately a reproduction of the past',[35] is what still provides law – we might as well call it legal science – with its most powerful tools. It creates general, comparable, static legal forms by separating parts of actions, detached from the flux of time as well as from the complex space relations from which they evolved.

[34] The German (legal) term *Tatbestand* – which might be best translated as 'state of offence' – refers to precisely this cut-out, that is, a static moment, separated from past and future, which is subject to isolation and consequently analysis.

[35] Bergson, Henri, *Creative Evolution* (Mineola, NY: Dover Publications, 2016) 45.

This is especially true for most of the legal systems in continental Europe, since the legal edifice relies heavily on analogy, which by definition refers to similarity and comparability. Whatever the (legal) case, the form will not, and in fact is not supposed to, bend. Instead, subjects have to make themselves fit into the – without doubt by no means objective, but rather gendered, racialised, class- and culture-related – form. This is why Deleuze calls the law 'an empty form of difference, an invariable form of variation'.[36] The differential repetition, as Deleuze envisions it, is inventive and creative, and therefore 'against the law', that is, 'against the similar form and the equivalent content of law'.[37] This is not to say that law does not aim for its own repeatability, but that this repetition is fundamentally different from Deleuze's concept. It pertains to the kind of repetition Bergson deplores, since it is unable to create new forms and only aims for a simple 'reproduction of the past'.[38] In order to attain the generality that sustains the static legal order, repetition can only pertain to form. As a consequence, individuality, singularity and whatever exceeds the given form, the fixed frame of the cut-out, is relentlessly sacrificed in the name of the law.

This insight has a significant effect on how we think time in regard to law. If law is sustained and applied in accordance with a non-differential, mechanical repetition of the ever-same form, it also introduces the future in the form of a certain predictability. Law is generally understood in relation to a self-produced, linear concept of time, which consists of continuous, almost mechanical repetitions of forms (cut-outs, frames, images). As the reproduction of the same, of likeness, mechanical repetition is in principle not creative. As a consequence, the (legal) past and the (legal) future become interchangeable, reducing the potentially inhabitable present of the legal subject to a ready-made form or mould. A series of images, side by side, one after the other, one before the other, relentlessly narrating a specific – national, international, supranational – legal fairytale now and, if needed, for eternity. This is what Deleuze means when he claims that a law, as empty form, 'compels its subjects to illustrate it only at the cost of their own change'.[39] This process of forcing them into pre-made forms of legal subjectivity does not result in what Agamben understands as 'bare life', a life cast outside the polis and the law,[40] but can be compared to Butler's 'frames', which operate within legal and political power relations and thereby shape both our perception

[36] Deleuze, Gilles, *Difference and Repetition* (London [u.a.]: Bloomsbury, 2014) 2.
[37] Ibid.
[38] Bergson, *Creative Evolution* 45.
[39] Deleuze, *Difference and Repetition* 2.
[40] Agamben, Giorgio, *Homo Sacer: Sovereign Power and Bare Life* (Stanford: Stanford University Press, 2010) 8.

and our understanding of precariousness, of whose life is grievable and, in regard to law, of whose life fits the law's narrative best – and at what price.[41] 'The subject who is crafted to appear before the law', Butler warns, 'is thus not fully determined by the law'; what's more, 'this extra-legal condition of legalization is implicitly (non-juridically) presupposed by law itself'.[42] Hence, law – exceeding the written text and comprising the infinitude of its unperceived forms – always also exists in the *in-between* of its proclaimed forms, that is, in the laws and the cases we acknowledge, and are in fact obliged to acknowledge, as 'the law'. Indeed, it is in the in-between spaces of the reproduced legal forms, in what Bergson calls 'duration, which is, as it were, a hyphen, a connecting link', in what is called an 'extra-legal' condition, that not only legal subjectivity but law itself unfolds. Sensing these in-betweens – the hyphens that not simply hover between two entities, but in fact affect and even constitute them – requires a different form of reading, which is to say a mode of reading that can take account of what constitutes the becoming of legal, biological and conceptual subject-assemblages.

The Book that Matters and Matters of Legal Form(s)

How closely the question of literature and genre is linked to that of legal forms and their replication was demonstrated in 2010 when scientists at the JCVI (J. Craig Venter Institute) 'inscribed' not only their names but also lines of literature into a genome of a synthetic microbe. As Sophia Roosth explains in more detail, the researchers used watermarks bearing non-coding nucleic acid scrawls. The fourth watermark not only bore the names of the scientists, a secret code that directs the code-breaker to a URL and email account, but also quotations by Richard Feynman, Robert Oppenheimer and James Joyce.[43] It was especially the latter – more precisely a line from *A Portrait of the Artist as A Young Man* – that displayed the complexity of the meaning of reading texts and books (as mediums) in regard to living and legal forms, since it did not take long for Venter to receive a letter from the Joyce estate that claimed a breach of copyright. Immediately, the question of whether or not this 'breach' would apply each time microbes multiply, resulting in an infinite number of copyright infringements, arose. Roosth mentions this example for two reasons. First, she emphasises the analogy between DNA and code and thus writing in order to show 'how such analogies come to matter not just as ways of thinking about biology but as ways of doing biology', which of course

[41] Butler, *Frames* 29.
[42] Ibid., 140.
[43] Roosth, Sophia, *Synthetic: How Life Got Made* (Chicago: University of Chicago Press, 2017) 96.

also involves legal questions. Second, she points out that synthetic biology disrupts and fractures divisions between copyright and patent law, 'problematizing what count as words or things, creative expressions or pragmatic tools, and identity as inhering in materiality or form'.[44] This suggests how complex and material the relations of law and (living as well as legal) form are, and how closely linked to how we understand the act of reading, which also pertains to our conceptions of book, text, quotation and reference. If a line by James Joyce can be inscribed on a genome, what kind of text does it embody, and can its replication be understood as potential copyright breaches, and what is its relation to the Joycean text from which it was taken? This becomes all the more peculiar if we take into account that the synthetic cell came to life, began to grow and divide, and thereby copied its entire DNA – including the literary line. Since – as Carl Zimmer, a science blogger who followed the development of this discussion closely, noted – every time an organism replicates, 'each spot in its DNA has a tiny chance of mutating', it is by now 'almost certain that Joyce's watermark has already been defaced by a mutation'.[45] The inscription and quotation became defaced and thus illegible due to the multiplication and all too differential repetition of its form. This is also the point where the discussion of the relation between law, form and differential replication would have become incredibly intricate, if the copyright to the Joyce text had not expired on New Year's Eve 2012. Already at the beginning of this essay we were prompted to think about the limits of quotation and textual references when confronted with de Castro's reference to a book he only imagines existing, and which in fact only comes into being as a place of reference for his beginner's guide. Thus, with every word, and every written line, he is shaping and changing the book, which at the same time is said to precede his book, even if it has not yet been written. In the case of the genome, a mutable entity, serving as a medium for literary inscription and thus also for a form of text, the issue of the limits – or outlines – of book and quotations takes on a more material dimension. In either case, the question of reproducibility and retrieval of form is taken to its limits and opens up possibilities for us to rethink forms in relation to literature (James Joyce), text (code, letters, sentences), medium and matter (cells, genomes), and law (legal forms, copyright, patent).[46]

[44] Roosth, *Synthetic* 97–8.

[45] Zimmer, Carl, 'James Joyce's Words Come To Life, And Are Promptly Desecrated', *Discover* blog *The Loom*, 21 May 2010 (last accessed 17 September 2018), http://blogs.discover-magazine.com/loom/2010/05/21/james-joyces-words-come-to-life-and-are-promptly-desecrated/

[46] See also Vanasco, Jeannie, 'Literary Immortality Through DNA Coding: An Investigation', *The New Yorker*, 23 March 2011 (last accessed 17 September 2018), https://www.newyorker.com/books/page-turner/literary-immortality-through-dna-coding-an-investigation.

Another remarkable study, led by Harvard geneticist Seth L. Shipman and published in the journal *Nature* in July 2017, demonstrates how living forms and differential repetition (or, in living forms, replication prone to mutation) can, due to technological developments, radically change our conceptions of the archive and its production. The study explained how the team of researchers inserted first an image of a human hand, and then even a GIF – a five-frame clip from Eadweard Muybridge's *Human and Animal Locomotion* – into a living E. coli bacteria by using a gene-editing system called CRISPR (clustered regularly interspaces short palindromic repeats). 'Here we use the CRISPR–Cas system to encode the pixel values of black and white images and a short movie into the genomes of a population of living bacteria', the authors write, and add that, in doing so, they 'push the technical limits of this information storage system and optimize strategies to minimize those limitations'.[47] In an interview with *The Guardian*, Shipman states that what they are trying to develop is 'a molecular recorder that can sit inside living cells and collect data over time'.[48] What this means is that it might not take long until it is possible to use this system to create cells that record events in their environment, or even provide some form of living record of their own existence. While this might already make us think about our understanding of reading, the fact that the human eye is not able to perceive DNA adds another layer to this issue, since what the researchers actually saw and what they present is only a computer representation of the sequenced DNA. As Natasha Myers writes in her recently published book *Rendering Life Molecular*, the task of modellers who work on molecular levels – for example, protein modellers – and who attempt to build sound models of things they cannot actually see is not an idle one. Faced with the question of how to 'fill in the gaps between a perceptible world of aggregate substances (like cells, tissues, and bodies) and the largely imperceptible realm of molecular phenomena', they build models on which our understanding of crucial facts of life depend. Indeed, these in-betweens – what falls outside perceptible forms of matter – determine our understanding of bodies, life, matter, and the evolutionary stories we tell ourselves and force onto others. This is why Myers cautions us to continue – as scholars in feminist and sciences studies have already been doing for a while now – to 'pay close attention to the techniques and practices

[47] Shipman, S. L., Nivala, J., Macklis, J. D. and Church, G. M., 'CRISPR-Cas Encoding of a Digital Movie Into the Genomes of a Population of Living Bacteria', *Nature* 547, No. 7663 (2017) 345.

[48] Sample, Ian, 'Harvard scientists pioneer storage of video inside DNA', *The Guardian*, 13 July 2017 (last accessed 17 September 2018), https://www.theguardian.com/science/2017/jul/12/scientists-pioneer-a-new-revolution-in-biology-by-embeding-film-on-dna.

that shape matter and materiality', in order 'to see what forms of life and what materialities are coming to matter in the twenty-first-century life science'.[49] The question of the relationship between reading and the necessary 'education of the senses' thus takes on a different dimension when thought in relation to contemporary scientific research and law.[50] In line with Sheila Jasanoff's claim that 'granting patents on living things involved decisions about where to draw the line between life and matter',[51] Sophia Roosth argues that nothing other than the presence of both patent and copyright in synthetic biology is enabled 'by assumptions of what life is *like* as well as how it *should be* remade, debugged, rewired, or rewritten'.[52] This is, without doubt, a question of how we read, and it is no coincidence that the human genome is still referred to as the 'Book of Life', an uncanny reference that should encourage us to register the urgency of rethinking the relations among the book, life and law.

Perhaps, in the book still to come, in a book *of* and *by* law that will unsettle legal thought and that will contain a section on the detective story, attention to the forms of autobiographies – perhaps encoded on living cells and readable with yet newer technologies than those that made *A Thousand Plateaus* performable – has to be paid in order to understand forms of life, of self and self-narration, and of the possibility to read ever-shifting forms that escape our immediate perception while simultaneously shaping and changing our conception of it.

Reading Movement: Legibility and Legality of Movement

Reading Movement

If the law is not exclusively represented by and embodied in the written legal text, that it is material, that it exceeds the almost mechanically reproducible forms, bears the potential of rupture, invention and breakage, we can perhaps open the concept of the law to what represents the greatest threat to the static legal order: unpredictable, non-linear, incalculable and thus destabilising movement. In order to demonstrate how strongly law adheres to stasis, how deeply it fears movement, it might suffice to think about the concept of property and ownership of land, whereby land is (legally) imagined as a rather static term, geographically locatable via co-ordinates, conceptualised

[49] Myers, Natasha, *Rendering Life Molecular* (Durham, NC: Duke University Press, 2015) xi.
[50] Ibid., 167, 172.
[51] Jasanoff, Sheila, 'Taking Life: Private Rights in Public Nature'. In K. Sunder Rajan (ed.), *Lively Capital: Biotechnologies, Ethics, and Governance in Global Markets* (Durham, NC: Duke University Press, 2012) 181.
[52] Roosth, *Synthetic* 83.

and controlled by means of planning and mapping, rather than what it is; namely, a constantly moving assemblage of, among other things, soil, water, animals, plants, air, light, culture, humans and non-humans. We just have to call to mind how 'land' is tied to the concept of territory, of states and their territorial claims, secured by borders, which undeniably serve to stop, or at least regulate, movement. In principle, from the point of a law that serves generality and comparability, everything that moves needs to be strictly directed and controlled. In spatial terms, we can think of roads, railways, sidewalks, gates, borders, frontiers, or we can think of airports and railway stations, which are said to pose the greatest 'security risk' precisely by dint of the more or less uncontrollable movement of bodies, germs, machines, beliefs, emotions. In temporal terms, we can imagine certain hierarchies, which require a linear and predictable movement, be it of bodies, the required age for entering elementary school, inheritance law, or even healthcare regulation. The incommensurability of law with forms of unpredictable movement becomes palpable in many ways and in regard to various legal problems, such as in debates on the rights of refugees, who are, needless to say, forced to move, or on (semi-)nomadic, in many cases indigenous, peoples, who often depend on natural, constantly moving, shifting and changing habitats. Similarly, the question of whether animals, plants, rivers or whole environments – all moving according to their own laws and circumstances, hence not subsumable under existing legal forms – can or should be legal subjects, can be seen from this angle. While there are arguments concerning the ethics of this question, the tendency of (Western) legal systems to arrest movement(s) plays a great role in the difficulty of integrating it into law and legal thinking.

Can movement be read, and if so, how can it be performed? An attempt to approach this question brings us back to Butler's concept of 'frames', for it not only builds a bridge between perception and conceptualisation, but also provides a method to perform a rereading of law that allows for movement and rupture. Frames, she argues, are 'subject to an iterable structure', meaning that 'they can only circulate by virtue of their reproducibility, and that very reproducibility introduces a structural risk for the identity of the frame itself'. Because the frame 'breaks with itself in order to reproduce itself', the reproduction becomes the site where a politically and, I would add, legally consequential break is possible.[53] To understand the legal order in terms of an accumulation of fixed forms (or frames) of cases and laws is to ignore the (constitutive) *in-betweens*, that is, what is declared legal waste, what is cut off, left out and suppressed in order to reproduce the ever-same – what is logically structured, organised and thus predictable. Indeed, according to Deleuze and

[53] Butler, *Frames* 24.

Guattari, *between* 'does not designate a localizable relation going from one thing to the other and back again', but 'a transversal movement that sweeps one *and* the other away, a stream without beginning or end that undermines its banks and picks up speed in the middle'.[54] What becomes the *between* is where the neither legal nor illegal drowning of the refugee happens, it is where environments move borders that do not – and perhaps never did – coincide with the legally determined borders of the states, shifting natural habitats and exposing populations to famine and drought, while it is still argued that their changed situation nevertheless needs to fit into the provided legal form. Between the scenarios and frames created by what is considered to be 'law', law – in its ever-changing entirety, materiality, fluidity – moves unperceived (though not unperceivable!), hidden, escaping our legal, political and ethical attention, seizing matter, getting woven into the legal texture without gaining access to the text of law.

Legibility and Legality of Movement

Imagine the law embodied, sitting on the couch. It looks slightly depressed, and severely suppressed. Perhaps it is purposely hiding or kept hidden; it's always hard to tell. Legal subconsciousness and legal self-narration strikes me as an odd combination. Nevertheless, now is the time, and here is the place, to ask the right questions. Were you moving enough? Were you moved by anything? What moved you? Did you do anything constructive? As usual, it was at work everywhere, functioning smoothly at times, at other times in fits and starts. It also breathed, heated, ate, shat and fucked.[55] In fact, it really did.

In his essay, 'Tracing Bacterial Legalities', Christopher Bear demonstrates in detail how the Bathing Water Directive (2006/7/EC), introduced in 2006 in its revised form by the European Union, was an attempt to respond to surfacing issues of fluidity, movement and dispersal. In following the flow of bacteria-infused animals, be it domestic dogs or shoreline birds, and that of the bacteria that emanate from them, he highlights how water quality regulation, namely the EU Directive, 'extends beyond the designated bathing water sites', rendering certain animals polluters, despite their bodily presence. As Bear shows, the movement of animals and the flow of faecal bacteria coincided with the flow of the law itself. It is precisely the movement of non-human actors, birds, dogs, faecal bacteria, sun, wind and water that challenges the Directive's attempts to presume a static environment where it can apply its

[54] Deleuze and Guattari, *A Thousand Plateaus* 25.
[55] Deleuze, Gilles and Guattari, Félix, *Capitalism and Schizophrenia* (Minneapolis: University of Minnesota Press, 1983) 1.

rules, norms and measurements. Since '[t]he actions and movements of animals increase the spatial complexity of the Directive's implementation', Bear's analysis shows how 'the managers' increasing ability to pinpoint sources of bacteria can lead to the construction of particular animals as polluters'.[56]

Studies of movement, moving bodies, the regulation of movement on land, sea, air, even in outer space,[57] take materiality into consideration and are often associated with space. This is why crucial contributions to the law have been made by legal geographers, who focused on the movement of certain entities through space(s), and by architects, who sought ways to read movement in space. Increasingly, technological developments and the rise of virtual spaces, virtual and augmented reality, have provoked even more complex issues in regard to law and movement. Since its release in July 2016, Niantic's location-based augmented reality videogame Pokémon Go has provoked various legal issues and discussions, many of them related to either trespassing on private property (while virtually only seeking a Pokémon or other virtual objects that Niantic has placed there), or to traffic accidents which led to attempts to legally force Niantic to update their game and disable it when players are driving. By focusing on East Jerusalem, Fabio Cristiano and Emilio Distretti show how Pokémon Go creates an augmented reality that reproduces suppressive legal and political structures by restricting movement of certain bodies while facilitating that of others. Pokémon Go uses GPS technology to locate and trace the player, and it uses the camera and the gyroscope on the player's mobile phone to project virtual objects and creatures on the display, as if they were at the same real-world location as the player. As a consequence, the game requires the players to walk through real space, looking for virtual objects, seeking other players in order to interact with them and their Pokémon. While the game has been praised for fostering social interactions between players, Cristiano and Distretti show that in East Jerusalem 'walking remains heavily disciplined through those polymorphous technologies of control that materialize Israeli infrastructural power and occupation', and which de facto hinders 'the intrinsic sociality of walking'.[58] In addition, movement is not only restricted by the translation of power dynamics into the augmented reality space, but also by poor mobile

[56] Bear, Christopher, 'Tracing bacterial legalities: the fluid ecologies of the European Union's Bathing Water Directive'. In Irus Braverman (ed.), *Animals, Biopolitics, Law: Lively Legalities* (New York: Routledge, 2016) 90.

[57] See Collis, Christy, 'The Geostationary Orbit: A Critical Legal Geography of Space's Most Valuable Real Estate', *SORE The Sociological Review* 57 (2009) 47–65.

[58] See Cristiano, Fabio and Distretti, Emilio, 'Along the Lines of the Occupation: Playing at Diminished Reality in East Jerusalem', *Conflict and Society* 3, No. 1 (2017) 130–43.

data connections. What is interesting is that, in order to read movement and its relation to the legal architecture of East Jerusalem, the researchers had to actually play the game. Reading as poaching – quite literally. Every story is a travel story. 'Readers are travellers', de Certeau states, for 'they move across lands belonging to someone else'. As a poaching traveller, the reader not only 'escapes from the law of each text', but also from the textual law.[59] Reading as poaching, travelling, sensing, perceiving, recording, carries a political imperative as well as an ethical responsibility. This is also why, as de Certeau puts it, '[a] politics of reading must thus be articulated on an analysis that, describing practices that have long been in effect, makes them politicizable'.[60]

Perhaps the book to come, the book *of* and *by* law that will unsettle legal thought, that will contain a section on the detective story, and will pay close attention to novel forms of autobiographies, will also show how every story is a travel story, and how every reader is a traveller. This book to come, then, will require its readers to travel across textual, legal, social, political and material spaces, and will caution them always to have their virtual travel books ready, in order to collectively record, sense, perceive and trace matter and movement in law and legal spaces.

Reading Law: Yet to Come

De Castro's homage to a book yet to come – his beginner's guide to this book – not only opens up our imagination for what might be possible in the future in relation to the past and for how we might take action in response to this potentiality. It also urges us to recognise the book as a performative medium, the potentiality of a creative, perhaps agential reading, and makes us aware of our complicity or activism in creating it. In fantasising about a manual for the beginner's guide to the book *of* and *by* law – always yet to come, material and immaterial, actual and virtual, text and reference, digital and analogue, synthetic cell and word, subject and object, inside and outside – I imagine a book which is and isn't a book, and whose becoming and coming into being cannot be separated from the act of reading. Reading law becomes a generative – rather than generic – practice that makes cases for counter-law(s). Detective stories yet to come, that feature a meticulously detecting collective, literate in law's multiplicity, at the same time tracing and being traced by clues. These clues, in turn, rather than reconstructing a presupposed narrative, generate stories that matter differently. As such, the book *of* and *by* law will create a different form of responsibility, a form that

[59] Certeau, *The Practice* 174.
[60] Ibid. 173.

takes response-ability – the ability to respond and to act – into consideration and raises questions not from within but *with*, that is, in relation to what is read. Reading territorial rights *with* the material and perceivable effects of climate change, and reading human rights *with* what is considered non-human, a-human, post-human, reading-with as creating references to laws yet to come.

Instead of forcing genre and form onto life and bodies, this book – as the becoming-book of the law which allows both law and book to become something else – exists not only *in* but *as* a material and conceptual relation. It opens up the question of autobiography anew and from a legal perspective, precisely because it asks about the possibilities of narrating a legal Self (*auto*), which necessarily unsettles legal categories like legal subject and legal object. Legal acts such as the granting of legal rights to the Whanganui River in New Zealand, or the Ganga and Yamuna rivers in India, the granting of rights to nature in Ecuador's constitution, or the discussion on creating a new legal category for robots – as proposed in the *Draft Report with Recommendations to the Commission on Civil Law Rules on Robotics* presented to the European Parliament by the Committee on Legal Affairs in 2016 – can be seen in the context of novel narrators of alternative legal selves.[61] This book would also uncover how the notion of life (*bio*), which – as adumbrated in relation to synthetic biology and genetics, but also to environmental studies and ethics – is always already entangled with what sustains it. Consequently, it prompts us to look closely at how the law defines and narrates what is considered both a life and aliveness.

This book *of* and *by* law will have to take account of its multiplicity, its material and discursive, human and non-human, legal and illegal assemblages. It will have to consider the state of things and bodies that mix and interpenetrate each other, and regimes of utterances that reorganise signs in a different way: 'new formulations appear, a new style for new gestures'.[62] Reading-*with*: new stories for new laws. Indeed, as Anna Tsing argues, assemblages 'show us

[61] The report argues the necessity of creating a new legal status for robots as follows: '[N]ot only are today's robots able to perform activities which used to be typically and exclusively human, but the development of autonomous and cognitive features – e.g. the ability to learn from experience and take independent decisions – has made them more and more similar to agents that interact with their environment and are able to alter it significantly.' Draft Report with recommendations to the Commission on Civil Law Rules on Robotics (2015/2103(INL)), available at http://www.europarl.europa.eu/sides/getDoc.do?pubRef=-//EP//TEXT+REPORT+A8-2017-0005+0+DOC+XML+V0//EN, (last visited: 16 September 2017).

[62] Deleuze, Gilles and Parnet, Claire, *Dialogues II* (New York: Columbia University Press, 2007) 70–1.

potential histories in the making'.[63] And yet, the potentiality of different legal histories in the making can only be actualised if we acquire skills to read the law in its multimediality and materiality, because, as Haraway states, 'it matters what stories make worlds, what worlds make stories', and it also 'matters what matters we use to think other matters with; it matters what stories we tell to tell other stories'.[64] Stories of faecal bacteria co-authoring directives, stories of life-assemblages ghost-writing human rights, stories of detective-collectives drafting counter-laws, stories of readers as travellers rewriting laws of virtual worlds.

It is in our relentless endeavour to categorise, that is, to determine the distinctiveness of these stories that will potentially have mattered differently, that we encounter one of the greatest challenges in imagining this book yet to come: it necessarily challenges our assumptions about genre, form and formation, which is to say, all the ways in which we apply and generalise, affiliate and analogise, organise and structure. It simply defies static definitions. There is no doubt that the book *of* and *by* law has never been, can never be, or ever become a code, although it refers to and partly even depends on it. At this point, in drafting a manual, the book *of* and *by* law might best be imagined as a common law book, or rather a common book *of* and *by* law. Or perhaps we have to stop imagining books, and start reading the law to come.

Bibliography

Agamben, Giorgio (2010): *Homo Sacer: Sovereign Power and Bare Life*, Stanford: Stanford University Press.

Barad, Karen (2003): 'Posthumanist Performativity. Toward an Understanding of How Matter Comes to Matter'. In *Signs*, Vol. 28, No. 3, Gender and Science: New Issues (Spring 2003), 801–31.

Bear, Christopher (2016): 'Tracing bacterial legalities: the fluid ecologies of the European Union's Bathing Water Directive'. In Irus Braverman (ed.), *Animals, Biopolitics, Law: Lively Legalities*, New York: Routledge, 79–96.

Bergson, Henri, Scott Palmer, W. and Paul, Nancy Margaret (1991): *Matter and Memory*. Cambridge, MA: MIT Press.

Bergson, Henri (2016): *Creative Evolution*, Mineola, NY: Dover Publications.

Brooks, Peter (2017): 'Retrospective Prophecies: Legal Narrative Constructions'. In Elizabeth S. Anker and Bernadette Meyler (eds), *New Directions in Law and Literature*, Oxford: Oxford University Press, 92–108.

[63] Tsing, Anna Lowenhaupt, *The Mushroom at the End of the World: On the Possibility of Life in Capitalist Ruins* (Princeton and Oxford: Princeton University Press, 2015) 25.

[64] Haraway, Donna J., *Staying with the Trouble: Making Kin in the Chthulucene* (Durham, NC: Duke University Press, 2016) 12.

Butler, Judith (2015): *Notes Toward a Performative Theory of Assembly*, Cambridge. MA: Harvard University Press.

Butler, Judith (2009): *Frames of War: When Is Life Grievable?*, London and New York: Verso.

Butler, Judith (2012): 'On This Occasion'. In Roland Faber, Michael Halewood and Deena Lin (eds), *Butler on Whitehead: On the Occasion*, Lanham, MD: Lexington Books.

Castro, Eduardo Viveiros de and Peter Skafish (2014): *Cannibal Metaphysics: For a Post-structural Anthropology*, Minneapolis: Univocal.

Certeau, Michel de (1988): *The Practice of Everyday Life*, Berkeley: University of California Press.

Collis, Christy (2009): 'The Geostationary Orbit: A Critical Legal Geography of Space's Most Valuable Real Estate', *SORE The Sociological Review* 57: 47–65.

Cristiano, Fabio and Distretti, Emilio (2017): 'Along the Lines of the Occupation: Playing at Diminished Reality in East Jerusalem', *Conflict and Society* 3, No. 1, 130–43.

Davies, Margaret (2015): 'The Consciousness of Trees', *Law and Literature*, Vol. 27, No. 2.

Deleuze, Gilles (2014): *Difference and Repetition*, London: Bloomsbury.

Deleuze, Gilles and Parnet, Claire (2007): *Dialogues II*, New York: Columbia University Press.

Deleuze, Gilles and Guattari, Félix (1983): *Capitalism and Schizophrenia*, Minneapolis: University of Minnesota Press.

Deleuze, Gilles and Guattari, Félix (2014): *A Thousand Plateaus: Capitalism and Schizophrenia*. Translated by Brian Massumi. Minneapolis and London: University of Minnesota Press.

Derrida, Jacques (1992): 'Force of Law: "The Mystical Foundation of Authority"'. In Drucilla Cornell, Michel Rosenfeld and David Gray Carlson (eds), *Deconstruction and the Possibility of Justice*, New York: Routledge, 1–67.

Forensic Architecture (2014): *Forensis: The Architecture of Public Truth*, Berlin: Sternberg Press.

Haraway, Donna J. (2016): *Staying with the Trouble: Making Kin in the Chthulucene*, Durham, NC: Duke University Press.

Jasanoff, Sheila (2012): 'Taking Life: Private Rights in Public Nature'. In K. Sunder Rajan (ed.), *Lively Capital: Biotechnologies, Ethics, and Governance in Global Markets*, Durham, NC: Duke University Press, 155–83.

Manning, Erin (2007): *Politics of Touch: Sense, Movement, Sovereignty*, Minneapolis and London:University of Minnesota Press.

Myers, Natasha (2015): *Rendering Life Molecular*, Durham, NC: Duke University Press.

Philippopoulos-Mihalopoulos, Andreas (2015): *Spatial Justice: Body, Lawscape, Atmosphere*, London: Routledge.

Philippopoulos-Mihalopoulos, Andreas (2014): 'Critical Autopoiesis and the Materiality of Law', *International Journal for the Semiotics of Law - Revue internationale de Sémiotique juridique* 27, No. 2.

Roosth, Sophia (2017): *Synthetic: How Life Got Made*, Chicago: University of Chicago Press.

Shipman, S. L., Nivala, J., Macklis, J. D. and Church, G. M. (2017): 'CRISPR-Cas Encoding of a Digital Movie Into the Genomes of a Population of Living Bacteria', *Nature* 547, No. 7663, 345–9.

Tsing, Anna Lowenhaupt (2015): *The Mushroom at the End of the World: On the Possibility of Life in Capitalist Ruins*, Princeton and Oxford: Princeton University Press.

Weizman, Eyal (2017): *Forensic Architecture: Violence at the Threshold of Detectability*, New York: Zone Books.

13

Registers of Gay Marriage in New Media and Law

Marco Wan

The seminal case of *Obergefell* v. *Hodges* (2015) guaranteed the right to marry to all gays and lesbians in America, and challenges to the legal restriction of marriage to heterosexual couples in different countries have followed in its wake.[1] The struggle for same-sex marriage was one that took place in the age of new media: in the years leading up to the Supreme Court Decision in 2015, numerous video clips, memes, tweets and other images circulated to advocate for equality. The question of gay marriage was one that was truly 'post-law' as defined in the introduction of this volume: the challenge to the constitutional status quo happened as much on the internet as in the law courts, and advocacy was carried out not only in the judicial realm, but on YouTube, on Facebook, on Twitter, on blogs and on myriad other platforms. As the legal historian Michael Klarman has noted, 'how gay marriage happens may be almost as important as that it happens', and new media is a crucial part of the story (Klarman 2013: 219). Klarman further underscored the importance of gay visibility to the achievement of equality; gay and lesbian couples that were able to marry in their own states before the right was nationally entrenched 'put a face on the issue, enabling Americans to see real people whose lives were affected by the law' (209). The circulation of images of people directly affected by the debate, whether of happy couples holding hands outside city halls or of gays recounting concrete instances of discrimination in the absence of the necessary legal protections, kept marriage equality firmly in view and contributed to the shift in public opinion that in turn formed the critical foundation for the Supreme Court decision (207). To understand how gay marriage became possible in America, it is as important to study the dynamic, diverse and diffuse processes at work in cyberspace as it is to examine the series of court cases that led to its legalisation.

[1] 135 S. Ct 2584 (2015).

This chapter examines both Supreme Court decisions and the various forms of new media that contributed to the legalisation of same-sex marriage. More specifically, it analyses the different linguistic registers through which the right to marry was articulated in the two domains. While the judgement is underpinned by the language of rights, new media deployed different vocabularies, frameworks and narrative strategies to demonstrate the importance of marriage equality, including the language of personal experience and the language of humour. In the early twenty-first century, rights discourse, personal narrative and comic representations constituted part of the vast and varied linguistic registers that gave voice to equality and enabled the love that once dared not speak its name to articulate its own legitimacy.

Speaking of Rights in the Supreme Court

This section focuses on the ways in which arguments for gay marriage were articulated in the language of rights in the two Supreme Court cases most directly related to marriage equality, *Obergefell* and *United States* v. *Windsor* (2013).[2] In *Obergefell*, fourteen same-sex couples and two men whose partners had died challenged state laws in Michigan, Kentucky, Ohio and Tennessee that defined marriage in exclusively heterosexual terms, arguing that state officials violated the Fourteenth Amendment of the US Constitution by denying them the right to marry or by refusing to recognise their marriages conducted in other states. Writing for the majority, Justice Anthony Kennedy underscores the 'transcendent' and 'enduring' importance of marriage, and holds that to deny gays and lesbians the right to marry or to refuse to recognise their marriages legitimately conducted in other states constitutes a violation of substantive due process and the equal protection of the laws (at 2591). Moreover, in response to arguments that the question of same-sex marriage should be resolved by the legislature rather than the courts, and through the democratic process rather than judicial intervention, Kennedy reaffirms the court's role as the guardian of individual rights: he opines that 'the Constitution contemplated that democracy is the appropriate process for change' only insofar as 'that process does not abridge fundamental rights', and notes that the right to marry is recognised as a fundamental right under the rubric of substantive due process (at 24). In other words, far from interfering in democratic decision-making through its ruling, the court was doing precisely what it was supposed to do by defining, delineating and guaranteeing fundamental rights in this case. Justice Kennedy also penned the majority decision in *Windsor*. In that case, Thea Spyer left her entire estate to Edith Windsor, to whom she was lawfully married in Canada, when she died in 2009, but Windsor was

[2] *United States* v. *Windsor* 133 S. Ct 2675 (2013).

barred from claiming federal estate tax exemption for surviving spouses by the Defense of Marriage Act (DOMA), which defined 'marriage' and 'spouse' to exclude same-sex partners. As a result, Windsor paid $363,053 in estate taxes, an amount she would not have had to pay if she had been married to a man. The court held that DOMA unconstitutionally violated both due process and equal protection principles applicable to the Federal government under the Fifth Amendment.

There is a key word that underscores Justice Kennedy's rights discourse in both cases: dignity. It is ultimately the refusal to recognise the equal dignity of gays and lesbians that denied the appellants the right to due process and to equal protection in the two cases, and it is for this reason that the court characterises the exact nature of the harm as 'dignitary wounds' (at 2606). In *Obergefell* Justice Kennedy is careful to delineate the different dimensions of such dignitary wounds. In his analysis of due process, he underscores that marriage cannot be dissociated from individual autonomy because decisions concerning marriage, like other decisions concerning one's sexual, familial and private life, are 'amongst the most intimate that an individual can make' (at 2599). To deny people the right to make such decisions without the threat of legal sanction would be to 'disparage their choices and diminish their personhood' (at 2602). Justice Kennedy's reasoning here can be traced back to the majority opinion he penned in *Lawrence* v. *Texas* (2003), in which the court stated that laws that intruded upon people's right 'to choose to enter upon relationships in the confines of their homes and their own private lives' undermined their 'dignity as free persons' (at 2478).[3] Furthermore, in *Obergefell* he underscores the dignitary harm not only to couples, but to their children: excluding same-sex couples from marriage inflicts a dignitary wound on children because they would 'suffer the stigma of knowing their families are somehow lesser' (at 2600). In terms of equal protection analysis, he opines that the less favourable treatment is premised on a classification that denied the 'equal dignity' of gays and lesbians (at 2603). Justice Kennedy concludes by noting the connection between due process and equal protection, and holding that the action and decisions of state officials violated both principles (at 2604). Specifically, their refusal to marry gays and lesbians or to recognise their marriage legitimately conducted elsewhere constituted a 'grave and continuing harm' (at 2604) to a minority group, in that it demeaned (at 2602), stigmatised (at 2602) and ultimately imposed a disability on the members of that group based on their sexual orientation.

The concept of dignity occupies a similarly central place in the court's language of rights in *Windsor*. Justice Kennedy begins by reiterating that

[3] 123 S. Ct 2472 (2003).

issues relating to marriage are regulated on the state level; he points out that DOMA goes against the grain of this principle, though he stops short of ruling that it violated the Constitution on federalism grounds (at 2690). However, he underscores that New York state's decision to allow same-sex marriage conferred upon gays and lesbians 'a dignity and status of immense import' (2692). By refusing to grant them federal benefits, DOMA took away the 'recognition, dignity and protection' which the state conferred. Such 'injury and indignity' constitutes 'a deprivation of an essential part of liberty' under the principle of substantive due process as guaranteed by the Fifth Amendment. He further points out that DOMA violates the principle of equal protection in that by treating same-sex marriage differently from heterosexual marriage, it tells gay and lesbian couples that 'their otherwise valid marriages are unworthy of federal recognition', thereby casting their unions as forms of 'second-tier marriage' (at 2694). As such, 'DOMA's principal effect is to identify a subset of state-sanctioned marriages and make them unequal' (at 2693). As in the case of *Obergefell*, he is explicit about the dignitary wounds such inequality inflicts: it imposes stigma (at 2693) and disability (at 2694), it creates disadvantage (at 2693), it humiliates (at 2694) and it demeans (at 2695). Justice Kennedy's reliance on dignity as the lynchpin of the right to equal protection and the right to marry under substantive due process, as well as his detailed catalogue of the effects of indignity, has led some critics to identify an over-veneration of marriage and an overly lavish rhetorical style in his judgements (Murray 2016). In his dissent in *Obergefell*, Justice Antonin Scalia dismisses the lofty descriptions of dignity in the majority opinion as 'mummeries and straining to be memorable passages' (at 2628). However, perhaps one way of understanding Justice Kennedy's rights discourse is that it necessarily strains, because the infliction of indignity arising from the undermining of fundamental rights which he seeks to describe constitutes no less than an erosion of the very humanity of gay and lesbian people, and no language is adequate to capture such a grave injury.

The Personal is the Political

On 7 May 2012, a young man living in California uploaded a short video entitled *It Could Happen To You* onto YouTube. Shane Crone, the narrator in the video, had been dating Tom Bridegroom for six years, when Tom accidentally fell off a rooftop and died. The clip tells the heartbreaking story of what happened to him after his boyfriend's death. Both men had come out to their families earlier, but unlike Shane's family which was supportive of his sexuality, Tom's family was outraged by the revelation. When Tom died, his family took his body away from Shane and back to Indiana; Shane was told not to attend the funeral as Tom's father and uncle had planned an attack should he

show up. Shane and Tom were not married, as gay marriage was not legal in California at the time, and so Shane had no lawful claim to Tom's body and no say over the events which unfolded. After Tom's death, Shane decided to devote his life to advocating for marriage equality, and the video was part of his efforts: by narrating his own painful experience of exclusion and rejection, he hoped to persuade viewers of the legal importance of marriage equality. As he notes towards the end of the clip:

> I need to fight for what's right. [. . .] Maybe that's why this all happened [. . .] It's to open my eyes and inspire me to want to make a change and want to fight for equality. I just don't know if people will listen. I guess no one is going to listen if I don't talk. And so I'm talking.

'And so I'm talking': storytelling is a powerful tool for minorities seeking to assert their rights; personal narratives of prejudice, discrimination and indignity can give concrete form to arguments about the importance of rights (Delagado 1989). As Shane notes in a talk in Holland three years after the video was uploaded, 'when you share a personal story with someone, it bonds you to that person', and it is this bond which generates much of the emotive force of such stories. In the age of new media, the importance of personal narratives as a form of advocacy is magnified in two ways. First, they can reach a much wider spectrum of viewers in a much shorter period of time. *It Could Happen To You* went viral not long after it was posted; in less than forty-eight hours it was viewed over one million times, and at the time of writing it had been viewed close to five and a half million times. Second, the visual dimension of such online narratives means that they make their legal arguments both cognitively and affectively: by literally putting a face to marriage equality, *It Could Happen To You* adds to the more abstract, legalistic language of rights the affective, and powerfully relatable, register of loss, pain, tears and anger. The video exemplifies the range of narrative and visual strategies for rights advocacy beyond the courtroom that are available to users and creators of new technological forms. So impactful was this short clip that it was later expanded into an award-winning full-length documentary, *Bridegroom*. The film was introduced by former US President Bill Clinton when it premiered at the Tribeca Film Festival.

The clip opens with a combination of words and images: shots of words written in a white font are set against a simple black background alternating with pictures of Shane and Tom. The two opening shots address the viewers directly: 'What if tragedy struck the one you loved?/Would you be prepared?' Like the title, the questions elicit a sense of empathy in the viewers by asking them to imagine themselves in a similar situation. A series of simple sentences then appears on the screen: 'I'm Shane./And this is my story./This is me./I grew up in a small town in Montana./This is Tom./He grew up in a small

town in Indiana.' By introducing his story through such minimalist language and syntax, the narrator creates a sense of simplicity and artlessness: this is an ordinary person narrating his experience with candour. The sentences are interspersed with iPhone footage of Tom and Shane on their travels and in various everyday situations: being silly in their living room, laughing with their snorkelling gear on at the beach, posing together in front of the camera on their vacation. The rawness of the footage again creates a sense of empathy; these are scenes which could have been taken from any viewer's life, captured with devices he or she also likely owns.

The clip catalogues the difficulties encountered by Shane in the immediate aftermath of Tom's death due to his lack of marital rights: he was turned away at the hospital when he tried to obtain more information about his partner, he could not inherit Tom's property without a will; they are mere roommates in the eyes of the law. Shane explicitly notes, 'Had Tom and I had the right to marry, many things would be different.' Even more powerful than the direct calls for advocacy towards the end of the narrative, however, are moments taken from the narrator's more personal encounters with Tom's homophobic mother. In a series of shots, the viewers read that 'On Mother's Day, Tom's Mother flew in to take him back home to Indiana/Even though he no longer considered Indiana his home.' This simple interaction gives concrete form to the more abstract concept of 'dignitary wounds' articulated by the courts: the injury here is inflicted not only on Shane, who is forced to passively witness the body of his loved one taken away, but on the deceased, as the action of Tom's mother explicitly goes against his wishes. Shane then tells the viewers: 'His mother began asking about his bank accounts./She then asked to go through our things./Again I relented./I allowed her to take what she wanted.' This series of shots bears testimony to the intrusion into Shane's life that the law not only allows, but enables: he 'relents' and 'didn't try to stop her' because he could not do so, as the law gave her the right to access the information and to take Tom's property. That segment ends with the next series of sentences: 'The coroner released Tom's body, and his mother left suddenly./She promised to keep me updated./But I never heard from her again.' In the clip, glimpses of a promise broken or brief allusions to a loved one taken away, drawn directly from a man's personal life, can stir the hearts and minds of viewers far more powerfully than the more legalistic arguments based on general, depersonalised concepts such as stigma or disability.

In cinematographic terms, the emotive force of the video also arises from the juxtaposition of contrasting images or ideas. After narrating the elaborate efforts through which Tom's family excluded Shane from the funeral – planning an attack should he show up, deliberately refraining from mentioning him in the obituary, etc. – a single sentence on the screen reads: 'I only wanted to love him'. The contrast between the family's protracted actions and the

simplicity of the sentiment underscores the excessive level of animosity and hatred demonstrated by the family. Another moment of contrast appears towards the end of the video. The viewers read that 'After some time I finally got to see Tom again./Tom had always wanted me to see where he grew up.' These sentences, however, are followed by an image of Tom's grave, with the caption 'But not like this'. The image is shaky and was obviously taken with an iPhone as Shane walked up to the grave, thus creating a further sense of immediacy. The disjuncture between the happier tone of the words and the bleakness of the image underscores the tragedy, not only of the death but of the fact that Shane could only visit Tom's grave in secret because he was purposefully erased from his life at the funeral.

Comedic Justice

It is not only in the register of sentimental personal narrative that new media engages with marriage equality. In the years leading up to *Obergefell*, a number of clips advocating for gay marriage in a humorous tone emerged on the internet. This set of images is particularly worthy of study, as humour and legal argumentation do not seem to make natural bedfellows: not only is humour usually considered to be a register far from that of the law, but fun, laughter and jokes are often regarded as antithetical to the solemnity of the justice system. However, it is perhaps precisely because the law is humourless that such visual interventions can propel us into thinking about constitutional issues differently. As Peter Goodrich has observed, 'when genuinely witty, comedy interferes productively with judgment' (Goodrich 2017: 363). He contends that 'in its acme, comedy overturns precedent by upending the stability of assumptions and by subverting the complacency of repetition'. By changing the tone, style and register of rights discourse, humour 'transforms motives and facilitates the irruption of novel reasons'. In light of Goodrich's argument, the clips' engagement with constitutional law through wit, laughter and jocular reasoning can be regarded as embodiments of a kind of 'comedic justice' (373).

Three examples serve to illustrate the strategies of rights advocacy through humour. The first example is a parody of an anti-gay marriage commercial entitled *The Gathering Storm* sponsored by the National Organization for Marriage (NOM). In the original video, a group of people stand against a conspicuous backdrop of dark storm clouds and express concerns about the impact that the legalisation of gay marriage would have on their lives. The narrators take turns speaking, repeating the argument against gay marriage in different ways, through different voices, to create an echoing or amplification effect underscoring its message that the threat of gay marriage is an issue of widespread concern. The clip opens with a description of the storm by three different characters: 'There is a storm gathering./The clouds are dark, and the winds are strong./And I am afraid'. The main thrust of the argument is that

marriage equality will disrupt their lifestyles against their will: 'Those advocates want to change the way I live', and 'They want to bring the issue into my life'. A young woman looks directly at the camera and says morosely, 'I will have no choice'. As the characters speak, the storm clouds move around ominously amid flashes of lightning in the background. The video ends with a man assuring the viewer that there is hope, because 'a rainbow coalition of people of every creed and colour are coming together in love to protect marriage'. The rainbow is realigned from its association with gay pride to the coalition. A ray of sunlight then disperses the clouds. The visual impact of the anti-gay marriage video is created through the metaphor of the storm cloud: by placing the characters against the backdrop of the clouds, the commercial represents marriage equality as a fierce and disruptive force that will wreak havoc on society. It therefore visually exaggerates the negative impact that married gay couples would have on societal values and norms. The storm could also be a biblical reference to evoke the possibility of the wrath of God should gay people gain the right to marry. The message is further reinforced by other forms of visual imagery in the conclusion: the narrator's reference to the 'rainbow coalition' detaches the symbol of the rainbow from its association with Gay Pride and realigns it with the organisation's anti-gay stance, and the rays of sunlight dispersing the clouds with which the advertisement closes are also overtly drawn from Biblical imagery.

The parody, created by the production company Funny or Die, mimics the style of the commercial by featuring a group of comedians in front of a similar moving storm cloud. It also begins in the same way: a nervous woman says, 'There is a storm gathering'. The humour which forms the crux of the parody's argumentative strategy consists of the literalisation of the metaphor in the NOM commercial: appropriating a line in the original video, another woman says: 'And I am afraid . . . because I have a fear of storms'. The conversion of the figurative to the physical reveals the extent to which the persuasiveness of NOM's message is dependent on the exaggeration of the menace of gay marriage which underpins the metaphor:

> Soon gay people will start falling out of the sky. Onto our homes. Onto our churches. And onto our families. A downpour of gay people threatening the way we live. This gay rain army won't stop. [. . .] And they won't stop till all of us AND our children are gay married.

The strategy of literalisation reveals the histrionic tone of the NOM commercial; the ridiculousness of the visual depiction of gay marriage as an all-encompassing, looming menace is paralleled in the ridiculousness of images of gay men falling from the sky. The parody ends with a further literalisation, this time of the commercial's ending: 'But we have hope. People of every creed, race and colour are coming together to build a giant umbrella of faith,

morality and righteousness that will protect us from this gay rain army. And that's not just a metaphor. We're actually building an umbrella.' The play on the figurative and literal meanings of umbrella reveals the dynamic of in-group/out-group that the commercial relies upon for its rhetorical force; it implicitly represents gay marriage supporters as an 'out-group' threatening the moral foundations of the 'in-group'. The parody seems to suggest that the umbrella is not so much a shelter for anti-gay marriage advocates from any intrusion on their rights as a mechanism for leaving sexual minorities out in the storm, without refuge.

The second example furthers this strategy of literalisation. In this commercial, a distraught husband returns home and tells his wife that the government may legalise same-sex marriage.[4] His wife reacts in shock, hugs him tightly, and asks through nervous tears: 'What is going to happen to our marriage? [. . .] I don't want to get a divorce or marry a woman.' As the couple ponder over why homosexuals want to 'destroy our civilisation', their daughter enters the room holding a teddy bear: 'Mommy, Daddy, if gay people are allowed to get married would you still love me?' Her father kneels down, gives her a hug and says, 'Let's hope it doesn't come to that', and the little girl frowns sceptically at his response. The segment responds to the absurdity of arguments suggesting that gay marriage would undermine the family; just because gays and lesbians marry does not mean that heterosexual couples would love their children any less. The literalisation strategy here shows that accusations of marriage equality undermining the sanctity of marriage and the family are groundless, as it visually demonstrates the lack of a clear link between gay marriage and the everyday lives of heterosexual married couples and their children.

The final example is a video in which a number of gay men jokingly threaten to marry straight men's girlfriends unless they support gay marriage. Entitled *Gay Men Will Marry Your Girlfriends*, the premise of the joke here is that if gay people are forced into straight marriages, then they would compete with heterosexual men for women and win the competition. The video has given rise to a number of sequels, in which straight men and straight women respond to the gay men's threat, and in which lesbians threaten to marry straight women's boyfriends unless they support gay marriage.

At first glance, the humour of the video seems to be premised on a number of stereotypes about gay men, including the stereotype of the muscular gay, the artsy or cultured gay, and the well-dressed or dandy-esque gay. In fact, the argument that gay men would be better suited to the straight marriage market is that these are the qualities that women supposedly admire. In the words of one of the characters, 'We are ripped./All of us are ripped.

[4] https://www.youtube.com/watch?v=6jrngYNGNeE

It doesn't seem statistically possible and yet it's true./Because we love going to the gym.' Another gay man says: 'What do you make your girlfriend for breakfast? Burnt scrambled eggs? We will make her a quiche.' A third says: 'You don't want to go dancing [with your girlfriend]? We teach a dance class. [. . .] Not in the mood to go to that Broadway show? We are. We're in it.' The entire sequence is also marked by an undercurrent of misogyny: the exchange between the speakers in the video on the one hand, and the viewers on the other, is based on the vision of women as objects that can be offered by one group of men to another in exchange for what they want. The joke therefore also seems to draw on the stereotype of the misogynistic gay.

However, it is not only gay men who are stereotyped in the video. The humour also relies on stereotypes of straight men. The joke that gay men are ripped because they love going to the gym is implicitly based on the idea that married straight men do not care about their bodies. The joke that straight men can only make burnt scrambled eggs for breakfast is based on the stereotype that straight men necessarily have unrefined palates. As the video asks: 'Do you even know the difference between hummus and babaganoush? You're a joke.' Finally, there is the stereotype of the heterosexual male dresser with no sense of fashion: 'We dress better than you. While you were spilling manwich on your cargo shorts, we were inspecting our Oxford shirts for the craftsmanship of their gauntlet buttons.'

What might be the effect of such stereotyping not only of gay men, but of men across the board? Perhaps somewhat paradoxically, the video could contribute not so much towards the perpetuation of stereotypes, but towards their debunking. The key to the strategy of advocacy in this video is its intended viewers: the clip is explicitly addressed to heterosexual men, and its reliance on the stereotypes about male *heterosexuality* constitutes a means to encourage not only interrogations of the stereotypes of the intended viewers themselves, but of stereotypes more broadly. In other words, if the intended (heterosexual male) viewers see the inaccuracies of the stereotypes of straight men, then they may be nudged to think critically about other stereotypes in the narrative, including the stereotypes of gay men. Seeing how oneself is portrayed inaccurately in the video would prompt reflection on how others might also be portrayed inaccurately in the same text. Much of the debate about same-sex marriage is about the debunking of stereotypes about gays and lesbians, and by prompting reflection of stereotypes as constructs, the video can be said to contribute towards critiquing some of the basic assumptions of the same-sex marriage debate.

Conclusion

In the era of new media, constitutional questions such as marriage equality are debated in a plurality of registers and in a multiplicity of forums. Gone

are the days when legal issues were only addressed by professionals with superior legal knowledge, and only within the grand chambers of the courts of justice. In the twenty-first century, anyone who knows how to record and upload a video can potentially make a significant intervention on a national or even global level. What, then, does this drastic widening of constitutional participation entail for the institution of law? Does it necessarily open the floodgates of populism, now that every person with internet access and a camera can attract the attention of millions of followers? The broadening of constitutional debate does not necessarily entail unbridled populism. Rather, it creates the conditions that move the law away from the technical rules and specialist vocabulary that structure legal discourse and towards wider civic awareness and engagement. New media enables people whose lives are directly affected by constitutional questions to show how law structures life. Through the internet, they can demonstrate to the world how it feels when law fails, they can show how the deprivation of rights undermines dignity, and they can give us a sense of what it is like to interact with the law on the ground rather than in the courtroom. New media therefore contributes to the democratisation of law and helps to create the conditions of participation for the ordinary citizen.

Bibliography

Delagado, R. (1989): 'Storytelling for Oppositionists and Others: A Plea for Narrative', *Michigan Law Review*, 87:8, 2411–41.

Goodrich, P. (2017): 'Proboscations: Excavations in Comedy and Law', *Critical Inquiry* 43, 361–88.

Klarman, Michael J. (2013): *From the Closet to the Altar: Courts, Backlash, and the Struggle for Same-Sex Marriage*, Oxford: Oxford University Press.

Lawrence v. *Texas* 123 S. Ct 2472 (2003).

Obergefell v. *Hodges* 135 S. Ct 2584 (2015).

United States v. *Windsor* 133 S. Ct 2675 (2013).

14

Kamikaze Law: On the Aesthetics of the Legal War on Terror

Laurent de Sutter

Terror in Paris!

On the evening of 13 November 2015, at around 9:20 pm, the crowd attending the football game between France and Germany at the Stade de France, in Saint-Denis, north Paris, was suddenly puzzled by what were thought to be explosions. But since the match had not been interrupted by the authorities, they passed unnoticed for a moment – until the news of the shootings in the 10th and 11th arrondissements of the city reached the phones of some spectators. Apparently, some co-ordinated attacks had targeted various locations in Paris, starting with the Stade de France, where François Hollande, then President of the French Republic, was watching the game. The sounds that had been heard were those produced by the detonation of bombs carried with them by a team of three men who decided to blow themselves up when they were refused entry to the stadium. Meanwhile, in the 10th arrondissement, another team had invaded the Bataclan concert hall, where an American rock band named Eagles of Death Metal was performing, and had started shooting at the public. By 9:40 pm, things were becoming clear: Paris was under attack – an attack aimed at killing the largest number of people possible, while damaging a symbol of what was considered representative of a certain way of life in the capital of France. Despite massive police intervention, the killers succeeded in holding the Bataclan until after midnight, adding almost a hundred deaths and three hundred wounded to the night's morbidity count. In total, 129 persons had been killed and more than 350 wounded by the time police forces managed to take down the three killers holding the concert hall. The fact was soon acknowledged by officials: these attacks were terrorist attacks, the deadliest in France since the Second World War, and the second most deadly to have taken place in Europe, after the 11 March 2004 attacks in Madrid. A press release from the Salafi terrorist group Daesh claiming responsibility for the events

confirmed this the following day, cheerfully congratulating the martyrs who had sacrificed themselves.[1]

The Long Emergency

On 14 November at 3:00 pm, during an exceptional meeting of the Council of Ministers, François Hollande declared France to be in a state of emergency – for the first time since the end of the 1960s, at the height of the Algerian independence war. As a result, following the terms of a law of 14 April 1955, a series of powers was put in the hands of the Minister of the Interior, as well as the Prefect of Paris, including a discretionary power to prohibit the circulation of persons or vehicles.[2] Every school, institution and public service was immediately closed, and every public demonstration prohibited, while police and gendarmerie forces were deployed in every corner of Paris, giving it the appearance of a city under siege. During the next few days, the surviving terrorists were hunted down – but the government decided to maintain the state of emergency, in an attempt to ensure that another attack did not materialise.[3] However, as the law stipulated that the state of emergency could only be maintained for twelve days, the government proposed to the Assemblée Nationale a text transforming this term, and allowing it for up to three months. The text, adopted on 20 November, also modified some controversial provisions of the previous law, on the ground that it was necessary to make the state of emergency more efficient than had previously been the case.[4] In particular, the new law broadened the spectrum of reasons for keeping an individual under house arrest, or for the dissolution of a group or association suspected of unlawful activities, making it an almost discretionary power. A couple of days later, on 24 November, the government issued a statement explaining that, under the new law, some provisions of the European Declaration of Human Rights could now be bypassed in certain cases. For instance, a police search could be enforced without all the necessary procedural requirements normally applicable to such a situation, without any possibility of complaining to a judicial institution. Ironically, the first victims of this new law were radical green activists, who were prohibited

[1] https://fr.wikipedia.org/wiki/Attentats_du_13_novembre_2015_en_France. For an analysis, see Laurent de Sutter, *Théorie du kamikaze* (Paris: PUF, 2016).

[2] Loi n° 55-385 du 3 avril 1955 relative à l'état d'urgence. See: https://www.legifrance.gouv.fr/affichTexte.do?cidTexte=JORFTEXT000000695350

[3] https://fr.wikipedia.org/wiki/Conséquences_sécuritaires_en_France_des_attentats_du_13_novembre_2015

[4] Loi n° 2015-1501 du 20 novembre 2015 prorogeant l'application de la loi n° 55-385 du 3 avril 1955 relative à l'état d'urgence et renforçant l'efficacité de ses dispositions. See: https://www.legifrance.gouv.fr/affichTexte.do?cidTexte=JORFTEXT000031500831&categorieLien=id

from leaving their house during the United Nations Climate Change conference gathering in Paris from 30 November to 12 December.

Another Rule of Law

Thanks to the new rules adopted on 20 November, the French government was free to act as it pleased; indeed, it voted again to prolong the state of emergency on 26 February 2016, deciding it would run until 1 November 2017. In total, this situation, which, under the previous law, should have long been resolved, lasted almost two years, during which time no other dramatic event took place in Paris, but there were more than 1,200 house searches and more than 260 house arrests. It didn't stop the Assemblée from voting on a new text on 20 October 2017, when it was decided to fully integrate a series of measures normally attached to the state of emergency to the everyday life of the law, as a means to fight terrorism.[5] This new law, like the previous decisions to prolong the state of emergency, was not welcomed by civic society, and many people denounced the dramatic reduction of a series of liberties, including the liberty to move and assembly, as well as freedom of expression. Not only did Amnesty International and the Ligue des Droits de l'Homme issue bitter criticisms, but official bodies such as the Commission Consultative des Droits de l'Homme and the Magistrates Association also issued warnings. For all of them, the broadening of the powers of inquiry given to the police and the executive authorities could be considered as endangering the democratic structure of France, without really helping to solve the problem of terrorism. In particular, the fact that those first affected by the new dispositions were not terrorists but militant ecologists, shed an embarrassing light on what could be seen as the real goal behind the decision to adopt them. Rather than being helpful in curbing terrorist movements that remained non-existent, these rules could be seen as useful tools in establishing a harsher atmosphere of policing in a time of political anger against the excesses of global capitalism. At least, this was the claim formulated by a series of intellectuals, signing as early as 24 November 2015 an open letter published in the pages of *Libération*, the main left-wing daily newspaper in France.[6] It is ironic that this critique was not only listened to; rather, it was openly laughed at: how could anyone *not* see that France was in danger?

[5] Loi n° 2017-1510 du 30 octobre 2017 renforçant la sécurité intérieure et la lutte contre le terrorisme. See: https://www.legifrance.gouv.fr/affichTexte.do?cidTexte=JORFTEXT00 0035932811&dateTexte=&categorieLien=id. For contextual analysis : https://fr.wikipedia. org/wiki/Loi_renforçant_la_sécurité_intérieure_et_la_lutte_contre_le_terrorisme

[6] Frédéric Lordon et al., 'Bravons l'état d'urgence, manifestons le 29 novembre', *Libération*, 24 November 2015, http://www.liberation.fr/debats/2015/11/24/bravons-l-etat-d-urgence-manifestons-le-29-novembre_1415769

Against Citizens

To be fair, France was not the first country to adopt strong legal instruments after a terrorist event; the United States had set a precedent through the passing of the infamous Patriot Act after the terrorist attacks of 11 September 2001. It seemed to be some sort of national reflex: once a country is attacked by forces deemed terrorist, its first move consists of protecting itself in such a way that the first victims of the new means of protection are the citizens themselves.[7] For an imperative maxim, this one was most peculiar – except if one makes the effort to understand that the history of the police in the Western world has always been to protect and serve their authorities *against* citizens. From medieval times to today, policing has always been the action by which the co-existence of powers and authorities with the rest of society is ensured, so that the former cannot be put at risk by the latter.[8] All those who denounced the measures taken by the different governments ruling France from November 2015 to November 2017 shared this intuition: they suspected that these were primarily aimed at protecting the possibility of policing itself. The law of 30 October 2017 was less anti-terrorist than pro-police, more concerned with smoothing the activities of those in charge of protecting the government than anything else – and indeed this is what it did. The first result, of course, was that it transformed the very essence of what it means to be a citizen under the rule of law; or, rather, it rendered visible what citizens had always been for authorities: *terrorists not yet caught* – at least potentially. But it was not the only effect produced by the adoption of the new law: besides transforming the meaning of what it is to be a citizen, or unveiling the true essence of the police, it also offered an unexpected view as to what precisely *is* a law. Understood as part of this division between police and citizens/terrorists, rules were to be seen not as the preservers of democracy, but, instead, as contributions to its ongoing destruction, more effective than any suicide bomb. The true terrorist, then, was not the suicide bomber, nor the citizen striving (seeking? – here it refers to the fact that, under the new law, every citizen is treated as if he/she could become a terrorist without even knowing it) to be one, but the law itself, whose exercise had as its sole purpose its own undermining – its own explosion.

Law as Bomb

The real suicide attack was not that of the three men blowing themselves up outside the Stade de France on 13 November 2015; it was the 31 October 2017 decision to incorporate the state of emergency into a newly normalised

[7] For an overview, see https://en.wikipedia.org/wiki/Anti-terrorism_legislation

[8] Cf. Laurent de Sutter, *Poétique de la police* (Aix-en-Provence: Rouge Profond, 2017).

life of the law. The kamikazes were only the trigger for a much larger process, which was left to the French authorities to perform – providing victory to Daesh without its members having to invest in what would be necessary for them to do themselves. Hollande and Emmanuel Macron, his successor as President, were those who destroyed what was the real target of the terrorists – not the 'symbols' of the French way of life, but the order allowing it. Indeed, there was something painfully pathetic in seeing people run en masse to bookstores to buy copies of Ernest Hemingway's 1964 autobiographical story, *A Moveable Feast*, translated in French as *Paris est une fête*. Thinking that Paris was and should remain 'a party' was what pushed radical Salafi to shoot and bomb places where the 'party' was happening. This fantasy belongs to the realm of delusions of the first order. Nobody cares about parties; what was much more important was the weird games that France was playing in the geopolitics of the Middle East – and especially in Syria, where Daesh was fighting a bloody war against the current regime. Moreover, if Paris was a party, it was soon terminated by the police, as is often the case when people are having too much fun, with bourgeois neighbours trying to get some sleep before work the next day. *It was the government that stopped the party;* it was the government that took decisions that achieved what the kamikaze attackers didn't – and were not even eager to achieve, as they knew they needed help. This support was happily provided by the authorities, through the actual targeting of Daesh: law itself was an ambiguous instrument whose essentially passive role could be manipulated by those in power to result in the most contradictory consequences. It was even possible to go as far as to state that the different governments in place between November 2015 and November 2017 in France could be considered as direct allies of Daesh – or, at least, as voluntary sub-contractors.

Outsourcing Destruction

To be fair, this was to be expected, since the history of kamikaze attacks is the history of the outsourcing of destruction – the history of the weak leading the strong to direct its strength against itself, so helping the weak to triumph.[9] When Vice-Admiral Ônishi Takijirô, whose belligerent attitude had finally overwhelmed the less hawkish factions of the Japanese military at the end of the Second World War, decided to launch what would be known as the 'Kamikaze' campaign, he was fully aware of the paradox of his position. In November 1944, Japan was on the verge of collapse, incapable of providing enough oil supplies to its troops, and forcing it to

[9] The following paragraphs reformulate, in a more compact way, some of the arguments developed in Laurent de Sutter, *Théorie du kamikaze*, op. cit.

use horse-power for transportation. It therefore considered radical action: Takijirô created *tokubestsu kôgekitai*, or 'special attack units', and used the last drops of remaining petroleum from occupied Malaysia for a massive suicide campaign. Young pilots in lightweight Mitsubishi A6M 'Zero' airplanes with just enough fuel for a one-way trip, dive bombed their planes, full of bombs, into enemy ships. When the first 'special attack unit' targeted the American fleet on 25 October 1944, and miraculously hit the jackpot by sinking, in less than half an hour, the aircraft-carrier *St Lo*, it struck the rest of the world as if a god had decided to intervene in the war. The explosion of the first plane, piloted by Lieutenant Seki Yukio, literally *blinded* observers the world over who thought they knew everything about warfare, but suddenly discovered something beyond their imagination. The irony is that this blinding flash resounded with the name of the 'special attack unit' sent to kill itself; as with every other unit, it bore the name of a Japanese deity that it would somehow incarnate – a deity whose name was Kamikaze. For reporters who returned to tell the story to the Western world, the whole operation suddenly acquired this name, which turned from the proper name to a common name – the name describing suicide soldiers. The fact that it had a special meaning in the official historiography of Japan added an extra layer of fear to the terrifying actions of the 'kamikaze' pilots.

When the Wind Blows

When reduced to its etymological roots, *kamikaze* indeed has a special meaning: a god (*kami*) inhabiting the wind (*kaze*) – and even inhabiting a specific wind, that blowing on the plain of Ise. There he would serve as protector of the sanctuary of the Amaterasu goddess, Kami of the Sun and ruler of all Kamis, whose genealogy would eventually lead to the Emperor of Japan, of whom she was a direct ancestor. This role played by Kamikaze is not only theoretical, as some of the most important monuments of Japanese historiography, such as the *Dainihonshi* or the *Nihonshôki* chronicles, have reported. In 1274, when Kublai Khan decided to invade Japan, Kamikaze blew so violently that the gigantic waves his fury provoked destroyed the whole fleet. The same scenario was repeated in 1281, with the same result; it was therefore only normal that, in 1944 – the first time that an 'invasion' of Japan had been attempted since the thirteenth century – Kamikaze would awaken from his sleep and blow again. Though Amaterasu's sanctuary was at Ise, and the goddess was an ancestor of the Emperor, Kamikaze shouldn't be considered as the guardian of just her temple, but of the whole of Japan, understood as its metonymy. When unleashing the squadron of kamikaze pilots on American boats, it was Kamikaze himself who blew through the wind of the explosions – it was these explosions that incarnated his power. So much so that what the reporters saw

on 25 October 1944 was *really* the manifestation of the fury of a god, and not a simple act of war coming from simple human beings. With the invention of 'kamikaze', the Japanese aimed at exceeding the limits of traditional war in such a way that the relationship of power between its own and its enemy's troops could be redistributed against every logic of warfare. Of course, this redistribution was not instant; what Vice-Admiral Takijirô hoped for was that the repeated use of this method would cause such fear and despair in the enemy that they would decide to abandon the war altogether. He was wrong – but he was also right.

The Betrayal of the Sun

In order to reply to the divine fury unleashed by the Japanese military authorities, the allied forces had to devise something similar – which took the form of the massive bombing of the country from February 1945 onwards. This bombing, mostly using incendiary bombs that would destroy entire cities thanks to most buildings in Japan still being made of wood, culminated in the dropping of two atomic bombs on 6 and 9 August 1945. If the Japanese asked for help from the protector of the Sun, the Americans invoked the unrestrained force of the Sun itself, thus turning against Japan the very deity that was supposed to embody their integrity and pride. Amaterasu turned her back on them for having made a wrongful use of Kamikaze, and put her power in the hands of their victims, creating another moment of shock and awe in the wake of the one produced by the 'special attack units'. In a dramatic reversal of fortunes, Japan saw its own order, the structure upon which its own identity was built, used against it – in a way that was precisely the one for which the allied troops had hoped. But this didn't change a thing about the nature of kamikaze attacks: even if the attacks were responded to in the most radical way, a power logic remained at work in this strategy – the logic of the parasite. If you don't have enough force to defeat your own enemy, or even to weaken him, then your only solution is to make sure the enemy self-destructs before it is too late for you: you must outsource your victory to him. The only manoeuvre that is required is some basic investment, in the hope that it would trigger a chain reaction leading the opposite side to make all the missing investments itself, so serving you while believing the contrary. But for that to happen something extraordinary is necessary – something that will blur the co-ordinates of thought in such a way that the human tendency to make mistakes will be exacerbated. The unbalancing of forces that kamikaze attacks aim to produce is an unbalancing that substitutes another type of rationality to the one that was in place – an unbalancing opening up the possibility of a world governed by a different set of rules.

One World Trade Center

The fact that kamikaze logic is one of unbalancing couldn't be better illustrated than with the 11 September 2001 and 13 November 2015 attacks, since this unbalancing is exactly what happened in both the United States and France. In New York, it was critically important that, in addition to the adoption of the Patriot Act, the brand-new One World Trade Center building was erected where the twin towers of the old World Trade Center had been destroyed. At first, the name given to the new building was slightly different: the laureate of the international competition launched to determine which architect would draw it, Daniel Libeskind, suggested 'Freedom Tower'. His project implied a single tower, shaped in a form that would recall the Statue of Liberty, while its height was supposed to be 1776 feet, the year of the Declaration of Independence of the United States. Even though this tower wasn't built, due to conflicts with the tenant of the previous World Trade Center, who complained that he would be losing useful floor rental with this silhouette, its magnitude remained. The One World Trade Center tower, rather than being subdued, actually exceeds the height of the previous tower by 131 metres, as if the only way to undo what had been done was by going beyond what had been there before. The unbalancing of forces provoked by the suicide squad of 11 September was still active in the project to build a monument to the destruction of the World Trade Center that would be bigger than what it commemorated. Just as the legal measures formulated in the Patriot Act relayed the excess manifested by the destruction of the Twin Towers by another manifestation of excess, the actual replacement of these towers had to be excessive as well. Indeed, instead of a monument to the strengths and values of the United States, the One World Trade Center building was actually a monument dedicated to the kamikaze team itself, whose actions would never be forgotten. One World Trade Center is an al-Qaeda colony in the middle of Manhattan, just as the anti-terrorist measures of the Patriot Act are a piece of al-Qaeda legislation – and definitely not a way to resist it.

Towards Daesh Law

It was the same in France: the decision to incorporate the basic rules of the state of emergency into ordinary law was a way to attune the legal and police order to the one desired by Daesh – to grant them what they wanted by way of legislation. There is a direct analogy between state of emergency and police regime, after all; the main difference between the two is that the former is supposed to be temporary, while the latter is permanent, or else it is doomed. By translating the state of emergency into the daily legal diet of France, the government of Macron set out the basis for the type of political system Daesh

was longing for, and had been applying to the territories under its command. It was not only a total reversal of the declared intentions of the legislation put forward by the government, but was also a complete reversal of what Giorgio Agamben had conceived as a 'state of exception'.[10] There is a fundamental difference between state of emergency and state of exception, insofar as the latter implies the temporary suspension of the legal system, whereas the former only concerns certain provisions.[11] But in both cases, the situation is the one which allows law its own transgression – the law permits the temporary legalisation of what is, and is supposed to again become, illegal, so that this illegality can be overcome when needed. With the translation of the state of emergency into everyday law, the move was the opposite: it was not about authorising transgression for a brief moment, but putting transgression at the very core of law itself. It was about making transgression the truth of law, about defining law as its own permanent transgression – and not transgression as a mere possibility left to law to enforce or prohibit depending on the circumstances. It was not about negating law; it was about making law its own permanent negation – as if it were possible to consider law in such a way that its essence becomes transgression as such, that there could be no difference between the two anymore. Such a move was much more radical than that leading to the state of exception; the banalisation of the state of emergency was the banalisation of the fact that *there is no such thing as law*.

Put the Blame on Norm, Babe

Laws are what can be used to undo law – rules and regulations are the inner enemy of law, understood as what, in the endless knitting of bonds between persons and things, always exceeds the realm of normativity.[12] This is the main lesson of the 13 November 2015 attacks from the point of view of legal theory: through rules, it is possible to enforce a state of emergency within law in such a way that law becomes impossible. With the generalisation of the state of emergency, the world of the legal finally triumphs over the world of the juridical; what was left of potentialities in the functioning of law was replaced by police directives. The fact that it went broadly unnoticed is easy to understand; in France, the triumph of normativism over law had long been ensured by what still remains its main monument, namely the Napoléon Civil Code of 1804. Itself the product of a long tradition which finally led to the eradication of all the evils of law, summarised in the supreme legal

[10] Giorgio Agamben, *État d'exception. Homo Sacer, II, 1*, translated by Joël Gayraud (Paris: Seuil, 2003).

[11] On all this, see François Saint-Bonnet, *L'état d'exception* (Paris: PUF, 2001).

[12] Cf. Laurent de Sutter, *Après la loi* (Paris: PUF, 2018).

insult of modernity, 'casuistry', the Code marked the beginning of the reign of norms and rules over law itself.[13] Such a reign would see its theoretical justification when Hans Kelsen decided to apply the distinction between *Sein* and *Sollen* to the legal world – the distinction between Being, the object of legal science, and Ought, the object of legal norms.[14] However, the fact that the link between 'Ought' and law was a very recent one, and, furthermore, mainly defended by philosophers wanting to solve what they considered to be the shortcomings of legal practice, wasn't part of his theory. In fact, it was a theory designed to mask this historical novelty as well as its philosophical sources, and present it as an eternal feature of law, whereas it was only an addition – for the Romans, law had nothing to do with norms.[15] The Civil Code in France perfectly illustrated this foreclosing of the non-normative and operational dimension of law: a foreclosing making room for the possibility of imprinting upon law whatever normative desire authorities might nurture. After November 2015, this desire was crystal clear: it was the desire to see law serve its master without any chance of slipping from its grip – it was a way to show that there couldn't be any law outside of norms and their enforcers.

Jupiter Ascending 2

The problem was that this desire was also precisely the one animating the kamikaze terrorists acting under the Daesh moniker; negating law was the first step towards the definition of a new order whose sole purpose was the reign of the Ought. The only difference was that the Ought in question was not necessarily identical in its content; but from the point of view of the form, the actions of the French government were structurally akin to those of the terrorists themselves. The authorities had transformed law into a bomb whose power was to become the one of the God – be it the fantasised Allah evoked by the kamikaze, or the Jupiter under which Macron placed his own presidency. While he was running for President of France, Macron never ceased to repeat it: the mistake committed by his predecessor was that he wanted to be a 'normal' President; Macron, on the contrary, wanted to be a 'Jupiterian' President. As the Sun, in Japanese mythology, is the Queen of the Gods, Jupiter, in the Roman world, was considered the King of the

[13] Cf. Jacques Krynen, *L'état de justice. France, XIIIe–XXe siècle, II, L'emprise contemporaine des juges* (Paris: Gallimard, 2012). See also Michel Bastit, *Naissance de la loi moderne* (Paris: PUF, 1990) and Denis Baranger, *Penser la loi. Essai sur le législateur des temps modernes* (Paris: Gallimard, 2018).

[14] Hans Kelsen, *Théorie pure du droit*, translated by Charles Eisenmann (Paris and Brussels: L.G.D.J. – Bruylant, 1999).

[15] Laurent de Sutter, *Après la loi*, op. cit.

divine world – the god of gods, whose power was as radiant as it was without limits or boundaries. Where Amaterasu could count on Kamikaze to protect her sanctuary, Macron, as a Jupiterian President, thought he could count on law – except that this hope had already been colonised by the kamikaze themselves, in a fantastic short-circuit. Kamikaze acted in such a way that he destroyed the fleets of Kublai Khan; Macron acted so that he would destroy what, in law, was enemy to its power, namely law itself – a destruction made possible by the kamikaze attacks. The continuity between these events was the continuity of self-destruction as a means of seizing power, as a way of setting up the foundations of a new order, as a form of creation working at forgetting the extant state of affairs. In the case of a liberal democracy like France, this state of affairs was that of the rule of law; after the November attacks, it was clear that the rule of law, even in its liberal form, was not normative enough; what was desired was the rule of rule. The last remnants of law, of its mysterious and fragile regime of bonds and relationships, had to be got rid of – and this is what happened.[16]

Imagine It

There is a paradox at stake with this long process of self-destruction: it was a matter of symbols and images – of explosions saturating the mediasphere of a country and, beyond it, the entire Western world. The bodies themselves were remarkably absent from the story; from the terrorists to their victims, it is as if there was no body involved, but only a stream of newsflashes and social media posts serving as a body in themselves. The body of the terrorist event of 13 November 2015 was an image-body whose very quality, as an image, was to produce a visual effect of destruction going further than the actual destruction itself. Just as One World Trade Center has become the oversized monument to the former towers of the World Trade Center, the images of the event were the oversized monument to what had actually happened. But, as Jean Baudrillard pointed out apropos 11 September 2001, it is possible that nothing actually happened *but* these images – that these images *are* the event in itself, whereas the rest are only its by-products.[17] Indeed, he might be right: it is plausible to conceive that we have definitely entered the realm of the purely *imaginal* world – a world where there is nothing but the images themselves. The terrorists somehow knew it, since what they decided to target were not strategic locations, but symbolic places, that is, places whose importance only depends on how they fit into the self-image of a country. As kamikaze, they knew that the only way they could defeat their enemy was not by putting him

[16] Cf. Laurent de Sutter, *Magic. Une métaphysique du lien* (Paris: PUF, 2015).
[17] Cf. Jean Baudrillard, *L'esprit du terrorisme* (Paris: Galilée, 2001).

on his physical knees (which would be impossible), but by enabling him to initiate the process of his own self-destruction. This strategy of outsourcing could work only if the balance of forces was reshuffled – or the battlefield displaced to a space where physical resistance is without any importance; and this is precisely what happened. Law having always been about images and abstractions, ideas and theories, representations and concepts, there was nothing more fragile than its structure – or more attuned to the weapon that the terrorists decided to use. They produced an image of radical destruction, so triggering the long process of self-destruction of the image itself; they just needed someone to imagine it on their behalf.

Index